Tom Daley

Made with Love

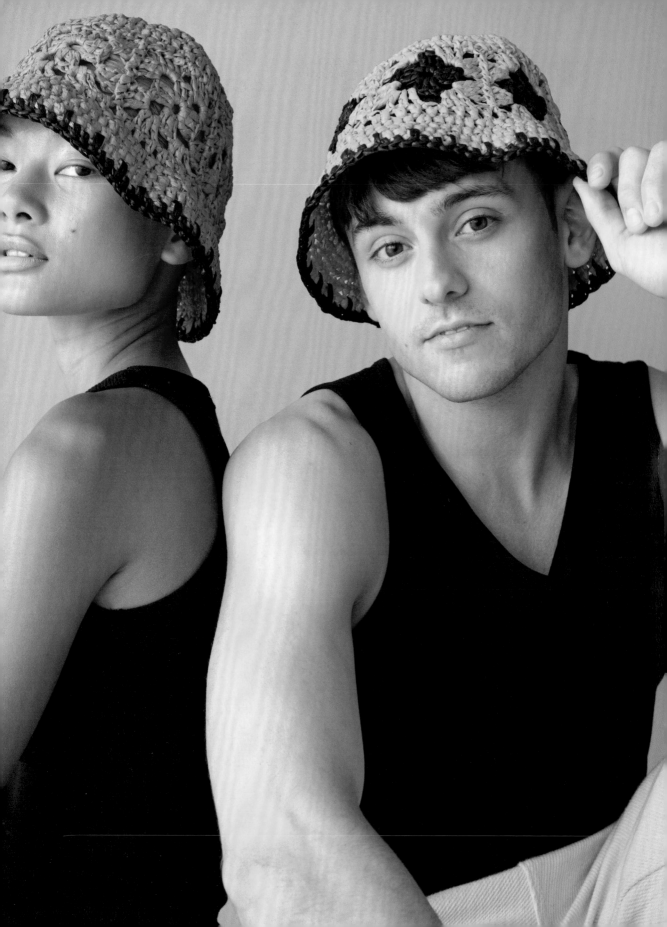

Tom Daley

Made with Love

Get hooked with **30 knitting** and **crochet** patterns

PHOTOGRAPHY BY DANIEL FRASER

Contents

TOM DALEY

MADE WITH LOVE

Introduction →

Without knitting and crochet
I wouldn't have won a gold medal
at the Tokyo Olympics. Now, I'm not
saying that I couldn't have done it.
I have been diving for 20 years and
Tokyo was my fourth Olympics.
Essentially I have been training for
my whole life to win Olympic gold.
I have put in an enormous
amount of effort and made many
sacrifices; it has not been an
easy journey, nor one without
preparation. However, it was the
calmness and focus that knitting
provided me when sitting up in the
spectator stands between events,
that helped to stop my mind
spiralling into anxious thoughts
and stay present in the moment,
aided by the rhythmic movement
of the stitches in my hands.

Team Great Knittin'

When the photographs of me knitting poolside at the Olympics went viral it felt quite surreal because I was just sitting there doing what I love to do, not thinking about anything or anyone else. I now wonder whether knitting and crochet may have been my secret weapons in that competition. There were no spectators at the event and our families were at home on the other side of the world, so for me, knitting gave me a concentration and a way to pass the time without getting stressed. I loved the fact that, after seeing me knit, other people thought about taking up knitting too and I was happy to be flying the flag for Team Great Knittin'!

When people talk to me about knitting or crochet – if they don't already knit or crochet themselves, (when they do they will usually get out their latest project to show me!) – they often say "I would love to do that, but it looks so complicated." I promise you do not need to be a crafting genius or have exceptional dexterity to have a go at knitting or crochet. They are both simply a series of interconnected loops that are formed by a continuous length of yarn (that's just another term for wool, or cotton, or whichever fibre you choose!) using needles or a hook to create a pattern. With a bit of patience and concentration, anyone can do it!

When I first started knitting; I remember I found the hardest part was holding the needles and yarn at the same time as trying to make the stitches – I dropped loads along the way. My knitting looked atrocious but I persevered and as my technique improved, I fell in love with the simple joy of the craft. Now I knit in every spare moment I have. It has brought me so much pleasure and allows me to be mindful and focus on the task at hand. If you are focusing on knitting, counting stitches, and creating textures, there is no space for other thoughts to creep in, and it allows me to reset, like meditation.

It is also an incredibly creative outlet; your knitting can be whatever you choose it to be and it will always be unique to you. It allows me to step outside of mainstream fast fashion to make my own catwalk-inspired looks that are totally individual to me, and that I know I'm going to love and feel amazing wearing.

Knitting and crochet are about much more than just making something new to wear or to gift to a loved one. Every item I have knitted tells a story; from the sweater that I made during the lockdown in 2020 (I was so proud of making something I could actually wear!) to the Olympic cardigan I finished while competing at the games in Tokyo, my projects are filled with colourful memories of the times they were created, literally knitted into every stitch.

How I started

I first picked up a pair of knitting needles after my husband Lance suggested that it might be a good way of relaxing at the poolside during diving training and competitions. During the bigger competitions, there can be a lot of waiting around and, for me, this was when the worries started to take hold. Lance told me that a lot of actors knit during downtime on a film set as a way of taking their minds away from their work. I decided to have a go. At the start of 2020, I watched a YouTube video and then practised on the plane during a long flight to a competition in Canada. I attempted to knit a simple square, but I ended up with a scrap of fabric riddled with holes. It was a disaster! While I was in Montreal, two of the other springboard divers – one from Australia and the other from Russia – spotted my attempts and both helped me to get started properly. They sat alongside me and taught me the basics and my second effort looked much better. This taught me another lesson about knitting; it is universal and can create a natural trust and ease between crafters.

By the end of that trip, I had made a scarf and I haven't looked back since! The year 2020 was a time when many of us were at home – working, trying to keep busy or isolating – and with pools and training gyms closed, it gave me both the time and opportunity to practise my craft. As an athlete, I am continuously trying to develop and hone my skills. While it would be great to make lots of scarves to wear myself or gift to others, I realised that I wouldn't be progressing with the craft if that was all I made. So with each item I knitted, I tried to learn a new technique or stitch. In doing this, I became more confident in my ability. Through knitting, I found a new challenge, something separate and different to my diving, that allowed me to both switch off from existing worries, and also to keep my brain engaged on an activity. I found that once you begin to understand the mechanics of the stitches, you can make them work for you, find ways to correct mistakes and discover the determination to follow your projects through to the end. Hopefully, resulting in a cool new item of clothing or eye-catching accessory to show off. Not to mention a great sense of achievement and pride.

Since then, I have created hundreds of items for my friends and family, I have launched my own Made with Love knitwear brand, and I have designed and knitted the scarves for my friend, designer Daniel Fletcher's AW22 London Fashion Week show. I have also become a part of a really welcoming community of knitters and crocheters. It's such a sociable activity and everyone is so encouraging about each other's creations. It's like a safe space of totally different, but like-minded individuals all sharing brilliant colours, amazing designs, and exciting textures. It is a world I knew nothing about until I became a part of it. Now I never want to leave and I want to invite everyone I know to the party!

" **Learning to** *knit* **or to** *crochet* **is a** *gift* **for life.**

TOM DALEY

"

Meditate through making

Despite being a slow craft, all the knitters I know have loads of energy and find it really hard to sit still and I include myself in that description. I find knitting to be an easy way to focus on the task in hand, empty my mind of extraneous thoughts and simply relax, plus it is something productive to do in my free time. When I was most active and didn't know how to stop or recovering from an injury and forced to stop, it allowed me to slow down and put my feet up.

For many years I have meditated every day using apps like Headspace but knitting has given me a new space to be meditative and now I choose knitting over other forms of meditation. Though people have been knitting for centuries, it's only recently that knitting has been recognised by scientists for its therapeutic qualities. It has now been proven to have a host of physical and mental well-being benefits. Research has shown it can help with anxiety and depression, reduce stress, distract from chronic pain and reduce loneliness and isolation.

For me, I find knitting a way to reset, in the same way as meditation or using breathing techniques. It takes me away from everything else and completely quietens my mind because I have to focus on exactly what I am doing – both the pattern instructions and the repetitive movement – so there is no space for other thoughts. It is the perfect level of concentration and because it is so repetitive, it is very calming. If I am having a bad day, I can do ten minutes of knitting and re-start with a clearer and more positive outlook. I even sometimes use it as a tool between work tasks, so I start each one fresh. Knitting is ideal for those moments when you may otherwise mindlessly reach for your phone to scroll through your social media feed or head to the cupboard for a snack because you are bored. It facilitates a moment of peacefulness and productivity. I used to be a terrible nail-biter but since I started knitting, I have stopped gnawing at my nails.

Whilst some projects can take a long time to complete, and become UFOs (that's Un-Finished-Objects!) in your project basket, the slow-moving and gentle nature of yarn crafts is all part of the enjoyment. Okay, you can't knit a sweater in a day but when you do finish – whether that is many days, weeks or even months later – it just feels more rewarding. This is the whole beauty of it. Don't put any time pressure on yourself, just be present in the process.

I also love to take my knitting and crochet outdoors and it is the perfect portable craft for travelling too. During the Olympics, I would sit outside on my hotel balcony in Tokyo, when the sun was setting over the horizon, and knit. I find that being outdoors in nature adds another level of calm, so pick up your yarn and needles and head out to your backyard, garden or a local park to knit and see how you feel. But be prepared to be approached by fellow knitters and crocheters, who may not be able to resist taking a closer look and commenting on your work, or sharing their own stories.

One of the most wonderful things about knitting and crochet is that they can be really sociable activities, as well as solitary ones. A craft club can be a great way to meet like-minded practitioners, share stories, swap tips and improve your skills. Find a nearby group through your local yarn store, via Facebook or Ravelry, or why not set up your own knitting or crochet circle with friends. The Patchwork Blanket on pages 180–187, which is designed to be made in lots of separate sections and then pieced together, is a great way to start and collaborate with others, with everyone knitting a different patch.

Love

Made with...

Made with love for those you love

There is something truly special about making something by hand for a friend, loved one or new baby, or even a new pooch. With a handmade gift, you know that the person who made it has really taken time and care and been invested in each tiny stitch. Although it is very easy to go online and buy a gift with the single click of a button for next day delivery, creating a handmade gift takes time and effort that cannot be exchanged or imitated, and which the recipient will find all the more precious. Plus it will be the only gift like it on the entire planet, so it does not get more personal than that!

I love the fact that I can create something unique for someone, tailor made to suit their style and tastes and completely personalised to them. All of the projects in this book are designed to be recipes that you can adapt and customise to suit you or the person you are making it for, that's the beauty of making something by hand rather than buying "off the shelf". One of the first items I made was a scarf for my mum for Mother's Day and I was able to choose a purple yarn, which is her favourite colour. I have always found seeing the reactions of my friends and family when I gift them something that I have made really special and that's all part of the fun for me.

In *Made with Love*, I have included the patterns for some of my favourite items for gifting, from a knitted dog hat for that beloved pooch to a crocheted plant holder to carry a housewarming plant, I hope these thoughtful gifts will surprise and delight the recipient.

How I approach design

I love the process of choosing yarns, colours, stitch textures and shapes when making items for my favourite people. From picking out the softest and warmest fibres, to deciding on acid brights or soft pastel colours, it is so individual. I draw inspiration from so many places; from watching reels on Instagram to flicking through editorial fashion shoots in magazines, from couture collections on the runway to the street style I see every day outside my front door in London.

I love using vivid colours for my makes. Sometimes I find that when you are buying ready-to-wear from a store, the rationale is to buy black or grey or another muted colour that goes with everything. Or you are limited to those colours that the fashion brands have decided that everyone must wear that season. But if you are choosing to make something from scratch, you have the choice to put any colours you like into it. Plus with knitting and crochet, you can choose the fibre from which the fabric will be made too! For each project in this book, I have given the yarn and shade that I have used, but you can make it any colour or yarn you want – just make sure to work a tension swatch (see page 74) before you dive into the project if you are substituting the yarn. I have included some of my favourite contemporary pastels and popping neons alongside classic and dramatic monochromes. But if you want to substitute the colour for all black or bright pink and lime green? Go for it! Show your personality through what you make.

Once you have an understanding of how the different knitting stitches and techniques work and how to use them to create fabrics and shapes, you can get creative and experiment. One of the greatest things about knitting and crochet is that it really doesn't matter too much if something goes wrong. I have made many things in the past, where the sleeves didn't quite fit or the sizing came up a bit off. I even once made a sweater that I couldn't get over my head! If this happens, don't panic! You can simply unravel your work and start again. It's just another opportunity to practice your craft and improve your skills. My advice is always just to enjoy the process, even if it doesn't go right every time – it's all part of the knitting and crocheting journey!

How to Use This Book

Whether you have never picked up a pair of knitting needles or a crochet hook in your life or you are a seasoned pro, I hope this book will inspire you to take some time for yourself and to start a new project. I have included my favourite yarns and colours to make fun, original and vibrant creations – I hope you love them as much as I do!

My first craft book, *Made with Love*, is divided into two main sections: knitting and crochet. At the start of each section, I guide you through all the basics, from casting on your first stitches or making a foundation row to working the basic stitches through to fastening off, weaving in your yarn ends and sewing up a project. Then I share my favourite designs for creating quick to make accessories and simple homewares up to more complex garments, some with stitch textures, some with colourwork and some with both!

I also demystify the secret codes of knitting and crochet. It can sometimes look like a foreign language but once you get started, it's not as complex as it looks – I promise! I think it's a bit like learning an unfamiliar language or taking up a new sport – it just takes a bit of practice to become proficient. Have you ever heard of the concept of muscle memory? The more you repeat a movement, the easier you find it and soon it becomes second nature. Before long, you will be able to knit or crochet whilst chatting, watching Netflix, or even with your eyes shut. Give it a week or two and you'll be hooked (pun intended)!

The speed at which you decide to work through the projects in this book is entirely up to you. If you are a more experienced knitter or crocheter, you may wish to dip in and out of the designs that speak the most to you, but if you are a beginner, I would advise starting by checking the skill level assigned to each project.

Take as long as you need to hone each new skill and refer back to the 'how to' guides; knitting and crochet are both slow crafts and that's all part of the enjoyment. If you drop a stitch, make a hole, create a disaster... don't stress! You can always pick up a dropped stitch or unravel a few rows and re-knit them. Got pressing things to do that are not knitting-related? Although it will become hard to imagine what could be more important – don't worry about that either. You can always put the needles or hook down once you've worked a few rows and pick it up again as soon as you have a spare moment. Just be sure to keep your work safely away from pets, children and nosy housemates. Most of all, just enjoy the process and the endless possibilities of what you can create.

Happy making!

Sizing

All the garments in this book are designed to be unisex and inclusive for all. Many people think that unisex items lean more towards boxy men's shapes that women can also wear. I like to think of it almost in reverse – flattering shapes that anyone can wear. Ultimately, you should always wear whatever makes you feel good.

Choosing a garment size

Sometimes it can be tricky to know the right garment size to knit or crochet from a pattern. Don't just plump for your usual clothing size as that may not match the dimensions that the pattern designer has used – every garment is designed to have a certain amount of ease, which differs from project to project. Ordinarily, garments are listed in generic sizes, such as small, medium, large and so on, but they will also include key measurements, such as the chest measurement. Children's garments are more usually presented as an age range, from 4 to 5 years, for example.

If you're not sure what size to choose, my advice is this: for comparison, take the measurements of your favourite sweater, cardigan or other garment that is similar in shape and fabric weight to the one you plan to make. This garment can be as tight-fitting or as loose-fitting as you wish, but bear in mind the amount of ease that has been designed into the garment you plan to make. Lie your existing garment flat and measure the chest width. Now find the closest match to that width on the size chart – that is the best size for you and the one that you're going to highlight to follow.

Following the pattern instructions

Pattern instructions will be written in more than one size. The smallest will be first and sit just outside the parentheses and then the larger sizes will follow inside the parentheses. When there is only one figure given in the instructions, this will apply to all sizes. When there is a 0 listed, then no stitches or rows are worked for that specific size. Remember this: if your size is the second in the size chart, it will always be the second in any sequence.

To ensure you always work the correct size when following lengthy pattern instructions, I advise highlighting or underlining the figures that correspond with your size in the pattern. This includes the number of balls of yarn you will need to complete your project, the number of stitches to be cast on or made in the foundation row, the number of stitches or rows worked in a certain stitch pattern or colour, the number of times to repeat an instruction or the length of any section in centimetres or inches. Marking your specific size within the instructions simplifies reading the pattern as you work as your eyes can flick straight to the correct number. If your pattern is in a book like this one, you may want to photocopy the relevant page.

Checking your tension

Before you start any new project, always check your tension (see pages 74 and 234). If your tension varies from that given in the pattern by even one stitch or row, change your knitting needle or crochet hook size up or down accordingly otherwise your garment will end up a different size from the dimensions stated on the size chart. Over a larger piece, any difference in tension will be exaggerated.

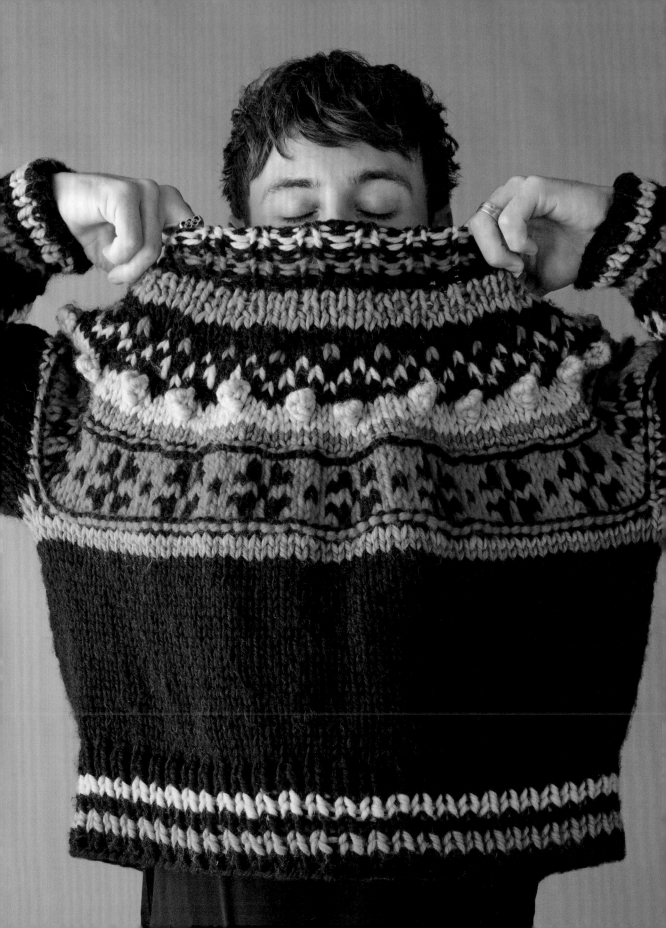

Yarn
Essentials

01-

There are many different types of yarns available in a multitude of fibres, colours, and textures. Yarn is one of my favourite things; I even got a yarn advent calendar one year for Christmas! When selecting the yarn for any project, the two most important factors are fibre and weight.

A quick guide

Fibre

Anything can be used as a yarn – as long as it is a continuous length that can be knitted or crocheted; it can be done. Yarns are broadly split into different categories.

1 • Animal fibres

Sheep's wool, alpaca, mohair, and silk are all examples of animal fibres. Wool is a firm favourite with knitters. Spun from the fleece of a sheep, it is durable and a great insulator so will keep you at the right temperature. It can also absorb moisture without feeling wet. Great for bobble hats in rainy weather! It can feel a bit scratchy against the skin, but different sheep breeds produce wool with various qualities. Merino wool is spun from the fleece of that breed of sheep and is softer than regular wool.

2 • Plant fibres

Cotton, hemp, bamboo, and linen are examples of plant fibres. These are non-allergenic and cooling, so are ideal for warmer months. Cotton is my go-to yarn choice for summer knits.

3 • Synthetic fibres

Nylon, acrylic, and polyester are all synthetic fibres. These tend to be inexpensive, wash well, and are easy to care for. These yarns are particularly hard-wearing so are ideal for items that you might use every day like cushions and throws. Synthetics are sometimes blended with natural fibres to enhance washability and strength. The synthetic fibres can help bind yarns like wool together to stop shedding or shrinking.

Whilst synthetic yarns may not seem as appealing as animal or natural fibres, they are becoming the go-to choice for vegans. If you are looking for yarns made from non-animal fibre sources or are concerned about the consumption of water or other natural resources in the production of some yarns, then there is an increasing number of synthetic options available.

Weight

All these fibres are spun to create yarns that are made up of one or more plies, or strands, twisted together. Some yarns are more twisted than others so have a slightly different quality, but generally it gives a yarn strength, making it harder to break when working with it.

Two single strands twisted together make a 2-ply yarn, or if eight are used, this would be 8-ply. The thickness of the yarn is decided by the thickness of the individual plies, not the number of plies, so a 4-ply yarn is not necessarily thicker than a single ply, but the general rule is the lower the number of plies, the finer the yarn. I love bulky roving yarns – which are long and narrow fibres – and some of the patterns in this book use the colourful Made With Love chunky yarn range that is really fun, as the projects work up so quickly. I just love the personality of these yarns!

While I prefer knitting and crocheting with bulky yarns as your work grows so quickly, chunky yarn isn't suitable for every project. Each yarn is classified as a certain weight, which refers to the thickness of the overall yarn. They can be lace weight or superfine through to super bulky or jumbo. As a general rule, the weights of yarns fall within standardised categories assigned by the Craft Yarn Council in the U.S. to help knitters and crocheters choose the right thickness of yarn to ensure every project is a success.

Yarn weight category and symbol	LACE 0	SUPER FINE 1	FINE 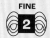 2	LIGHT 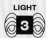 3	MEDIUM 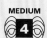 4	BULKY 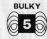 5	SUPER BULKY 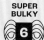 6	JUMBO 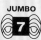 7
Type of yarns in category	2-ply (fingering)	3-ply (sock), baby	4-ply (sport), baby	Double knitting (light worsted)	Aran (worsted), afghan	Chunky (bulky), craft, rug	Super chunky (super bulky)	Jumbo
Knit tension (gauge) in stocking (stock-inette) stitch to 10cm (4 inches)	33–40 sts	27–32 sts	23–26 sts	21–24 sts	16–20 sts	12–15 sts	7–11 sts	6 sts and fewer
Recommended knitting needles in metric size	1.5–2.25mm	2.25–3.25mm	3.25–3.75mm	3.75–4.5mm	4.5–5.5mm	5.5–8mm	8–12.75mm	12.75mm and larger
Recommended knitting needles in U.S. size	000–1	1–3	3–5	5–7	7–9	9–11	11–17	17 and larger
Crochet tension (gauge) in double (single) crochet to 10cm (4 inches)	32–42 sts	21–32 sts	16–20 sts	12–17 sts	11–14 sts	8–11 sts	7–9 sts	6 sts and fewer
Recommended crochet hook in metric size	Steel hook 1.6–1.4mm	2.25–3.5mm	3.5–4.5mm	4.5–5.5mm	5.5–6.5mm	6.5–9mm	9–15mm	15mm and larger
Recommended crochet hook in U.S. size	Steel hook 6, 7, 8	B–1 to E–4	E–4 to 7	7 to I–9	I–9 to K–10½	K–10½ to M–13	M–13 to Q	Q and larger

Worsted is a medium-weight yarn and sits in the middle of the range. It is often used for hats, scarves, sweaters, and a myriad of other items because you can see the individual stitches. For beginners, I always suggest starting with a chunkier yarn, so bulky is my go-to choice. Once you have got to grips with the most comfortable way to hold the yarn and let it flow, your knitting will grow quite fast and that feels really rewarding.

Fibre choice is also important when starting out. Generally, I would recommend wool because it has a natural elasticity and is quite forgiving. A wool blend or super-wash wool is a good choice because as a blended synthetic fibre, it flows more easily. Cotton is also lovely to work with because it is strong and unlikely to break but is flat with less stretch and a bit slower to knit with. I would go for something mid-range – a decent quality but not too expensive!

As part of the instructions for every project in this book, you will see the recommended weight of yarn to use. If you are shopping in store and don't know what you need – just ask. I would also consider the availability of what you need – the last thing you want to do is run out of yarn mid-project! In my opinion, it's best to buy a bit too much yarn so this doesn't happen and then use up any yarn remnants in smaller projects (see page 339 for my yarn stash-busting tips). Within the projects, there are a few smaller items that are ideal for smaller amounts of yarn.

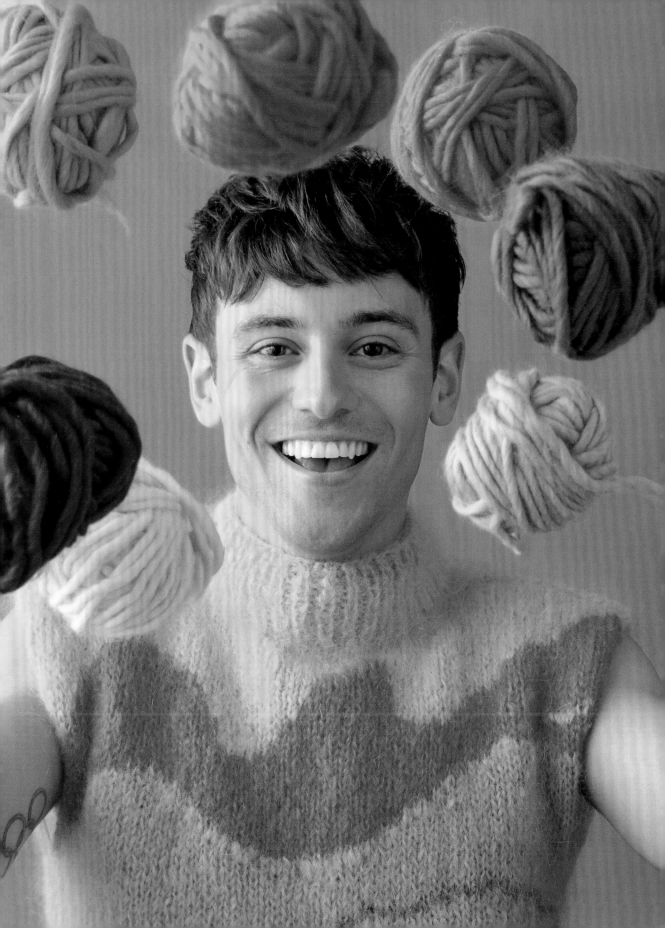

Label talk

Yarn is packaged in different ways, but it will always be accompanied by a yarn label, which is sometimes called a ball band. The yarn is wound like a ball, skein, hank, or on a cone – basically in different shapes – with a helpful label, which you must always read carefully.

Shade names and dye lot numbers

Some brands label their yarns with a code for each different colour they offer. I prefer to give the yarns in my range a name rather than a number for each shade. Some of those names mean a lot to me personally, like Aquatic Blue and Gold Medal, but they are also an evocative description of the shade of the yarn.

Knitters and crocheters sometimes talk about dye lots but what does this mean? Yarns are available in many different natural and dyed colours. A dye lot is a batch of yarn that has been dyed at the same time, so even if yarns have the same shade name or number, if they are dyed at different times, this means the colour could vary because of differences in temperature, dyeing time, and other factors. When you are buying yarn, make sure all the balls or skeins have been dyed in the same lot (they will have the same unique number) so the colour of the yarn is consistent throughout your project.

TOM'S TIP:

If you are giving a knitted or crocheted item as a gift, always keep a ball band (yarn label) to pass on to the recipient so they know how to care for it and won't shrink it in the wash. Or if it's something for yourself or someone in your family, take a photo of the label so you can always go back to it and check the care instructions.

Reading yarn labels

Yarn labels are all slightly different and laid out in a variety of ways, but most packaging includes the following information:

 The name of the **brand**

 The name of the **yarn**

 The **weight category** of the yarn (and if the yarn is from a U.S. manufacturer, also the relevant Craft Yarn Council symbol)

 The **weight of the yarn** in grams or ounces that is packaged in the ball, skein, hank or cone

The **length of the yarn** in metres and/or yards

The **fibre content**, including the percentages of each type of fibre that makes up the yarn

 The colour information, including the **shade name or number** and the **dye lot number**

 The **recommended knitting needle or crochet hook size** to achieve the given tension (gauge)

The **recommended tension (gauge)**, including number of stitches and rows to 10cm (4 in) (see pages 74 and 234)

 Care instructions, including washing, drying, and ironing – these instructions apply to the yarn as to any finished knitted or crocheted item.

Buying yarn

Yarns are held together in various ways and packages for sale, and the general way they are presented is called "put-ups". This includes balls, hanks, and skeins in various weights.

Ball

A ball of yarn is usually wound roughly by hand into a spherical shape. The working end of the yarn is on the outside of the ball, which will move around a fair bit when in use.

Hank

A hank is an attractive, loosely wound coil of yarn that is then twisted into a rope. It is usually the more delicate yarns that are sold in hanks. Before working with the yarn, you need to untwist the hank and then wind the yarn into a ball by hand, or you can use a ball winder. As you wind the untwisted hank into a ball, check the yarn for any faults or knots.

Cone

These yarns are machine wound onto stiff cardboard or plastic cones. They can often be quite heavy as the cones can store large quantities of yarn.

Skein

In a skein, the yarn is wound into a loose, oblong or donut shape. Skeins are ready to use – just find the working end from inside the centre. A skein doesn't move around too much when in use.

Substituting yarn

Yarn substitution is a term that describes using a different yarn to the one recommended in the pattern. With so many yarns available, understanding how to substitute one yarn for another is so useful. It gives you lots more choice when thinking about your next project and sourcing supplies. There are several reasons why you may want to substitute a yarn – maybe you are looking for a vegan-friendly alternative to animal fibres, or a yarn that is more affordable, or the recommended yarn is no longer available. You may even spot a yarn that you love and want to make something with it. It took me a while to feel confident with subbing yarns, but here are my tips for things to think about:

1 • Check the tension

The first step is to always check the tension (gauge). You will need to knit or crochet a decent-size swatch before continuing with your project. As well as ensuring your swatch gives the right tension (gauge), the designer will have ensured that the stitch pattern works with the yarn to create a certain effect. Solid-coloured and smooth yarns will give greater stitch definition than multi-coloured or tweedy yarns, for example. Even if something is 5mm (¼ inch) out, it may have a real impact on the size of the shape of the garment or the finished item.

2 • Think about fibre

When subbing yarns, look for alternatives with a similar fibre content, so they have a tension (gauge) close to the recommended yarn. Any slight difference between yarns may have a big knock-on effect on the way the stitches look. Generally, plant-based fibres do not have as much stretch as animal fibres, unless they are blended with elastane, acrylic, or polyester. The same garment designed in stretchy wool will look quite different when made up in flat cotton. A common substitution is a wool yarn for a wool blend yarn.

3 • Calculate the meterage

It is important to check meterage (yardage) – the length of the yarn in the ball, skein or hank – compared to the one you are substituting. This is so you do not run out of yarn, midway through your project. Every pattern will tell you how much yarn you need, so divide the amount specified in the pattern by the meterage (yardage) of the balls you want, to know what number to buy.

4 • Weigh everything up

While it is a good idea to stick to the recommended yarn weight, it can be a case of experimenting. You can substitute two strands of lighter weight yarn for a single strand in a heavier weight. In this case, remember to calculate the amount of yarn in metres or yards needed to complete the project. Doubling up yarns to create an interesting colour or textural effect (see page 303). It is not always an exact science, so your tension (gauge) is the best guide.

Knit
Essentials

02-

One of the great things about knitting is its simplicity. Because you only need a handful of items to get going, I find it to be the perfect hobby when I am travelling a lot for my diving. Chuck it all in a bag and off you go! If you are like me then you're going to have a couple of projects on the go at the same time. I always have a bigger one, like a sweater or blanket, that I knit at home and then something smaller and portable, like a scarf or hat, that I can take with me to work on when I am on the move.

Knitting kit list

As the book goes on, I will tell you more about what I have learned about knitting. My initial advice is to start with the basics and grow your knitting kit as you learn and progress. When you first start it can be tempting to throw lots of money at beautiful needles and expensive yarn, but it makes more sense to buy items on a project-by-project basis and grow your knitting-essentials kit gradually.

As a bare minimum to start knitting, you need:

- Yarn
- Knitting needles
- Scissors
- Tape measure
- Yarn needle

You can buy these items almost anywhere including high street stores, the haberdashery section of department stores, large hobby and craft retailers, online specialists and, increasingly, I like to support independent and local spinners for quality small-batch yarns when I am not using my own yarns.

• Yarn

In the beginning, yarns might all look the same to you but in terms of knitting, there are big differences. As you become more experienced, you will learn what types of yarn suit certain projects and how they can ensure everything you knit is a success.

• Knitting needles

Needles come in various shapes, sizes, and materials. The most common materials are metal, wood, bamboo, and plastic. There are several metal options including aluminium, stainless steel, brass, or nickel. The different sizes are based on needle diameter – the smaller the size, the thinner the width. These come in slightly different sizes, whether you are in the UK or the U.S.

To start with, I think larger straight needles are better for beginner knitters, so I would suggest trying bamboo needles because they are easy to work with, a bit less slippery, warm, and quite gentle on your hands. Some yarns can stick to bamboo making it harder if you are a beginner, but they can hold more slippery yarns really easily. They are also strong and inexpensive. I also like the sound that they make; it is less metal on metal and more of a gentle tapping noise!

Some yarns will work better with certain materials and needle sizes, and generally heavier yarns are paired with larger-sized needles, whilst finer yarns are paired with thinner needles. Sharper points also make it easier to work with finer yarns, whilst rounder points are better for bulkier yarns and safer for kids. Check any pattern instructions for the suggested needle size. I would always say to experiment with material and length, as the more you knit, the more you will discover about how to create the type of knitted fabric you love.

As well as straight needles, there are other styles:

Circular needles

These are two tapered needles connected by a flexible cord and are used to knit in a continuous round, for projects like sleeves, hats, and sweaters. Like straight needles, they are available in different sizes. With these, the weight of the work rests in your lap, so there is less strain on your hands, shoulders and arms so if you are making something big, like a blanket, I would always recommend using these. You are also less likely to drop a needle on the floor if you are knitting on the move. I love using circular needles.

Double-pointed needles

These needles (abbreviated to dpns) have a point at each end and come in packs of four or five. With these needles, stitches can be worked with one end and can be removed from the other end, avoiding the need to turn your work at the end of each row. They are used for knitting things in the round that are too small for circular needles, like socks. As a general rule, I prefer to use a circular needle with a smaller connecting wire rather than dpns for making smaller items, but this is down to individual preference.

Cable needles

These are very short needles with points at each end, and sometimes a bend in the middle, which are used to make a cable pattern by holding the stitches you are not actively using. Most people have two cable needles – one thin and one thick.

- ### Scissors

A small pair of scissors is an essential item, so you can snip as you go.

- ### Tape measure

This is necessary so that you can check your tension (gauge) square and measure the dimensions of your work. A wooden ruler can also be useful to check tension as, unlike a dressmaker's tape measure, it will not stretch and distort over time.

- ### Large-eyed yarn needle

You will use this needle to sew in any loose yarn ends and join your project pieces together (like joining together the front and back sides of a sweater). They come with large eyes so the yarn passes through them easily and are also slightly blunt at the tip so that they don't split the yarn. These needles come in packs where there will be a variety of sizes, just make sure the eye you of the needle you use is easily large enough to thread the yarn through.

- ### Other items

If you can see yourself getting the knitting bug, here are some other pieces you might like to collect. I found that I acquired them slowly as I gained more experience. They are not essential but good to have!

Stitch holders

These hold open stitches when you are completing another part of your knitting or need your needles for another project. You can always improvise using safety pins, nappy pins, or even paper clips!

Stitch markers

These are handy little tools that you can use to identify an important place in your knitting or keep track of increases and decreases. They come in different shapes and colours to fit your needles. If I am doing a project where I have to count lots of rows (like a 200-row project), every 10 rows I will clip on a safety pin-style stitch marker so I know where I am.

Row counters

Some stitch patterns are complicated, so row counters can help you keep track of which row you are on. With each row, you turn the wheel to the next number until you complete the required amount. You may prefer to write it down with a pen and paper (this is what I do).

Crochet hook

You will need a crochet needle for picking up dropped stitches in your knitting. Like knitting needles, crochet hooks are available in different sizes.

Pins

These are used to hold pieces of knitting together before you sew them. Long, thick pins with large, coloured heads are easier to see and less likely to split the yarn.

Blocking board and blocking pins

Blocking helps to ensure that your knitting lies flat with lovely, neat edges. It is also a technique used to stretch and shape a piece of knitted fabric to the dimensions given in the pattern instructions. When you steam or spray block a knitted piece, you can manipulate it into the right shape and size. This also makes sewing up or finishing the garments easier. These boards come in a range of sizes and the pins will help you pin out the edges of your project. Blocking can also be done with a towel on a flat surface but having a board does make it easier.

Needle size gauge

This knitting gadget will tell you what size your needles are if you poke them in the hole until you find the one that fits. This is useful if you use vintage needles that can be picked up cheaply in charity shops and thrift stores.

Bobbins

These are little plastic frames that around which you can wrap different coloured yarns. They are handy if you do a lot of colourwork because it means you don't have to work with full balls of each colour. Instead, you can wind off amounts of each one. I don't personally use them. I just have everything laid out on a table. Complex colourwork is not an on-the-go project!

Pompom maker

There are loads of ways to make pompoms. Clip-together pompom makers are really easy to use, but sometimes I make them using two circles of cardboard or even by wrapping the yarn around my fingers.

Point protectors

These little rubber caps that cover the points of your knitting needles when you are not using them help to keep your stitches on your needles securely as your masterpiece progresses. This is a must-have if you are like me and always on the go or when you have small children who like to pick things up!

Of course, you can add anything else you fancy to this kit list. You will find that craft shops, both online and on the high street, will be filled to the brim with tantalising tools and gadgets.

Knitting basics →

Right. It's time to get knitting. Grab your needles and some yarn and stick with me as I talk you through the basic techniques.

KNITTING

Holding the needles

If you are a beginner, the first question you are probably wondering is, 'How do I hold my knitting needles?' There is no right or wrong answer, but I would always advise trying some different techniques and seeing what feels most natural to you. Don't be afraid to hold them in your own way! The most common ways to hold the needles are:

Like a knife

Pick up the needles with your hands resting lightly on top of the needles and tips pointing towards each other. Your hands should be near the tips of the needles, but not right at the ends. This is the way I hold my needles. The downside of this holding style is that you have to lift your right hand off the needle to wrap the yarn around the tip of the needle, so it can be a bit slower and harder to maintain an even tension.

Like a pencil

Hold the working needle as if you are holding a pencil, with your thumb and forefinger lightly gripping the needle close to the pointed tip and the shaft resting at the base of your thumb, with the tips pointing towards each other. Hold the needle that contains the stitches about to be worked with the 'knife' grip. With this technique, you do not need to let go of the needles when working a stitch but simply slide your right hand forward to manipulate the yarn. With this holding style, it can be easier to maintain an even tension and consistent flow of yarn.

Holding the yarn

Just as there is no single right way to hold the needles, there are different ways of holding the yarn around your fingers to control the tension, so you can produce even stitches. The aim is to achieve a constant flow of yarn that is neither too tight or too loose. You can hold the yarn in either your left or right hand.

Holding the yarn in your right hand

Holding the yarn in your right hand (or RH) is called the English style or 'throwing' and most beginners find this way the easiest to learn. Hold the needle that is carrying the stitches in your left hand (or LH) and the wrap the yarn around your fingers in one of the following three ways.

Method one: With your palm upwards, wind the yarn over the little finger of your RH, under your third finger, then over your centre finger and under your index finger. When knitting, use your RH index finger to wrap the yarn around the point of the needle to work a stitch and control the tension of the yarn.

Method two: With your palm upwards, wind the yarn around the little finger of your RH, under your third finger, then over your centre finger and under your index finger. When knitting, use your RH index finger to wrap the yarn around the point of the needle to work a stitch and control the tension of the yarn.

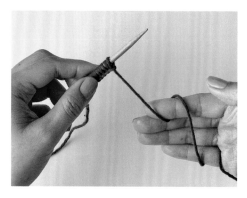

Method three: With your palm upwards, wind the yarn around the little finger of your RH, over your third and centre fingers, then around your index finger. When knitting, use your RH index finger to wrap the yarn around the point of the needle to work a stitch and control the tension of the yarn.

Holding the yarn in your left hand

Holding the yarn in your left hand (LH) is called the Continental style or 'picking'. Hold the needle that is carrying the stitches in your RH, then wind the yarn around your fingers in one of the following ways.

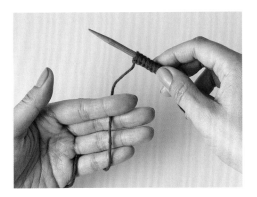

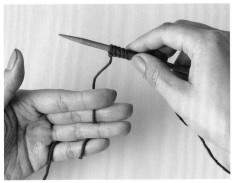

Method one: With your palm upwards, wind the yarn around the little finger of your LH, over the third and centre fingers, then under your index finger. When knitting, use your LH index finger to wrap the yarn around the point of the needle to work a stitch and control the tension of the yarn.

Method two: With your palm upwards, wind the yarn around the little finger of your LH, under the third finger, over the centre finger, then under your index finger. When knitting, use your LH index finger to wrap the yarn around the point of the needle to work a stitch and control the tension of the yarn.

(TOM'S TIP:)

The way you knit is exactly the same whatever yarn holding technique you choose to use. Always use the way that feels most comfortable to you. I have the yarn running between my index and third fingers to control the tension and let the yarn run through my hand. I just find this the most natural way for me.

Making a slip knot

Almost every knitting project starts with a slip knot, which is counted as the first cast-on stitch. The slip knot acts as an anchor for the rest of your knitting.

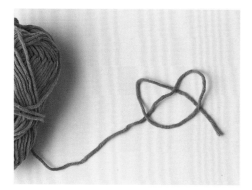

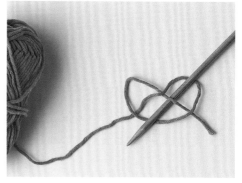

One: With the yarn end on your right, unwind about 15cm (6 inches) from the ball. Make a loop by forming an upside-down U-shape and folding the right side goes over the left side. Place the yarn at the back of your loop.

Two: Put your fingers through the loop making it larger and pull through the yarn to form another U. Slip the loop onto your needle and pull the tail of the yarn so the knot lies at the base of the loop – this is your slipknot.

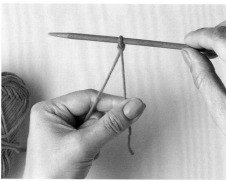

Three: Pull the yarn that is attached to the ball to tighten the slipknot, and you're ready to start knitting.

Casting on

Casting on is the term used to describe putting the first row of stitches onto your needles, so you can start creating your masterpiece. There are many ways to cast on, so ask a few different knitters and they will give you different ways to cast on. Some are worked with one needle and others are worked with two. Whatever method you use, do not cast on too tightly; your stitches should be able to move freely up and down your needle. My favourite method is the long-tail cast on.

Thumb cast-on method

This is one of the easiest ways to cast on. It is done with just one needle and produces a cast-on edge that has good elasticity.

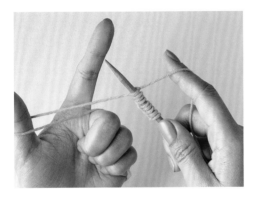

One: Start with a slipknot and place it on the RH needle leaving a yarn end with enough length to make all the stitches (around 2.5cm or 1 inch) per stitch. With the needle in your RH grab the yarn tail (not attached to the ball) with your LH, making a thumbs-up sign. Wind your thumb behind the yarn.

Two: Touch the needle to the front of your thumb and slide the tip into the loop from the bottom. Wrap the working end of the yarn (attached to the ball) around the needle in an anti-clockwise direction (from the back to the front).

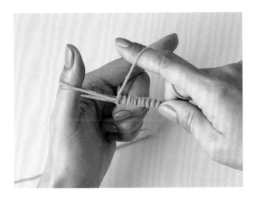

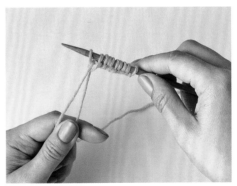

Three: Slide the loop on your thumb up and over the tip of the needle, then slip your thumb out of the loop.

Four: Pull the yarn tail to tighten up the new stitch. Repeat until you have the required number of stitches on your needle.

Cable cast-on method

This cast-on method is a specific way of casting on for stocking stitch patterns. It has a firm and decorative edge and is good for items like blankets.

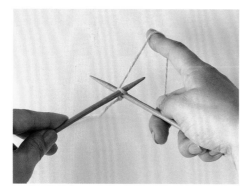

One: Make a slipknot and place it on your LH needle. With the working end of the yarn in your RH, put the tip of the RH needle into the stitch on the LH needle. Wrap the yarn around the RH needle anti-clockwise and draw it through to the front as if to knit, but do not slip the stitch off the end of the needle.

Two: Bring the RH needle towards you and pull on the stitch to make it a little larger. Transfer the new stitch to the LH needle – you now have two stitches.

Three: To make the next stitch, put the tip of the RH needle between the two stitches on the LH needle. Wrap the yarn anti-clockwise round the RH needle again, then draw it through to the front.

Four: Pull the needle towards you as before and transfer this stitch onto the LH needle – you now have three stitches. Repeat the last two steps until you have the right number of stitches on your needle.

Long-tail cast-on method

This is my favourite way of casting on because I think it is the quickest and most secure. It provides a firm and elastic edge and is also a good way for beginners to learn. I also think it looks really neat.

One: Make a slipknot and place it on your RH needle, leaving a long tail of yarn. Ensure the tail is facing towards you and insert your LH thumb and index finger between the two strands of yarn.

Two: Close your fingers around the yarn and insert the RH needle under the loop of the strand that is wrapped around your thumb.

Three: Then scoop up the loop that has been formed around your index finger and bring it down.

Four: Bring your yarn out through the thumb loop and tighten the loop on the needle to form the new stitch.

Basic stitches →

Once you have cast on, you can start to knit. There are two main knitting stitches – the knit stitch and the purl stitch. These two stitches can be worked in different combinations to create various textures or knitted fabrics, or stitch patterns.

KNITTING

Knit stitch

The knit stitch is the basis of most other stitch patterns – a bit like a front dive, I guess! Learn this one and you will be a pro-knitter in no time. In any pattern, knit is abbreviated to k, so k1 means knit one stitch, while k1 row translates to knit one row.

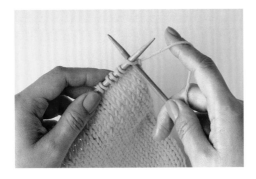

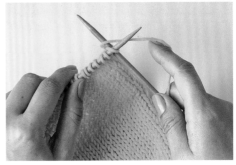

One: Hold the needle with the cast-on stitches in your left hand (LH) with the working yarn (attached to the ball) at the back of the needle. This should be approx. 2.5cm (1 inch) from the tip of the needle. Insert the point of the right hand (RH) needle into the first stitch on the LH needle, from front to back and under the LH needle.

Two: Wrap the yarn around the point of the RH needle, in an anti-clockwise direction (from the back to the front), so the yarn slides between the two needles.

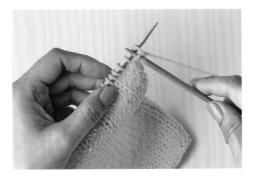

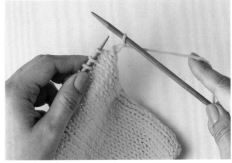

Three: Pull the RH needle towards you and slip the tip under the LH needle to form a loop – you now have one loop on the RH needle. Slide the stitch just worked off the LH needle by gently pulling the RH needle to your right.

Four: Gently tighten the yarn as necessary. Repeat until you have a full row of knit stitches on the RH needle. Start a new row by transferring the needle holding the stitches back into your LH and creating a new row of stitches on the RH needle.

TOM'S TIP:

For left-handers, you need to reverse the right-handed knit stitch, so move the yarn from the right to the left by wrapping the yarn clockwise – instead of anti-clockwise. The yarn should be at the back and you should end the stitch from front to back.

Purl stitch The purl stitch is an equally important stitch. Purl is abbreviated to p, so p1 means purl one stitch. If you purl every row, the finished fabric will look the same as knitting every row, except the process is much slower.

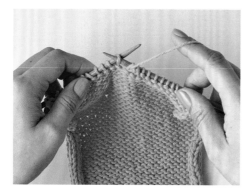

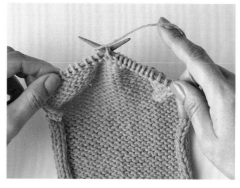

One: Hold the needle with the cast-on stitches in your LH, with the working yarn (attached to the ball) at the front of the needle. Insert the tip of the RH needle into the first stitch on the LH needle, from back to front (rather than front to back as with the knit stitch).

Two: Wrap the yarn around the RH needle in an anti-clockwise direction, finishing with the yarn in front of your needles again.

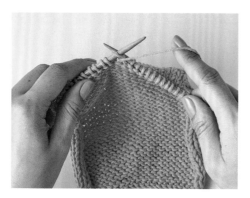

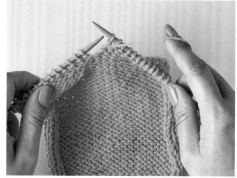

Three: Slide the RH needle down and behind the tip of the LH. Slide the stitch just worked off the LH needle by gently pulling the RH needle to your right.

Four: Gently tighten the yarn as necessary. Repeat until you have a full row of purl stitches on the RH needle. Start a new row by transferring the needle holding the stitches back into your LH and creating a new row of stitches on the RH needle.

Joining in a new ball of yarn

When you have finished one ball of yarn, you will need to add a new ball to carry on knitting. It is the same technique used as when you are re-joining yarn to stitches held on a stitch holder or starting a different colour and it is always best to make the change at the end of a row, leaving a tail of about 10cm (4 inches).

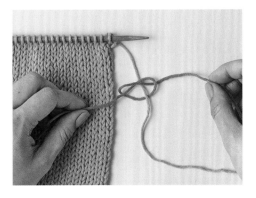

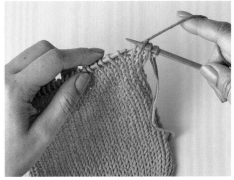

One: Place your work down and make a cross shape with the new yarn under the old working yarn. Loosely tie the new yarn in a knot around the old yarn. Slide the knot up until it is next to the knitting needle. Tighten the knot by pulling both ends of the yarn.

Two: Start knitting with your new yarn – easy! Where you have added in a new yarn or changed colour, you will be left with loose yarn ends that will need to be sewn into your knitting to secure them, so they don't unravel (see page 88).

TOM'S TIP:

When you're first learning to knit, count your stitches after each row to ensure that your knitting is correct and you haven't dropped any stitches. Always complete an entire row of stitches before putting your needles down. So, if someone calls or WhatsApps you, don't be tempted to answer as you will quite likely forget where you were.

Increasing and decreasing →

Increasing and decreasing stitches means adding or reducing the number of stitches to increase or decrease the width of your knitting, which can give it an angled shape or turn a flat fabric into something more three-dimensional. So, if you are making a sweater or cardigan, for example, this will help to shape it. Increasing and decreasing can also add an attractive detail to your design.

KNITTING

Increasing

Some methods of increasing stitches make more of a visual impact than others. The most popular ways are knit front and back (kfb) and make one (m1). The main difference is that with kfb two stitches are made from one existing stitch and m1 makes the increase from the horizontal strand between two existing stitches. The results look quite different, so it is important to use whatever increase has been specified in the pattern to ensure that the finished item looks like the designer intended. I know increasing might sound terrifying, but once you have done it a few times, you will soon get the hang of it!

Knit front and back (kfb or inc)

This increase turns one stitch into two by knitting into both the front and back of the loop. However, it does leave a visible bar of yarn across the base of the increased stitch, which is why it is also known as a bar increase. This method of increasing is commonly used in sweater patterns, but it creates a slight hole where the increase is worked and so is best worked on the edge where the knitting will be incorporated into a seam.

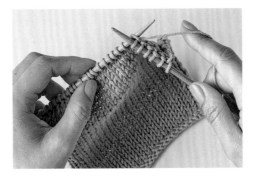

One: Make a knit stitch in the front of the next stitch on the LH needle in the usual way, but do not slide off the original stitch.

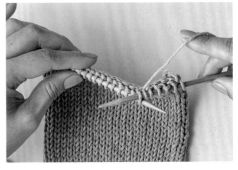

Two: Then insert the RH needle through the back loop of the same stitch on the LH needle.

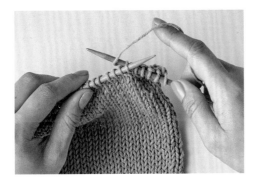

Three: Bring the yarn from behind and wrap it around the point of the RH needle in an anti-clockwise direction. Draw the yarn through the loop by going into and out of the stitch (in the same way you would make a knit stitch).

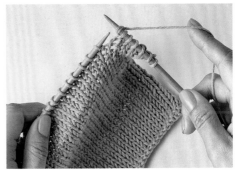

Four: Slide the original stitch off the LH needle – you now have two stitches.

Purl front and back (pfb or inc)

As with the equivalent technique on a knit row, this increasing method on a purl row leaves a visible bar at the base of the stitch and a slight hole, so again, it is best worked on the edges of a garment where it will disappear into a side seam.

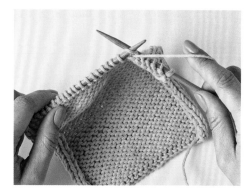

One: Make a purl stitch in the front of the next stitch on the LH needle in the usual way, but do not slide the original stitch off the LH needle.

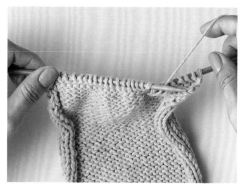

Two: Angle the RH needle backwards, then insert it through the back loop of the same stitch on the LH needle.

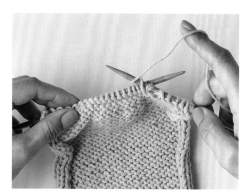

Three: Wrap the yarn around the point of the RH needle in an anti-clockwise direction. Draw the yarn through the loop by going into and out of the stitch (in the same way you would make a purl stitch), then slide the original stitch off the LH needle. You have now increased by one stitch.

Make one (m1)

This increase is made by making use of the bar in between two stitches. A make-one-left (m1l) picks up the loop front to back and knits through the back loop. A make-one right (m1r) picks up the loop from back to front and knits through the front loop. Some patterns do not state which method to use, so check to ensure you are using the best increase method.

Make one left (m1l) on knit row

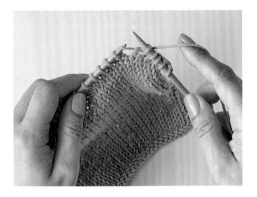

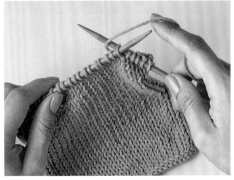

One: Insert the LH needle under the horizontal strand running between two stitches from front to back. Lift it onto the LH needle.

Two: Insert the RH needle knitwise into the back of the loop formed by the lifted strand of yarn on the LH needle.

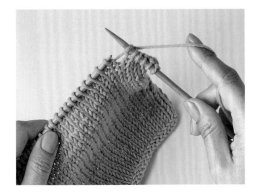

Three: Knit that loop of yarn just as you would knit through the back loop. Slide both stitches off the LH needle. You have now increased by one stitch.

Make one right (m1r) on knit row

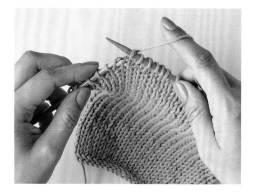

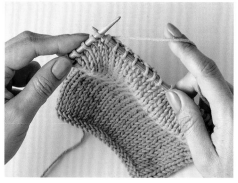

One: Insert the LH needle under the horizontal strand running between two stitches from back to front. Lift it onto the LH needle.

Two: Insert the RH needle knitwise into the front of the loop formed by the lifted strand of yarn on the LH needle.

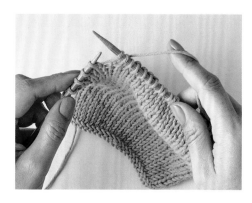

Three: Knit that loop of yarn just as you would knit a regular stitch. Slide both stitches off the LH needle. You have now increased by one stitch.

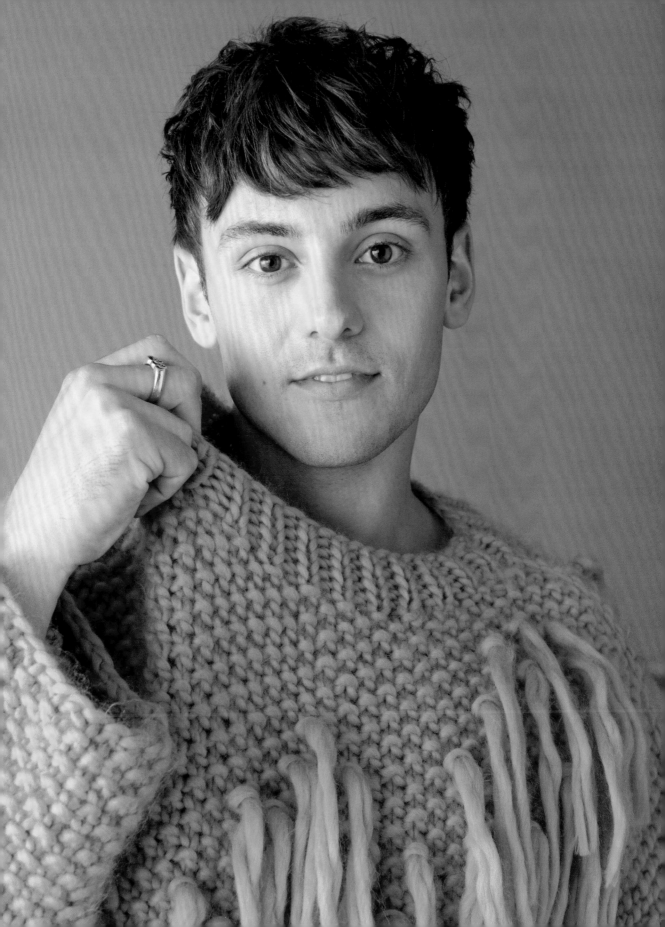

Decreasing

In the same way you shape garments by increasing stitches, there will be times you need to decrease to shape your project. As a general rule, decreases are made so that they slope in the same direction as the edge of the knitted fabric for a neat look.

Knit two together (k2tog)

The most common way of decreasing is to pick up two stitches and knit them together to become one stitch. This is called knit two together (k2tog) and creates a decrease that slopes to the right. You can also purl two together (p2tog). This can be done at the start, end, or middle of a row.

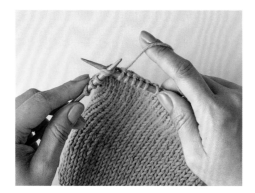

One: Instead of inserting the tip of the RH needle into one stitch, insert it into two stitches at the same time, from left to right.

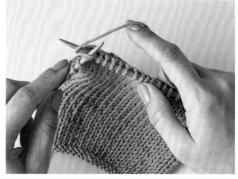

Two: Wrap the yarn around the RH needle just as you would when knitting a single stitch. Draw the loop of working yarn through both stitches.

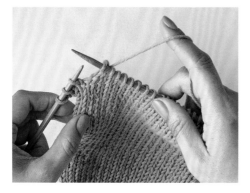

Three: Complete the stitch as normal by dropping both stitches off the LH needle. You have now decreased by one stitch.

Knit two together through back loops (k2togtbl)

This way to decrease is similar to k2tog, except you knit into the back of the stitches. It creates a decrease that slopes to the left. You can also purl two together through the back loop (p2togtbl), which is the corresponding right-leaning version of p2tog.

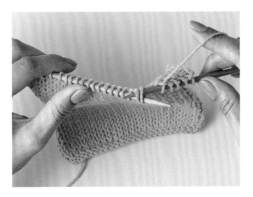

One: Instead of inserting the tip of the RH needle into one stitch, insert it into two stitches at the same time at the back of the work, from right to left.

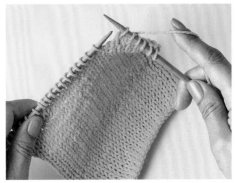

Two: Wrap the yarn around the RH needle just as you would when knitting a single stitch. Complete the stitch as normal, leaving just one stitch on the RH needle.

Purl two together through back loops (p2tog tbl)

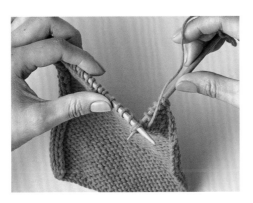

One: Insert the tip of the RH needle through two stitches at the same time at the back of the work, from left to right.

Two: Wrap the yarn around the RH needle just as you would when knitting a single stitch. Complete the stitch as normal, leaving just one stitch on the RH needle.

Slip one, knit one, pass slipped stitch over (s1 k1 psso)

Whereas k2tog creates a decrease that slopes to the right, this method of decreasing slants to the left and so k2tog and k2tog tbl are often used in tandem on opposite sides of a garment to create symmetrical shaping.

One: Insert the RH needle knitwise into the next stitch on the LH needle and slip it onto the RH needle.

Two: Knit the next stitch on the LH needle in the usual way.

Three: Using the LH needle, lift the slipped stitch on the RH needle over the stitch just knitted, then slide it off both needles. You have now decreased by one stitch.

Slip slip knit (ssk)

This is another left-sloping decrease and the mirror image of k2tog. You can also slip slip purl (ssp), which is the mirror image of a p2tog. This can be done at the start, end, or middle of a row.

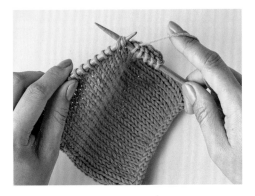

One: Slip two stitches knitwise from the LH needle onto the RH needle without knitting them.

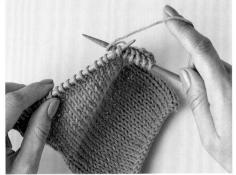

Two: Insert the LH needle in the front loops of these stitches. Wrap the yarn the normal way around the RH needle and knit the two stitches together to form one stitch.

Slip slip purl (ssp)

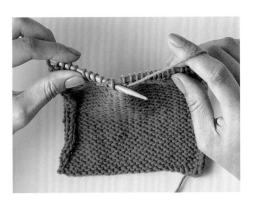

One: Slip two stitches purlwise from the LH needle onto the RH needle without purling them.

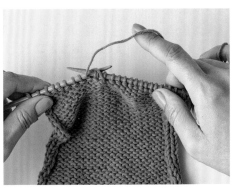

Two: Insert the LH needle in the front loops of these stitches. Wrap the yarn the normal way around the RH needle and purl the two stitches together to form one stitch.

Navigating your knitting →

This is not reading a knitting pattern or charted instructions but simply looking at your knitting to make sure you are doing it correctly. You need to be able to understand and identify the stitches, so you can understand what you have done, know where you're going, and spot any mistakes.

KNITTING

Counting and marking stitches and rows

It is good practice to keep a count of the number of stitches in a row and the amount of rows that you have worked in your knitting. Checking the number of stitches can be done easily by counting the loops on the needle, whereas to count rows you need to be able to identify the individual stitches. Often a pattern instructs you to work a certain number of rows and if you haven't kept a tally as you work either on a row counter or paper, then you will need to do a row count to doublecheck.

Counting on stocking stitch

To count the stitches on stocking (stockinette) stitch, look for the 'V' shapes. Each V made of two diagonal strands is one knit stitch. To identify the number of rows, simply count the 'V's from the bottom to the top of your knitting. Ignore the cast-on row at the bottom edge.

Counting on garter stitch

Counting on garter stitch is trickier because of the peaks and valleys. The peak is one row and the valley represents another, so count each from the bottom to the top of your knitting to determine the number of rows. Ignore the cast-on row at the bottom edge.

Counting on stitch patterns

Each curved horizontal line represents a purl stitch and each V-shape represents a knit stitch in moss (seed) stitch. Once you have learned how to identify the two, you will find it easy to count rows in other textured stitch patterns.

Casting off →

You've made it to the end
and finished a knitted piece?
Well-done! Casting off, as it is
known in the UK, or binding
off if you are in the U.S., is
the term used for creating
an end to your knitting so the
stitches can be secured and
will not unravel. This is the
way that I cast off all the time.

KNITTING

Casting-off (binding off) knitwise

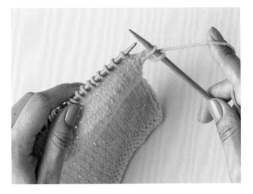

One: To cast off (bind off), start a new row and knit two stitches. Remember that it has to be two stitches!

Two: Slide the LH needle into the first stitch that has just been knitted. Lift it over the second stitch and off the needle. There is now one stitch on your RH needle – the other one has been cast off (bound off).

Three: Knit one more stitch so you have two stitches on your RH needle and repeat the process. When you only have one stitch left, cut off the yarn giving it at least a 15-cm (6-inch) tail.

Four: Pull the stitch over the yarn tail and pull the tail all the way through. Tighten it all up to secure. Depending on what the piece is for, the long yarn end can be used to sew together the project.

Casting off (binding off) purlwise

Depending on the pattern you are working from, you may be instructed to cast off (bind off) on a purl row, in which case you will need to work purl stitches that are then lifted over each other in the same way as casting off knitwise.

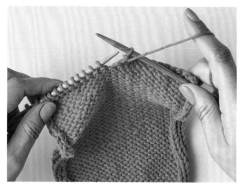

One: Start by purling two stitches in the usual way. Slide the LH needle into the first purled stitch from left to right, at the back of the work. Bring it over the top of the second stitch and off the needle.

Two: There is now one stitch on your RH needle – the other one has been cast off (bound off). Purl one more stitch so you have two stitches on your RH needle and repeat this process until you have one stitch left. Fasten off as for a knitwise cast off (bind off).

(TOM'S TIP:) ↓

When casting off (binding off) try to not do it too tightly, so keep your tension on your right needle looser than you would when knitting normally. Alternatively, go up a needle size to give the edge a bit more elasticity.

Casting off (binding off) on three needles

This is a useful technique when you need to cast off (bind off) two pieces of knitting together, for example to create a neat shoulder seam.

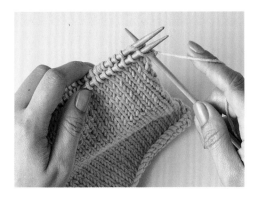

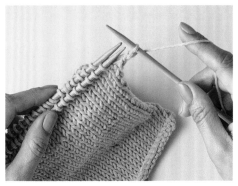

One: Hold the two pieces of knitting together in your left hand with their right sides touching. The points of the needles should be parallel and facing in the same direction. Using a third needle, slide the point of this needle into the first stitch of the knitting on the front needle and then into the first stitch of the knitting on the back needle.

Two: Wrap the working yarn from the front piece anti-clockwise around the tip of the third needle, then draw the loop through both stitches at the same time. Drop the stitches just knitted off their respective needles, leaving the new stitch on the third needle. Knit the next two stitches in the same way, so you now have two stitches on the third needle.

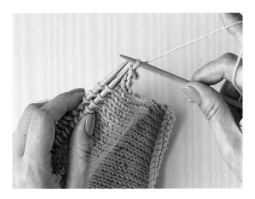

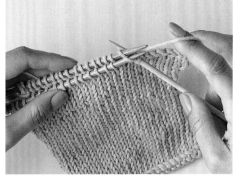

Three: Using the tip of one of the needles in your left hand, pass the first stitch on the third needle over the second stitch and drop that stitch off the third needle just as if you were casting off (binding off) knitwise.

Four: Knit the next two stitches from the front and back pieces together as before and repeat all the steps until you have one stitch left. Fasten off in the same way as for a knitwise cast off (bind off).

Stitch patterns every knitter should know →

The knit stitch and the purl stitch are the basis of creating all the other patterns and textures within knitting – you just need to know how to combine them to achieve the effect you want.

KNITTING

Go-to easy stitch patterns

Having the knit stitch and purl stitch in your locker opens up a whole range of stitch patterns, especially when they are used in conjunction with increases, decreases and yarn overs. Here are some of the most common ones to kickstart your repertoire.

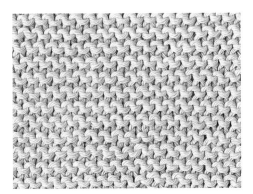

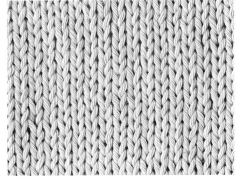

Garter stitch

This stitch is created by knitting every row. It forms a ridged pattern that is the same on both sides, other than at the cast-on edge. This is the perfect stitch for your first attempt at knitting and can be used in many different ways to create beautiful knitting. It creates a series of wave-like ridges, created with interlocking stitch loops. If your pattern does not tell you, you can choose your RS and for me, this is normally the side that has the first row of knitted stitches.

Stocking (stockinette) stitch

This is my favourite stitch pattern. It reminds me of my Christmas stocking when I was a kid. Stocking stitch, or stockinette stitch, is created by alternately knitting and purling rows. It creates different textures on each side of the work. The knit side is flat with small 'V's – this is the front or the right side (RS). The purl side is ridged and is the back or the wrong side (WS). Stocking stitch shows off the quality of the yarn, so it is often used for colourwork. With stocking stitch, the fabric naturally curls in at the edges, so it is often deliberately used to create rolled cuffs or hems, instead of rib.

Reverse stocking (stockinette) stitch

This is worked in the same way as stocking (stockinette) stitch except that you purl the first row and knit the second, so the front of the fabric is the ridged purl side and the back is the smooth knit side.

Moss (seed) stitch

Moss (seed) stitch is made up of single knit and purl stitches alternating both horizontally and vertically. This creates a versatile textured fabric that lies flat and is fully reversible, so it is popular for all sorts of items.

TOM'S TIP:

```
What is known as moss stitch in the
UK is called seed stitch in the U.S.
If an American pattern calls for
seed stitch or a British pattern
tells you to work moss stitch, it
is exactly the same thing. I know -
it's all a bit confusing!
```

Rib stitches

Rib stitch is a textured vertical stripe pattern that is used for flexible, elastic necklines, hems and cuffs on garments, as well as scarves and hats. It is made by knitting and purling stitches in one row, then purling and knitting the same stitches in the next row to create alternate columns of knit and purl stitches. The different types of rib stitches are worked using varying combinations — any pattern will tell you what combination of stitches to work and in what order. Rib stitches create a lovely stretchy fabric. The stretchiness will depend on the column width — the narrower the column the stretchier the fabric.

Single rib stitch (1x1 rib)

Double rib stitch (2x2 rib)

Single rib stitch, which is often abbreviated to 1x1 rib, alternates single knit stitches with single purl stitches, creating thin columns. The main thing to remember as you alternate stitches is to move the yarn after each stitch: it needs to be at the back of your knitting for each knit stitch and at the front for every purl stitch worked.

Double rib stitch, or 2x2 rib, alternates two knit stitches with two purl stitches. This creates a fabric that is slightly less stretchy than single rib stitch. This stitch pattern is best worked over a multiple of four stitches.

TOM'S TIP:

If you don't take the yarn forwards and backwards between the rib stitches, you will be left with extra loops lying across the needle. Count your stitches carefully at the end of each row and if there are too many, this might have happened!

Reading a knitting pattern →

Once you have tackled the basics – casting on, knit, purl, and casting off (binding off) – you'll be ready to start your first project. The first time I looked at a knitting pattern, it looked completely incomprehensible. However, over time I got the hang of working out what I needed to know. There are loads of abbreviations and knitting terms and once you have used them a few times, they will be super-easy to understand.

KNITTING

Understanding knitting abbreviations

Knitting patterns commonly use abbreviations, to make them quicker to read. So, k is knit, p is purl, co is cast on, and so on. Any abbreviation outside of the norm used within a specific pattern are usually included at the start of the instructions.

General

Instructions are written using UK terminology with the U.S. terminology given in round brackets () afterwards

[] instructions are given for the smallest size first, with changes for the larger sizes given in order within square brackets afterwards

() work any instructions within round brackets as many times as directed afterwards

* repeat instructions following the single asterisk as many times as directed afterwards

* * repeat instructions between asterisks as many times as directed or from a given set of instructions

alt alternate
approx. approximately
beg begin or beginning
bet between
cc contrast colour
circ circular
cm centimetre(s)
cn cable needle
CO cast on
cont continue
dec decrease or decreasing
dpns double-pointed needles
foll follow or following
g gram(s)
gt st garter stitch
in inch(es)
inc increase or increasing
k knit

k1b knit stitch in row below
kfb knit into front and back of a stitch – single knit increase
k2tog knit two stitches together
k2tog tbl knit two stitches together through back loops
kwise knitwise
LH lefthand
m marker
m1 or m1k make one stitch or make one stitch knitwise by picking up and knitting into back of loop between stitch just worked and next stitch – single knit increase

m1r make one right – right-leaning knit increase
m1l make one left – left-leaning knit increase
m1p make one purlwise
m1rp make one right – right-leaning purl increase
m1lp make one left – left-leaning purl increase
mb make bobble
mc main colour
meas measure(s)
oz ounce(s)
p purl
p2tog purl two stitches together
p2tog tbl purl two stitches together through back loops
patt pattern
pfb purl into front and back of a stitch – single purl increase
pm place marker
prev previous
psso pass slipped stitch over

p2sso pass two slipped stitches over
pwise purlwise
rem remain or remaining
rep repeat
Rev St st reverse stocking (stockinette) stitch
RH righthand
rnd round
RS right side
skp slip next stitch, knit next stitch, pass slipped stitch over the knit stitch
sl1k slip one stitch knitwise
sl2k slip two stitches knitwise
sl1p slip one stitch purlwise
sl2p slip two stitches purlwise
sl st slip stitch
sm slip marker
ssk slip next two stitches separately knitwise then insert lefhand needle through front of these two stitches and knit together

ssp slip slip purl
st(s) stitch(es)
St st Stocking (stockinette) stitch
tbl through back loop
tfl through front loop
tog together
WS wrong side
wyab with yarn at back
wyif with yarn in front
yb yarn to back of work between needles
yds yards
yfwd yarn to front of work between needles
yo yarn over
yon yarn over needle

Reading a knitting pattern

Think of it like following a recipe – it makes sense to have everything you need to hand before you cast on and get started. Some patterns use slightly different writing styles and I have tried to keep mine as straightforward as possible.

Most commercial knitting patterns follow this format:

1 Skill level: Some patterns advise the skill level. As a beginner, I would advise looking for scarves and blankets that are relatively easy to build confidence. The first item I completed was my simple red and white striped sweater. The first pattern in this book is designed to get you started from scratch.

2 Measurements: If the pattern is for a garment, there is usually a range of sizes given in a chart from which to choose based on the measurements given. If a project is one-size then the finished dimensions are shown.

3 What you will need: This tells you the type of yarn, standard yarn weight, meterage (yardage) and number of balls needed to complete the project, plus any other equipment, like stitch markers, a cable needle and a yarn needle.

4 Tension (gauge): This is the recommended number of stitches and rows in a certain area, usually 10cm (4 inch) square. Achieving the recommended tension given in the instructions is especially important when making garments.

5 Abbreviations: This gives you the key to unlock all the abbreviations used in the pattern.

6 Special techniques: This highlights any particular techniques used within the design, and refers you to the pages where they are explained in detail.

7 Pattern instructions: This is either written out line-by-line or presented in chart form with a key alongside to decode the chart. Designers will aim to give you the right information and tips in order to make your work a success

8 Finishing instructions: This tells you how to complete your project, including sewing up seams and adding any other decorative touches.

EASY

Balloon Sleeve Cardigan

A simple edge-to-edge cardigan with dramatic balloon-shaped cuffs, this easy to knit project creates a big impact. Designed to be cropped to sit at the waist, for a flattering fit. I love the back neck detail where the two fronts meet at the centre of the back neck for a neat and comfortable finish when worn.

- Stitch markers
- Stitch holders
- Yarn needle

Tension (gauge)
13 sts and 17 rows to 10cm (4 in) over St st stitch using 6mm (US 10) needles. Change needle size as necessary to achieve correct tension (gauge).

Abbreviations
See page 69.

Special technique
Short-row shaping (see pages 102–103).

Measurements
See chart below

What you will need
- Debbie Bliss Nell
 78% mohair, 13% merino wool,
 9% polyamide
 100m (109 yards) per 50g (1¾ oz)

Quantity:
- 7[7:8:9:9] x 50g (1¾ oz) balls in Lilac
- 1 pair 6mm (US 10) knitting needles

	XS	S/M	L/XL	XXL	XXXL	
Adult size			111.5–117	122–137	142–156	cm
	71–86	91.5–106.5	44–46	48–54	56–61	in
To fit chest	28–34	36–42	138.5	147.5	157	cm
	117	126	54½	58	61¾	in
Actual chest	46	49½	54	56	58	cm
	50	52	21¼	22	22¾	in
Length	19¾	20½	45	43	43	cm
	45	45	45	17	17	in
Sleeve length	17¾	17¾	17¾			cm

Working from a chart

Charts are visual representations of knitting instructions. They condense more complex stitch and colourwork patterns, so they take up less space than if the instructions were written out row-by-row. They are particularly useful for designs like colour motifs, intarsia (a colourwork technique that involves knitting in blocks of colour, see page 165) and Fairisle (a traditional knitting technique used to create patterns in multiple colours, see page 143). Some designers will provide both written instructions and a chart. Charts also help you to envisage how the finished piece should look so you can identify where you are as you knit – and spot any mistake sooner.

Charts can be really helpful as you learn to knit. The chart will be laid out as a grid, with little cells like graph paper. These cells are not square but wider than they are tall to reflect the proportions of the knit stitch.

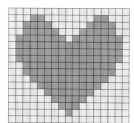 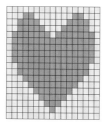

The two charts above show how different a simple heart motif looks when knitted versus when drawn out on square graph paper. This is important if you decide to create your own motif. You can buy special knitter's chart paper or create your own.

Each cell in a chart represents one knitted stitch and will either be filled with colour or have a symbol inside it to denote a colour or texture stitch. Each horizontal line of cells represents one knitted row. Every chart is accompanied by a key that tells you what each colour or symbol denotes.

So, the question is: How do you read a knitting chart? The first clue: Not like a book! A chart shows how your work will look on the right side. The pattern instructions will clearly state when you need to start working from any chart, how to place it within your knitting, how much of the chart to work and whether it needs to be repeated. The very first stitch of the motif or pattern is usually worked on a right side row, so it is represented by the cell at the bottom righthand corner of the chart, but it can be the bottom lefthand corner if you begin working from the chart on a wrong side row.

It is always a good idea to take the time to read any pattern and chart instructions before you start knitting, so you know what to expect, but at the same time don't overthink it. Take it row by row and it will all start to make sense and fall into place.

• Pay attention to any key provided – different patterns may use varying symbols.

• Start reading from the bottom of the chart and work your way up.

• Right side rows are always read from right to left.

• Wrong side rows are always read from left to right.

• When working in the round, every row is a right side row read from right to left.

• Mark off each row as you complete it. Some knitters use removable highlighter tape or sticky notes to show their place. I just tick them off in pencil as I go.

Patterns may use a repeat section, so if your chart only has 16 cells in a row but you need to work 64 stitches in a row, do not panic! When a colour or stitch pattern is repeated several times across a row, often it is only the repeated section that is charted, plus any extra stitches at the start and end of the rows. The pattern repeat is clearly indicated, usually by a line pointing to the repeated stitches. These stitches will be worked across the rows as many times as needed, while those stitches outside the repeat will be worked just once either at the start or end of the row. The instructions will tell you where to place the pattern within your work and how many times to work the repeat across a row and for how many rows. If the repeat extends across the width of the chart, simply work from edge to edge.

Colour motif chart and key

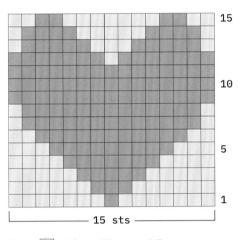

L———— 15 sts ————

Key: A k on RS, p on WS

B k on RS, p on WS

Stitch pattern chart and key

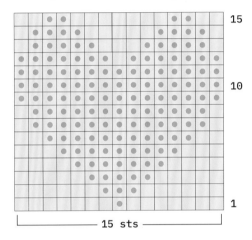

L———— 15 sts ————

Key: A k on RS, p on WS

B p on RS, k on WS

Repeat pattern chart and key

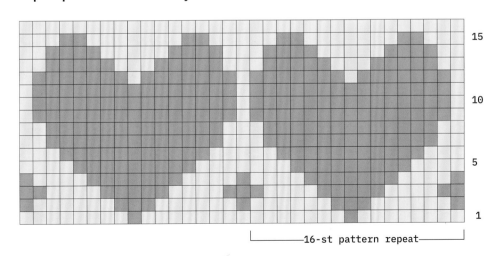

L————16-st pattern repeat————

Working a tension or gauge swatch

I know it's tempting to dive straight into creating something new, but before you start you will need to knit a tension or gauge swatch. This will tell you how many stitches and rows you need to work to produce a 10-cm or 4-inch square to achieve the same dimensions in your work as the pattern designer intended. Before you start any project, this is a way to determine whether you need to work more tightly or loosely if the item you're making requires an exact fit.

For complete beginners, you could skip this bit for any patterns that do not need precise dimensions. However, it is good practice to get into the habit of completing a tension (gauge) swatch as it is an essential part of the making process. It is useful to learn to how to adjust your tension (gauge) even though it can feel a bit tedious at times.

If the pattern states the number of stitches and rows measured over 10cm (4 inches), always work a tension swatch at least a few centimetres (an inch) larger as often side stitches can be tighter than the main fabric. For this reason, take the measurement from the centre of the swatch.

Lay your swatch flat or block it without stretching it. Measure a 10-cm (4-inch) section, both horizontally and vertically, marking the edges of the area with pins. Now count the number of stitches and rows inside the two pins. If it meets the number given in the pattern instructions, then great! If not, you may need to go up a needle size if you are a tight knitter, or down a size, if you are a loose knitter.

The general rule is that one difference in needle size will create a difference of one stitch in the tension (gauge). Knit the swatch again to check you are on track. Every knitter's work is different, so every garment will end up looking and fitting slightly differently, but to me this is one of the best things about knitting. Practice really does make perfect!

TOM'S TIP: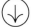

Once you have made a tension or gauge swatch with a certain type of yarn and size of needles, create a label for it, with this information. Often patterns will call for the same yarn and needles, so you won't have to do a new tension or gauge swatch for every project. Once you have finished with swatches you could always patchwork them together and make something new, like a scarf or a blanket.

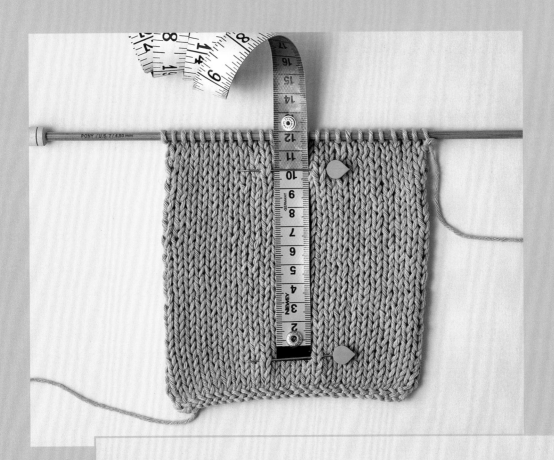

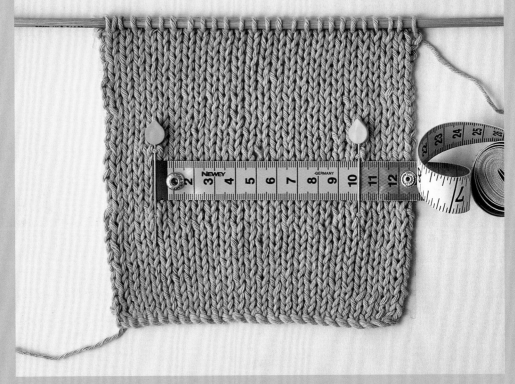

Troubleshooting tips →

We all have moments when our knitting goes wrong, but don't worry – fixing mistakes can be easier than you may fear! I've made loads of mistakes in my work and each time every one was different. I think that embracing your mistakes and learning from them is all part of the making process.

KNITTING

Picking up a dropped stitch

We've all been there. You're happily knitting when you notice a dreaded 'ladder' where a stitch has slipped off the needle. My first tip is don't panic! As soon as you notice it, lay your piece flat, so you can see exactly what is going on. If you have dropped a stitch while doing stocking (stockinette) stitch, it is easier to correct with the knit side facing.

Picking up one stitch over one row on knit side

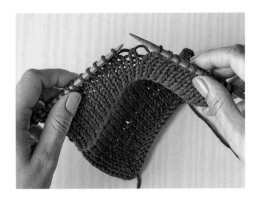

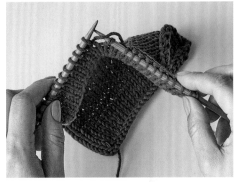

One: If you have noticed one dropped stitch on stocking (stockinette) stitch, it will look something like this.

Two: Insert the RH needle into the loop of the dropped stitch and under the strand of the yarn below, so both the strand and stitch are on the needle.

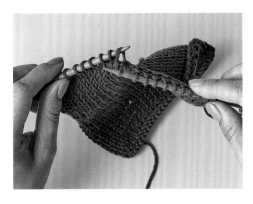

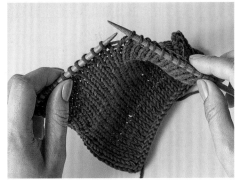

Three: Insert LH needle from front to back and pull the stitch over the strand.

Four: You have corrected your dropped stitch! Put the stitch on your LH needle, so you can continue.

Picking up one stitch over one row on purl side

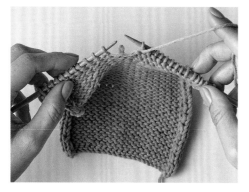

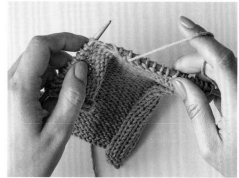

One: Dropped a purl stitch? If the purl side of stocking (stockinette) stitch is facing you or you're working in garter stitch, it will look like this.

Two: Insert the RH needle through the loop of the dropped stitch and the yarn strand.

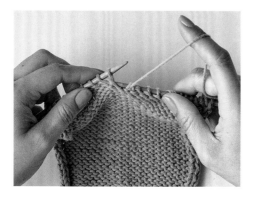

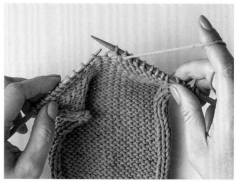

Three: Insert the LH needle through the stitch, pulling the stitch over the strand and off, forming a new stitch on the RH needle.

Four: The dropped stitch is fixed, so place it onto the LH needle so you can continue.

Picking up a 'ladder' over a few rows on knit side

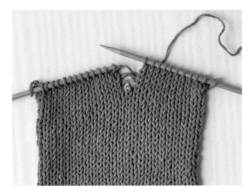

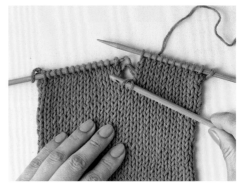

One: As soon as you can see the problem, stop what you are doing.

Two: Insert your crochet hook into the stitch from front to back, so the first yarn bar, or 'rung', is behind the dropped stitch.

Three: Hook the crochet hook onto the yarn bar and pull it through to the front of the dropped stitch, so you have climbed one row. Keep climbing the ladder through the dropped stitches row by row until you get back to the row of knitting you are on.

Four: Put the final dropped stitch onto the LH needle and continue to work the row. If you have turned the work to pick up a dropped stitch, be sure the working yarn is next to the last stitch on the RH needle, so you will start again in the right place.

TOM'S TIP:

Picking up one stitch over a few rows on purl side is similar to repairing a dropped knit stitch a few rows down but it is worked backwards. With the purl side of your knitting facing you, insert your crochet hook through the loop from back to front. Use the hook to catch the horizontal strand of yarn that is above the dropped stitch and climb your way back up to the top of your knitting. (I find it easier to turn the work over so that the knit side is facing me, and pick up the knit stitch instead!)

Picking up edge stitches

Because the first stitch on the needle is usually the loosest and the one nearest the point of the needle, it is often the stitch that gets dropped most frequently. When an edge stitch has been dropped, it will have been dropped by two rows rather than one and so a large loop of yarn will be visible. The simplest way to pick up and re-make these loops into stitches is to use a crochet hook and work from the right side of the fabric.

One: Insert a crochet hook into the dropped stitch and catch the large loop of yarn.

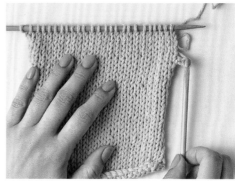

Two: Draw the yarn through the dropped stitch, but only a loop that is the size of a single stitch; don't pull the whole of the large loop through. You have re-made one stitch.

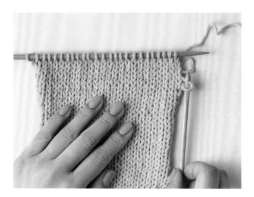

Three: Catch the large loop again and draw a second loop through the stitch on the hook; this is the second re-made stitch and the last one to be made from the large loop. If there is more than one large loop, re-make them all into stitches in this way, making two stitches from each large loop.

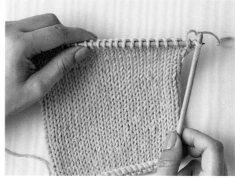

Four: At the top, the final re-made stitch is made from the working yarn. Pull a loop of the yarn through the stitch on the crochet hook, then place this last stitch back onto the knitting needle, making sure it is facing the right way.

Extra stitches

From time to time, you may find yourself looking at your knitting thinking, 'Hmmm, that looks like too many stitches'. You might notice holes or the sides of your fabric slanting upwards. It's a common beginner mistake and might happen from accidental yarn overs or knitting between stitches. The best way to stop this from happening is to look at your knitting carefully from time to time and also to count your stitches repeatedly. Just admire your work regularly!

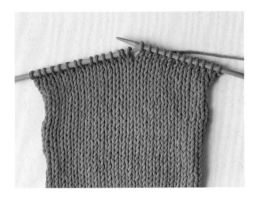

One: If the extra stitch was a yarn over within the last two rows or you notice that there are too many stitches in the middle of the row no more than few rows back, the best idea is to simply unravel and reknit.

Two: Always check the first stitch of a row before you start knitting. If it has swivelled upwards on the needle it may look like it is two stitches, so be sure to knit the stitch on the needle, not the two strands below.

Incomplete stitch on knit row

One: You may spot an incomplete stitch. The right part of the stitch will look baggy and there will be a hole. Pick up your knitting normally and knit up to the incomplete stitch.

Two: To fix it take your RH needle and insert it through the front of the left part of the incomplete stitch – this can be a bit fiddly, so persevere. Transfer the yarn up and over the right part of the incomplete stitch and slide the RH needle out so the stitch sits on the LH needle. This fixes the stitch and you can continue knitting.

Twisted stitches

If you think of a stitch as having two legs – the right leg should be at the front, with the left leg behind. This should be the same regardless of whether you are working in knit stitch or purl stitch. If you notice a twisted stitch, the chances are that you wrapped the yarn the wrong way around your needle or you put your stitch back on your needle the wrong way round. So, what can you do about it?

Twisted stitch on knit row

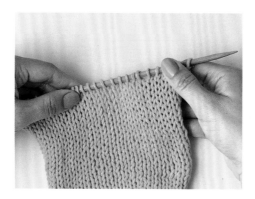

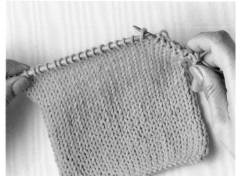

One: Look at your row of knit stitches. If the right leg of any stitch is sitting behind the left leg, then the stitch is twisted.

Two: Work up to your twisted stitch and take the stitch off the LH needle and correct its position, then transfer it back onto the LH needle.

Unpicking stitches one by one

Wrong stitch or in the wrong place? Don't stress! All sorts of mistakes mean you may have to unpick your knitting. Unpicking one stitch at a time is called 'tinking', which means 'backwards knitting'. Cute name!

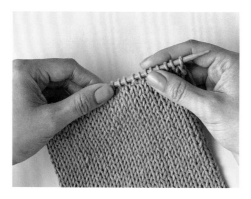

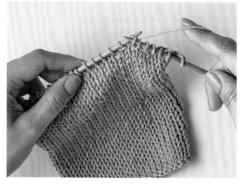

One: Before starting a new row, check over the row just worked for any errors – here one stitch has become twisted on the needle, meaning that right leg of the stitch is sitting to the back of the needle rather than the front. The easiest thing to do it to unpick the stitches one by one up to the error in order to re-knit it.

Two: Holding the needle carrying the stitches in your LH, insert the tip of the RH needle into the row directly below the one on the LH needle that you want to unravel. Carefully drop the stitch off the LH needle and pull the yarn towards you so that the stitch of the row below transfers to the RH needle. Repeat this until you reach the error that you have identified.

Unravelling rows

If all else fails, you may need to unravel your knitting for a few rows. You can either freestyle and unravel your yarn and knitting to the point beyond the mistake and pick up the loose stitches with your needles, or you can do it in a more controlled way, using a 'lifeline' – a length of yarn that you thread through a lower row or round. This means you do not need to worry about unravelling too far, dropping stitches, or getting them twisted. It is an excellent way to rescue your knitting if you have made a mistake. Unravelling your work is called ripping out or frogging. It's a bit nerve-racking at first but gets easier after you have done it a few times.

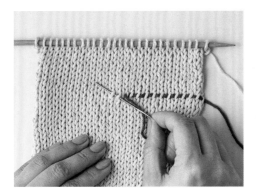

One: Thread a yarn needle with a length of waste yarn in a contrast colour to the work. Pass the needle through the front of each stitch in the row to which you want to unravel.

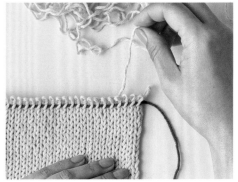

Two: Slide the knitting off the knitting needle. Now pull out the yarn to unravel the knitting row by row until you reach the lifeline. The lifeline will stop the work from unravelling further and hold the stitches in a row facing the right direction to be picked up.

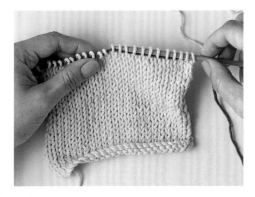

Three: Following the lifeline, slip each stitch back onto the knitting needle, pulling out the yarn as you go. Check that the working yarn is at the tip of the knitting needle, then you can start knitting again.

TOM'S TIP:

It can be great practice to put regular lifelines into your work as a preventative measure. If you make a mistake, simply unravel your knitting to the lifeline and continue. Lifelines can be anything – a contrasting colour yarn, string, or ribbon! It is better if the lifeline is thinner than the yarn you are working with though, so it does not stretch out the stitches that it is threaded through.

Finishing your makes →

Now it's time to work some magic and turn your crumpled knitted fabric into something special. After investing a lot of your time in knitting the pieces, how you apply the final touches to your project can make a huge difference. A whole book could be written about how to sew up and finish items off, but here I have covered the most useful basic techniques to learn, so you can make your items look gorgeous. As with anything knitting-related, the more you practise, the easier you will find it.

KNITTING

Blocking

So you have finished all the pieces – well done! Blocking is a method used to smooth out your work and set the shapes of your pieces. You basically shape it, wet it, and then leave it to dry. This allows the yarn fibres to relax and will create a more relaxed, fluid finish. It can also even out the size of your pieces and so, with the help of your tension swatch, you can ensure all the parts of your project are the size that they need to be.

The two main blocking methods I use are steam blocking and spray blocking. You can buy a lot of tools for blocking or just make do with what you have at home. The main tools are:

Blocking pins: These are T-shaped pins designed to hold the piece in place, but you can use long dressmaking pins that do NOT have a plastic head (they may melt when steamed or pressed with an iron).

Blocking wires: These are flexible wires that can be woven into pieces to help block curves on the sides of a project. Wires are particularly useful for blocking lace and finer yarns.

Blocking board: These have a grid on them, like graph paper, so you can easily measure your pieces and make sure they are straight. If you do not have a blocking board, you can use a padded surface like a large piece of foam or a folded towel. One great idea is to make your own blocking board. Simply get an MDF board and cover it with a layer of wadding and gingham fabric pulled tight and stapled to it.

Tape measure or ruler: If you need to block a piece to specific dimensions stated in a pattern, then you'll need a tape measure or ruler to ensure you block each piece to the correct size.

Steam iron: An electric iron that generates a good amount of hot steam is invaluable for blocking knitted and crocheted pieces. But always take good care when steaming a piece and make sure that you don't scald yourself.

Spray bottle: A basic spray bottle that you can pick up at a hardware store or gardening centre can be used to mist an item as an alternative to steaming.

Pinning out a piece for blocking

Take time when shaping and pinning out any piece as once it has been steamed or sprayed, any irregularities in the shaping will become 'set' as it dries. For a garment, pin the centre length and then width, followed by the corners. Use as many pins as you need to make it smooth or use special blocking wires to create smooth edges. All pins or wires will come with instructions on how to get the best results.

Lay out the knitted piece right side down on the blocking board or surface. Use the printed grid or checked pattern of the gingham fabric to make sure that any edges that are supposed to be straight are straight.

Using a tape measure or ruler, ease the piece to the correct dimensions given in the pattern instructions.

Using blocking pins or dressmaking pins, pin the piece out, sliding the pins through the edge stitches of the piece and into the board or wadding. Start by pinning out the corners and then work around the edges between pinned corners. Use lots and lots of pins, placing them around 1cm (½ inch) apart, to make sure the edges are smooth.

Take care to make sure that the piece is symmetrical, if necessary. If blocking any piece that has a knitted rib, do not stretch the ribbing as it may lose its elasticity.

Blocking methods

I prefer to block a piece by either spray or steam blocking. You can wet block, where the piece is fully submerged in lukewarm water, but that method is not suitable for all fibres and I find that the piece then takes ages to dry. With wet blocking, a fabric can sometimes stretch and grow in size, or even felt slightly. Check the ball band to see if the manufacturer gives any advice on the best method to use for blocking. Go lightly when blocking as pressing too firmly may flatten a delicate stitch pattern or cable, losing its three-dimensionality, or the fabric could go limp.

Steam blocking

This method is my preferred way to block items.

• Hold a steam iron or a steamer above your item, hovering a few centimetres (an inch) away from the surface, so the steam penetrates the fibres. Do not allow the plate of the iron to touch the piece.

• Now the fibres have relaxed, you can manipulate them further into shape, if you need to.

• After steaming, leave your garment to rest and dry thoroughly before unpinning.

Spray blocking

This method is best for delicate fibres.

• Use a specially designed flattening spray or fill a clean spray bottle with wool wash (I like to do this so my knitting smells nice, rather than like a soggy sheep!). Or you can just use room temperature water.

• Spritz the knitted fabric with a fine mist. You don't need to saturate the fabric, you just need to dampen it with enough moisture to make some steam.

• Hover the hot iron (with the steam function turned off) over the piece to turn the moisture from the spray that is now within the knitted fibres into steam.

• Re-adjust the shape of your piece. Spray any dry sections as you reshape it.

• Leave your garment to rest and dry thoroughly before unpinning; this may take a day or two.

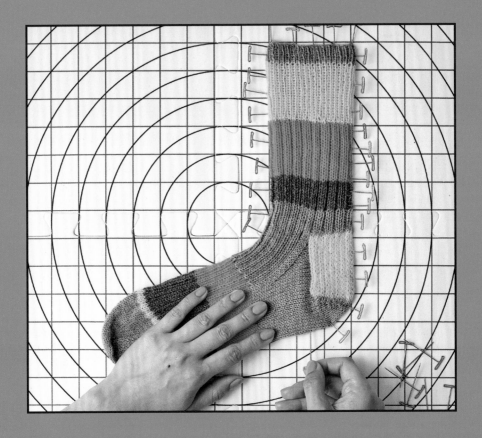

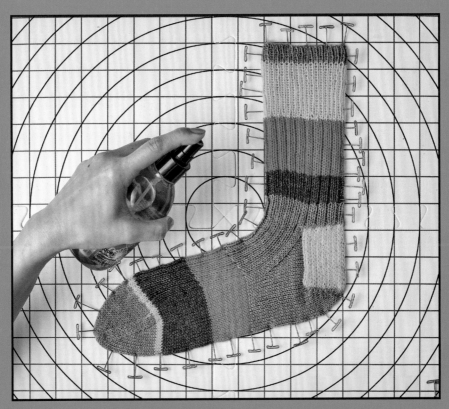

Sewing in yarn ends

When you have finished knitting your pieces, you will be left with yarn ends that need sewing in. I hate this bit, but you have to do it to neaten your pieces up. After all your knitting efforts, it is worthwhile. There are no hard and fast rules about weaving or sewing in yarn ends, but it is important that they are secure and not visible from the right side of your piece.

Sewing in yarn ends on cast-on and cast-off (bound-off) edges

Leave your cast-on and cast-off (bound-off) yarn ends as long as possible, then use these ends for sewing up seams. Any other yarn ends need to be discreetly hidden within the knitted fabric. Sew any seams before tackling the remaining yarn ends not being seamed that need to be woven in.

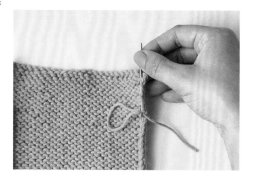

One: Using a blunt-tipped sewing needle, take the tip under a few stitches along the edge of the piece. Turn, then take it back again in the opposite direction. Trim the yarn end back, so it's all neat and tidy.

Sewing in yarn ends on stripes or intarsia

In intarsia and colourwork pieces, you will be left with yarn ends not just at the start and finish of your piece but throughout your work. When sewing in yarn ends, you need to weave the yarn ends on the same colour stitches.

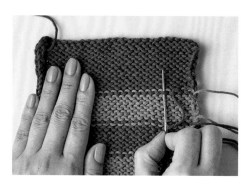

One: Using a blunt-tipped sewing needle, take the tip through the purl bumps of a few stitches across the WS of the piece, following the row along the colour join.

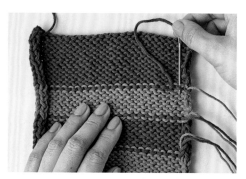

Two: Turn, then take it back again in the opposite direction. Trim the yarn end to neaten. Weave each yarn end into stitches of its own colour and make sure all the stitches lie flat.

Sewing
seams →

As I have done more knitting,
I've found that different ways
of sewing suit different
garments depending on the
edge and angle I am working
at. I always try to use the yarn
I am working with, providing
it is strong enough, to sew the
seams unless the pattern calls
for another type of yarn or
thread. Whatever yarn you use,
make sure it can be laundered
in the same way.

Sewing seams with mattress stitch

This will give your knitted stocking (stockinette) stitch piece a neat, virtually invisible finish or seam. It is also used when working in rib stitch and it is ideal for sewing up hats and sweaters. I like it because it is worked from the right side and so as you stitch up, you can see how the finished garment will look. You can work this stitch on garter stitch, but you alternate working into the top and bottom loops of the stitches. Taking a whole stitch into the seam is the neatest way of working mattress stitch, but if the yarn is bulky or if you need a slimmer seam then take half a stitch, although it won't be quite as invisible.

Sewing an invisible seam edge to edge

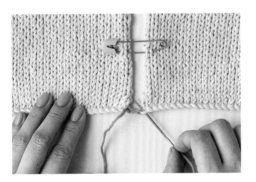

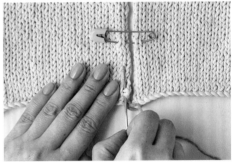

One: With RS facing up, line the items up next to each other. Thread a blunt-tipped sewing needle with your yarn and pass up through the RH piece and down through the LH piece, like a figure of eight, so the yarn comes from the back of the RH piece between the first and second edge stitches.

Two: Working from the front, take the needle across to the opposing left-hand piece and take it under the horizontal bar between the first and second stitches and bring the yarn underneath.

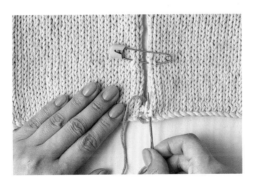

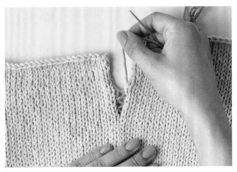

Three: Take the needle across again to the right-hand piece and take it under the next two horizontal bars between the first and second stitches. If the pieces are big you might want to stabilize them with safety pins, so they do not slip around.

Four: Continue to the end, alternating between the left and right sides, taking the needle under two bars at a time, adjusting the tension as you go. When you have worked a few centimetres (an inch), gently pull the yarn taut to close the seam. As you close the seam, the edge stitches of each piece turn to the back of the work, leaving a slight ridge.

Knit Essentials

Sewing an invisible horizontal seam

This is another way to make an invisible seam to join cast-on and cast-off (bound-off) edges.

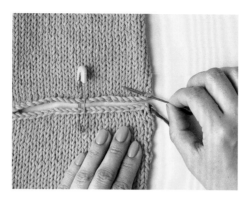

One: Line up the two edges horizontally, with the right sides facing upwards. Insert the needle under the first stitch on the right, just above the cast-on edge.

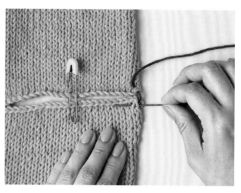

Two: Take the needle back down under the corresponding stitch on the cast-off (bound-off) edge.

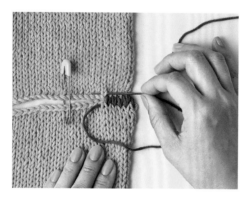

Three: Insert the needle under the next stitch to the left on the top edge, then back down again. Your yarn will form a line of 'V' shapes.

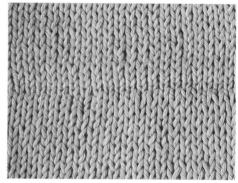

Four: Continue to the end to complete the seam. Pull the yarn taut as you work to conceal the cast-on and cast-off (bound-off) edges, which will turn to the back of the work.

Sewing an invisible vertical–horizontal seam

If you are attaching a vertical edge to a horizontal edge, such as the top of a sleeve to an arm, it is a similar technique to the invisible horizontal seam.

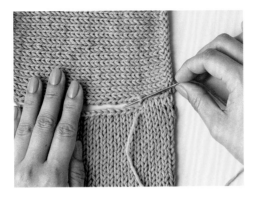

One: Line up the pieces. Insert the needle under a stitch of the bound-off edge of the vertical item, then insert it under one horizontal bar between the first and second stitch of the horizontal piece.

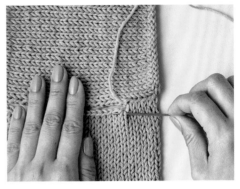

Two: On the vertical piece, insert the needle down through the centre of the next stitch and then up through the centre of the adjacent stitch.

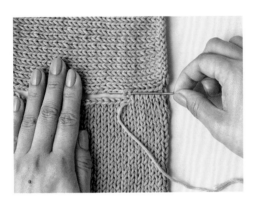

Three: If there are more stitches in the vertical piece, occasionally pick up two horizontal bars on the horizontal piece and then under the corresponding stitch on the other side.

Four: Continue to the end to complete the seam. Pull the yarn taut as you work to conceal the edges of each piece.

"

Handmade *knits* **have love** *invested* **in every** *stitch.*

TOM DALEY

"

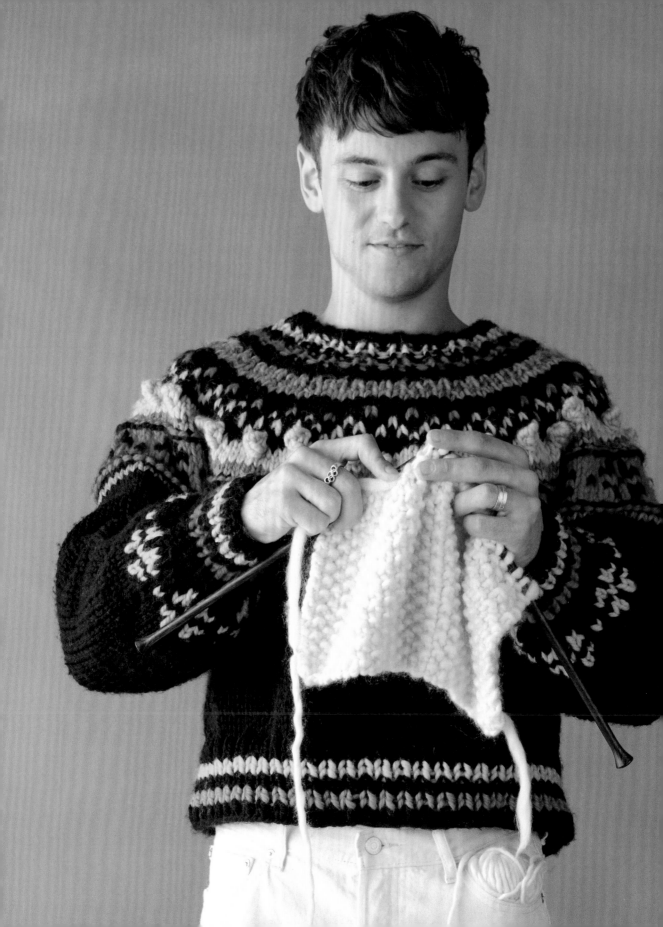

Knit Projects

03–

Ribbed Dickie

A dickie is like a neck and chest warmer to wear under a jacket or coat for warmth and cosiness. It is slightly shaped at the front to sit flat over the chest. This pattern uses a super-chunky yarn, so it is quick to knit up. This dickie is ideal for adding a pop of seasonal colour to liven up an old coat but does not add any bulk or weight.

Measurements
One size
Approx. 34cm (13½ in) wide
Approx. 21cm (8¼ in) from shoulder to hem and 32cm (12½ in) overall from neck edge to hem

What you will need
- Rowan Big Wool
 100% merino wool
 80m (87 yards) per 100g (3½ oz)
Quantity:
One-colour version
- 2 x 100g (3½ oz) balls in Citron (091)
Three-colour stripe version
- **A** 1 x 100g (3½ oz) ball in Midori (093)
- **B** 1 x 100g (3½ oz) ball in Steel Blue (052)
- **C** 1 x 100g (3½ oz) ball in Oasis (092)

- 1 pair of 10mm (US 15) needles
- 10mm (US 15) circular needle, 40cm (16 in) length
- Stitch holders
- Stitch marker
- Yarn needle

Tension (gauge)
11 sts and 12 rows to 10cm (4 in) over 1x1 rib using 10mm (US 15) needles. Change the needle size as necessary to achieve the correct tension (gauge).

Abbreviations
See page 69.

Special technique
Short-row shaping (see pages 102–103).

Slip 8 sts onto a stitch holder for shoulder. With RS of work facing, slip centre 21 sts onto a stitch holder.

Rejoin yarn to rem 8 sts and rib across all sts, picking up the wrap as you work.

Cut yarn leaving a long end.

Slip 8 sts onto a stitch holder for shoulder.

Front

Using 10mm (US 15) needles, cast on 33 sts and work in rib as follows:

Next row (RS): *P1, k1, rep from * to last st, p1.

Next row: *K1, p1, rep from * to last st, k1.

Next row (inc): (P1, k1) twice, p1, m1, rib as set to last 5 sts, m1, (p1, k1) twice, p1. *35 sts.*

Next row: (K1, p1) twice, k2, *p1, k1, rep from * to last 5 sts, (k1, p1) twice, k1.

Next row: (P1, k1) twice, p2, *k1, p1, rep from * to last 5 sts, (p1, k1] twice, p1.

Next row: (K1, p1) twice, k2, *p1, k1, rep from * to last 5 sts, (k1, p1) twice, k1.

Next row (inc): (P1, k1) twice, p1, m1, *p1, k1, rep from * to last 6 sts, p1, m1, (p1, k1) twice, p1. *37 sts.*

Next row: *K1, p1, rep from * to last st, k1.

Next row: *P1, k1, rep from * to last st, p1.

Next row: *K1, p1, rep from * to last st, k1.

Repeat last 2 rows 6 times more to complete 22 rows in total.

Shape shoulders

Next row: Rib as set to last 4 sts, wrap next st and turn.

Next row: Rib as set to last 4 sts, wrap next st and turn.

Next row: Rib 4 sts as set, turn.

Next row: Rib across all sts, picking up the wrap as you work.

Cut yarn leaving a long end.

Slip 8 sts onto a stitch holder for shoulder. With RS of work facing, slip centre 21 sts onto a stitch holder.

Rejoin yarn to rem 8 sts and rib across all sts picking up the wrap as you work.

Cut yarn leaving a long end.

Slip 8 sts onto a stitch holder for shoulder.

To make one-colour version

Back

Using 10mm (US 15) needles, cast on 37 sts and work in rib as follows:

Next row (RS): *P1, k1, rep from * to last st, p1.

Next row (WS): *K1, p1, rep from * to last st, k1.

Repeat last 2 rows 10 times more to complete 22 rows in total.

Shape shoulders

Next row (RS): Rib as set to last 4 sts, wrap next st and turn.

Next row (WS): Rib as set to last 4 sts, wrap next st and turn.

Next row: Rib 4 sts as set, turn.

Next row: Rib across all sts, picking up the wrap as you work.

Cut yarn leaving a long end.

Join both shoulders using the three-needle cast off (bind off) method with wrong sides tog so that the seam is on the outside of your work and work the sts in rib.

Neck

With RS facing, using 10mm (US 15) circular needle and beg at the left shoulder, pick up and knit 2 sts down left front neck, rib as set across 21 sts from centre front stitch holder, pick up and knit 2 sts up right front neck, 3 sts down right back neck, rib as set across 21 sts from centre back stitch holder and pick up and knit 3 sts up left back neck, place marker to show start of round. *52 sts.*
Work in rib as follows, slipping marker as you work:
Next round: *P1, k1, rep from * to end of round.
Repeat last round 15 times more.
Cast off (bind off) in rib.

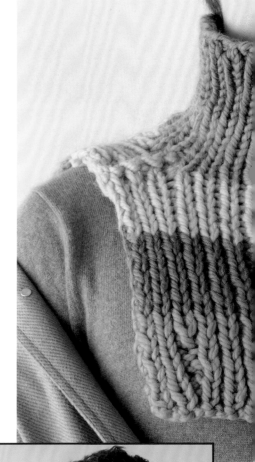

To finish

Weave in any yarn ends.

To make stripe version

Work the same as the one-colour version but use the following stripe sequence:
8 rows **A**
8 rows **B**
8 rows **C**
8 rows **A**
8 rows **B**

Finish the final 2 rows of the shoulder shaping using **C**.
Use **A** to pick up the sts for neck and work 7 more rows in rib using **A**.
Finish the neck with 8 rows **B** and cast off (bind off) using **B**.

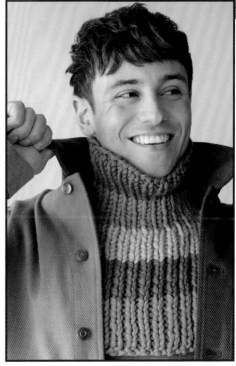

Masterclass

Short-row shaping

This technique involves turning the work before the row is completed, hence the term "short rows". The result is that one part of the work has more rows than the rest, creating shaping for elements such as heels or collars.

Wrapping and turning on a knit row

If you just turn on a short row, a hole will appear between the stitches worked and not worked. This can be fixed by "wrapping" a slipped stitch at the point where the work is turned. When all the short rows are complete, you then work across the entire row of stitches, and pick up the wraps around the slipped stitches to hide them, so that each hole is still closed but the wrap has disappeared. Depending on how many short rows the pattern asks you to make, there may be several wraps to pick up in one row.

One Knit to the position of the turn. Slip the next stitch purlwise from the lefthand needle to the righthand needle.

Two Bring the yarn forward between the points of the needles.

Three Slip the stitch back onto the lefthand needle.

Four Take the yarn to the back, ready to purl the next row, and turn the work.

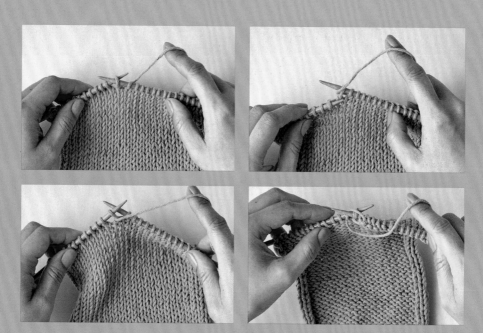

Picking up the wrap on a knit row

One To hide the wrap, knit to the wrapped stitch. Insert the righthand needle up through the front of the wrap.

Two Keeping the wrap on the righthand needle, insert the needle into the stitch and knit the wrap and the stitch together as one stitch.

Picking up the wrap on a purl row

One To hide then wrap, purl to the wrapped stitch. Insert the righthand needle up through the back of the wrap.

Two Keeping the wrap on the righthand needle, insert the needle into the stitch and purl the wrap and the stitch together as one stitch.

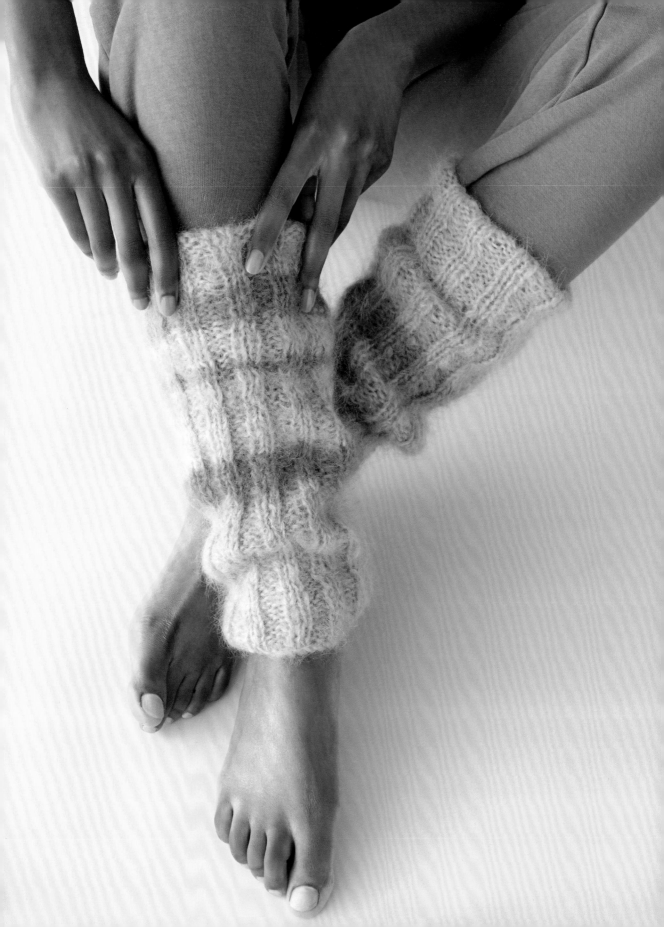

Leg Warmers

Fun and retro accessories, made using trendy mohair yarn in modern pastel colours, these leg warmers are knitted on circular needles to be seam-free for comfort and in stretchy rib for a good fit. A great beginner's project for learning to work in the round, I think these also make a fabulous gift or for heading out to the roller disco!!

Measurements
One size
Approx. 22cm (8¾ in) around and
40cm (16 in) long

What you will need
- Debbie Bliss Nell
 78% mohair, 13% merino wool,
 9% polyamide
 100m (109 yards) per 50g (1¾ oz)
Quantity:
- **A** 1 x 50g (1¾ oz) ball in Lilac (05)
- **B** 1 x 50g (1¾ oz) ball in Rose (09)
- **C** 1 x 50g (1¾ oz) ball in Aqua (06)
- **D** 1 x 50g (1¾ oz) ball in Jade (07)
- 6mm (US 10) circular knitting needle,
 40cm (16 in) length, or double-pointed
 needles
- Stitch marker
- Yarn needle

Tension (gauge)
22 sts and 17 rows to 10cm (4 in) over
2x2 rib on 6mm (US 10) needles. Change
needle size as necessary to achieve
correct tension (gauge).

Abbreviations
See page 69.

Special technique
Working in the round (see pages 112–113).

Note: Avoiding a colour jog
When working in the round and knitting different colour stripes, there will always be a "jog" in each new colour at the start of the round. To disguise this, work the first round in the new colour yarn, leaving the tail of the new colour at the WS of the work for sewing in later. When you reach the start of the second round, slip the righthand needle purlwise into the stitch below the first stitch in the new colour and lift it onto the lefthand needle. Knit the lifted stitch and first stitch of the last round together in the new colour.

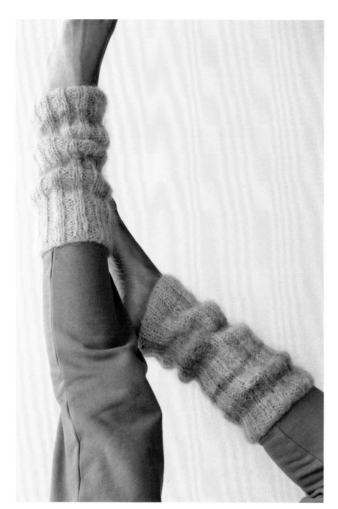

Stripe sequence

12 rounds **A**
4 rounds **B**
2 rounds **A**
8 rounds **C**
6 rounds **D**
6 rounds **A**
2 rounds **C**
4 rounds **B**
2 rounds **D**
4 rounds **B**
2 rounds **A**
6 rounds **D**
2 rounds **A**
8 rounds **C**

To make

(Make two the same)
Using 6mm (US 10) circular needles or double-pointed needles and **A**, cast on 44 sts.
Place marker to show start of round and join to work in the round, taking care not to twist the stitches.
Round 1: *K2, p2, rep from * to end of round.
Rep Round 1, following stripe sequence as given, until work meas 40cm (16 in) from cast-on edge.
Cast off (bind off) in rib as set.

To finish

Weave in any yarn ends.

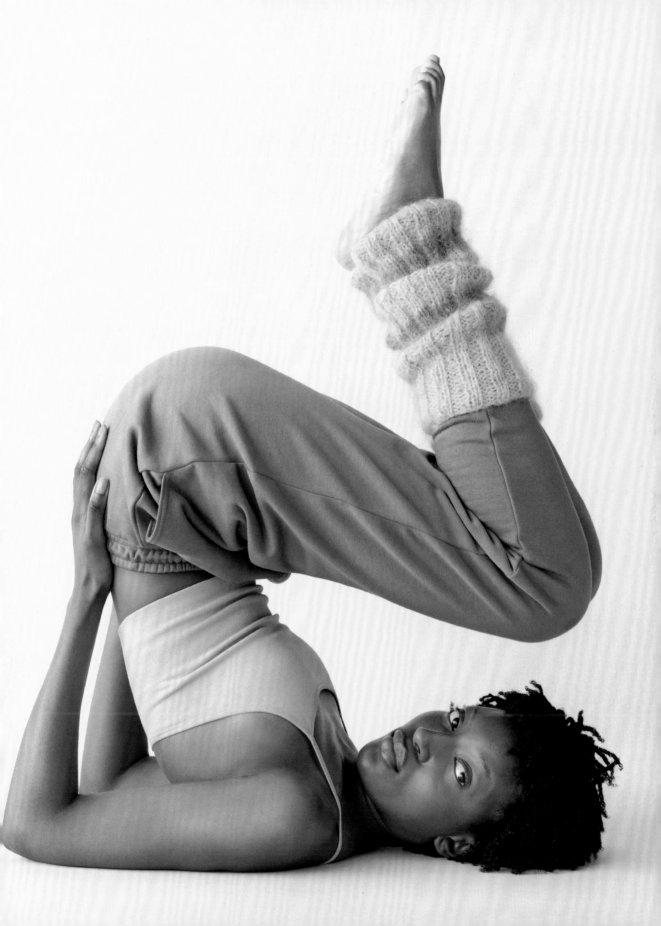

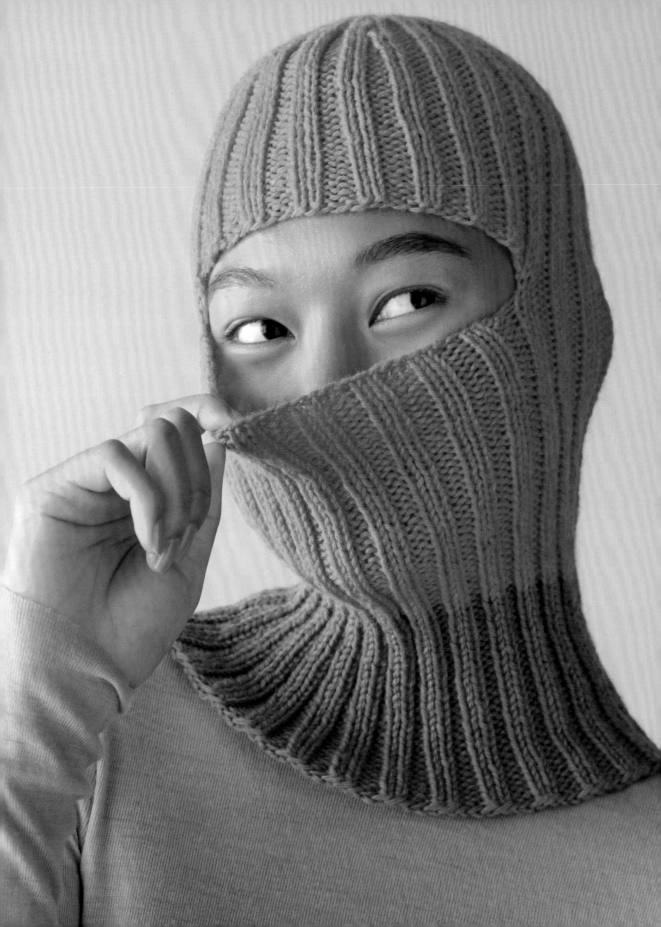

Balaclava

This super-trendy accessory keeps your head, ears, and neck warm during winter or on the ski slopes. Pull it down over your face for maximum warmth or fold it up to form a hat when going indoors. A great beginner's project to learn simple colour change and shaping for the crown, as well as casting stitches on and off in the middle of a row for the front opening. You'll soon be making them for all your friends.

Measurements
One size
Approx. 38cm (15 in) long

What you will need
- Rowan Pure Wool Superwash Worsted
 100% wool
 200m (218 yards) per 100g (3½ oz)
Quantity:
- **A** 1 x 100g (3½ oz) ball in Periwinkle (146)
- **B** 1 x 100g (3½ oz) ball in Tiger (201)
- 4mm (US 6) circular needle, 40cm
 (16 in) length
- Set of four 4mm (US 6) double-pointed
 needles
- Stitch marker
- Yarn needle

Tension (gauge)
33 sts and 28 rows to 10cm (4 in) over rib using 4mm (US 6) needles. Change needle size as necessary to achieve correct tension (gauge).

Abbreviations
See page 69.

Special technique
Working in the round (see pages 112–113).

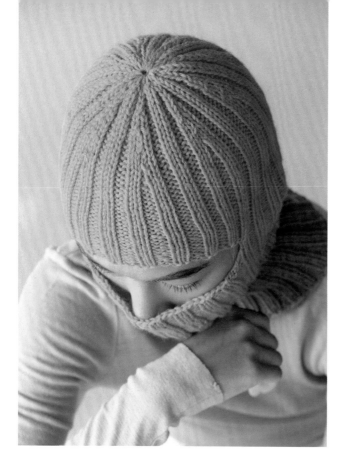

Shape crown

Once knitting becomes too tight for the circular needle, transfer the work evenly onto three double-pointed needles and knit with the fourth needle.

Round 1: *K2, p2tog, (k2, p2) twice, rep from * to end of round. *99 sts.*

Rounds 2 and 3: *K2, p1, (k2, p2) twice, rep from * to end of round.

Round 4: *K1, ssk, (k2, p2) twice, rep from * to end of round. *90 sts.*

Rounds 5 and 6: *K4, p2, k2, p2, rep from * to end of round.

Round 7: *K1, k2tog, k1, p2, k2, p2, rep from * to end of round. *81 sts.*

Rounds 8 and 9: *K3, p2, k2, p2, rep from * to end of round.

Round 10: *K1, k2tog, p2, k2, p2, rep from * to end of round. *72 sts.*

Rounds 11 and 12: *K2, p2, rep from * to end of round.

Round 13: *K2tog, p2, k2, p2, rep from * to end of round. *63 sts.*

Rounds 14 and 15: *K1, p2, k2, p2, rep from * to end of round.

Round 16: *K1, p2tog, k2, p2tog, rep from * to end of round. *45 sts.*

Round 17: *K1, p1, k2tog, p1, rep from * to end of round. *36 sts.*

To make

Using 4mm (US 6) circular needle and **A**, cast on 108 sts, place marker to show start of round and work in the round as follows, making sure that stitches are not twisted when you start working:

Rib round: *K2, p2, rep from * to end of round.

Repeat last round 27 times more, ending at marker.

Change to **B** and work a further 36 rounds in rib as set, ending at marker.

Make front opening

Next round: Rib 38 sts as set, cast off (bind off) next 34 sts in patt, rib as set to end of round.

Next round: Rib as set, casting on 34 sts over the cast-off (bound-off) sts of previous round, rib as set to end of round.

Work a further 22 rounds in rib as set, ending at marker.

To finish

Cut working yarn leaving long end. Thread yarn through rem sts, sliding them off the needles, pull up tightly and fasten off securely.

Weave in any yarn ends.

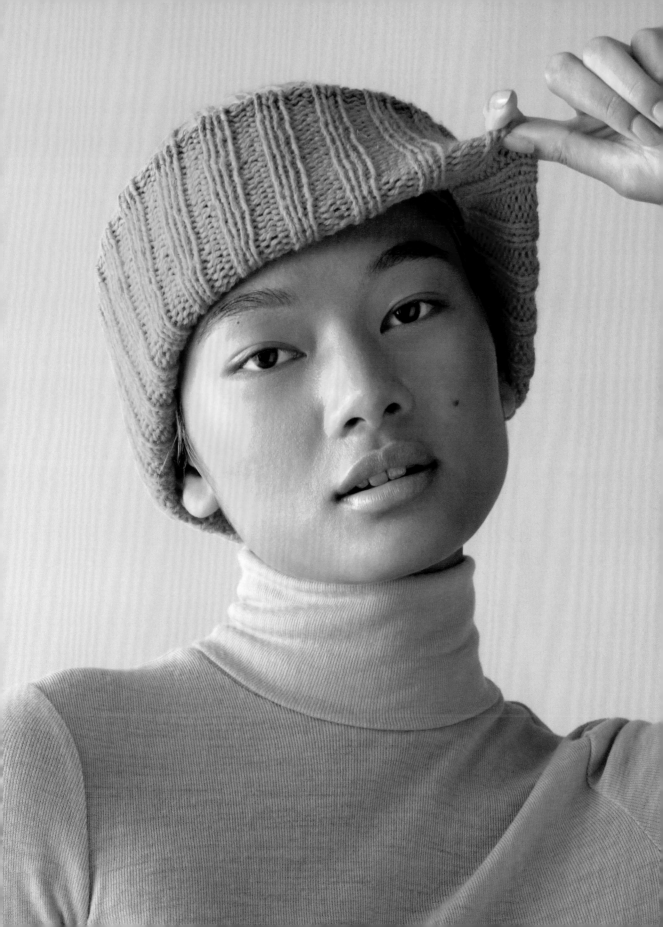

Masterclass

Working in the round

Working in the round, or circular knitting as it is also known, can be a quick way of knitting as you are always working on the right side and you don't have any side seams to sew once you've finished.

Knitting on circular needles

One Circular needles, where two short needles are connected by a flexible cable, are also good for making heavier projects, like a throw, as the weight of the knitted fabric can rest on your lap on the connecting cable.

Two Using your preferred cast-on method, cast on the number of stitches needed on to one of the points of the short needles just as you would if using regular needles. Spread out the cast-on stitches evenly along the length of the cable between the two points, but without stretching them. Before you join the stitches into a round, it is crucial to check the cast-on edge is not twisted.

Three Slip the first stitch from the lefthand needle onto the righthand needle in order to close the gap between the first and last cast-on stitches.

Four Lift the last stitch on the righthand needle over the stitch just slipped from the lefthand needle without dropping either stitch – you are simply reversing the positions of the stitches.

Five The first stitch in the first round is the beginning of the round – all subsequent rounds start in the same position, unless instructed otherwise. Place a stitch marker on the needle at the start of the first round before knitting the first stitch.

Knit the stitches from the lefthand needle point onto the righthand needle point, sliding them along the connecting cable as you work. When you get back to the stitch marker, you have completed one round. Slip the stitch marker onto the righthand needle point, ready to knit the next round.

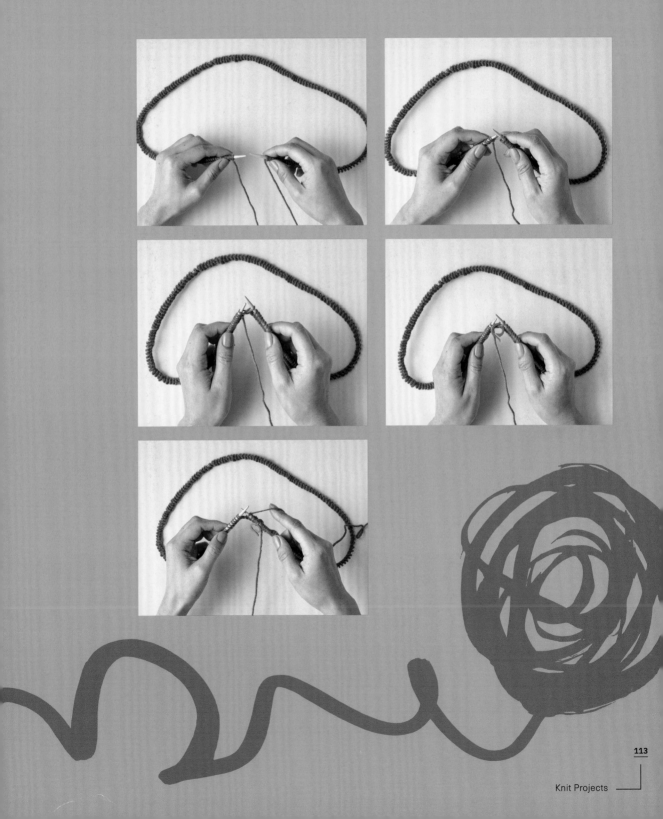

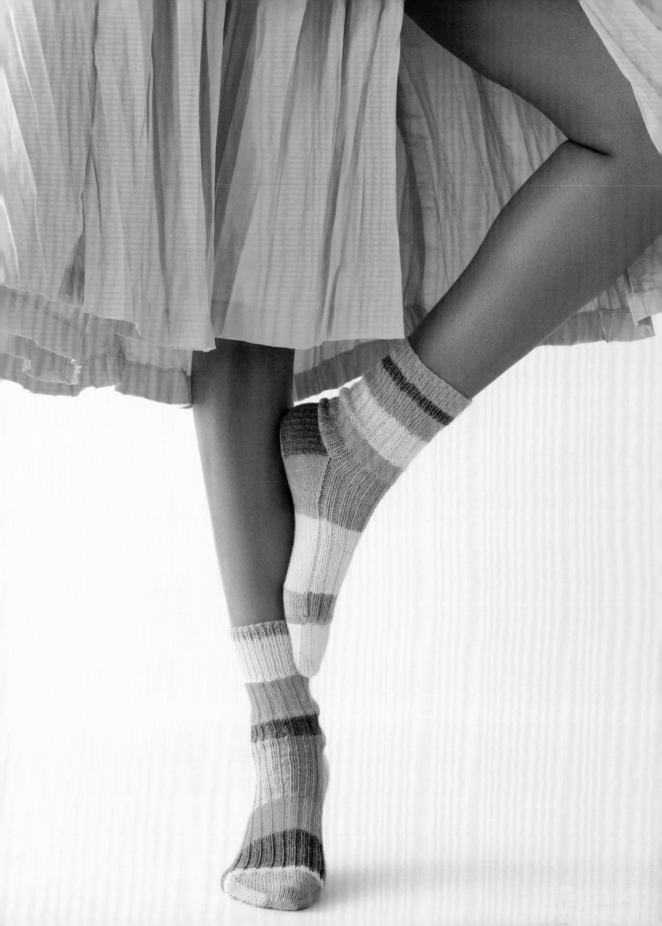

Odd Socks

Socks are one of the first projects that come to mind when people take up knitting, but they aren't always the easiest. This is a starter pattern and the only sock pattern that you'll need. Making a matching pair can be boring, so these are deliberately mis-matched with neon colours to stand out from the crowd. Designed with rib for stretch across the top, a denser rib for a reinforced heel, and stocking stitch for comfort on the sole, these socks are made using a special sock yarn.

Measurements

Adult size	S	M	L	
Foot circumference	20	23	25	cm
	8	9	10	in

What you will need
- Coop Knits Socks Yeah!
 75% fine superwash merino wool, 25% nylon
 212m (231 yards) per 50g (1¾ oz)

Quantity:
- **A** 1 x 50g (1¾ oz) hank in Chryso (108)
- **B** 1 x 50g (1¾ oz) hank in Helium (1001)
- **C** 1 x 50g (1¾ oz) hank in Melanite (121)
- **D** 1 x 50g (1¾ oz) hank in Xenon (1004)

- 2.5mm (US 1–2) circular knitting needle
 or double-pointed needles
- Stitch marker (optional)
- Stitch holders
- Yarn needle

Tension (gauge)
36 sts and 50 rows to 10cm (4 in) over St st on 2.5mm (US 1–2) needles. Change needle size as necessary to achieve correct tension (gauge).

Abbreviations
See page 69.

Special techniques
Working in the round (see pages 112–113). Grafting stitches together (see page 119).

To make

First sock

Cuff and leg

Using **A**, cast on 64[72:80] sts. Join to work in the round. Place beg of round marker.
Round 1: * K1, p1, rep from * to end of round.
This round sets 1x1 rib.
Work a 7 rounds more in 1x1 rib.
Change to **B**.
Next round: Knit.
Work 22 rounds in 1x1 rib.
Change to **D**.
Next round: Knit.
Next round: * P2, K2, rep from * to end of round.
This round sets 2x2 rib.
Work 19 rounds more in 2x2 rib.
Change to **C**.
Next round: Knit.
Work 8 rounds in 2x2 rib.
Change to **A**.
Next round: Knit.
Work 8 rounds in 2x2 rib.

Heel flap

Next round: Using **A** patt 30[34:38], using **B**, knit across rem 34[38:42] sts.
Turn work so WS is facing. Work heel flap back and forth on next 34[38:42] sts. Keep rem 30[34:38] sts on stitch holder for instep.
Row 1 (WS): Sl1p, purl to end.
Row 2: (Sl1k, k1) 17[19:21] times.
Rep these 2 rows a further 13[14:15] times, then Row 1 once more.

Heel turn

Change to **A**.
Row 1 (RS): Sl1k, k20[22:24], ssk, k1, turn, leave rem sts unworked.
Row 2: Sl1p, p9, p2tog, p1, turn, leave rem sts unworked.
Row 3: Sl1k, knit to 1 st before gap, ssk, k1, turn.
Row 4: Sl1p, purl to 1 st before gap, p2tog, p1, turn.
Rep these 2 rows until all heel sts have been worked. *22[24:26] sts rem.*

Gusset

Now working in the round once more continue as folls:
Set-up round: Sl1k, k21[23:25], pick up 15[16:17] sts along edge of heel (this is one stitch from every slipped stitch), rib 30[34:38] sts, pick up 15[16:17] sts down edge of heel, k37[40:43]. You are now at the start of the sock upper.
Place beg of round marker. *82[90:100] sts.*
Round 1: Rib 30[34:38], ssk, k to last 2 sts, k2tog. *2 sts dec.*
Round 2: Rib 30[34:38], k to end of round.
These 2 rounds set gusset shaping.
Dec as set until 64[72:80] sts rem.
Work 8 rounds in patt as set.
Change to **D**.
Next round: Knit.
Work 16 rounds in pattern.
Change to **C**.
Next round: Knit.
Cont in pattern until work meas 6[6:7] cm (2¼[2¼:2¾] in) less than desired foot length.
Change to **B**.
Next round: Knit.
Pattern 2 rounds.

Shape toe

Change to **A**.
Next round: (K1, ssk, k26[30:34], k2tog, k1) twice. *4 sts dec. 60[68:76] sts.*
Next round: Knit.
Next round: (K1, ssk, k24[28:32], k2tog, k1) twice. *4 sts dec. 56[64:72] sts.*
Next round: Knit.
Working 2 sts less between decreases continue in this way until 20[24:24] sts rem.

To finish

Cut yarn leaving a 30cm (12 in) end.
Join toe sts using the grafting technique (see page 119).
Weave in any yarn ends, sewing them into the sock upper rather than the sole as this part of the sock gets less wear.

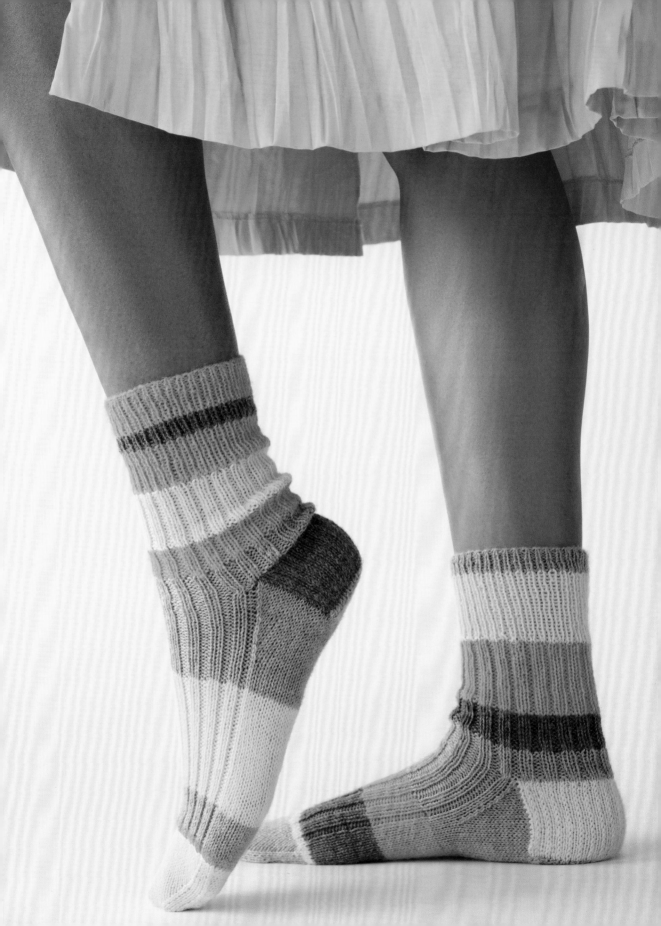

Second sock

Cuff and leg

Using **D** cast on 64[72:80] sts. Join to work in the round. Place beg of round marker.
Round 1: *K1, p1, rep from * to end of round. This round sets 1x1 rib.
Work 11 rounds more in 1x1 rib.
Change to **C**.
Next round: Knit.
Work 6 rounds in 1x1 rib.
Change to **D**.
Next round: Knit.
Work 11 rounds in 1x1 rib.
Change to **B**.
Next round: Knit.
Next round: *P2, k2, rep from * to end of round.
This round sets 2x2 rib.
Work a 18 rounds more in 2x2 rib.
Change to **D**.
Next round: Knit.
Work 9 rounds in 2x2 rib.
Change to **A**.
Next round: Knit.
Work 8 rounds in 2x2 rib.

Heel flap

Next round: Using **A**, patt 30[34:38], using **C** knit across rem 34[38:42] sts.
Turn work so WS is facing. Work heel flap back and forth on next 34[38:42] sts. Keep rem 30[34:38] sts on stitch holder for instep.
Row 1 (WS): Sl1p, purl to end.
Row 2: (Sl1k, k1) 17[19:21] times.
Rep these 2 rows a further 13[14:15] times, then Row 1 once more.

Heel turn

Change to **A**.
Row 1 (RS): Sl1k, k20[22:24], ssk, k1, turn, leave rem sts unworked.
Row 2: Sl1p, p9, p2tog, p1, turn, leave rem sts unworked.
Row 3: Sl1k, knit to 1 st before gap, ssk, k1, turn.
Row 4: Sl1p, purl to 1 st before gap, p2tog, p1, turn.
Repeat these 2 rows until all heel sts have been worked. *22[24:26] sts rem*.

Gusset

Now working in the round once more continue as follows:
Set up round: Sl1k, k21[23:25], pick up 15[16:17] sts along edge of heel (this is one stitch from every slipped stitch), rib 30[34:38] sts, pick up 15[16:17] sts down edge of heel, k37[40:43]. You are now at the start of the sock upper.
Place beg of round marker. *82[90:98] sts*.
Round 1: Rib 30[34:38], ssk, knit to last 2 sts, k2tog. *2 sts dec*.
Round 2: Rib 30[34:38], knit to end of round.
These 2 rounds set gusset shaping.
Dec as set until 64[72:80] sts rem.
Work 5 rounds as set.
Change to **B**.
Next round: Knit.
Continue 30 rounds in pattern for 7cm (2¾ in).
Change to **A**.
Next round: Knit.
Continue in pattern until work meas 6[6:7]cm (2¼[2¼:2¾] in) less than desired foot length.
Change to **D**.
Next round: Knit.
Pattern 2 rounds.

Shape toe

Change to **B**.
Next round: (K1, ssk, k26[30:34], k2tog, k1) twice. *4 sts dec. 60[68:76] sts*.
Next round: Knit.
Next round: (K1, ssk, k24[28:32], k2tog, k1) twice. *4 sts dec. 56[64:72] sts*.
Next round: Knit.
Working 2 sts less between decreases continue in this way until 20[24:24] sts rem.

To finish

Cut yarn leaving a 30cm (12 in) end.
Join toe sts using the grafting technique (see masterclass opposite).
Weave in any yarn ends, sewing them into the sock upper rather than the sole as this part of the sock gets less wear.

Masterclass

Grafting stitches together

Grafting two separate pieces together into one seamless creation can be neatly done using this particular technique, which gives for a super-tidy finish. This can be used in items where you do not want to feel a seam, such as the toe of a sock.

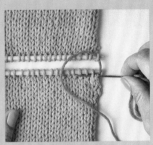

One With the same number of stitches on both needles, place the needles parallel, with the RS of the work facing upwards. Cut the working yarn from the back piece leaving a long tail around four times the length of the edge to be grafted. Thread a yarn large-eyed sewing with the yarn tail. To start, bring the needle from the back to the front piece and pass it through the first stitch of the front piece as if to purl. Pull the yarn through, leaving the stitch on the needle. From the back again, bring the needle through the first stitch of the back piece as if to knit and pull the yarn through, leaving the stitch on the needle. Take the needle through the first stitch of the front piece as if to knit and take it off the needle. Then, take the needle through the next stitch of the front piece as if to purl, leaving the stitch on the needle.

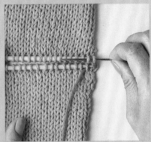

Two Take the needle through the first stitch of the back piece as if to purl and take it off needle. Take the needle through the next stitch of the back piece as if to knit, leaving the stitch on the needle.

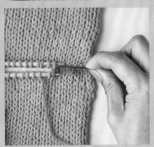

Three Continue taking the needle through a stitch from the front and then through the next stitch from the back, alternating between the front and back pieces, until you have one stitch left on each needle. To complete the last two stitches, slip the front stitch knitwise and slip the back stitch purlwise. Take the yarn to the inside of your work.

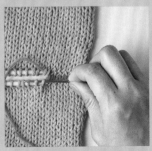

Four Adjust the sewn stitches as you make them so that they have the same tension as the knitted stitches. If the sewn stitches are uneven, you can use the sewing needle to ease the yarn along the row to even up the tension. Sew the yarn end into the wrong side of your knitting.

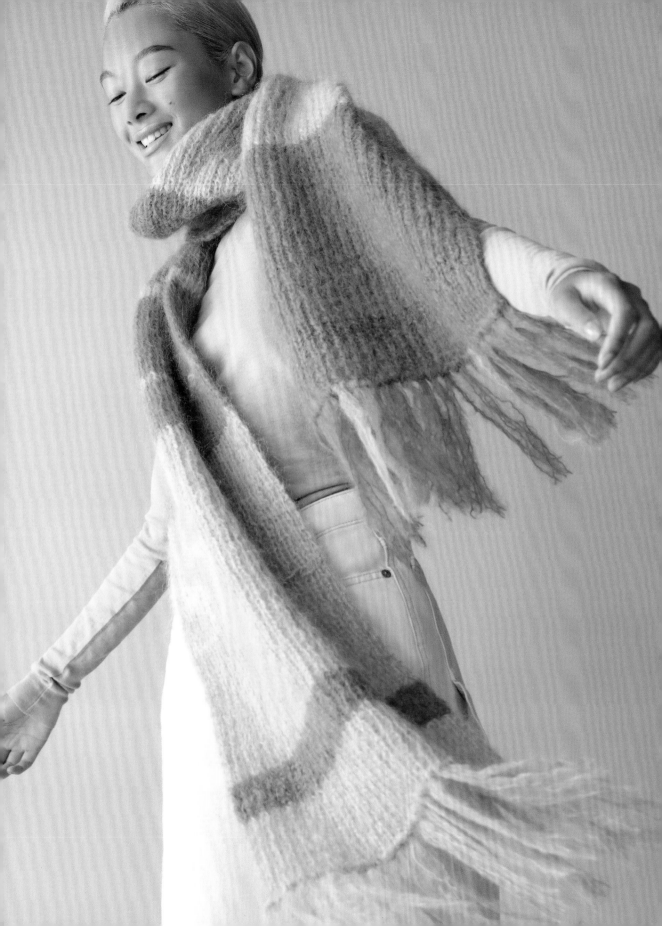

Long Scarf

A scarf was the first thing I ever knitted, and this is another brilliant beginner's project – a super-long scarf in pastel-bright block colours of chunky mohair yarn. Using a rib stitch adds texture, but also means that the scarf lays flat so the edges do not curl inwards, and that it is fully reversible. For a designer finish, fringe the scarf in blocks of colour – it's all in the detail!

Measurements
One size
Approx. 32cm (12½ in) wide and 210cm (82½ in) long

What you will need
- Debbie Bliss Nell
 78% mohair, 13% merino wool,
 9% polyamide
 100m (109 yards) per 50g (1¾ oz)

Quantity:
- **A** 2 x 50g (1¾ oz) balls in Jade (07)
- **B** 2 x 50g (1¾ oz) balls in Heather (04)
- **C** 2 x 50g (1¾ oz) balls in Lilac (05)
- **D** 2 x 50g (1¾ oz) balls in Willow (08)
- **E** 1 x 50g (1¾ oz) ball in Rose (09)

- 1 pair 6mm (US 10) knitting needles
- 6mm (US J/10) crochet hook
- Yarn needle

Tension (gauge)
17 sts and 18 rows to 10cm (4 in) over 1x1 rib using 6mm (US 10) needles. Change needle size as necessary to achieve correct tension (gauge).

Abbreviations
See page 69.

Special technique
Adding fringing (see page 197).

Note: Joining in new colours
On the row before you need introduce the new colour, work to the last stitch. Take the end of the new colour and use it together with the current yarn in work to complete the last stitch, creating a "double stitch". On the first stitch of the next row, work the double stitch as one stitch with just the new colour. This will securely anchor your new yarn and avoid creating any unsightly knots or bumps.

Stripe sequence

8 rows **A**
4 rows **B**
42 rows **A**
28 rows **C**
8 rows **D**
24 rows **E**
4 rows **A**
12 rows **E**
8 rows **D**
24 rows **B**
24 rows **C**
8 rows **D**
8 rows **E**
36 rows **B**
8 rows **A**
4 rows **C**
24 rows **A**
2 rows **E**
14 rows **A**
36 rows **C**
28 rows **D**
8 rows **B**
16 rows **D**

To make

Using 6mm (US 10) needles and **A**, cast on 55 sts and work in rib as follows:
Row 1 (RS): P1, *k1, p1, rep from * to end.
Row 2: *K1, p1, rep from * to last st, k1.
Rep these 2 rows following stripe sequence as given.
Cast off (bind off) in rib.

To finish

Weave in any yarn ends neatly along the row, not up the sides of the scarf.

Fringing
Add a tassel (see masterclass on page 197) to every alternate stitch along both cast-on and cast-off (bound-off) edges to create an evenly spaced fringe. Use 35cm (14 in) lengths of yarn and follow the photographs as a colour guide. Trim the fringing to approx. 15cm (6 in), or to the length preferred.

Fringe Sweater

Deceptively easy to knit, this cropped. boxy sweater looks fab on both you and your mini me! Made in rectangles of repeating moss stitch, in this pattern you will learn easy short-row shaping for the shoulders, creating a neater finish than stepped shoulders, and a three-needle cast off to provide a smart external seam. Have fun with adding fringing in coordinating or contrast colours, but don't get too carried away – sometimes less is more!

Measurements

See chart below for adult sizes and see chart on page 129 for junior sizes.

Materials

- MWL The Chunky One
 100% merino wool
 65m (71 yards) per 100g (3½ oz)

ADULT SIZE Quantity:
- 10[11:13:14:15] x 100g (3½ oz) balls in Gold Medal

JUNIOR SIZE Quantity:
- **A** 5[5:6] x 100g (3½ oz) balls in Lychee White
- **B** scraps in Jump Pink, for fringing
- **C** scraps in Aqua Blue, for fringing
- **D** scraps in Limoncello, for fringing
- **E** scraps in Toweling Teal, for fringing
- 1 pair 12mm (US 17) knitting needles
- 10mm (US 15) circular needle, 60cm (24 in) length
- Stitch markers
- Stitch holders
- 8mm (US L/11) crochet hook
- Yarn needle

Tension (gauge)

9 sts and 12 rows to 10cm (4 in) over moss (seed) st on 12mm (US 17) needles. Change needle size as necessary to achieve correct tension (gauge).

Abbreviations

See page 69.

Special technique

Short-row shaping (see pages 102–103).

Adult size	XS	S	M	L/XL	XXL	
To fit chest	71–86	91.5–106.5	111.5–117	122–137	142–158	cm
	28–34	36–42	44–46	48–54	56–62	in
Actual chest	118	126.5	140	153.5	166.5	cm
	46½	49¾	55	60½	65½	in
Length	54	56	58	60	62	cm
	21¼	22	22¾	23½	24½	in
Sleeve length	36	36	36	36	36	cm
	14¼	14¼	14¼	14¼	14¼	in

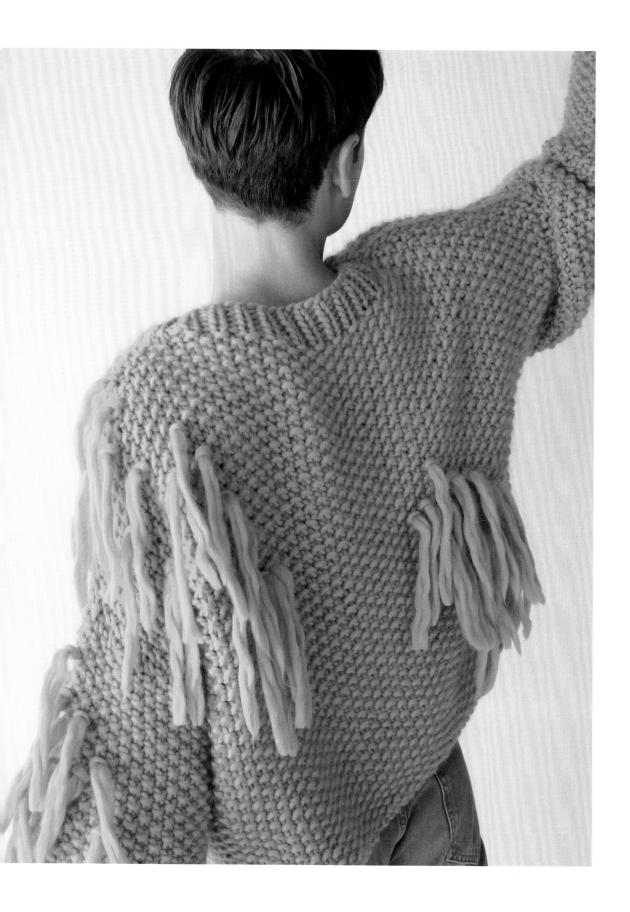

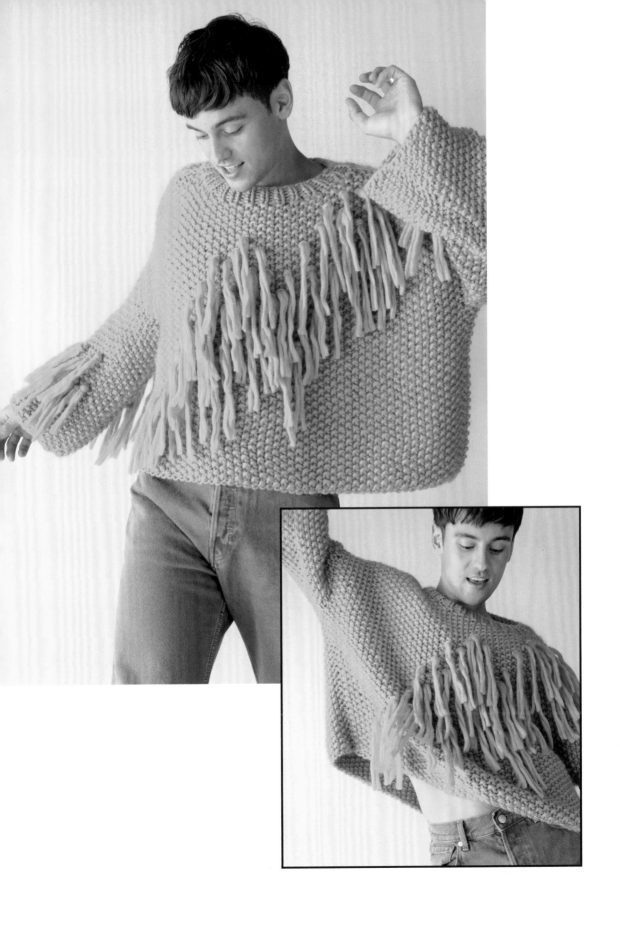

Note: The first row is the right side of the work. To maintain moss (seed) st, if the st on lefthand needle presents as a knit stitch, work st as purl; if the st on lefthand needle presents as a purl stitch, work st as knit. Alternatively, attach a stitch marker to the right side of your work to keep track of it.

To make adult size

Back

Using 12mm (US 17) needles, cast on 55[59:65:71:77] sts.
Next row (RS): *K1, p1, rep from * to last st, k1.
Repeat last row for moss (seed) st until work meas 49[51:53:55:57]cm (19¼[20:20¾:21¾:22½] in) from cast-on edge, ending with RS facing for next row, placing markers at both sides when work meas 30[31:32:33:34]cm (11¾[12¼:12½:13:13½] in) from cast-on edge to show start of armholes.

Shape shoulders
Next row (RS): Patt to last 6[7:8:9:10] sts, wrap next st and turn.
Next row: Patt to last 6[7:8:9:10] sts, wrap next st and turn.
Next row: Patt to last 12[13:15:16:18] sts, wrap next st and turn.
Next row: Patt to last 12[13:15:16:18] sts, wrap next st and turn.
Next row: Patt 6[6:7:8:9] sts, turn.
Next row: Patt across all 18[19:22:24:27] sts, picking up wraps as you work.
Cut yarn leaving a long end.
Slip these 18[19:22:24:27] sts onto a stitch holder for shoulder.

With RS facing, slip centre 19[21:21:23:23] sts onto stitch holder for neckband.
Rejoin yarn to rem sts at neck edge and patt across all 18[19:22:24:27] sts, picking up wraps as you work.
Cut yarn leaving long end.
Slip these 18[19:22:24:27] sts onto a stitch holder for shoulder.

Front

Using 12mm (US 17) needles, cast on 55[59:65:71:77] sts.
Next row (RS): *K1, p1, rep from * to last st, k1.
Repeat last row for moss (seed) st until work meas 49[51:53:55:57]cm (19¼[20:20¾:21¾:22½] in) from cast-on edge, ending with RS facing for next row, placing markers at both sides when work meas 30[31:32:33:34]cm (11¾[12¼:12½:13:13½] in) from cast-on edge to show start of armholes.

Shape neck and shoulders
Next row (RS): Patt 23[24:27:29:32], turn and leave rem sts on stitch holder.
Next row: Cast off (bind off) 3 sts, patt to last 6[7:8:9:10] sts, wrap next st and turn.
Next row: Patt to end of row.
Next row: Cast off (bind off) 2 sts, patt to last 12[13:15:16:18] sts, wrap next st and turn.
Next row: Patt to end of row.
Next row: Patt across all 18[19:22:24:27] sts, picking up wraps as you work.
Cut yarn leaving a long end.
Slip these 18[19:22:24:27] sts onto stitch holder for shoulder.

With RS facing, slip centre 9[11:11:13:13] sts onto stitch holder.
Rejoin yarn to rem sts at neck edge and work as follows:
Next row (RS): Cast off (bind off) 3 sts, patt to last 6[7:8:9:10] sts, wrap next st and turn.
Next row: Patt to end of row.
Next row: Cast off (bind off) 2 sts, patt to last 12[13:15:16:18] sts, wrap next st and turn.
Next row: Patt to end of row.
Next row: Patt across all 18[19:22:24:27] sts, picking up wraps as you work.
Cut yarn leaving long end.
Slip these 18[19:22:24:27] sts onto stitch holder for shoulder.

Join both shoulders using the three-needle cast-off (bind-off) method with WS of work together so the external seam is on the outside of your work.

Sleeves (both alike)

With RS facing and using 12mm (US 17) needles, pick up and knit 35[37:39:41:43] sts evenly between armhole markers and work in moss (seed) st as follows:
Next row: *K1, p1, rep from * to last st, k1.
Repeat last row for moss (seed) st until sleeve meas 36cm (14¼ in) from pick-up. Cast off (bind off) in moss (seed) st.

Neckband

With RS facing and using 10mm (US 17) circular needle, starting at left shoulder seam, pick up and knit 7 sts down left front neck, patt across 9[11:11:13:13] sts from holder, pick up and knit 7 sts up right front neck, 3 sts down right back neck, patt across 19[21:21:23:23] sts from holder and pick up and knit 3 sts up left back neck. Join to work in the round and place marker to show start of round. *48[52:52:56:56] sts.*
Next round: *K1, p1, rep from * to end of round.
Repeat this round for 1x1 rib until neckband meas 3.5cm (1½ in), ending at marker.
Cast off (bind off) in rib.

To finish

Weave in any yarn ends.
Join side and sleeve seams.

Fringing
Cut any leftover yarn into lengths of approx 33cm (13 in) long. For each fringe, take a length of yarn and fold in half. Push the crochet hook from back to front through the raised bump of a stitch. Using the crochet hook, pull the folded yarn down half-way through the stitch, then take the loop and pull the ends through to secure. Repeat in random patches across the front, back and sleeves, using the photograph as a guide. Trim each fringe to neaten to 15cm (6 in), or as preferred.

To make junior size

To fit age	2–3	4–5	6–7	years
Actual chest	64.5	73.5	82	cm
	25½	29	32¼	in
Length	33	35	37	cm
	13	13¾	14½	in
Sleeve length	17	17	17	cm
	6¾	6¾	6¾	in

Back

Using 12mm (US 17) needles and **A**, cast on 31[35:39] sts.
Next row (RS): *K1, p1, rep from * to last st, k1.
Repeat last row for moss (seed) st until work meas 28[30:32]cm (11[11¾:12½] in) from cast-on edge, ending with RS facing for next row, placing markers at both sides when work meas 16cm (6¼ in) from cast-on edge to show start of armholes.

Shape shoulders
Next row (RS): Patt to last 3[4:5] sts, wrap next st and turn.
Next row: Patt to last 3[4:5] sts, wrap next st and turn.
Next row: Patt to last 7[8:9] sts, wrap next st and turn.
Next row: Patt to last 7[8:9] sts, wrap next st and turn.
Next row: Patt 3[3:4] sts, turn.
Next row: Patt across all 10[11:13] sts, picking up wraps as you work.
Cut yarn leaving long end.
Slip these 10[11:13] sts onto stitch holder for shoulder.

With RS facing, slip centre 11[13:13] sts onto stitch holder for neckband.
Rejoin yarn to rem sts at neck edge and patt across all 10[11:13] sts, picking up wraps as you work.
Cut yarn leaving long end.
Slip these 10[11:13] sts onto stitch holder for shoulder.

Front

Using 12mm (US 17) needles, cast on
31[35:39] sts.
Next row (RS): *K1, p1, rep from * to last
st, k1.
Repeat last row for moss (seed) st until
work meas 28[30:32]cm (11[11¾:12½] in)
from cast-on edge, ending with
RS facing for next row, placing markers
at both sides when work meas 16cm
(6¼ in) from cast-on edge to show start of
armholes.

Shape neck and shoulders
Next row (RS): Patt 14[15:17], turn and
leave rem sts on stitch holder.
Next row: Cast off (bind off) 2 sts, patt to
last 3[4:5] sts, wrap next st and turn.
Next row: Patt to end of row.
Next row: Cast off (bind off) 2 sts, patt to
last 7[8:9] sts, wrap next st and turn.
Next row: Patt to end of row.
Next row: Patt across all 10[11:13] sts,
picking up wraps as you work.
Cut yarn leaving long end.
Slip these 10[11:13] sts onto stitch holder
for shoulder.

With RS facing, slip centre 3[5:5] sts onto
stitch holder.
Rejoin yarn to rem sts at neck edge and
work as follows:
Next row (RS): Cast off (bind off) 2 sts, patt
to last 3[4:5] sts, wrap next st and turn.
Next row: Patt to end of row.
Next row: Cast off (bind off) 2 sts, patt to
last 7[8:9] sts, wrap next st and turn.
Next row: Patt to end of row.
Next row: Patt across all 10[11:13] sts,
picking up wraps as you work.
Cut yarn leaving long end.
Slip these 10[11:13] sts onto stitch holder
for shoulder.

Join both shoulders using the three-needle
cast-off (bind-off) method with WS of work
together so the external seam is on the
outside of your work.

Sleeves (both alike)

With RS facing and using 12mm (US 17)
needles, pick up and knit 23[25:29] sts
evenly between armhole markers and work
in moss (seed) st as follows:
Next row: *K1, p1, rep from, * to last st, k1.
Rep last row until sleeve meas 17cm
(6¾ in) from pick-up.
Cast off (bind off) in moss (seed) st.

Neckband

With RS facing, using 10mm (US 15) circular
needle and **A**, starting at left shoulder seam,
pick up and knit 6 sts down left front neck,
patt across 3[5:5] sts from holder, pick up
and knit 6 sts up right front neck, 3 sts down
right back neck, patt across 11[13:13] sts
from holder and pick up and knit 3 sts up
left back neck. Join to work in the round
and place marker to show start of round.
32[36:36] sts.
Next round: *K1, p1, rep from * to end of
round.
Repeat this round for 1x1 rib until neckband
meas 2.5cm (1 in), ending at marker.
Cast off (bind off) in rib.

To finish

Weave in any yarn ends.
Join side and sleeve seams.

Fringing
Cut scraps of contrast colour yarns
(**B**, **C**, **D**, **E**) into lengths of approx. 22cm
(9 in) long. For each fringe, take a length
of yarn and fold in half. Push the crochet
hook from back to front through the raised
bump of a stitch. Using the crochet hook
pull the folded yarn down half-way through
the stitch, then take the loop and pull the
ends through to secure. Repeat in random
patches of colour across the front, back
and sleeves using the photograph as a
guide. Trim each fringe to neaten to 10cm
(4 in), or as preferred.

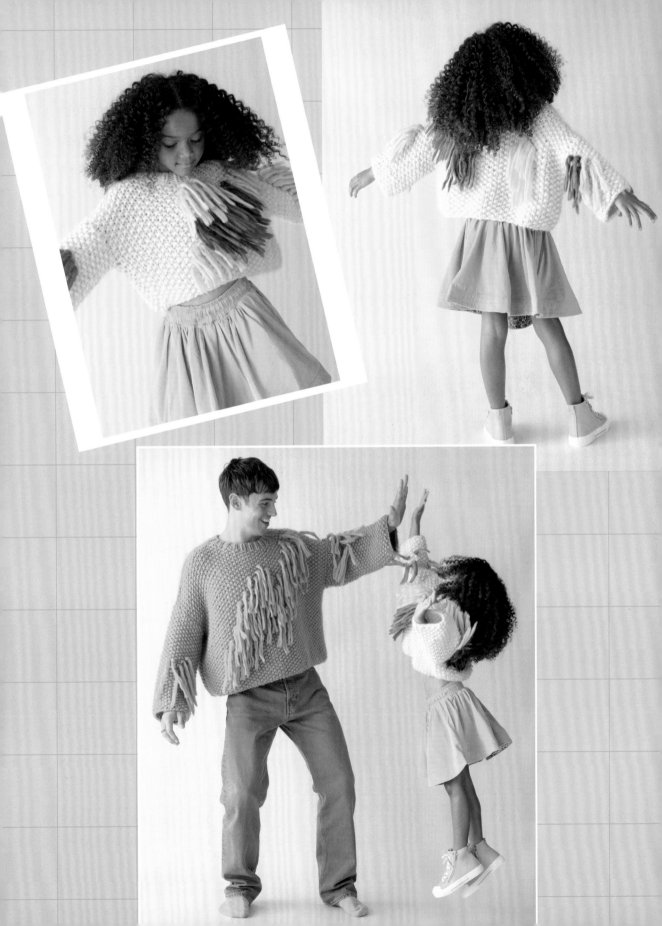

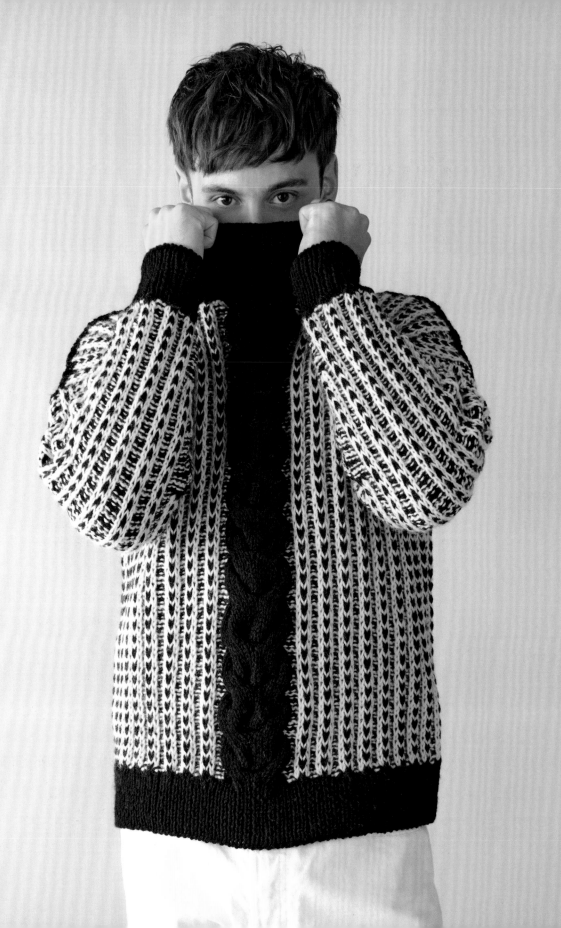

Cable Sweater

This sweater is a modern take on a traditional cable jumper, knitted in bold monochrome black and white with a slip stitch pattern to the front, back and sleeves and an oversized central cable. It is a great way to practise your cables (which are much easier to master than they appear!) and a stylish autumnal knit, ideal for layering up.

Measurements
See chart below. Suggested ease of 15cm (6 in) to 30cm (11¾ in).

Materials
- Cascade 220
 100% Peruvian highland wool
 200m (218 yards) per 100g (3½ oz)
Quantity:
- **A** 4[4:5:5:6:7] x 100g (3½ oz) balls in Black
- **B** 4[4:5:5:6:7] x 100g (3½ oz) balls in Natural
- 1 pair 5mm (US 8) knitting needles
- 1 pair 5.5mm (US 9) knitting needles
- 4.5mm (US 7) circular needle, 40cm (16 in) length
- 5mm (US 8) cable needle
- Stitch markers
- Stitch holders
- Yarn needle

Tension (gauge)
21 sts and 28 rows to 10cm (4 in) over two-colour rib on 5.5mm (US 9) needles. Change needle size as necessary to achieve correct tension (gauge).

Abbreviations
See pages 69 and 134.

Special techniques
Working cables (see page 137).
Working intarsia (see page 165).
Short-row shaping (see pages 102–103).

Note
The front is knitted using the intarsia colourwork method.

Adult size	XS	S/M	L/XL	XXL	XXXL	XXXXL	
Actual chest	109.5	121	132.5	144	161	172.5	cm
	43	47¾	52¼	56¾	63½	68	in
Length	61	63	65	67	69	71	cm
	24	24¾	25½	26½	27¼	28	in
Sleeve length	48	49	49	49	50	50	cm
	19	19¼	19¼	19¼	19¾	19¾	in

Special abbreviations

C10B (cable 10 back): Slip next 5 sts onto cable needle and hold at back of work, knit next 5 sts from left-hand needle, then knit 5 sts from cable needle.

C10F (cable 10 front): Slip next 5 sts onto cable needle and hold at front of work, knit next 5 sts from left-hand needle, then knit 5 sts from cable needle.

1x1 rib

Row 1 (RS): *K1, p1, rep from * to end of row.
Row 2: *K1, p1, rep from * to end of row.

2 colour rib pattern

Row 1 (RS): Using **B**, *p3, k1, slip 1 st purlwise, k1, rep from * to last 3 sts, p3.
Row 2: Using **B**, k3, *p3, k3, rep from * to end of row.
Row 3: Using **A**, *p3, yb, slip next 3 sts purlwise, yfwd, rep from * to last 3 sts, p3.
Row 4: Using **A**, k3, *yfwd, slip 1 st purlwise, p1, slip 1 st purlwise, yb, k3, rep from* to end of row.

Cable pattern worked over 20 sts

Row 1 (RS): Knit.
Row 2: Purl.
Row 3: Knit.
Row 4: Purl.
Row 5: C10B, C10F.
Row 6: Purl.
Row 7: Knit.
Row 8: Purl.
Row 9: Knit.
Row 10: Purl.
Row 11: Knit.
Row 12: Purl.
Rep these 12 rows.

To make

Back

Using 5mm (US 8) needles and **A**, cast on 108[122:132:146:162:178] sts and work 15 rows in 1x1 rib.
Next row (WS inc): Rib 10[16:14:19:17:29], m1, (rib 11[15:13:18:16:30], m1) 8[6:8:6:8:4]

times, rib to end. *117[129:141:153:171:183] sts*. Change to 5.5mm (US 9) needles.
Work in **2 colour rib pattern** as above until work meas 60[62:64:66:68:70]cm (23½[24½:25¼:26:26¾:27½] in) from cast-on edge, ending with RS facing for next row, placing markers at both sides when work meas 37[38:39:40:41:42]cm (14½[15:15¼:15¾:16¼:16½] in) from cast-on to show start of armholes.

Shape shoulders

The shoulders are worked in short row shaping. You will have to strand the colour you are not using over a few stitches so that it is in the right place for keeping the pattern correct.
Keeping pattern correct, work as follows:
Next row: Patt to last 8[11:12:14:16:18] sts, wrap next st and turn.
Next row: Patt to last 8[11:12:14:16:18] sts, wrap next st and turn.
Next row: Patt to last 16[21:24:28:33:36] sts, wrap next st and turn.
Next row: Patt to last 16[21:24:28:33:36] sts, wrap next st and turn.
Next row: Patt to last 25[31:36:42:50:55] sts, wrap next st and turn.
Next row: Patt to last 25[31:36:42:50:55] sts, wrap next st and turn.
Next row: Patt 10 sts, turn.
Next row: Patt across all 35[41:46:52:60:65] sts, picking up wraps as you work.
Cut yarn leaving a long end.
Slip these 35[41:46:52:60:65] sts onto a holder for shoulder.
With RS facing, slip centre 47[47:49:49:51:53] sts onto a holder.
Rejoin correct colour yarn to rem sts and patt to end of row picking up wraps as you work.
Cut yarn leaving a long end.
Slip these 35[41:46:52:60:65] sts onto a holder for shoulder.

Front

The front is worked in 2 colour rib with a centre cable panel worked in **A**. You will need to work the front using the intarsia

method so you will have to work with separate balls of yarn as follows:
1 ball **A** and 1 ball **B** for first 2 colour rib section, 1 ball **A** for centre cable section and 1 ball **A** and 1 ball **B** for second 2 colour rib section. You may find it easier to wind the yarn onto large bobbins which stops them getting too tangled as you work. When working in intarsia always cross the yarn on the WS of your work to avoid holes.

Using 5mm (US 8) needles and **A**, cast on 108[122:132:146:162:178] sts and work 15 rows in 1x1 rib.
Next row (WS inc): (Rib 7[10:9:11:11:16], m1) 6[3:6:5:6:4] times, (rib 8[9:8:12:10:17], m1) 3[7:3:3:3:2] times, (rib 7[10:9:11:11:16], m1) 5[2:5:4:5:4] times, rib to end. *122[134:146:158:176:188] sts.*

Change to 5.5mm (US 9) needles and work row 1 of 2 colour rib and cable pattern as follows:
Next row (RS): P0[0:0:0:3:3] using **B**, work Row 1 of 2 colour rib using **B** on next 51[57:63:69:75:81] sts, place marker, work Row 1 of cable pattern using **A** over next 20 sts, place marker, work Row 1 of 2 colour rib using **B** on next 51[57:63:69:75:81] sts, p0[0:0:0:3:3] using **B**.
Beg with Row 2 of both patterns continue in patt until work meas 55[57:58:60:61:63] cm (21¾[22½:22¾:23½:24:24¾] in) from the cast-on edge, ending with RS facing for next row, and placing markers at both sides when work meas 37[38:39:40:41:42] cm (14½[15:15¼:15¾:16¼:16½] in) from cast-on edge to show start of armholes.

Shape neck
Next row (RS): Patt 48[54:59:65:73:78], turn leaving rem sts on stitch holder.
Next row: Cast off (bind off) 5 sts, patt to end of row. *43[49:54:60:68:73] sts.*
Next row: Patt to end of row.
Next row: Cast off (bind off) 3 sts, patt to end of row. *40[46:51:57:65:70] sts.*
Next row: Patt to last 3 sts, work 2 sts tog to dec, k1. *39[45:50:56:64:69] sts.*

Next row: P1, k2tog, patt as set to end of row. *38[44:49:55:63:68] sts.*
Next row: Patt to end of row.
Next row: P1, k2tog, patt as set to end of row. *37[43:48:54:62:67] sts.*
Next row: Patt to end of row.
Next row: P1, k2tog, patt as set to end of row. *36[42:47:53:61:66] sts.*
Next row: Patt to end of row.
Work until front meas same as back to shoulder shaping, ending with WS facing for next row.

Shape shoulders
The shoulders are worked in short row shaping. You will have to strand the colour not in use over a few stitches so that it is in the right place for keeping pattern correct.
Next row (WS): P1, k2tog, patt to last 8[11:12:14:16:18] sts, wrap next st and turn.
Next row: Patt to end of row.
Next row: Patt to last 16[21:24:28:33:36] sts, wrap next st and turn.
Next row: Patt to end of row.
Next row: Patt to last 25[31:36:42:50:55] sts, wrap next st and turn.
Next row: Patt 10, turn.
Next row: Patt across all 35[41:46:52:60:65] sts, picking up wraps as you work.
Cut yarn leaving a long end.
Slip these 35[41:46:52:60:65] sts onto a holder for shoulder.

With RS facing, slip centre 26[26:28:28:30:32] sts onto a holder. Rejoin correct colour yarn to rem sts and work as follows:
Next row (RS): Cast off (bind off) 5 sts, patt to end of row. *43[49:54:60:68:73] sts.*
Next row: Patt to end of row.
Next row: Cast off (bind off) 3 sts, patt to end of row. *40[46:51:57:65:70] sts.*
Next row: Patt to last 3 sts, work sts 2 tog to dec, p1. *39[45:50:56:64:69] sts.*
Next row: K1, k2tog, patt as set to end of row. *38[44:49:55:63:68] sts.*
Next row: Patt to end of row.
Next row: K1, k2tog, patt as set to end of row. *37[43:48:54:62:67] sts.*
Next row: Patt to end of row.
Next row: K1, k2tog, patt to end of row.

135

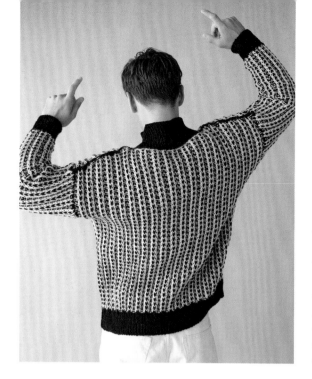

36[42:47:53:61:66] sts.

Next row: Patt to end of row.
Work until front meas same as back to shoulder shaping, ending with RS facing for next row.

Shape shoulder

Next row (RS): K1, k2tog, patt to last 8[11:12:14:16:18] sts, wrap next st and turn.
Next row: Patt to end of row.
Next row: Patt to last 16[21:24:28:33:36] sts, wrap next st and turn.
Next row: Patt to end of row.
Next row: Patt to last 25[31:36:42:50:55] sts, wrap next st and turn.
Next row: Patt 10, turn.
Next row: Patt across all 35[41:46:52:60:65] sts, picking up wraps as you work.
Cut yarn leaving a long end.
Slip these 35[41:46:52:60:65] sts onto holder for shoulder.

Sleeves (both alike)

The sleeves are worked in 2 colour rib throughout. Work increases as follows:
RS increase: P1, m1, patt to last st, m1, p1.
WS increase: K1, m1, patt to last st, m1, k1.

Work increases in Rev st st until you have enough sts to work another pattern repeat.

Using 5mm (US 8) needles and **A**, cast on 44[46:50:52:54:54] sts and work 15 rows in 1x1 rib.
Next row (WS inc): Rib 7[9:7:10:13:13], m1, (rib 5[7:6:8:14:14], m1) 6[4:6:4:2:2] times, rib to end of row. *51[51:57:57:57:57] sts.*
Change to 5.5mm (US 9) needles and work in 2 colour rib as above, inc 1 st at both ends of 3rd row and every following 5th[5th:5th:5th:5th:4th] row until 89[93:97:101:105:109] sts.
Cont straight in patt as set until sleeve meas 48[49:49:49:50:50] cm (19[19¼:19¼:19¼:19¾:19¾] in) from cast-on edge, ending with RS facing for next row.
Cast off loosely.
Join both shoulders using **A** and three-needle cast off (bind off) method using k3, p3 rib with WS of work tog so seams are visible on outside of your work.

Neckband

With RS facing, 4.5mm (US 7) circular needle, **A**, and starting at left shoulder seam, pick up and knit 17 sts down left front neck, k26[26:28:28:30:32] sts from front holder, pick up and knit 17 sts up right front neck, 3 sts across right back neck, k47[47:49:49:51:53] sts from back holder and pick up and knit 4 sts across left back neck, place marker to show start of round. *114[114:118:118:122:126] sts.*
Next round: *K1, p1, rep from * to end of round.
Repeat this round for 1x1 rib until neckband meas 9cm (3½in), ending at marker.
Cast off (bind off) in rib.

To finish

Weave in any yarn ends.
With RS of work facing, pin and sew sleeves between armhole markers.
Join side and sleeve seams.

Masterclass

Working cables

Cabling is a traditional technique designed to add three-dimensional texture to knitting by moving a group of stitches across the fabric so the cable appears to travel over the piece. Usually worked in stocking (stockinette) stitch on a background of reverse stocking stitch for contrast, but other stitches can be used.

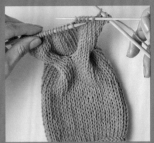

Cable back (cb)

Cable stitches are held at the back of the work on a short cable needle while the next stitches from the LH needle are worked. The stitches on the cable needle are then worked to create the "twist". A cable back creates a twist to the right. Any number of stitches can be used to make cables of varying thickness.

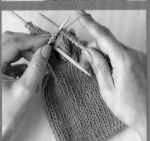

One Work to the position of the cable as instructed in the pattern. Slip the specified number of stitches from the LH needle onto the cable needle (here it is five).

Two Hold the cable needle and the stitches on it at the back of the work, then knit the next specified number of stitches from the LH needle. Now knit the stitches from the cable needle to complete the twist.

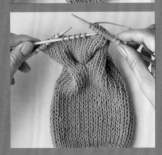

Cable front (cf)

Cable back and cable front are often used together to create a cable that snakes along the knitted fabric. A cable front is worked in the same way as a cable back, except the cable stitches are held at the front of the work. A cable front creates a twist to the left.

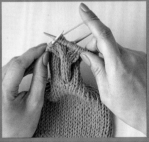

One Work to the position of the cable as instructed in the pattern. Slip the specified number of stitches from the LH needle onto the cable needle (here it is five).

Two Hold the cable needle and the stitches on it at the front of the work, then knit the next specified number of stitches from the LH needle. Now knit the stitches from the cable needle to complete the twist.

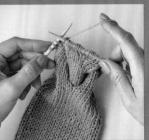

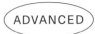

Top Down Fairisle Sweater

This cosy Fairisle sweater is a play on the traditional knits named after the colourwork technique originating from the Shetland Islands, the northernmost part of Scotland. Featuring bright neons on a black background using the stranding technique, this sweater will also help practise simple increases.

Measurements
See chart below

What you will need
- Rowan Big Wool
 100% merino wool
 80m (87 yards) per 100g (3½ oz)

Quantity:
- **A** 5[5:6:7:7] x 100g (3½ oz) balls in Black
- **B** 1[1:1:1:1] x 100g (3½ oz) ball in Oasis
- **C** 1[1:1:1:1] x 100g (3½ oz) ball in Cerise
- **D** 1[1:1:1:1] x 100g (3½ oz) ball in Midori
- **E** 1[1:1:1:1] x 100g (3½ oz) ball in Steel Blue
- **F** 1[1:1:1:1] x 100g (3½ oz) ball in Citron

- 10mm (US 15) circular needle, 40cm (16 in), 60cm (24 in), 80cm (32 in) and 100cm (40 in) length
- Stitch markers
- Stitch holders
- Yarn needle

Tension (gauge)
9 sts and 10 rounds to 10cm (4 in) meas over St st on 10mm (US 15) needles. Change needle size as necessary to achieve correct tension (gauge).

Abbreviations
See page 69.
MB: make bobble as (k1, p1) twice all into next st, turn and p4, turn and sl2k, k2tog, pass the 2 slipped sts over (bobble completed)

Special techniques
Working in the round (see pages 112–113).
Stranding (see page 143).
Picking up stitches (see page 171).

Adult size	XS	S/M	L/XL	XXL	XXXL	
To fit chest	71–86	91.5–106.5	111.5–117	122–137	142–158	cm
	28–34	36–42	44–46	48–54	56–62	in
Actual chest	124.5	133.5	142	151	160	cm
	49	52½	56	59½	63	in
Length	54	58	60	64	68	cm
	21.25	22¾	23½	25¼	26¾	in
Sleeve length	50	51	51	52	52	cm
	19¾	20	20	20½	20½	in

Notes

Joining a new colour in the round to avoid the jog

1. Patt first round in new colour. Insert working needle in RH leg of first stitch in row below and lift it onto LH needle.
2. Insert working needle in first stitch of last round and stitch below and knit the 2 stitches together.

Needle lengths

Change to longer circular needles as required when increasing stitches for the yoke. When you separate the sleeves from the body you may prefer to change back to a shorter needle for the body.

To make

Yoke

Note: Begins at neck edge at centre back. Using 10mm (US 15) 40cm (16 in) circular needle and **A**, cast on 40[42:44:46:48] sts. Place marker to show beg of round and join to work in the round, ensuring sts are not twisted.

Round 1: *K1, p1, rep from * to end of round. Work 1 round more in rib as set.
Change to **B** and work 2 rounds in rib.
Change to **A** and work 2 rounds in rib.
Change to **C** and work 2 rounds in rib.
Change to **A** and work 2 rounds in rib.

Work yoke chart

Changing needle length as necessary and working from yoke chart Rounds 1 to 26, continue as follows to shape yoke, noting that pattern repeat is shown on chart with a red outline, and working increases for each size as given below:

Size XS only

Round 2: (K1, m1, k1) 20 times. *60 sts.*
Round 8: K6, (m1, k1) 48 times, k6. *108 sts.*
Round 12: K6, (m1, k5) 20 times, k2. *128 sts.*
Round 15: K7, (m1, k6) 20 times, k1. *148 sts.*
Round 18: K7, (m1, k5) 28 times, k1. *176 sts.*

Yoke chart

					
☐	Knit		▨	C	
•	Purl		▨	D	
⑪	MB		▨	E	
■	A		▨	F	
▨	B		☐	Repeat	

Size S/M only

Round 2: (M1, k2) 10 times, m1, k1, (m1, k2) 10 times, m1, k1. *64 sts.*

Round 8: *(M1, k2) 4 times, (m1, k1) 15 times, (m1, k2) 4 times, m1, k1, rep from * once more. *112 sts.*

Round 12: *K2, (m1, k5, m1, k4) 6 times, m1, rep from * once more. *136 sts.*

Round 15: *K2, (m1, k6, m1, k5) 6 times, m1, rep from * once more. *160 sts.*

Round 18: *K2, (m1, k7, m1, k6) 6 times, m1, rep from * once more. *184 sts.*

Size L/XL only

Round 2: *(M1, k2) 5 times, m1, k1, (m1, k2) 5 times, m1, k1, rep from * once more. *68 sts.*

Round 8: *(M1, k2) 5 times, (m1, k1) 13 times, (m1, k2) 5 times, m1, k1, rep from * once more. *116 sts.*

Round 12: *K2, (m1, k5) 5 times, m1, k4, (m1, k5) 5 times, m1, k2, rep from * once more. *140 sts.*

Round 15: K2, (k1, m1, k4) 27 times, m1, k3. *168 sts.*

Round 18: K6, (k1, m1, k4) 32 times, k2. *200 sts.*

Size XXL only

Round 2: *(M1, k2) 5 times, (m1, k1) twice, (m1, k2) 5 times, m1, k1, rep from * once more. *72 sts.*

Round 8: *(M1, k2) 4 times, (m1, k1) 19 times, (m1, k2) 4 times, m1, k1, rep from * once more. *128 sts.*

Round 12: *K4, (m1, k5) 12 times, rep from * once more. *152 sts.*

Round 15: *K5, (m1, k5) 14 times, k1, rep from * once more. *180 sts.*

Round 18: *K6, (m1, k6) 14 times, rep from * once more. *208 sts.*

Size XXXL only

Round 2: *(M1, k2) 5 times, (m1, k1) 3 times, (m1, k2) 5 times, m1, k1, rep from * once more. *76 sts.*

Round 8: *(M1, k2) 5 times, (m1, k1) 17 times, (m1, k2) 5 times, m1, k1, rep from * once more. *132 sts.*

Round 12: *K5, (m1, k5) 12 times, k1, rep from * once more. *156 sts.*

Round 15: *K6, (m1, k5) 14 times, k2, rep from * once more. *184 sts.*

Round 18: *K2, (m1, k6) 6 times, (m1, k5) 3

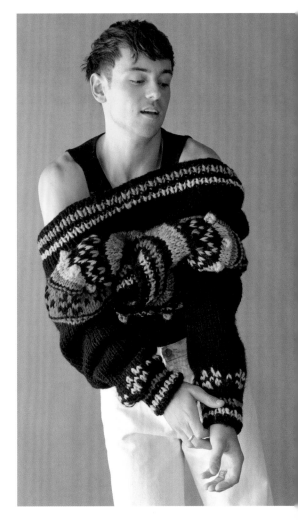

times, (m1, k6) 6 times, m1, k3, rep from * once more. *216 sts.*

Sizes L/XL, XXL and XXXL only

Knit 1 round in D.

Sizes XXL and XXXL only

Knit 1 round in **A**.

All sizes

Divide for body and sleeves

Set up round: Working in **D[D:A:A:A]**, k26[28:30:32:34] for first half of back, leave next 36[36:40:40:40] sts on a holder for sleeve, using backwards loop method cast on 4 sts for underarm, patt 52[56:60:64:68] for front, leave next 36[36:40:40:40] sts on a holder for sleeve, using backwards loop method cast on 4 sts, patt 26[28:30:32:34]. *112[120:128:136:144] sts.*

Body

Using A, knit 20[24:25:28:32] rounds.
Work in k1, p1 rib as follows:
2 rounds **A**
2 rounds **F**
2 rounds **A**
2 rounds **D**
2 rounds **A**
Cast off (bind off) in rib.

Sleeves (both alike)

Using 10mm (US 15) needles 40cm (16in) length and with **A** and right side of work facing, starting halfway across underarm cast-on edge, pick up and knit 2 sts, k36[36:40:40:40] sts from sleeve holder, pick up and knit 2 sts from rem underarm cast-on edge. Place marker to show beg of round and join to work in the round. *40[40:44:44:44] sts.*
Using **A**, knit 33[34:34:35:35] rounds.

Work sleeve chart
Beginning each round with stitch 1[1:7:7:7] and ending with stitch 8[8:2:2:2], work from sleeve chart Rounds 1 to 5 as set.
Next round (dec): Using **A**, *K2, k2tog, rep from * to end of round. *30[30:33:33:33] sts.*
Work in k1, p1 rib as follows:
2 rounds **A**, while dec 0[0:1:1:1] st on 1st round. *30[30:32:32:32] sts.*
2 rounds **C**
2 rounds **A**
2 rounds **B**
2 rounds **A**
Cast off (bind off) in rib.

Sleeve chart

8	7	6	5	4	3	2	1	
								5
								4
								3
								2
								1

8 7 6 5 4 3 2 1

■ With A, knit on RS rows

□ With F, knit on RS rows

To finish

Weave in any yarn ends.
Gently steam on reverse.

Masterclass

Stranding

The bands of colour motifs around the yoke and cuffs of this sweater are knitted using the stranded colourwork technique. As the sweater is knitted in stocking (stockinette) stitch in the round, you knit every stitch while alternating colours, following the charts showing the placement of the colour stitches.

The bands of motifs in Fairisle designs only ever use two colours, and so when working stranded colourwork you need to carry the strand of yarn not in use across the back of the fabric until you need to use it again. This results in strands of yarn laying across the wrong side of the work, which are known as floats, and is done to keep strand neat and prevent the fabric from puckering. The most important thing when stranding yarns across your work is to maintain an even tension with the floats. They must be long enough to span the width of the stitches they are sitting behind, even when the knitted fabric is slightly stretched, but not so loose that the stitches lose definition.

Many knitters often knit stranded colourwork with a tighter tension (gauge) than usual, tightening up because of all the switches between different colour yarns. Going up a needle size for the stranded colourwork bands can be a good idea and helps to compensate for this natural tightening of tension. Another tip for achieving a good tension is to spread out the stitches just worked on the right needle each time you switch to a different colour yarn. If the knitted stitches are all bunched up together, the float at the back of the work will be too short. If they are spread out, the float will span the full width of those stitches and the fabric will be less likely to pucker.

Stranding on a knit row

One On a knit row, drop the working yarn. Bring the new colour over the top of the dropped yarn and work to the next colour change.

Two Drop the working yarn. Bring the new colour under the dropped yarn and work to the next colour change. Repeat these two steps for all subsequent colour changes.

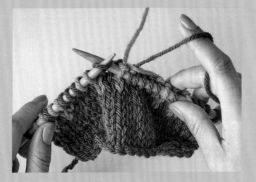 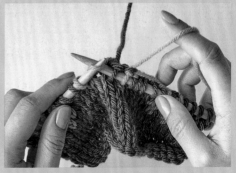

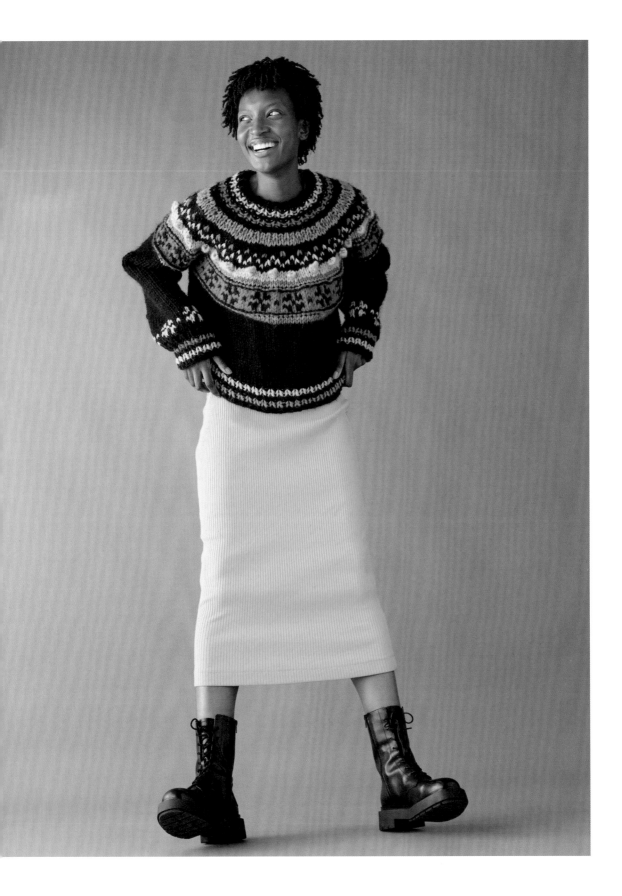

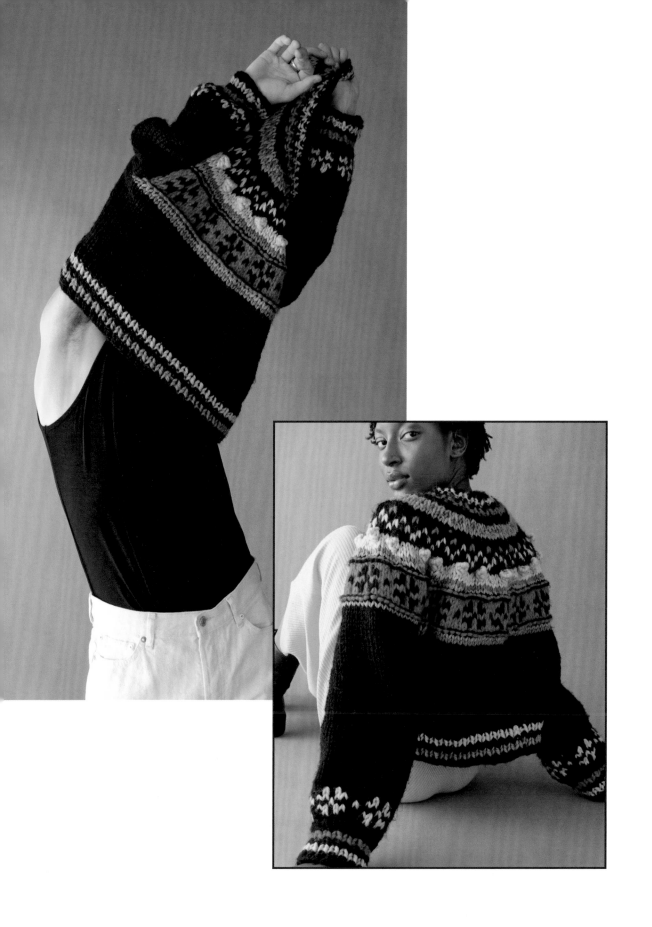

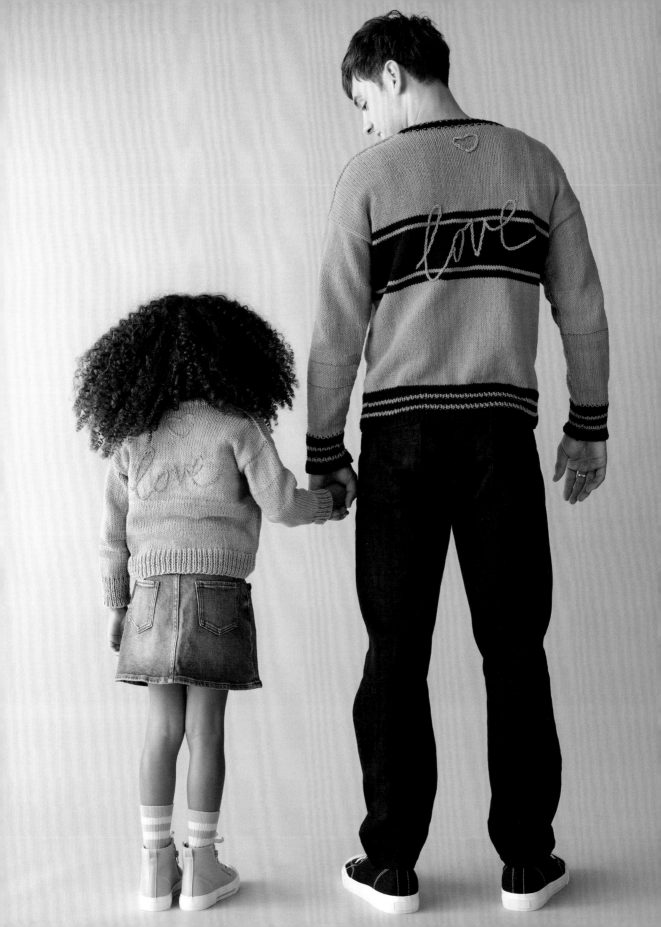

Varsity Cardigan

Inspired by 1950s letterman jackets, this classic cardigan is sporty with a vintage twist. Knitted in three colours, with patch pockets and asymmetric stripe detailing in the rib buttonbands, hem and cuffs. Customise to make it unique to you, using embroidery and applique letters simply oversewn on to the front. Knitted in a recycled cotton yarn, this jacket is perfect for warm spring days and chilly summer evenings, with the added cool factor of being planet friendly too.

Measurements
See chart below for adult sizes and see chart on page 152 for junior sizes

What you will need
- Kremke Soul Wool Karma Cotton
 70% cotton, 30% recycled polyamide
 105m (114 yards) per 50g (1¾ oz)

ADULT SIZE Quantity:
- **A** 3[3:4:4:4] x 50g (1¾ oz) balls in Black
- **B** 8[8:9:10:11] x 50g (1¾ oz) balls in Orange
- **C** 1[1:1:1:1] x 50g (1¾ oz) ball in Aquamarine

JUNIOR SIZE Quantity:
- **A** 2[2:3] x 50g (1¾ oz) balls in Violet
- **B** 3[4:5] x 50g (1¾ oz) balls in Lime
- **C** 1[1:1] x 50g (1¾ oz) ball in Deep Pink
- 1 pair 4mm (US 6) knitting needles
- 3.75mm (US 5) circular needle, 80cm
 (32 in) length
- Stitch holders
- Stitch markers
- 2 small buttons approx. 11mm (½ in) (for
 adult size only)
- 4 large buttons approx. 20mm (¾ in)
- Yarn needle

Tension (gauge)
18 sts and 26 rows to 10cm (4 in) over St st on 4mm (US 6) needles. Change needle size as necessary to achieve correct tension (gauge).

Abbreviations
See page 69.

Special techniques
Short-row shaping (see pages 102–103)
Adding surface embroidery (see page 155)

Adult sizes	XS	S/M	L/XL	XXL	XXXL	
To fit chest	71–86	91.5–106.5	111.5–117	122–137	142–158	cm
	28–34	36–42	44–46	48–54	56–62	in
Actual chest	104.5	115.5	129	144.5	160	cm
	41¼	45½	50¾	57	63	in
Length	61	63	65	67	69	cm
	24	24¾	25½	26¼	27	in
Sleeve length	45.5	47	47	48	48	cm
	18	18½	18½	19	19	in

To make adult size

Hem and cuff stripe sequence	Body stripe sequence
6 rows **A**	4 rows **A**
2 rows **B**	2 rows **B**
4 rows **A**	24 rows **A**
2 rows **B**	2 rows **B**
6 rows **A**	4 rows **A**

Back

Using 4mm (US 6) needles and **A**, cast on 96[106:118:132:146] sts and follow hem and cuff stripe sequence above work in rib as follows.

Rib row: *K1, p1, rep from * to end of row. Work 19 more rows in rib as set.

Using **B** and beg with a knit row, work 54[56:58:62:64] rows in St st, ending with RS facing for next row. Work should meas 28[29:30:31:32] cm (11[11½:11¾:12¼:12½] in) from cast-on edge.

Continue in St st and follow body stripe sequence above, and placing markers at both sides when work meas 38[39:40:41:42] cm (15[15¼:15¾:16¼:16½] in) from cast-on edge to show start of armholes.

Using **B**, work 48[50:54:56:58] rows straight, ending with RS facing for next row. Work should meas 60[62:64:66:68] cm (23½[24½:25¼:26:26¾] in) from cast-on edge.

Shape shoulders

Next row (RS): Knit to last 8[10:11:13:15] sts, wrap next st and turn.

Next row: Purl to last 8[10:11:13:15] sts, wrap next st and turn.

Next row: Knit to last 17[20:22:26:29] sts, wrap next st and turn.

Next row: Purl to last 17[20:22:26:29] sts, wrap next st and turn.

Next row: Knit to last 25[29:33:38:43] sts, wrap next st and turn.

Next row: Purl to last 25[29:33:38:43] sts, wrap next st and turn.

Next row: K8[9:10:12:13], turn.

Next row: Purl across all 33[38:43:50:56] sts, picking up wraps as you work.

Cut yarn leaving a long end.

Slip these 33[38:43:50:56] sts onto a stitch holder for shoulder.

With RS of work facing, slip centre 30[30:32:32:34] sts onto a stitch holder. Rejoin yarn to rem 33[38:43:50:56] sts and knit across all sts, picking up wraps as you work.

Cut yarn leaving a long end.

Slip these 33[38:43:50:56] sts onto a stitch holder for shoulder.

Left front

Using 4mm (US 6) needles and **A**, cast on 45[50:56:63:70] sts and follow hem and cuff stripe sequence above work in rib as follows:

Sizes XS and XXL only

Rib row 1: K1, *p1, k1, rep from * to end of row.

Rib row 2: P1, *k1, p1, rep from * to end of row.

Sizes S/M, L/XL and XXXL only

Rib row 1: *P1, k1, rep from * to end of row.

Rib row 2: As Rib row 1.

All sizes

Continue in rib as set for 18 rows more.

Using **B** and beg with a knit row, work 54[56:58:62:64] rows in St st, ending with RS facing for next row. Work should meas 28[29:30:31:32] cm (11[11½:11¾:12¼:12½] in) from cast-on edge.

Continue in St st and follow body stripe sequence above for 22[22:22:26:28] rows, ending with RS of work facing for next row.

Shape front neck

Left neck decreases are worked as follows:

RS row dec: Knit to last 5 sts, k2tog, k3.

WS row dec: P3, p2tog, purl to end of row.

Starting with a RS row dec, dec as above on next and every following 5th[5th:5th:5th:4th] row, while completing body stripe sequence. When stripes are complete, continue in **B** only, shaping neck edge as set until 33[38:43:50:56] sts rem, and placing a marker at side edge when work meas 38[39:40:41:42] cm (15[15¼:15¾:16¼:16½] in) from cast-on edge to show start of armhole. Work 7[9:8:6:14] rows straight, ending with WS facing for next row.

Shape shoulder

Next row (WS): Purl to last 8[10:11:13:15] sts, wrap next st and turn.
Next row: Knit to end of row.
Next row: Purl to last 17[20:22:26:29] sts, wrap next st and turn.
Next row: Knit to end of row.
Next row: Purl to last 25[29:33:38:43] sts, wrap next st and turn.
Next row: Knit to end of row.
Next row: Purl across all sts, picking up wraps as you work.
Cut yarn leaving a long end.
Slip these 33[38:43:50:56] sts onto a holder for shoulder.

Right front

Using 4mm (US 6) needles and **A**, cast on 45[50:56:63:70] sts and follow hem and cuff stripe sequence above work in rib as follows:
Sizes XS and XXL only
Rib row 1: K1, *p1, k1, rep from * to end of row.
Rib row 2: P1, *k1, p1, rep from * to end of row.
Sizes S/M, L/XL and XXXL only
Rib row 1: *K1, p1, rep from * to end of row.
Rib row 2: As Rib row 1.
All sizes
Continue in rib as set for 18 rows more.
Using **B** throughout and beg with a knit row work 76[78:80:88:92] rows in St st, ending with RS facing for next row.

Shape front neck

Right neck decreases are worked as follows:
RS row dec: K3, k2tog tbl, knit to end of row.
WS row dec: Purl to last 5 sts, p2tog tbl, p3.

Starting with a RS row dec, dec as above on next and every following 5th[5th:5th:5th:4th] row until 33[38:43:50:56] sts rem, and placing marker at side edge when work meas 38[39:40:41:42] cm (15[15¼:15¾:16¼:16½] in) from cast-on edge to show start of armhole. Work 6[8:7:5:13] rows straight, ending with RS facing for next row.

Shape shoulder

Next row (RS): Knit to last 8[10:11:13:15]

sts, wrap next st and turn.
Next row: Purl to end of row.
Next row: Knit to last 17[20:22:26:29] sts, wrap next st and turn.
Next row: Purl to end of row.
Next row: K to last 25[29:33:38:43] sts, wrap next st and turn.
Next row: Purl to end of row.
Next row: Knit across all sts, picking up wraps as you work.
Cut yarn leaving a long end.
Slip these 33[38:43:50:56] sts onto a holder for shoulder.
Using **B**, join both shoulders using three-needle cast off (bind off) method, with wrong sides of work together so seam is on outside of work.

Sleeves

Right sleeve stripe sequence
33[37:37:39:39] rows **B**
24 rows **C**
42 rows **B**

Left sleeve stripe sequence
53[57:57:59:59] rows **B**
6 rows **C**
6 rows **B**
6 rows **C**
28 rows **B**

Sleeve pattern
With RS facing, 4mm (US 6) needles and **B**, pick up and knit 80[84:88:90:94] sts evenly between armhole markers.
Beg with a purl row and working in correct sleeve stripe sequence above, work 5 rows in St st, ending with RS facing for next row.
Next row (RS, dec): K3, k2tog, knit to last 5 sts, k2tog tbl, k3. *2 st dec.*
Work 4[4:3:3:3] rows straight.
Sizes XS and S only
Next row (WS, dec): P3, p2tog tbl, purl to last 5 sts, p2tog, p3. *2 st dec.*
Sizes M, L/XL and XXL only
Next row (RS, dec): K3, k2tog, knit to last 5 sts, k2tog tbl, k3. *2 st dec.*

1st small buttonhole on row 6[6:6:6:6] from cast-on.
2nd small buttonhole on row 16[16:16:16:18].
3rd large buttonhole on row 27[29:31:31:35].
4th large buttonhole on row 49[51:53:55:59].
5th large buttonhole on row 71[73:75:79:83].
6th large buttonhole on row 93[95:97:103:107].

When indicated, work buttonholes as follows:
Small buttonholes
Row 1: Work to buttonhole marker, knit 2 together, yarn over.
Row 2: Work yarn over as a stitch on this row.

Large buttonholes
Row 1: Work to buttonhole marker, knit 2 together, yarn over twice, knit 2 together tbl.
Row 2: Work yarnovers as follows: purl into first yarn over and then purl into back of second yarn over.
Work in intarsia. When changing colour, always twist colours on WS of work.

With RS facing, 3.75mm (US 5) circular needle, and **B**, pick up and knit 123[127:129:133:137] sts up right front, 3 sts across right back neck, k30[30:32:32:34] sts from back holder, pick up and knit 4 sts across left back neck and 123[127:129:133:137] sts down left front. Do not join, work in rows. *283[291:297:305:315] sts.*

Row 1 (WS): Using B, *k1, p1, rep from * to left shoulder seam, place marker, change to **A** and continue in rib as set to last st, k1.
Row 2: Using A rib as set to marker, change to **B** and rib to end of row.
Row 3: Using B rib to marker, change to **A** and rib to end of row.
Row 4: Using B rib to marker, change to **C** and rib to end of row.
Row 5: Using C rib to first buttonhole marker, work row 1 of small buttonhole, rib to second marker and work row 1 of small buttonhole, rib to next buttonhole marker and work row 1 of large buttonhole, rep for rem 3 large buttonholes, rib to marker at shoulder, change to **A** and rib to end of row.
Row 6: Using B rib to marker, change to **C**

All sizes

Dec as above on every following 5th[5th: 4th:4th:4th] row until 42[46:46:48:50] sts rem. Continue straight in St st until sleeve stripe sequence completed.
Now follow hem and cuff stripe sequence, work in 1x1 rib as for back for 20 rows.
Cast off (bind off) in rib.

Pockets (make two)

Using 4mm (US 6) needles and **B**, cast on 25 sts and beg with a knit row, work 26 rows in St st, ending with RS facing for next row.
Next row (RS): *K1, p1, rep from * to last st, k1.
Next row: *P1, k1, rep from * to last st, p1.
Rep last 2 rows 4 times more.
Cast off (bind off) in rib.

Button band
Place markers counting from cast-on along left front for buttonhole placement and along right front for buttons as follows:

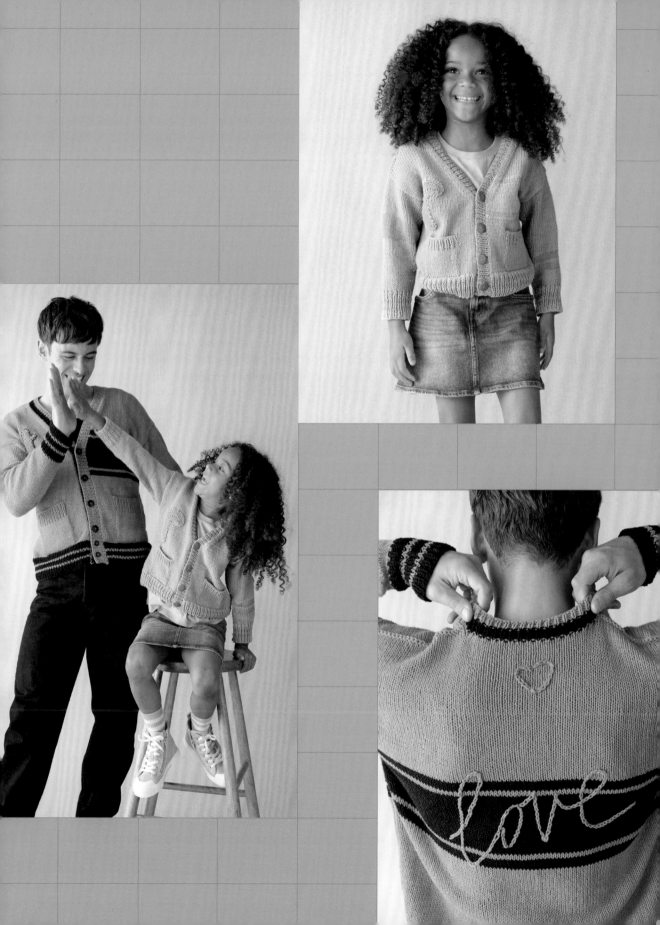

and work row 2 of buttonholes, rib to end of row.

Row 7: Using C rib to marker, change to **B** and rib to end of row.

Row 8: Using **B** rib as set to end of row, removing marker as you work.

Row 9: Using **B** rib as set to end of row. Cast off (bind off) in rib.

To make junior size

Junior size	2–3	4–5	6–7	years
Actual chest	70	76.5	81.5	cm
	27½	30	32	in
Length	36	38	40	cm
	14¼	15	15¾	in
Sleeve length	26	27	28	cm
	10¼	10¾	11	in

Hem and cuff stripe sequence
4 rows **A**
2 rows **B**
2 rows **A**
2 rows **B**
4 rows **A**

Body stripe sequence
2 rows **A**
2 rows **B**
16 rows **A**
2 rows **B**
2 rows **A**

Back

Using 4mm (US 6) needles and **A**, cast on 60[66:70] sts and foll hem and cuff stripe sequence above work in rib as follows:
Rib row: *K1, p1, rep from * to end of row. Work 13 more rows in rib as set.
Using **B** and beg with a knit row, work 28[30:32] rows in St st, ending with RS facing for next row. Work should meas 16[17: 17.5] cm (6¼[6¾:7] in) from cast-on edge. Continue in St st and following body stripe sequence above, and placing markers at both sides when work meas 22[23:24] cm (8¾[9:9½] in) from cast-on edge to show start of armholes.
Using **B**, work 26[28:30] rows straight, ending with RS facing for next row. Work should meas 35[37:38.5] cm (13¾[14½:15¼] in) from cast-on edge.

Shape shoulders

Next row (RS): Knit to last 7[8:8] sts, wrap next st and turn.

Next row: Purl to last 7[8:8] sts, wrap next st and turn.

Next row: Knit to last 14[15:16] sts, wrap next st and turn.

Next row: Purl to last 14[15:16] sts, wrap next st and turn.

Next row: K6[7:7], turn.

Next row: Purl across all 20[22:23] sts, picking up wraps as you work.
Cut yarn leaving long end.
Slip these 20[22:23] sts onto a holder for shoulder.

With RS of work facing slip centre 20[22:24] sts onto a holder. Rejoin yarn to rem 20[22:23] sts and knit across all sts, picking up wraps as you work.
Cut yarn leaving long end.
Slip these 20[22:23] sts onto a holder for shoulder.

Left front

Using 4mm (US 6) needles and **A**, cast on 33[36:38] sts and follow hem and cuff stripe sequence above work in rib as follows:
Size 2–3 only
Rib row 1: K1, *p1, k1, rep from * to end of row.
Rib row 2: P1, *k1, p1, rep from * to end of row.
Sizes 4–5 and 6–7 only
Rib row 1: *P1, k1, rep from * to end of row.
Rib row 2: As Rib row 1.
All sizes
Continue in rib as set for 13 rows more.

Using **B** and beg with a knit row, work 28[30:32] rows in St st, ending with RS facing for next row. Work should meas 16[17: 17.5] cm (6¼[6¾:7] in) from cast-on edge. Cont in St st and follow body stripe sequence above for 14 rows, ending with RS of work facing for next row.

Shape front neck

Left neck decreases are worked as foll:
RS row dec: Knit to last 5 sts, k2tog, k3.
WS row dec: P3, p2tog, purl to end of row.
Starting with a RS row dec, dec as above

on next and 3[4:5] following alt rows, then on every foll 3rd row, while completing body stripe sequence. When stripes are complete, continue in **B** only, shaping neck edge as set until 20[22:23] sts rem, and placing marker at side edge when work meas 22[23:24] cm (8¾[9:9½] in) from cast-on edge to show start of armhole.

Work 1 row straight, ending with WS facing for next row.

Shape shoulder

Next row (WS): Purl to last 7[8:8] sts, wrap next st and turn.
Next row: Knit to end of row.
Next row: Purl to last 14[15:16] sts, wrap next st and turn.
Next row: Knit to end of row.
Next row: Purl across all sts, picking up wraps as you work.
Cut yarn leaving a long end.
Slip these 20[22:23] sts onto a stitch holder for shoulder.

Right front

Using 4mm (US 6) needles and **A**, cast on 33[36:38] sts and follow hem and cuff stripe sequence above work in rib as follows:

Size 2–3 only

Rib row 1: K1, *p1, k1, rep from * to end of row.
Rib row 2: P1, *k1, p1, rep from * to end of row.

Sizes 4–5 and 6–7 only

Rib row 1: *K1, p1, rep from * to end of row.
Rib row 2: As Rib row 1.

All sizes

Continue in rib as set for 12 rows more.

Using B throughout and beg with a knit row, work 42[44:46] rows in St st, ending with RS facing for next row.

Shape front neck

Right neck decreases are worked as follows:
RS row dec: K3, k2tog tbl, knit to end of row.
WS row dec: Purl to last 5 sts, p2tog tbl, p3.
Starting with a RS row dec, dec as above on next and 3[4:5] foll alt rows, then on every foll 3rd row until 20[22:23] sts rem, and

placing a marker at side edge when work meas 22[23:24] cm (8¾[9:9½] in) from cast-on edge to show start of armhole.

Work 2 rows straight, ending with RS facing for next row.

Shape shoulder

Next row (RS): Knit to last 7[8:8] sts, wrap next st and turn.
Next row: Purl to end of row.
Next row: Knit to last 14[15:16] sts, wrap next st and turn.
Next row: Purl to end of row.
Next row: Knit across all sts, picking up wraps as you work.
Cut yarn leaving a long end. Slip these 20[22:23] sts onto a holder for shoulder.

Using B, join both shoulders using three-needle cast off (bind off) method, with wrong sides of work together so seam is on outside of your work.

Sleeves

Right sleeve stripe sequence	Left sleeve stripe sequence
13[17:19] rows **B**	33[37:39] rows **B**
12 rows **C**	4 rows **C**
28 rows **B**	2 rows **B**
	4 rows **C**
	10 rows **B**

Sleeve pattern

With RS facing, 4mm (US 6) needles and **B**, pick up and knit 50[54:56] sts evenly between armhole markers.

Beg with a purl row and working in correct sleeve stripe sequence above, work 13[3:7] rows in St st, ending with RS facing for next row.

Next row (RS, dec): K3, k2tog, knit to last 5 sts, k2tog tbl, k3.
Dec as above on every foll 4th[6th:6th] row until 34[38:40] sts rem.
Continue straight in St st until sleeve stripe sequence completed.

Now follow hem and cuff stripe sequence, work in 1x1 rib as for back for 14 rows.
Cast off (bind off) in rib.

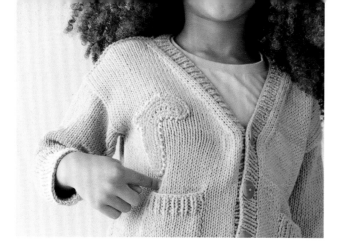

Pockets (make two)

Using 4mm (US 6) needles and **B**, cast on 15 sts and beg with a knit row, work 16 rows in St st, ending with RS facing for next row.
Next row (RS): *K1, p1, rep from * to last st, k1.
Next row: *P1, k1, rep from * to last st, p1.
Repeat last 2 rows twice more.
Cast off (bind off) in rib.

Button band

Place markers counting from cast-on along left front for buttonhole placement and along right front for buttons as follows:
1st buttonhole on row 6[6:8] from cast-on.
2nd buttonhole on row 21[23:25].
3rd buttonhole on row 36[40:42].
4th buttonhole on row 51[57:59].

When indicated, work buttonholes as foll:
Row 1: Work to buttonhole marker, knit 2 together, yarn over.
Row 2: Work yarn over as a stitch on this row.

Work button band in intarsia. When changing colour, always twist colours on WS of work.

With RS facing, 3.75mm (US 5) circular needle and B, pick up and knit 73[77:81] sts up right front, 3 sts across right back neck, k20[22:24] sts from back holder, pick up and knit 4 sts across left back neck and 73[77:81] sts down left front. Do not join, work in rows. *173(183:193) sts.*
Row 1 (WS): Using **B**, *K1, p1, rep from * to left shoulder seam, place marker, change to A and continue in rib as set to last st, k1.

Row 2: Using **A**, rib as set to marker, change to B and rib to end of row.
Row 3: Using **C**, rib to first buttonhole marker, work row 1 of buttonhole, rib to second marker and work row 1 of buttonhole, rep for rem 2 buttonholes, rib to marker at shoulder, change to **A** and rib to end of row.
Row 4: Using **B**, rib to marker, change to **C** and work row 2 of buttonholes, rib to end of row.
Row 5: Using **B**, rib as set to end of row, removing marker as you work.
Row 6: Using **B**, rib as set to end of row. Cast off (bind off) in rib.

To finish

Weave in any ends. Gently steam on reverse. Using leftover yarn **C** and photograph as a guide, use chain stitch to embroider "love" (or word of your choice) across band of colour **A** on back of cardigan. Use chain stitch and yarn **C** to embroider a heart just below centre top back neck. Weave in any ends on WS of work.
Customise cardigan with a crochet letter of your choice (see pages 308–315), made using yarn **C**, and sew to front of cardigan, approx. 16cm (6¼ in) down from top of shoulder for adult size and 11cm (4½in) down from top of shoulder for junior size, using oversew stitch and yarn **A** to contrast. Join side and sleeve seams.
For adult size, Place each pocket approx. 9cm (3½ in) in from edge of button band and 8cm (3¼ in) up from cast-on edge, above rib.
For junior size, place each pocket approx 6cm (2¼in) in from edge of button band and 5.5cm (2in) up from cast-on edge, above rib. Pin and sew into position using mattress stitch or whip stitch.
Sew on buttons to match buttonholes.

Masterclass

Adding chain stitch embroidery

Chain stitch is a versatile embroidery stitch, which is used to create curved, flowing lines. This makes it the perfect choice for the joined-up letters used on this cardigan.

One Draw a motif or write a word onto your knitted fabric using a washable or fading fabric pen. Thread a blunt-tipped needle with a 40 cm (18 in) length of yarn and bring it up at the start point, leaving a tail at the back for weaving in later. Loop the yarn from left to right, then re-insert the needle at the start point and bring it out two stitches below.

Two Pull the needle through the knitted fabric and out over the loop. Draw the yarn up gently to make a loop or "chain".

Three Insert the needle inside the loop, ready to make the next stitch and bring the tip of the needle out the same distance below. Repeat the first two steps and continue to the end of the line drawn line, keeping the stitches even and regular. Finish off by anchoring the final loop down with a small straight stitch. Weave the ends in at the back, along the back of the embroidery.

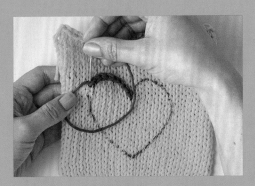 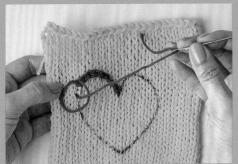

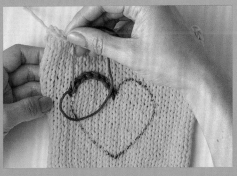

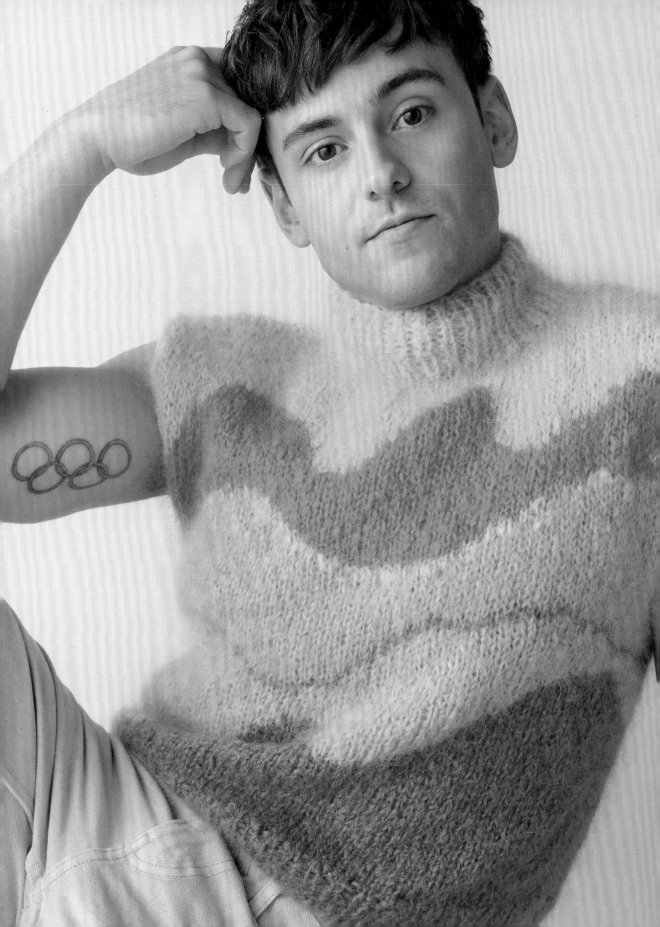

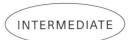
Swirl Vest

With fluid swirls of colour that remind me of a summer sunset, this sleeveless vest is a versatile piece to be worn on its own or layered up. In this pattern you will work from a chart using the intarsia technique, which begins in the rib hem. Sleeveless with a raw edge armhole, this fuzzy mohair vest is perfect if you don't enjoy knitting sleeves!

Measurements
See chart below

Materials
- Debbie Bliss Nell
 78% mohair, 13% merino wool,
 9% polyamide
 100m (109 yards) per 50g (1¾ oz)

Quantity:
- **A** 2[3:3:3:4] x 50g (1¾ oz) balls in Heather
- **B** 3[3:4:4:5] x 50g (1¾ oz) balls in Lilac
- **C** 2[2:2:3:3] x 50g (1¾ oz) balls in Corn
- **D** 1[1:1:2:2] x 50g (1¾ oz) ball(s) in Sunset
- **E** 1[1:1:1:1] x 50g (1¾ oz) ball in Jade
- **F** 1[1:1:1:1] x 50g (1¾ oz) ball in Rose
- **G** 1[1:1:2:2] x 50g (1¾ oz) ball(s) in Willow

- 1 pair of 6mm (US 10) knitting needles
- 6mm (US 10) circular needle, 40cm
 (16 in) length
- Stitch markers
- Stitch holders
- Yarn needle

Tension (gauge)
13 sts and 17 rows to 10cm (4 in) over St st using 6mm (US 10) needles. Change needle size as necessary to achieve correct tension (gauge).

Abbreviations
See page 69.

Special techniques
Working intarsia (see page 165).
Short-row shaping (see pages 102–103).

Note
Back and front are worked using the intarsia colourwork method.

Adult size	XS	S	M	L/XL	XXL	
To fit chest	71–86	91.5–106.5	111.5–117	122–137	142–158	cm
	28–34	36–42	44–46	48–54	56–62	in
Actual chest	89	104.5	123	138.5	154	cm
	35	41¼	48½	54½	60¾	in
Length	52	54	56.5	57.5	60	cm
	20½	21¼	22¼	22¾	23½	in

To make

Back

Using 6mm (US 10) needles and **A**, cast on 56[66:78:86:96] sts.
Now work from Back chart, changing colour and working in intarsia where indicated and working first 11[11:13:13:15] rows of chart in k1, p1 rib.
When working from chart and working in k1, p1 rib, beg RS rows on stitch 24[19:13:9:4] and knit until you have completed stitch 79[84:90:94:99]. Beg WS rows on stitch 79[84:90:94:99] and purl until you have completed stitch 24[19:13:9:4].
When Row 11[11:13:13:15] of chart is complete, increase as follows:
Next row (WS inc): (Rib 11[13:16:12:14], m1) 4[4:4:6:6] times, rib to end of row.
60[70:82:92:102] sts.
After you have completed this increase row, when working from chart beg RS rows on stitch 22[17:11:6:1] and knit until you have completed stitch 81[86:92:97:102]. Beg WS rows on stitch 81[86:92:97:102] and purl until you have completed stitch 22[17:11:6:1].
Now beg with a knit row, continue in St st, placing markers at both sides on Row 53[55:57:57:59] to show start of armholes, until Row 88[92:96:98:102] has been completed, ending with RS facing for next row.

Shape shoulders and back neck
Next row (RS): Knit to last 5[7:8:9:10] sts, wrap next st and turn.
Next row: Purl to last 5[7:8:9:10] sts, wrap next st and turn.
Next row: Knit to last 11[14:18:20:21] sts, wrap next st and turn.
Next row: Purl to last 11[14:18:20:21] sts, wrap next st and turn.
Next row: K1[3:3:6:9], k2tog, k3, turn.
Next row: Purl across all 16[21:25:30:34] sts, picking up wraps as you work.
Cut yarn leaving a long end.
Slip these 16[21:25:30:34] sts onto a stitch holder for shoulder.

With RS facing, slip centre 26[26:30:30:32] sts onto a holder. Rejoin yarn to rem sts and work as follows:
Next row: K3, k2tog tbl, knit to end of row picking up wraps as you work.
Cut yarn leaving a long end.
Slip these 16[21:25:30:34] sts onto a stitch holder for shoulder.

Front

Using 6mm (US 10) needles and **A**, cast on 56[66:78:86:96] sts.
Now work from Front chart, changing colour and working in intarsia where indicated and working the first 11[11:13:13:15] rows of chart in k1, p1 rib.
When working from chart and working in k1, p1 rib, begin RS rows on stitch 24[19:13:9:4] and knit until you have completed stitch 79[84:90:94:99]. Begin WS rows on stitch 79[84:90:94:99] and purl until you have completed stitch 24[19:13:9:4].
When Row 11[11:13:13:15] of chart is complete, increase as follows:

Next row (WS inc): (Rib 11[13:16:12:14], m1) 4[4:4:6:6] times, rib to end of row.
60[70:82:92:102] sts.
After you have completed this increase row, when working from Front chart begin RS rows on stitch 22[17:11:6:1] and knit until you have completed stitch 81[86:92:97:102]. Begin WS rows on stitch 81[86:92:97:102] and purl until you have completed stitch 22[17:11:6:1].
Now, beg with a knit row, continue in St st, placing markers at both sides on Row 53[55:57:57:59] to show start of armholes, until Row 84[88:92:94:98] has been completed, ending with RS facing for next row.

Shape neck and shoulders
Next row (RS): K16[21:25:30:34] sts, k2tog, k3, turn leaving rem sts on a holder.
Next row: P3, p2tog, purl to end of row.

Next row: Knit to last 5 sts, k2tog, k3.
Next row: Purl to end of row.
Next row: Knit to last 5 sts, k2tog, K3.
Next row: Purl to last 5[7:8:9:10] sts, wrap next st and turn.
Next row: Knit to last 5 sts, k2tog, k3.
Next row: Purl to last 11[14:18:20:21] sts, wrap next st and turn.
Next row: Knit to end of row.
Next row: Purl to end of row picking up wraps as you work.
Cut yarn leaving a long end.
Slip these 16[21:25:30:34] sts onto a holder for shoulder.
With RS facing, slip centre 18[18:22:22:24] sts onto a holder. Rejoin yarn to rem sts and work as follows:
Next row (RS): K3, k2tog tbl, knit to end of row.
Next row: Purl to last 5 sts, p2tog tbl, p3.
Next row: K3, k2tog tbl, knit to end of row.
Next row: Purl to end of row.
Next row: K3, k2tog tbl, knit to last 5[7:8:9:10] sts, wrap next st and turn.
Next row: Purl to end of row.
Next row: K3, k2tog tbl, knit to last 11[14:18:20:21] sts, wrap next st and turn.
Next row: Purl to end of row.
Next row: Knit to end of row picking up wraps as you work.
Cut yarn leaving a long end.
Slip these 16[21:25:30:34] sts onto a holder.
Join both shoulders using three-needle cast-off (bind-off) method with wrong sides of work tog so that the seam is on the outside of your work.

Neckband

With RS facing, 6mm (US 10) circular needle and **C**, and starting at left shoulder, pick up and knit 10 sts down left front neck, k18[18:22:22:24] sts from front holder, pick up and knit 10 sts up right front neck, 3 sts across right back neck, k26[26:30:30:32] sts from back holder, pick up and knit 3 sts across left back neck, pm to show start of round. *70[70:78:78:82] sts.*
Work in the round as follows:
Next round: *K1, p1, rep from * to end of round.
Repeat last round 4 times more.

Next round (inc): Inc 1 st at both ends of round. *72[72:80:80:84] sts.*
Continue in rows in rib as set and intarsia method using **F** and **C** as follows:
Next row (RS): Rib 3[3:4:4:4] in **F**, rib in **C** to last 6[6:7:7:7] sts, rib 6[6:7:7:7] in **F**.
Next row: Rib 7[7:8:8:8] in **F**, rib in **C** to last 7[7:8:8:8] sts, rib 7[7:8:8:8] **F**.
Next row: Rib 13[13:14:14:15] in **F**, rib in **C** to last 7[7:8:8:9] sts, rib 7[7:8:8:9] in **F**.
Next row: Rib 10[10:12:12:13] in **F**, rib in **C** to last 16[16:17:17:18] sts, rib 16[16:17:17:18] in **F**.
Next row: Rib 19[19:21:21:22] in **F**, rib in **C** to last 15[15:17:17:18] sts, rib 15[15:17:17:18] in **F**.
Next row: Rib 19[19:21:21:22] in **F**, rib in **C** to last 21[21:22:22:23] sts, rib 21[21:22:22:23] in **F**.
Cast off (bind off) in rib in colours as set by last row.

To finish

Weave in any yarn ends.
Join side seams by matching markers.
Using **C** join the row ends on the neckband.

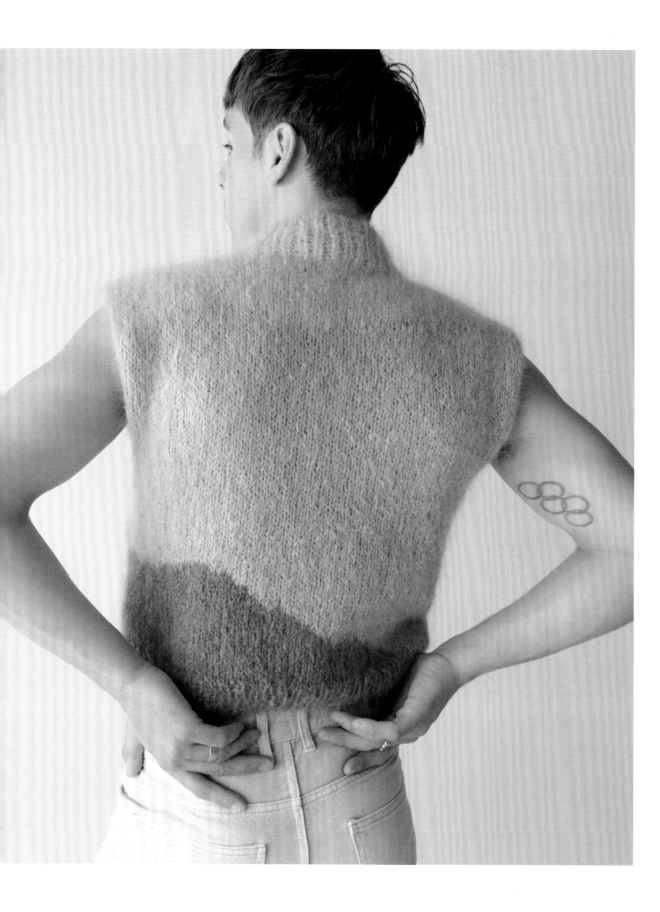

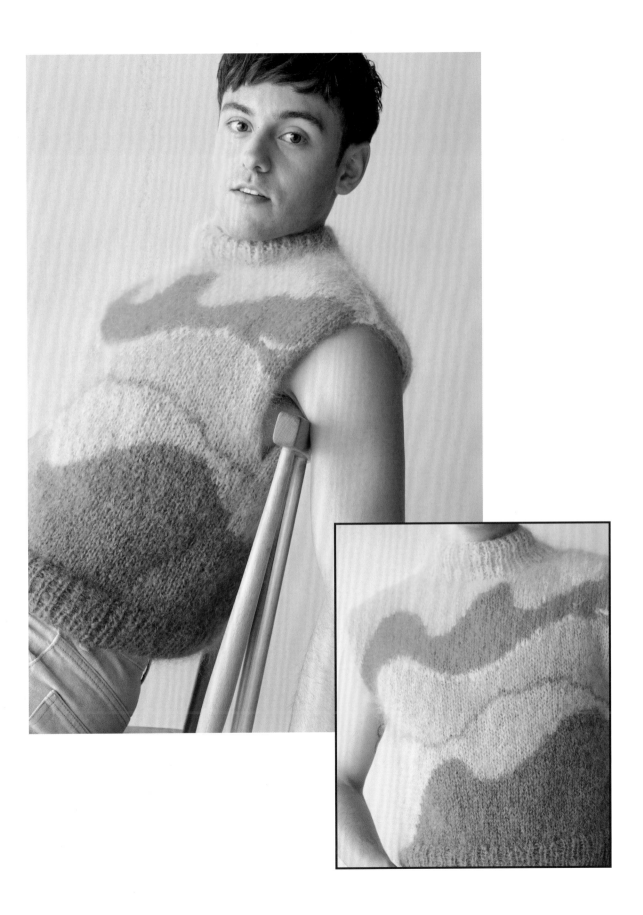

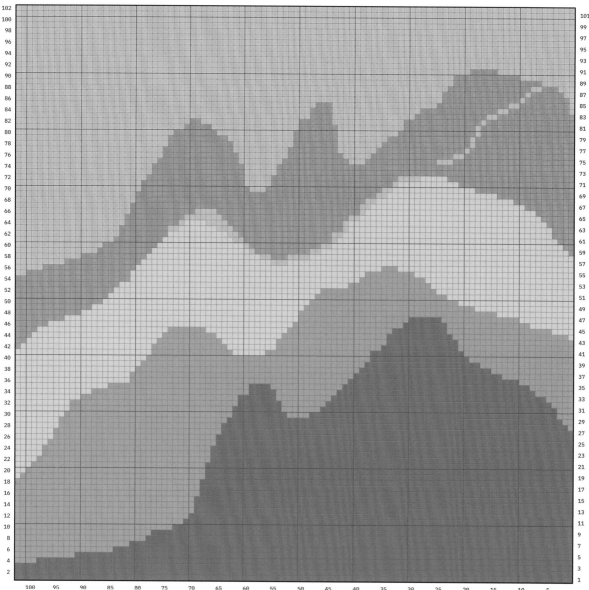

With A, knit on RS rows and purl on WS rows.

With B, knit on RS rows and purl on WS rows.

With C, knit on RS rows and purl on WS rows.

With D, knit on RS rows and purl on WS rows.

With E, knit on RS rows and purl on WS rows.

With F, knit on RS rows and purl on WS rows.

With G, knit on RS rows and purl on WS rows.

Knit Projects

Back

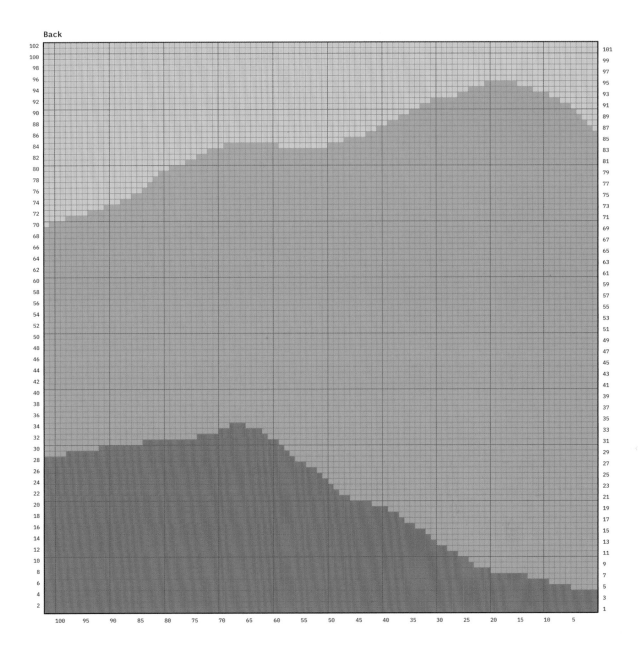

With A, knit on RS rows and purl on WS rows.

With B, knit on RS rows and purl on WS rows.

With G, knit on RS rows and purl on WS rows.

Masterclass

Working intarsia

When switching from using one colour yarn to a second colour yarn within the
same row, you need to "twist" those yarns together to avoid making a hole in the
knitted fabric. In effect, you are "twisting" the two colour yarns to link them
together. Be careful not to overtwist the yarn or the fabric will not lie flat.
The object is to link together the two separate colour sections so that they form
a single fabric.

One To join in a new colour on a knit row, work up to the colour change. Drop the
old colour. Pick up the new colour from under the old colour and knit to the next
colour change.

Two On a purl row, work up to the colour change. Drop the old colour. Pick up the new
colour from under the old colour and purl to the next colour change.

When knitting using several colours across a row, organise the yarns into
"bobbins" – small windings of individual yarns. To work out how much yarn you
will need, calculate the number of stitches that specific area then twist the
yarn around the knitting needle that number of times, adding a small amount more
for sewing in ends. Once you have measured out the correct amount of yarn, either
wind it into a small bobbin by hand or wrap it around a shop-bought bobbin.

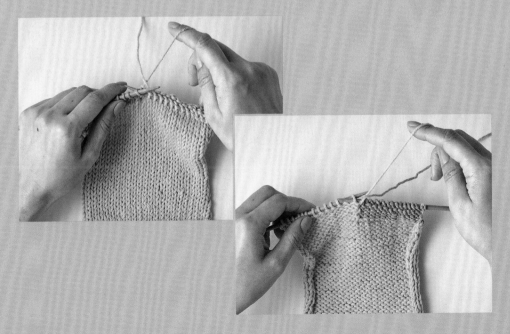

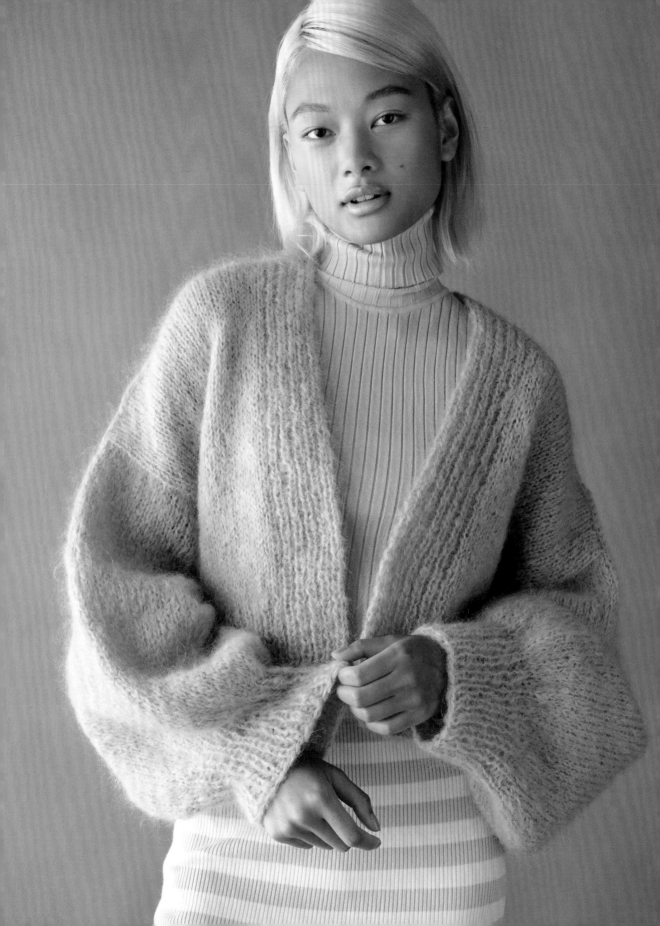

Balloon Sleeve Cardigan

A simple edge-to-edge cardigan with dramatic balloon-shaped cuffs, this easy to knit project creates a big impact. Designed to be cropped to sit at the waist, for a flattering fit. I love the back neck detail where the two fronts meet at the centre of the back neck for a neat and comfortable finish when worn.

Measurements
See chart below

What you will need
- Debbie Bliss Nell
 78% mohair, 13% merino wool,
 9% polyamide
 100m (109 yards) per 50g (1¾ oz)
Quantity:
- 7[7:8:9:9] x 50g (1¾ oz) balls in Lilac
- 1 pair 6mm (US 10) knitting needles
- Stitch markers
- Stitch holders
- Yarn needle

Tension (gauge)
13 sts and 17 rows to 10cm (4 in) over St st stitch using 6mm (US 10) needles. Change needle size as necessary to achieve correct tension (gauge).

Abbreviations
See page 69.

Special technique
Short-row shaping (see pages 102–103).

Adult size	XS	S/M	L/XL	XXL	XXXL	
To fit chest	71–86	91.5–106.5	111.5–117	122–137	142–156	cm
	28–34	36–42	44–46	48–54	56–61	in
Actual chest	117	126	138.5	147.5	157	cm
	46	49½	54½	58	61¾	in
Length	50	52	54	56	58	cm
	19¾	20½	21¼	22	22¾	in
Sleeve length	45	45	45	43	43	cm
	17¾	17¾	17¾	17	17	in

To make

Back

Using 6mm (US 10) needles, cast on 78[84:92:98:104] sts.
Next row: *K1, p1, rep from * to end of row.
Repeat last row 11 times more.
Beg with a knit row, cont in St st until work meas 41[43:45:47:49]cm (16¼[17:17¾:18½:19¼] in) from cast-on edge, ending with RS facing for next row and placing markers at both sides when work meas 16[17:18:19:20]cm (6¼[6¾:7:7½:7¾] in) from cast-on edge, to mark start of armholes.

Shape shoulders
Next row (RS): Knit to last 5[6:7:8:9] sts, wrap next st and turn.
Next row: Purl to last 5[6:7:8:9] sts, wrap next st and turn.
Next row: Knit to last 9[12:13:14:16] sts, wrap next st and turn.
Next row: Purl to last 9[12:13:14:16] sts, wrap next st and turn.
Next row: Knit to last 14[17:19:20:22] sts, wrap next st and turn.
Next row: Purl to last 14[17:19:20:22] sts, wrap next st and turn.
Next row: Knit to last 19[22:25:26:28] sts, wrap next st and turn.
Next row: Purl to last 19[22:25:26:28] sts, wrap next st and turn.
Next row: Knit to last 24[27:31:32:34] sts, wrap next st and turn.
Next row: Purl to last 24[27:31:32:34] sts, wrap next st and turn.
Next row: Knit to last 29[32:36:38:40] sts, wrap next st and turn.
Next row: Purl to last 29[32:36:38:40] sts, wrap next st and turn.
Next row: Knit to last 34[37:41:44:46] sts, wrap next st and turn.
Next row: Purl to last 34[37:41:44:46] sts, wrap next st and turn.
Next row: K5[5:5:5:6], turn and purl across all sts picking up wraps as you work.
Cut yarn leaving a long end.

Slip these 39[42:46:49:52] sts onto a holder for shoulder.
With RS facing, rejoin yarn to rem sts and knit across all sts picking up wraps as you work.
Cut yarn leaving a long end.
Slip these 39[42:46:49:52] sts onto a holder for shoulder.

Right front

Using 6mm (US 10) needles, cast on 39[42:46:49:52] sts and work as follows:
Next row: *P1, k1, rep from * to last 1[0:0:1:0] st, p1[0:0:1:0].
Next row: K1[0:0:1:0], *p1, k1, rep from * to end of row.
Work a further 10 rows in rib as set.
Cont in St st with rib edges as follows:
Next row (RS): (P1, k1) 5 times, p1, knit to end of row.
Next row: Purl to last 11 sts, (k1, p1) 5 times, k1.
Repeat last 2 rows until work meas 41[43:45:47:49]cm (16¼[17:17¾:18½:19¼] in) from cast-on edge, ending with RS facing for next row and placing marker at side edge when work meas 16[17:18:19:20]cm (6¼[6¾:7:7½:7¾] in) from cast-on edge.

Shape shoulder
Next row: Patt to last 5[6:7:8:9] sts, wrap next st and turn.
Next row: Patt as set.
Next row: Patt to last 9[12:13:14:16] sts, wrap next st and turn.
Next row: Patt as set.
Next row: Patt to last 14[17:19:20:22] sts, wrap next st and turn.
Next row: Patt as set.
Next row: Patt to last 19[22:25:26:28] sts, wrap next st and turn.
Next row: Patt as set.
Next row: Patt to last 24[27:31:32:34] sts, wrap next st and turn.
Next row: Patt as set.
Next row: Patt to last 29[32:36:38:40] sts, wrap next st and turn.

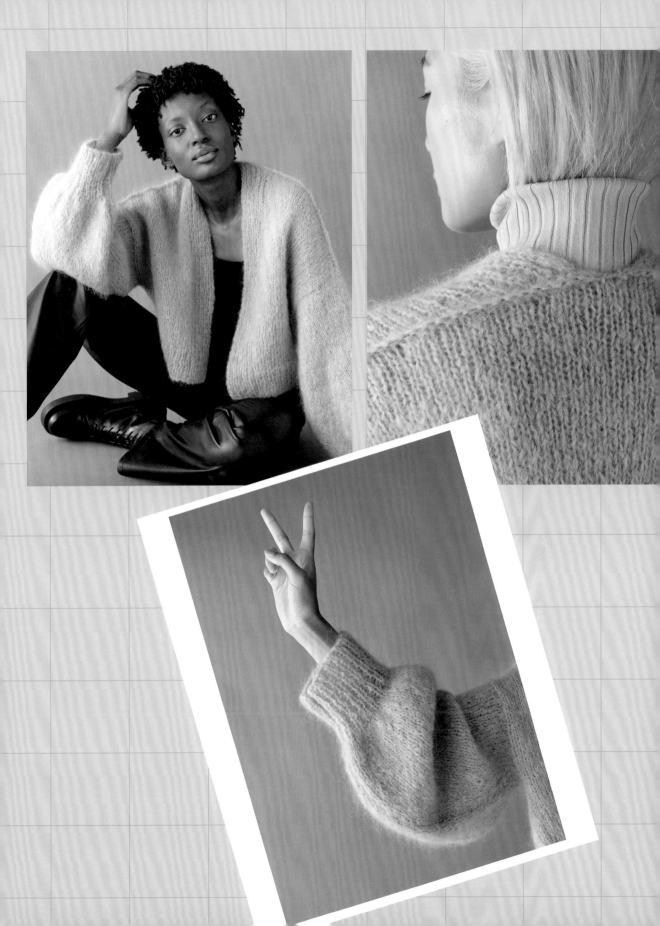

Next row: Patt as set.
Next row: Patt to last 34[37:41:44:46] sts, wrap next st and turn.
Next row: Patt 5[5:5:5:6], turn and patt across all sts picking wraps up as you work. Cut yarn leaving a long end.
Slip these 39[42:46:49:52] sts onto a holder for shoulder.

Left front

Using 6mm (US 10) needles, cast on 39[42:46:49:52] sts and work as follows:
Next row: P1[0:0:1:0], *k1, p1, rep from * to end of row.
Next row: *K1, p1, rep from * to last 1[0:0:1:0] st, k1[0:0:1:0].
Work a further 10 rows in rib as set.
Cont in St st with rib edge as follows:
Next row (RS): Knit to last 11 sts, (p1, k1) 5 times, p1.
Next row: (K1, p1) 5 times, k1, purl to end of row.
Repeat last 2 rows until work meas 41[43:45:47:49]cm (16¼[17:17¾:18½: 19¼) in) from cast-on edge, ending with WS facing for next row and placing marker at side edge when work meas 16[17:18:19:20]cm (6¼[6¾:7:7½:7¾] in) from cast-on edge.

Shape shoulder
Next row (WS): Patt to last 5[6:7:8:9] sts, wrap next st and turn.
Next row: Patt as set.
Next row: Patt to last 9[12:13:14:16] sts, wrap next st and turn.
Next row: Patt as set.
Next row: Patt to last 14[17:19:20:22] sts, wrap next st and turn.
Next row: Patt as set.
Next row: Patt to last 19[22:25:26:28] sts, wrap next st and turn.
Next row: Patt as set.
Next row: Patt to last 24[27:31:32:34] sts, wrap next st and turn.
Next row: Patt as set.
Next row: Patt to last 29[32:36:38:40] sts,

wrap next st and turn.
Next row: Patt as set.
Next row: Patt to last 34[37:41:44:46] sts, wrap next st and turn.
Next row: Patt 5[5:5:5:6], turn and patt across all sts picking wraps up as you work. Cut yarn leaving a long end.
Slip these 39[42:46:49:52] sts onto a holder for shoulder.
Join shoulders using three-needle cast off (bind off) method with wrong sides of work tog so seams are on outside of your work.

Sleeves (both alike)

With RS facing and 6mm (US 10) needles, pick up and knit 62[64:68:70:72] sts evenly between markers.
Starting with a purl row, work 3 rows in St st, ending with RS facing for next row.
Next row (RS inc): K3, m1, knit to last 3 sts, m1, k3. *2 sts inc.*
Inc as above on every foll 4th[4th:6th:4th: 6th] row until 80[84:84:88:88] sts.
Cont straight until sleeve meas 35[35:35: 33:33]cm (13¾[13¾:13¾:13:13] in) from pick-up, ending with RS facing for next row.
Next row (RS dec): K1, *k2tog, rep from * to last st, k1. *41[43:43:45:45] sts.*
Next row: Purl.
Next row: *K1, p1, rep from * to last st, k1.
Next row: *P1, k1, rep from * to last st, p1.
Rep last 2 rows 6 times more.
Cast off (bind off) in rib.

To finish

Weave in any yarn ends.
Join side and sleeve seams.

Masterclass

Picking up stitches

When adding to a piece of knitting, like working the sleeves of this cardigan that are knitted from the shoulders down to the cuffs, you need to pick up stitches from the main piece. This is simple to do, using a knitting needle and working from the right side of the work, but you need to make sure all the stitches are picked up evenly across the piece for a neat finish. For a cast-off edge, put the needle or hook into the stitches immediately below the cast-off edge. For a cast-on edge, put the needle or hook into the stitches of the cast-on row. For a row edge, put the needle or hook into the space between the edge stitch and the next stitch – but as the stitches you are picking up are wider than the rows that you are picking them up from, after every third picked-up stitch, skip one row.

One The technique is shown here along a cast-off edge, but the principle is the same on a cast-on, side edge or any other edge. With the right side of the work facing you, insert the point of a knitting needle from front to back into the knitted piece at the point you want to start picking up from. Loop the yarn around the tip of the needle.

Two Draw the loop through to the front to form a new stitch on the needle. If you start picking up on the righthand end of an edge, then the first row will be a wrong side row.

Three Continue in this way along the edge, between any markers, to pick up the number of stitches as stated in the pattern. Pull each stitch taut as you go.

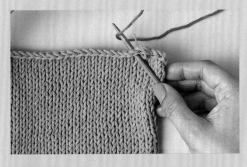
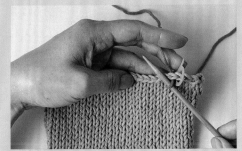

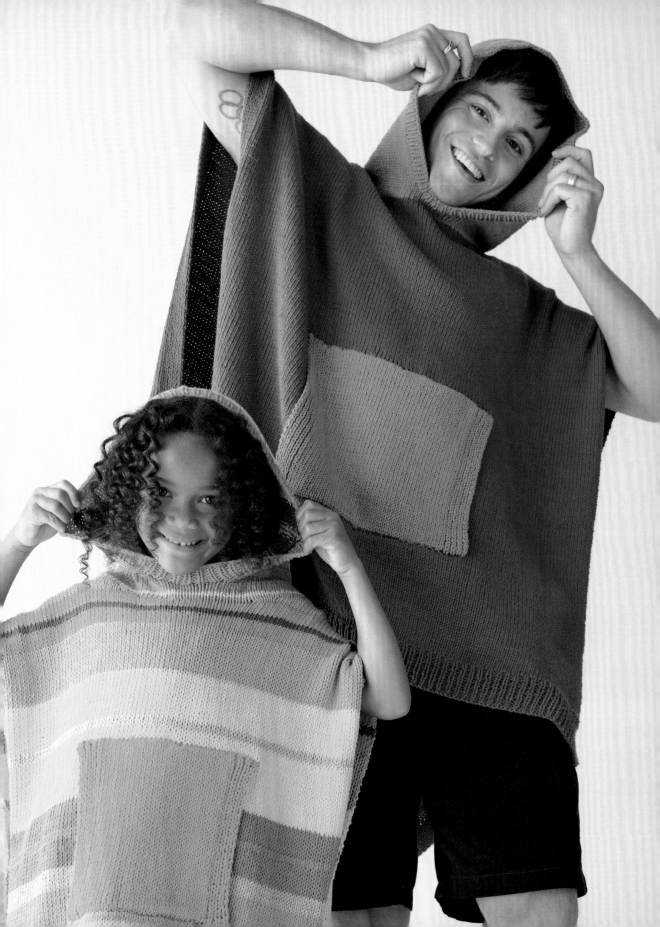

Hooded Poncho

This is an easy to throw on cover-up, perfect for the beach or poolside. It is made with cotton yarn to be absorbent and breathable. Knitting cotton is different to wool as it has less elasticity, so be careful not to split the yarn when making stitches. The patch pocket is designed to be sewn on at whatever height is comfortable for you. The junior version is based on the first thing I ever made for my son Robbie and is designed for comfort. However, the fun does not have to stop once you have completed it. This garment can easily be fringed or further customised to your taste.

Measurements

Adult Size	S/M	L/XL	
Actual chest	173	213	cm
	68	83¾	in
Length	77	87	cm
	30¼	34¼	in
Hood length	38	38	cm
	15	15	in

Junior Size	One Size	
Actual chest	116	cm
	45¾	in
Length	64	cm
	25¼	in
Hood length	29	cm
	11½	in

What you will need

- Paintbox Yarns Cotton Aran
 100% cotton, 85m (93 yards) per 50g (1¾ oz)

ADULT SIZE Quantity:
- **A** 18[25] x 50g (1¾ oz) balls in Sailor Blue
- **B** 4[4] x 50g (1¾ oz) balls in Grass Green

JUNIOR SIZE Quantity:
- **A** 5 x 50g (1¾ oz) balls in Marine Blue
- **B** 4 x 50g (1¾ oz) balls in Blood Orange
- **C** 1 x 50g (1¾ oz) balls in Sailor Blue
- **D** 3 x 50g (1¾ oz) balls in Buttercup Yellow
- **E** 1 x 50g (1¾ oz) ball in Pale Lilac
- **F** 2 x 50g (1¾ oz) balls in Grass Green
- **G** 1 x 50g (1¾ oz) ball in Lipstick Pink
- 1 pair 4.5mm (US 7) knitting needles
- 4.5mm (US 7) circular needle, 60cm
 (23 in) length
- 4mm (US 6) circular needle, 60cm
 (23 in) length
- Stitch holders
- Stitch marker
- Yarn needle

Tension (gauge)

18 sts and 24 rows to 10cm (4 in) over St st using 4.5mm (US 7) needles. Change needle size as necessary to achieve correct tension (gauge).

Abbreviations

See page 69.

Special techniques

Short-row shaping (see pages 102–103).

To make adult size

Back

Using 4.5mm (US 7) needles and **A**, cast on 157[193] sts and work in rib as follows:
Row 1 (RS): *P1, k1, rep from * to last st, p1.
Row 2: *K1, p1, rep from * to last st, k1.
Rep last 2 rows 5 times more, inc 1 st on last row. *158[194] sts.*
Continue in St st with rib edges as follows:
Next row (RS): Rib 9 sts as set, knit to last 9 sts, rib as set to end of row.
Next row: Rib 9 sts as set, purl to last 9 sts, rib as set to end of row.
Rep last 2 rows until work meas 77[87]cm (30¼[34¼] in) from cast-on edge, ending with RS facing for next row.

Shape shoulders
Next row: Patt to last 15[19] sts, wrap next st and turn.
Next row: Purl to last 15[19] sts, wrap next st and turn.
Next row: Knit to last 29[37] sts, wrap next st and turn.
Next row: Purl to last 29[37] sts, wrap next st and turn.
Next row: Knit to last 43[55] sts, wrap next st and turn.
Next row: Purl to last 43[55] sts, wrap next st and turn.
Next row: K14[20], turn and patt across all sts, picking up wraps as you work.
Cut yarn leaving a long end. Slip these 57[75] sts onto a holder for shoulder. With RS of work facing, slip centre 44[44] sts onto a holder. Rejoin yarn to rem 57[75] sts and patt across all sts, picking up wraps as you work. Cut yarn leaving a long end. Slip 57[75] sts onto a holder for shoulder.

Front

Work as for back until front meas 74[84]cm (29¼[33] in) from cast-on edge, ending with RS facing for next row.

Shape neck and shoulders
Next row: Patt 68[86] sts, turn and slip rem 90[108] sts onto a holder.
Next row: Cast off (bind off) 4 sts, patt to end of row. *64[82] sts.*
Next row: Patt as set to end of row.
Next row: Cast off (bind off) 3 sts, patt to end of row. *61[79] sts.*
Next row: Patt as set to end of row.
Next row: Cast off (bind off) 2 sts, patt to end of row. *59[77] sts.*
Next row: Patt as set to end of row.
Next row: Cast off (bind off) 2 sts, purl to last 15[19] sts, wrap next st and turn.
Next row: Knit.
Next row: Purl to last 29[37] sts, wrap next st and turn.
Next row: Knit.
Next row: Purl to last 43[55] sts, wrap next st and turn.
Next row: K14[20], turn and patt across all sts, picking up wraps as you work.
Cut yarn leaving a long end. Slip these 57[75] sts onto a holder for shoulder. With RS facing, slip centre 22[22] sts onto a holder. Rejoin yarn to rem 68[86] sts and work as follows:
Next row (RS): Cast off (bind off) 4 sts, patt to end of row. *64[82] sts.*
Next row: Patt as set to end of row.
Next row: Cast off (bind off) 3 sts, patt to end of row. *61[79] sts.*
Next row: Patt as set to end of row.
Next row: Cast off (bind off) 2 sts, patt to end of row. *59[77] sts.*
Next row: Patt as set to end of row.
Next row: Cast off (bind off) 2 sts, knit to last 15[19] sts, wrap next st and turn.
Next row: Purl.
Next row: Knit to last 29[37] sts, wrap next st and turn.
Next row: Purl.
Next row: Knit to last 43[55] sts, wrap next st and turn.
Next row: P14[20], turn and patt across all sts, picking up wraps as you work.
Cut yarn leaving a long end. Slip 57[75] sts onto a holder for shoulder.
Using **A**, join shoulders using three-needle cast off (bind off) method with wrong sides together so seams are on outside of work.

Hood

(Worked the same for both sizes.)
With RS facing, 4.5mm (US 7) circular needle and **A**, and starting at left shoulder seam, pick up and knit 18 sts down left front neck, k22 sts from front holder, pick up and knit 18 sts up right front neck, 3 sts across right back neck, k44 sts from back holder and pick up and knit 3 sts from left back neck, place marker to show start of round. *108 sts.*
Work in the round as follows:
Next round: Knit.
Change to **B** and knit 7 rounds, ending at marker. K33 sts, slip last 8 sts on to a holder, knit to end of row ending at holder. Remove marker and turn. *100 sts.*
Beg with a purl row, continue in St st until work meas 26cm (10¼ in) from pick-up edge, ending with RS facing for next row.

Shape hood top
Next row (RS dec): K47, k2tog, pm, k2, skp, knit to end of row. *98 sts.*
Next row: Purl.
Next row: Knit.
Next row (WS dec): Purl to 4 sts before marker, p2tog tbl, p2, sm, p2tog, purl to end. *96 sts.*
Next row: Knit.
Next row: Purl.
Next row (RS dec): Knit to 2 sts before marker, k2tog, sm, k2, skp, knit to end of row. *94 sts.*
Next row: Purl.
Next row: Knit.
Next row (WS dec): Purl to 4 sts before marker, p2tog tbl, p2, sm, p2tog, purl to end. *92 sts.*
Next row: Knit.
Next row: Purl.
Next row (RS dec): Knit to 2 sts before marker, k2tog, sm, k2, skp, knit to end of row. *90 sts.*
Next row: Purl.
Next row: Knit.
Next row (WS dec): Purl to 4 sts before marker, p2tog tbl, p2, sm, p2tog, purl to end. *88 sts.*

Next row: Knit.
Next row: Purl.
Next row (RS dec): Knit to 2 sts before marker, k2tog, sm, K2, skpo, knit to end of row. *86 sts.*
Next row (WS dec): Purl to 4 sts before marker, p2tog tbl, p2, sm, p2tog, purl to end. *84 sts.*
Repeat last 2 rows until 56 sts rem.
Next row: K28 sts, removing marker as you work. Slip rem 28 sts onto a second needle. Fold work in half with wrong sides of work together so seam is on outside of your work, cast off (bind off) the 2 sets of sts using three-needle cast-off (bind off) method.

Rib edging
(Worked the same for both sizes.)
With RS facing, 4mm (US 6) circular needle and **B**, starting at centre of cast-off (bound-off) stitches, pick up and knit 4 sts from centre front, 68 sts up right front to top seam, 68 sts down left front and 4 sts from centre front, pm to show start of round. *144 sts.*
Next round: *K1, p1, rep from * to end of round.
Work 5 rounds more in 1x1 rib, ending at marker.
Cast off (bind off) in rib.

Pocket

(Worked the same for both sizes.)
Using 4.5mm (US 7) needles and **B**, cast on 61 sts and work as follows:
Row 1 (RS): (P1, k1) 4 times, p1, knit to last 9 sts, (p1, k1) 4 times, p1.
Row 2: (K1, p1) 4 times, k1, purl to last 9 sts, (k1, p1] 4 times, k1.
Repeat last 2 rows until work meas 22cm (8¾ in) from cast-on edge.
Cast off (bind off) in patt as set.

To finish

See instructions on page 178.

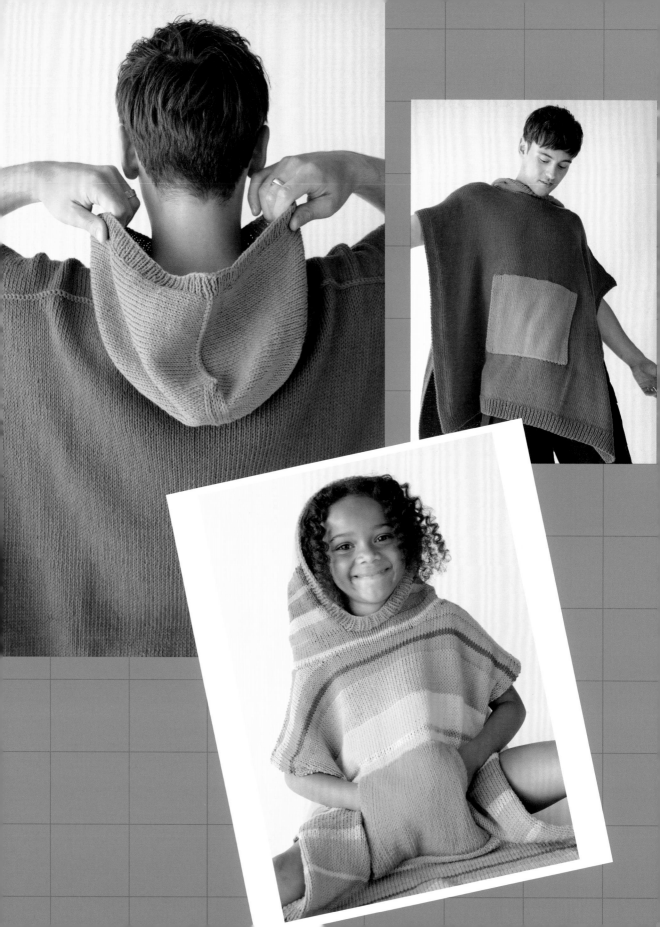

To make junior size

Colour sequence for back and front

20 rows **A**	17 rows **D**
5 rows **B**	2 rows **E**
2 rows **C**	12 rows **D**
5 rows **B**	14 rows **A**
12 rows **A**	5 rows **B**
2 rows **D**	2 rows **C**
12 rows **A**	5 rows **B**
5 rows **E**	5 rows **A**
7 rows **F**	5 rows **G**
2 rows **G**	7 rows **A**
7 rows **F**	

Back

Following the colour sequence above, work as follows throughout:
Using 4.5mm (US 7) needles and **A**, cast on 107 sts.
Row 1 (RS): *P1, k1, rep from * to last st, p1.
Row 2: *K1, p1, rep from * to last st, K1.
Repeat last 2 rows 4 times more, inc 1 st on last row. *108 sts.*
Continue in St st with rib edges as follows:
Next row (RS): Rib 7 sts as set, knit to last 7 sts, rib as set to end of row.
Next row: Rib 7 sts as set, purl to last 7 sts, rib as set to end of row.
Repeat last 2 rows until work meas 61cm (24 in) from cast-on edge, ending with RS facing for next row.

Shape shoulders

Next row (RS): Patt to last 9 sts, wrap next st and turn.
Next row: Purl to last 9 sts, wrap next st and turn.
Next row: Knit to last 18 sts, wrap next st and turn.
Next row: Purl to last 18 sts, wrap next st and turn.
Next row: Knit to last 26 sts, wrap next st and turn.
Next row: Purl to last 26 sts, wrap next st and turn.
Next row: K8, turn and patt across all sts, picking up wraps as you work.

Cut yarn leaving a long end. Slip these 34 sts onto a holder for shoulder.
With RS facing, slip centre 40 sts onto a holder. Rejoin yarn to rem 34 sts and patt across all sts, picking up wraps as you work.
Cut yarn leaving a long end. Slip these 34 sts onto a holder for shoulder.

Front

Work as for back until front meas 58cm (22¾ in) from cast-on edge, ending with RS facing for next row.

Shape neck and shoulders

Next row (RS): Patt 45 sts, turn and slip rem 63 sts onto a holder.
Next row: Cast off (bind off) 4 sts, patt to end of row. *41 sts.*
Next row: Patt as set to end of row.
Next row: Cast off (bind off) 3 sts, patt to end of row. *38 sts.*
Next row: Patt as set to end of row.
Next row: Cast off (bind off) 2 sts, patt to end of row. *36 sts.*
Next row: Patt as set to end of row.
Next row: Cast off (bind off) 2 sts, purl to last 9 sts, wrap next st and turn.
Next row: Knit.
Next row: Purl to last 18 sts, wrap next st and turn.
Next row: Knit.
Next row: Purl to last 26 sts, wrap next st and turn.
Next row: K8, turn and patt across all sts, picking up wraps as you work.
Cut yarn leaving a long end. Slip these 34 sts onto a holder for shoulder.
With RS facing, slip centre 18 sts onto holder.
Rejoin yarn to rem 45 sts and work as follows:
Next row (RS): Cast off (bind off) 4 sts, patt to end of row. *41 sts.*
Next row: Patt as set to end of row.
Next row: Cast off (bind off) 3 sts, patt to end of row. *38 sts.*
Next row: Patt as set to end of row.
Next row: Cast off (bind off) 2 sts, patt to end of row. *36 sts.*

Knit Projects

Next row: Patt as set to end of row.

Next row: Cast off (bind off) 2 sts, knit to last 9 sts, wrap next st and turn.

Next row: Purl.

Next row: Knit to last 18 sts, wrap next st and turn.

Next row: Purl.

Next row: Knit to last 26 sts, wrap next st and turn.

Next row: P8, turn and patt across all sts, picking up wraps as you work.

Cut yarn leaving a long end. Slip these 34 sts onto a holder for shoulder. Using **A**, join shoulders using three-needle cast off (bind off) method with wrong sides together so seam is on outside of work.

Colour sequence for hood

2 rows **D**	2 rows **B**
5 rows **G**	7 rows **C**
2 rows **F**	17 rows **D**
5 rows **G**	2 rows **E**
5 rows **A**	Finish hood using **D**
7 rows **C**	

Hood

Note: Pick-up and first round are worked in same colour used when finishing body. Then follow the colour sequence above. With RS facing, 4.5mm (US 7) circular needle and **A**, starting at left shoulder seam, pick up and knit 18 sts down left front neck, 18 sts from front holder, 18 sts up right front neck, 2 sts across right back neck, 40 sts from back holder and 2 sts from left back neck, pm to show start of round. *98 sts.* Work in the round as follows:

Next round: Knit.

Change to **D** and, following colour sequence for hood, knit 7 rounds, ending at marker. K31 sts from marker, slip last 8 sts onto a holder, knit to end of row ending at holder. Remove marker and turn. *90 sts.* Beg with a purl row, continue in St st until work meas 16cm (6¼ in) from pick-up edge, ending with RS facing for next row.

Shape hood top

Next row (RS dec): K42, k2tog, pm, k2, skpo, knit to end of row. *88 sts.*

Next row: Purl.

Next row: Knit to 2 sts before marker, k2tog, sm, k2, skpo, knit to end of row.

Next row: Purl.

Repeat last 2 rows until 56 sts rem.

Next row: K28 sts, removing marker as you work. Slip rem 28 sts onto a second needle. Fold work in half and with wrong sides of work together so seam is on outside of work, cast off (bind off) the 2 sets of sts using three-needle cast off (bind off) method.

Rib edging

With RS facing, 4mm (US 6) circular needle and **B**, and starting at centre of cast-off (bound-off) sts, pick up and knit 4 sts from centre front, 54 sts up right front to top seam, 54 sts down left front and 4 sts from centre front, pm to show start of round. *116 sts.*

Next row: *K1, p1, rep from * to end of round. Work 5 rounds more in 1x1 rib, ending at marker. Cast off (bind off) in rib.

Pocket

Using 4.5mm (US 7) needles and **B**, cast on 43 sts and work as follows:

Row 1 (RS): (P1, K1) 3 times, p1, knit to last 7 sts, (p1, k1) 3 times, p1.

Row 2: (K1, p1) 3 times, k1, purl to last 7 sts, (k1, p1) 3 times, k1.

Repeat last 2 rows until work meas 18cm (7 in) from cast-on edge. Cast off (bind off) in patt as set.

To finish

Weave in any yarn ends.

For adult size, place pocket approx. 35[40] cm (13¾[15¾] in) down from top of shoulder and approx. 26[36]cm (10¼[14¼] in) in from each side edge to centre the pocket.

For junior size, place pocket approx. 24cm (9½ in) down from top of shoulder and approx.18cm (7 in) in from each side edge to centre the pocket.

Pin and sew into position using duplicate stitch or whip stitch.

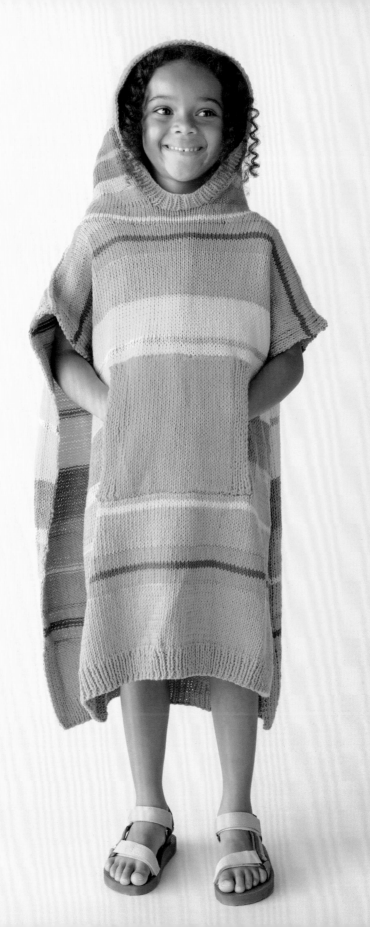

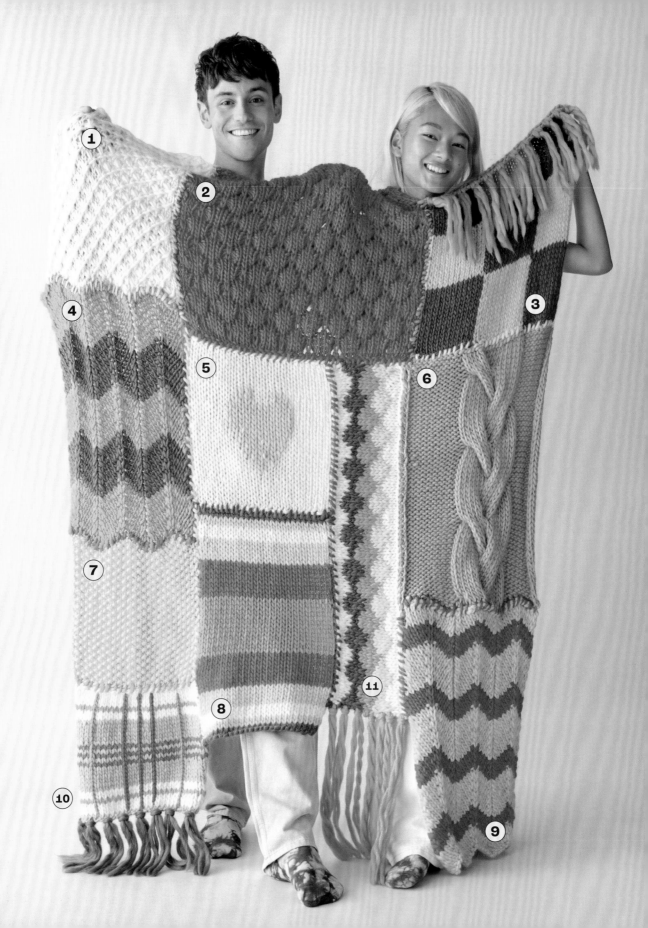

Patchwork Blanket

A fun way to practise different knitting techniques, including textured stitches, intarsia, striping, and duplicate stitch. Each of the eleven patches is knitted individually then simply sewn together at the end. Designed to be asymmetric with added fringing and contrast colour stitching, there is no right or wrong way to make this blanket. Gather your friends together and each knit one patch to make a shared memory blanket or set yourself a goal to make a patch a week whilst taking some time out for you.

Measurements
One size
Approx. 150cm (59 in) long x 115cm (45¼ in) wide

What you will need
- MWL The Chunky One
 100% merino wool
 65m (71 yards) per 100g (3½ oz)
Quantity:
- **A** 5 x 100g (3½ oz) balls in Lychee White
- **B** 3 x 100g (3½ oz) balls in Jump Pink
- **C** 3 x 100g (3½ oz) balls in Toweling Teal
- **D** 2 x 100g (3½ oz) balls in Aqua Blue
- **E** 3 x 100g (3½ oz) balls in Gold Medal
- **F** 3 x 100g (3½ oz) balls in Aquatic Blue
- **G** 3 x 100g (3½ oz) balls in Limoncello

- 1 pair 12mm (US 17) knitting needles
- Cable needle
- 8mm (L/11) crochet hook
- Yarn needle

Tension (gauge)
8.5 sts and 11 rows to 10cm (4 in) over St st on 12mm (US 17) needles. Change needle size as necessary to achieve correct tension (gauge). The tension will vary for some of the patches and is given in the instructions for these patches.

Abbreviations
See page 69.

Special techniques
Working a cable (see page 137).
Working duplicate stitch (see page 187).
Adding fringing (see page 197).

Notes
This blanket has been designed as 11 separate patches. Each patch teaches a different technique.

To make

Patch one: Star stitch

Measurements

Approx. 30 x 45cm (11¾ x 17¾ in)

Yarn

A Lychee White

Tension (gauge)

12 sts to 10cm (4 in) over pattern.

Special abbreviation

Make star: P3tog leaving sts on lefthand needle, yo, then purl 3 sts together again and allow sts to drop off lefthand needle.

Using 12mm (US 17) needles and **A**, cast on 37 sts.
Row 1 (RS): Knit.
Row 2: P1, *make star, p1, rep from * to end of row.
Row 3: Knit.
Row 4: P3, make star, *p1, make star, rep from * to last 3 sts, p3.
Repeat last 4 rows until work meas 45cm (17¾ in) from cast-on edge, ending with RS facing for next row.
Cast off (bind off).

Patch two: Bubble stitch

Measurements

Approx. 42 x 50cm (16½ x 19¾ in)

Yarn

B Jump Pink

Tension (gauge)

8.5 sts to 10cm (4 in) over pattern.

Special abbreviation

k5B Knit 5th st below by slipping next st off lefthand needle and drop st 4 rows down, leaving 4 ladder strands across. Working from front to back, insert point of LH needle through live st on 5th row down and under strands. Using RH needle knit st normally catching ladder strands at same time.

Using 12mm (US 17) needles and **B**, cast on 35 sts.
Purl 1 row.
Work in pattern as foll:
Row 1 (RS): Knit.
Row 2: Purl.
Row 3 to 4: Rep Rows 1 to 2.
Row 5: K3, *k5B, k3, rep from * to end of row.
Row 6: Purl.
Row 7 to 10: Rep Rows 1 to 2 twice.
Row 11: K1, *k5B, k3, rep from * to last 2 sts, k5B, K1.
Row 12: Purl.
Repeat last 12 rows until work meas 50cm (19¾ in) from cast-on edge, ending with RS facing for next row.
Cast off (bind off).

Patch three: Intarsia checkerboard

Measurements

Approx. 42 x 45cm (16½ x 17¾ in)

Yarn

C Toweling Teal
D Aqua Blue
E Gold Medal

Note: Use separate balls for each square and always twist the yarn on the WS of the work when changing colour to avoid holes.

Using 12mm (US 17) needles and beg with **C**, cast on 12 sts in **C**, join **D** and cast on 12 sts in **D**, join in another ball of **C** and cast on 12 sts in **C**. *36 sts.*
Next row (RS): K12 **C**, k12 **D**, k12 **C**.
Next row: P12 **C**, p12 **D**, p12 **C**.
Repeat last 2 rows 7 times more.
Next row: K12 **D**, k12 **C**, k12 **D**.
Next row: P12 **D**, p12 **C**, p12 **D**.
Repeat last 2 rows 7 times more.
Next row: K12 **C**, k12 **D**, k12 **C**.
Next row: P12 **C**, p12 **D**, p12 **C**.
Repeat last 2 rows 7 times more.
Change to **E**.
Knit 1 row.
Purl 1 row.
Cast off (bind off).

Patch four: Wide stripe chevron in two colours

Measurements
Approx. 35 x 50cm (13¾ x 19¾ in)

Yarn
E Gold Medal
C Toweling Teal

Tension (gauge)
9.5 sts and 10 rows to 10cm (4 in) over pattern.

Using 12mm (US 17) needles and **E**, cast on 33 sts.
Row 1 (RS): *K2tog, k2, knit into front and back of each of next 2 sts, k3, skp, rep from * to end of row.
Row 2: Purl.
Row 3: *K2tog, k2, knit into front and back of each of next 2 sts, k3, skp, rep from * to end of row.
Row 4: Purl.
Row 5: *K2tog, k2, knit into front and back of each of next 2 sts, k3, skp, rep from * to end of row.
Row 6: Purl.
Row 7: *K2tog, k2, knit into front and back of each of next 2 sts, k3, skp, rep from * to end of row.
Row 8: Purl.
Change to **C** and repeat Rows 1 to 8.
Change to **E** and repeat Rows 1 to 8.
Change to **C** and repeat Rows 1 to 8.
Change to **E** and repeat Rows 1 to 8.
Work should meas 50cm (19¾ in) from cast-on edge, ending with RS facing for next row.
Cast off (bind off).

Patch five: Stocking stitch with duplicate stitch heart

Measurements
Approx. 30 x 30cm (11¾ x 11¾ in)

Yarn
A Lychee White
D Aqua Blue

Special abbreviations
Full stitch: Use duplicate stitch to embroider over existing knit stitch, using a V shape to cover stitch completely.
Half stitch right: Use duplicate stitch to embroider over right half of existing knit stitch, working only half of usual V shape of a duplicate stitch, working from lower left corner to upper right corner.
Half stitch left: Use duplicate stitch to embroider over left half of existing knit stitch, working only half of usual V shape of a duplicate stitch, working from lower right corner to upper left corner.

Using 12mm (US 17) needles and **A**, cast on 25 sts.
Beg with a knit row, work 32 rows in St st, ending with RS facing for next row.
Cast off (bind off).
Using **D** and working from chart, use duplicate stitch to embroider heart. Place first stitch of bottom of heart on stitch 13 of row 9 from cast-on edge.

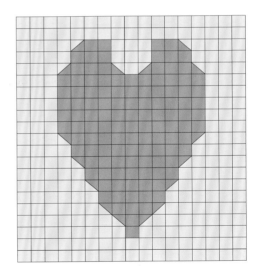

☐	With A, knit on RS rows, purl on WS rows
▨	With D, work full stitch in duplicate st
◹	With D, work half stitch right
◺	With D, work half stitch left

Patch six: Wide cable on reverse stocking stitch

Measurements
Approx. 40 x 50cm (15¾ x 19¾ in)

Yarn
F Aquatic Blue

Tension (gauge)
10 sts to 10cm (4in) over pattern.

Special abbreviations
C12F (cable 12 front): slip next 6 sts onto a cable needle and hold at front of work, knit next 6 sts from LH needle, then knit sts from cable needle.
C12B (cable 12 back): slip next 6 sts onto a cable needle and hold at back of work, knit next 6 sts from LH needle, then knit sts from cable needle.

Using 12mm (US 17) needles and **F**, cast on 40 sts.

Row 1 (RS): P11, k18, p11.
Row 2: K11, p18, k11.
Row 3: P11, k6, C12F, p11.
Row 4: K11, p18, k11.
Row 5: P11, k18, p11.
Row 6: K11, p18, k11.
Row 7: P11, k18, p11.
Row 8: K11, p18, k11.
Row 9: P11, k18, p11.
Row 10: K11, p18, k11.
Row 11: P11, C12B, k6, p11.
Row 12: K11, p18, k11.
Row 13: P11, k18, p11.
Row 14: K11, p18, k11.
Row 15: P11, k18, p11.
Row 16: K11, p18, k11.
Repeat these 16 rows until work meas 50cm (19¾ in) from cast-on edge. ending with RS facing for next row.
Cast off (bind off) in pattern.

Patch seven: Moss (seed) stitch

Measurements
Approx. 30 x 30cm (11¾ x 11¾ in)

Yarn
G Limoncello

Tension (gauge)
9 sts and 12 rows to 10cm (4 in) over moss (seed) st.

Using 12mm (US 17) needles and **G**, cast on 27 sts.
Work in moss (seed) st as follows:
Next row: *K1, p1, rep from * to last st, k1.
Repeat last row until work meas 30cm (11¾ in) from cast-on edge.
Cast off (bind off) in pattern.

Patch eight: Stripe sequence

Measurements
Approx. 30 x 46.5cm (11¾ x 18¼ in)

Yarn
C Toweling Teal
D Aqua Blue

A Lychee White
B Jump Pink
G Limoncello
E Gold Medal

Using 12mm (US 17) needles and **C**, cast on 26 sts.
Beg with a knit row, work in St st in following sequence:

1 row **C**	8 rows **B**
2 rows **D**	5 rows **G**
3 rows **A**	3 rows **A**
5 rows **G**	2 rows **D**
8 rows **B**	1 row **C**
13 rows **E**	

Cast off (bind off) using **C**.

Patch nine: Narrow stripe chevron in three colours

Measurements
Approx. 35 x 50cm (13¾ x 19¾ in)

Yarn
G Limoncello
B Jump Pink
D Aqua Blue

Tension (gauge)
9.5 sts and 9.5 rows to 10cm (4 in) over pattern.

Using 12mm (US 17) needles and **G**, cast on 33 sts.
Row 1 (RS): *K2tog, k2, knit into front and back of each of next 2 sts, k3, skp, rep from * to end of row.
Row 2: Purl.
Row 3: *K2tog, k2, knit into front and back of each of next 2 sts, k3, skp, rep from * to end of row.
Row 4: Purl.
Change to **B** and repeat Rows 1 to 4.
Change to **D** and repeat Rows 1 to 4.
Repeat this three-colour sequence three times more. Work should meas 50cm (19¾ in) from cast-on edge, ending with RS facing for next row.

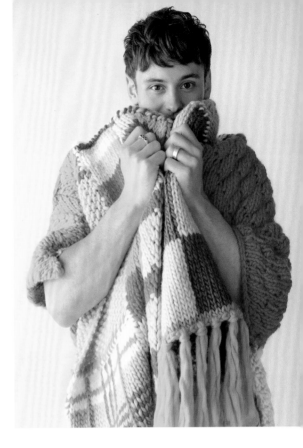

Cast off (bind off).

Patch ten: Stocking stitch stripes with surface embroidery

Measurements
Approx. 30 x 28cm (11¾ x 11 in)

Yarn
A Lychee White
E Gold Medal
F Aquatic Blue
B Jump Pink

Using 12mm (US 17) needles and **F**, cast on 26 sts.
Beg with a knit row, work in St st as follows:

3 rows **A**	1 row **F**
1 row **E**	1 row **B**
2 rows **A**	6 rows **F**
6 rows **F**	2 rows **A**
1 row **B**	1 row **E**
1 row **F**	4 rows **A**
1 row **B**	Cast off (bind off) using **A**.

Using the photograph as a guide, work surface crochet slip stitch to embroider 2 vertical bars of **E** and 3 vertical bars of **B**: Using a crochet hook, make a slip knot. Keep the working yarn at the back, insert hook through the fabric from front to back, yarn round hook, pull through and repeat to create each vertical lines. Fasten off.

Patch eleven: Slip stitch diamonds

Measurements
Approx. 17 x 68cm (6¾ x 26¾ in)

Yarn
A Lychee White
G Limoncello
E Gold Medal
D Toweling Teal

Tension (gauge)
10 sts and 10 rows to 10cm (4in) over pattern.

Note: This patch is worked side to side rather than bottom up.
Using 12mm (US 17) needles and **A**, cast on 68 sts.
Row 1 (RS): Using **A**, knit.
Row 2: Using **A**, purl.
Row 3: Using **G**, k2, *sl4, k2, rep from * to end or row.
Row 4: Using **G**, p3, sl2, *p4, sl2, rep from * to last 3 sts, p3.
Row 5 and 6: Using **G**, repeat Rows 1 and 2.
Row 7: Using **E**, k1, sl2, k2, *sl4, k2, rep from * to last 3 sts, sl2, k1.
Row 8: Using **E**, p1, sl1, p4, *sl2, p4, rep from * to last 2 sts, sl1, p1.
Rows 9 and 10: Using **E**, rep Rows 1 and 2.
Rows 11 and 12: Using **D**, rep Rows 3 and 4.
Rows 13 and 14: Using **D**, rep Rows 1 and 2.
Rows 15 and 16: Using **A**, rep Rows 7 and 8.
Cast off (bind off).

To finish

Using the photograph as a guide, assemble the patches and pin them into position, overlapping the chevron edges at the front of the work. Sew patches together using short lengths of leftover yarn in random colours and whip stitch.

Add fringing
Cut leftover yarn into varying lengths, as follows, and leave to one side.
For top of Patch Three, cut 24 lengths of **E** approx 38cm (15 in) long.
For bottom of Patch Ten, cut 18 lengths of **C** approx 33cm (13 in) long.
For bottom of Patch Eleven, cut 14 lengths of **C** approx 70cm (27½ in) long.
For each fringe, take a length of yarn and fold in half. Push crochet hook from back to front through the raised bump of a stitch. Using the crochet hook pull the folded yarn down half-way through the stitch, then take the loop and pull the ends through to secure. Repeat along the patch edges, using the photograph as a guide. Trim each fringe to neaten, as desired.

Masterclass

Working duplicate stitch

This technique is also referred to as Swiss darning, but I call it duplicate stitch as that sums up exactly what it is – an embroidered stitch worked over the top of a finished piece to duplicate a knit stitch. Worked in the same weight yarn, the embroidered duplicate stitches will be a bit fatter and feel slightly raised. It is a fantastic way to add decoration to your knitting, like the cute heart motif here, but it's also a sneaky way to cover up any errors you didn't manage to correct while knitting.

Working duplicate stitch horizontally

One Thread a blunt-tipped sewing needle with yarn the same weight as that used to knit with. Work from right to left. From the back, bring the needle out at the base of a knitted stitch to be embroidered. Pass the needle around the top of stitch, going under the "legs" of the stitch above.

Two Insert the needle back through the base of the same stitch and pull the yarn taut, covering the knitted stitch completely. Bring the needle through to the base of the next stitch to the left.

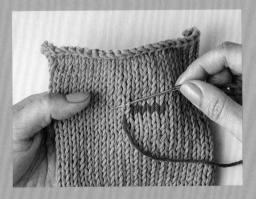
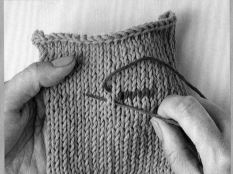

Working duplicate stitch vertically

One Work from bottom to top. From the back, bring the needle out at the base of a knitted stitch to be embroidered. Pass the needle around the top of the stitch, going under the "legs" of the stitch above.

Two Insert the needle back through the base of the same stitch and pull the yarn taut, covering the knitted stitch completely. Bring the needle through at the base of the stitch above.

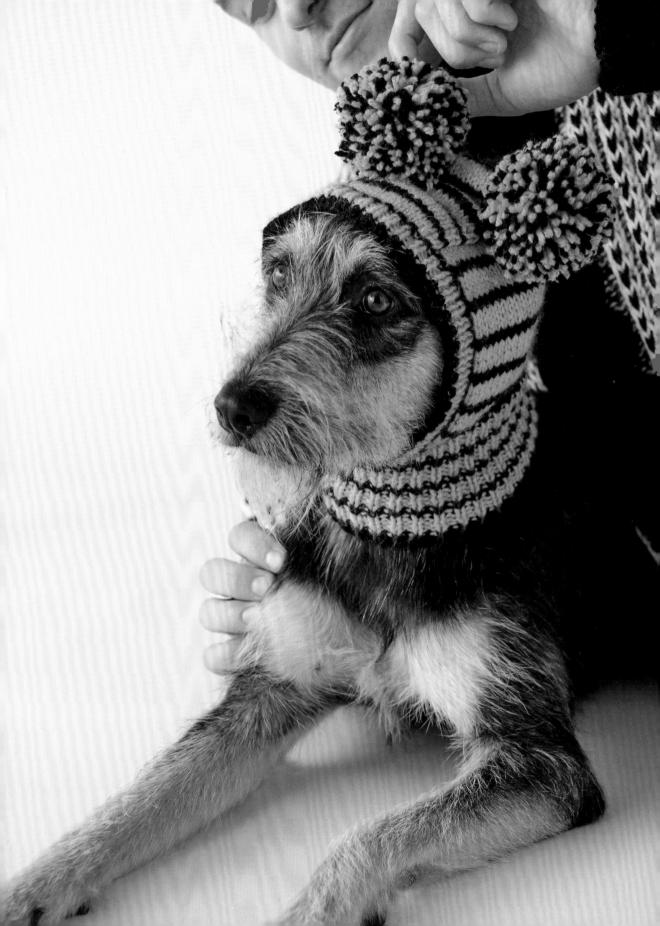

Dog Hat

I mean, who doesn't love a dog in a hat? I do love dressing up dogs; the first item I was photographed knitting at the Olympics was a jumper for Izzy the Frenchie! This fun and playful hat is knitted in neon colour stripes with contrast black, and two pompoms for added cute factor. Ideal for all pooches, from your neighbour's greyhound to your Auntie's poodle – and of course Ned, pictured here. Note of caution: a dog should never be left alone wearing any garment or with a pompom.

Measurements
One size
Head circumference 32cm (12½ in)
Finished length 22cm (8¾ in)
Will fit medium to large size dog breeds

What you will need
- Schachenmayr Bravo
 100% acrylic
 133m (145 yards) per 50g (1¾ oz)
Quantity:
- **A** 1 x 50g (1¾ oz) ball in Black (08226)
- **B** 1 x 50g (1¾ oz) ball in Neon pink (08234)
- **C** 1 x 50g (1¾ oz) ball in Neon green (08233)

- 1 pair 3.25mm (US 3) knitting needles
- 1 pair 3.75mm (US 5) knitting needles
- Stitch holders
- Pompom maker or cardboard for pompoms
- Scissors
- Yarn needle

Tension (gauge)
23 sts and 30 rows to 10cm (4 in) over St st on 3.75mm (US 5) needles. Change needle size as necessary to achieve correct tension (gauge).

Abbreviations
See page 69.

Special technique
Making pompoms (see page 191).

To make

Stripe sequence
2 rows **A**
2 rows **B**
2 rows **C**

Using 3.25mm (US 3) needles and
A, cast on 71 sts and follow stripe
sequence as given working in rib as follows:
Row 1 (RS): *K1, p1, rep from * to last st, k1.
Row 2: *P1, k1, rep from * to last st, p1.
Repeat last 2 rows a further 11 times.
Next row: Rib to last 9 sts and slip
these unworked sts onto a holder. *62 sts.*
Next row: Rib to last 9 sts and slip these
unworked sts onto a second holder. *53 sts.*
Change to 3.75mm (US 5) needles and
starting with a knit row, continue in St st
and follow stripe sequence as set until
work meas 23cm (9 in) from cast-on edge,
ending with RS facing for next row.

Shape crown
Row 1 (RS): K34, k2tog tbl, turn. *1 st dec.*
Row 2: Sl1, p15, p2tog, turn. *1 st dec.*
Row 3: Sl1, k15, k2tog tbl, turn. *1 st dec.*
Rep last 2 rows until 17 sts rem.
Leave rem 17 sts on stitch holder.

With RS facing, slip 9 sts from second
holder onto a 3.25mm (US 3) needle,
keeping stripe sequence correct pick up

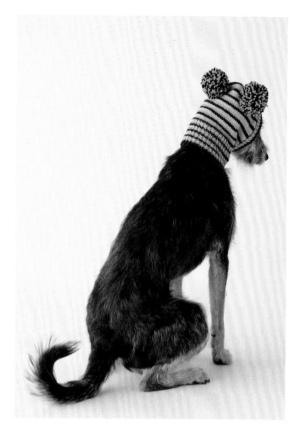

and knit 33 sts along side of hat, k17 sts
from crown holder, pick up and knit 33
sts along other side of hat, then rib as set
across 9 sts from rem holder. *101 sts.*
Starting with **A** and following stripe
sequence as set, work 9 rows in rib.
Cast off (bind off) using a 3.75mm (US 5)
needle.

To finish

Weave in any yarn ends.
Join neckband at front.

Pompoms (make 2)
Make two pompoms (see opposite) using
a pompom maker or cardboard circles
approx. 6cm (2½ in) in diameter. Measure
8m (9 yards) each of 2 colours and hold
together to wind the pompom. Using the
long yarn ends on the pompoms, sew
securely to the hat in the ear positions.

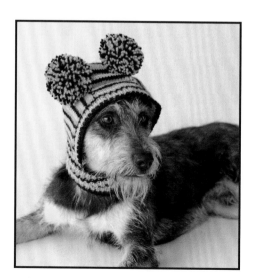

Masterclass

Adding pompoms

Who doesn't love a pompom? They bring such joy and they're a great way to use up scraps of yarn. They're really easy to make, either with a store-bought pompom maker or in the traditional way with two circles of stiff cardboard, slightly wider in diameter than the finished size of the pompom with a hole in the centre of each, measuring just under half the diameter.

One If you're using a pompom maker, open out the two parts and hold them together. Wind two yarns along each half in turn until the semicircular gap is filled, then fasten the catches. If you're using cardboard, thread a large-eyed needle with two long strands of yarn. Holding the circles together, stitch the yarn continually through the centre and around the outer edges, keeping the strands close together, until the centre space is almost filled.

Two Insert the tip of sharp scissors between the two sides of the pompom maker or two cardboard circles and snip through the layers of yarn all around the edge.

Three Slip a length of yarn through the centre space and wrap it tightly around the yarn strands. This will be the centre of the pompom. Firmly knot the yarn, leaving long ends that can later be used to attach the pompom. Remove the pompom maker or cardboard circles.

Four Fluff up the pompom and trim any uneven strands of yarn sticking out for a neat, round finish.

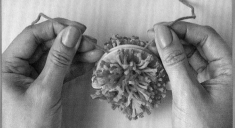
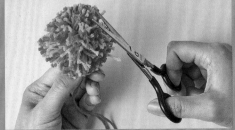

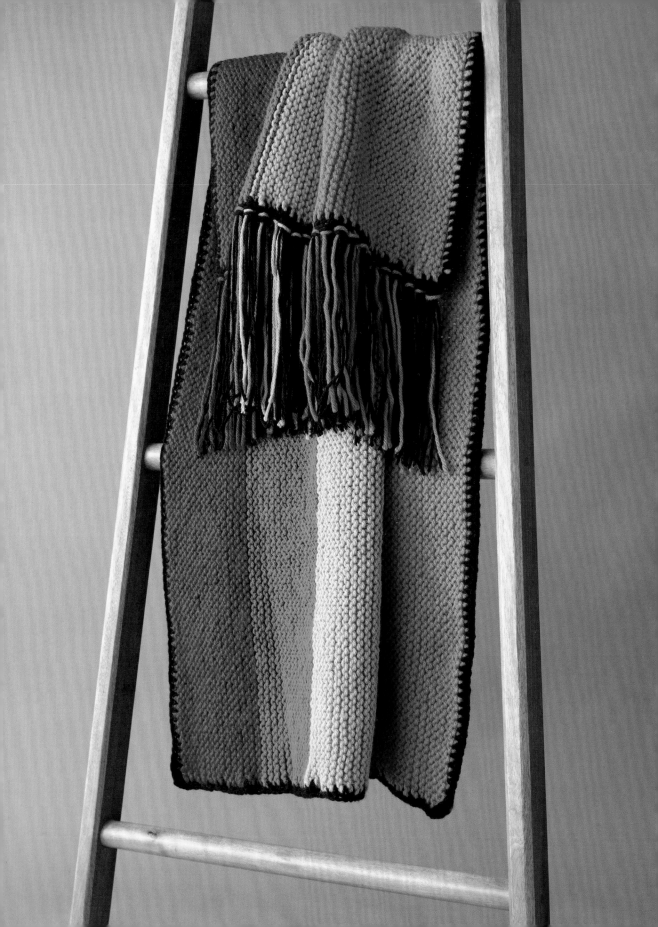

Stroller Blanket

A knitted blanket is a fantastic gift for a child – unique, thoughtful, and sure to become a treasured heirloom, made with love to last a lifetime. This super-simple garter stitch blanket, made using only the knit stitch, features vertical blocks of bright colours with a contrast crochet edging and tassels along one side to show when tucked into the stroller or car seat. I have used a machine-washable yarn, which is a must-have for toddlers and kids! For safety, do not add any fringing or tassels if you make this blanket for a new baby.

Measurements
One size
Approx. 60 x 90cm (23 x 35 in), excluding crochet edging and fringing

What you will need
- Hayfield Bonus Chunky
 100% acrylic
 137m (150 yards) per 100g (3½ oz)
Quantity:
- **A** 1 x 100g (3½ oz) ball in Cobalt (653)
- **B** 1 x 100g (3½ oz) ball in Emerald (916)
- **C** 1 x 100g (3½ oz) ball in Lime Green (785)
- **D** 1 x 100g (3½ oz) ball in Paprika (700)
- **E** 1 x 100g (3½ oz) ball in Raspberry (846)
- **F** 1 x 100g (3½ oz) ball in Black (965), for edging and fringing

- 1 pair 6.5mm (US 10½) knitting needles
- 6mm (US J/10) crochet hook
- Yarn needle

Tension (gauge)
13 sts and 23 rows to 10cm (4 in) over garter st on 6.5mm (US 10½) needles. Change needle size as necessary to achieve correct tension (gauge).

Abbreviations
See page 69.

Special techniques
Adding crochet edging (see page 196).
Adding fringing (see page 197).

To make

Using 6.5mm (US 10½) needles and **A**, cast on 117 sts and work 30 rows garter st (knit every row).
Change to **B** and work 30 rows garter st.
Change to **C** and work 30 rows garter st.
Change to **D** and work 30 rows garter st.
Change to **E** and work 30 rows garter st.
Cast off (bind off).

To finish

Weave in any yarn ends.

Crochet edging

Using 6mm (US J/10) crochet hook, rejoin **F** to the corner of one long edge and work as follows:
Next round: Ch2 (count as 1htr), 2htr in same space, 1htr in every st to next corner, 3htr in corner, 1htr between every 2 ridges of garter st, 3htr in corner, 1htr in every st, 3htr in corner and 1htr between every 2 ridges of garter st to end of round.
Join with sl st to top of beg ch2.
Fasten off.

Fringing

Add a fringing tassel (see page 197) to every alternate stitch of the crochet edging along both short ends to create evenly spaced fringing that matches with each colour section of the knitted blanket. Use 45cm (18 in) lengths of yarn, holding together 2 lengths of yarn **F** and 1 of another colour to match the knitted stitches in each section and follow the photographs as a colour guide. (In total, you will need 80 lengths of **F**, and 8 lengths each of other 5 colours **A**, **B**, **C**, **D** and **E**.) Trim the fringing to approx. 18cm (7 in), or to the length preferred.

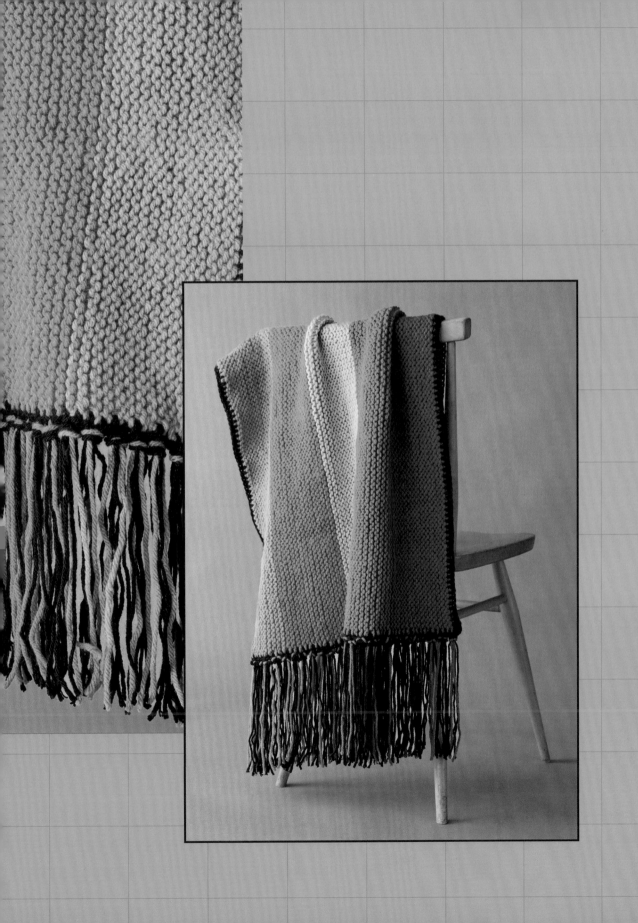

Masterclass

Adding a crochet edging

A crocheted border gives a tidy finish to a knitted edge and it also makes a good base for fringing. Work in half trebles, using a matching yarn for a minimal subtle look, or a contrast colour for maximum visual impact.

One When crocheting along the row ends of garter stitch, work a half treble crochet under the first knitted stitch on every alternate row. Bring the yarn up at one corner of the knitted piece and work one half treble crochet into each "valley" between two rows of knit stitch.

Two To turn the square corner, work three half treble crochets in the same place under the last edge stitch to build up a cluster of stitches.

Three Continue along the cast-off (bound-off) edge, working one treble crochet into every stitch on the final row. Work along the cast-on edge in the same way.

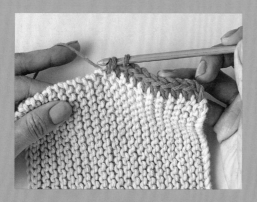

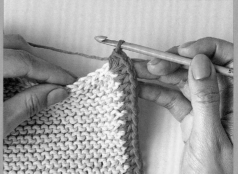

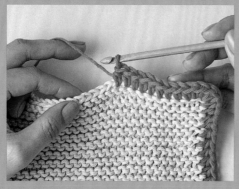

Adding fringing

This is one of the simplest ways to add decorative detail to an item. You can add fringing to cast-on and cast-off (bound-off) edges, but also along the row ends or to a crocheted border. I love fringing made from long lengths of yarn for extra swish.

One Cut strands of yarn that are slightly longer than twice the finished length of the tassel. Take two or more strands and fold them in half.

Two Insert a large crochet hook through the stitch where you want to place the tassel, from front to back. Lay the folded end of the yarn over the hook.

Three Draw the hook back through the stitch, pulling the folded yarn partially through to form a loop. Tuck the ends through the loop and gently pull to secure the tassel.

Four Repeat along the edge to create an evenly spaced fringing. Trim the cut ends of the yarn to the same length.

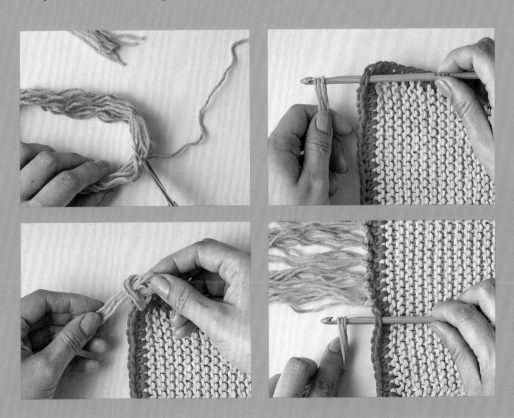

Crochet
Essentials

04-

If you are new to crochet, you will need just a few items to get you started. It really requires very little equipment, just a hook, some yarn and a pair of scissors for snipping your yarn. You can read more about yarns on pages 22–28.

Crochet kit list

Choosing the right crochet hook

Much like knitting needles, crochet hooks come in a variety of sizes and are also made in different materials, including metal, wood, and plastic. I started with a set of basic metal hooks I found online, and discovered that as I crocheted more, I started to experiment and found out what worked best for me.

Standard hook sizes span from 2mm to 10mm. (US 4 to N/P-15). Most people have a favourite hook size to use. For me, this is a 4mm or 4.5mm (US G/6) hook, but it depends on the weight of the yarn you are using. Basically, the thicker the yarn, the thicker the hook. The smallest hooks are specialist lace hooks and these range from 0.6mm to 1.75mm and are metal. The largest hooks are 10mm (US N/P-15) and are used for making chunkier crocheted items. Check the label on any yarn – it will be labelled with the recommended size of hook to work with (see page 26). One of the best things about crochet is how quickly it grows at first, even with a standard 4mm (US G/6) hook!

You want to make sure that whatever style of hook you use is comfortable to hold; you just have to figure out what you prefer. The handle of a crochet hook is most often straight with an indentation for the grip. However, some hooks have ergonomically shaped handles with a thumb rest to make them comfortable to hold.

Nowadays, I try to make more sustainable choices. My favourite hooks to use are made from bamboo because, like bamboo knitting needles, they are warm to the touch and they are recyclable.

Hook size conversion chart

metric	2.00	2.25	2.50	2.75	3.25	3.50	3.75	4.00	5.00	5.50	6.00	6.50	8.00	9.00	10.00
imperial	14	13	12	11	10	9	8	7	6	5	4	3	0	00	000
U.S.	4	B-1	1/0	C-2	D-3	E-4	F-5	G-6	H-8	I-9	J-10	K10½	L-11	M/N-13	N/P-15

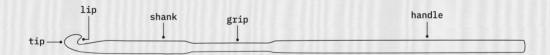

tip → lip shank grip handle

Crochet basics →

With these instructions, you can go from a beginner to a fully-fledged crocheter in no time. If you are left-handed, simply hold the hook and yarn in the exact mirror image of the techniques shown here for right-handed crocheters.

CROCHET

Holding the hook

Like learning to hold knitting needles, finding the most comfortable way to hold your crochet hook can just be a case of experimenting until you find the most natural position for you. There are two main ways to hold a crochet hook:

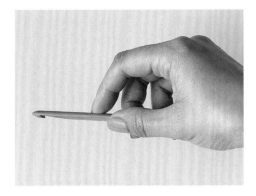

Like a knife

In your right hand, hold the hook with your hand over the hook and your palm facing down. Place your thumb on one side and your fingers on the other side. Grip the hook exactly like you would when holding a knife to cut food.

Like a pencil

In your right hand, hold the hook between your index finger and thumb, with your third finger underneath to balance and control the hook. Grip the hook just like you would if holding a pencil when writing.

If you're a knitter, the chances are you will instinctively hold your crochet hook in the same way that you hold your knitting needle. In both positions, your thumb should be around 5cm (2 inches) from the tip of the hook – some crochet hooks will have a special thumb rest located here. When you start, if your stitches are too loose or tight, finding a good position for your crochet hook will help. If you want to hold your hook in a completely different way, go ahead!

Holding the yarn

You will also need to hold your yarn in your left (or free) hand, so you can control the flow and tension. This is called your yarn hand. Most people wrap the yarn around the little finger and lace it through their other fingers, so it ends up over the tip of their forefinger. Here are two different methods for you to try — the forefinger method and the middle finger method. Again, try both of them and settle on the one that feels most comfortable for you.

Forefinger method

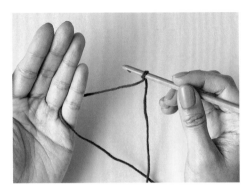

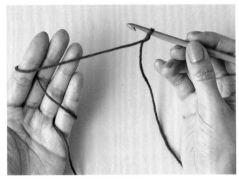

One: Hold the hook with the slip knot in your right hand. With palm upwards, take the working yarn (the end attached to the ball) between the little finger and the next finger and wrap it clockwise around your little finger.

Two: Take the yarn across the next two fingers, then behind and around the index finger.

Three: Hold the yarn, beneath the slip knot, between the thumb and middle finger of your left hand. Now raise your index finger. You are ready to crochet, working with the yarn between the hook and your index finger.

Tensioning the yarn

You do have to apply some tension to the tail end of the yarn, otherwise you'll find yourself attempting to crochet in mid air. Depending on the method you're using to control the working yarn, use either the second or third finger and thumb of your left hand to pull gently on the tail end of the yarn by pinching it just below the hook to control your project and stop it from wobbling around too much. I use my index finger a bit like a claw to tension the yarn. It's not the most elegant approach but it works for me!

Middle finger method

One: Hold the hook with the slip knot in your right hand. With palm upwards, take the working yarn (the end attached to the ball) between the little finger and the next finger and wrap it clockwise around your little finger.

Two: Take the yarn behind your other fingers and round, in front of your index finger.

Three: Hold the yarn, just below the slip knot, between the thumb and forefinger of your left hand. Now raise your middle finger to control the yarn and pull it through your fingers. You will be working with the yarn between the hook and your middle finger.

Making the first loop and working a foundation chain

The first stitch on your hook will be made using a slip knot (see page 40).
Once this is on your hook, it is time to get crocheting and to make the
first chain of stitches. This first chain is called a foundation chain.
The other stitches are then built on top of these foundation chain stitches,
so you can create interesting three-dimensional shapes and pieces.

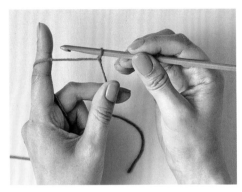

One: With a slip knot on your hook, encircle the working yarn with the hook just above the slip knot in an anticlockwise direction. This is called yarn round hook (yrh) or yarn over (yo) and is used in lots of different crochet techniques.

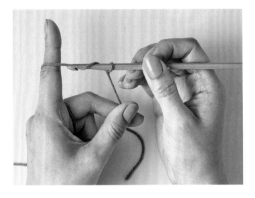

Two: Holding the base of the slip knot with your yarn hand, with your other hand bring the tip of the hook towards you so that the working yarn is caught in the lip of the hook – if necessary, rotate the hook to hold the yarn in place.

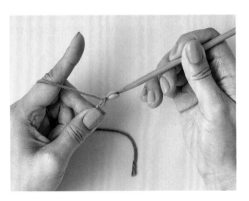

Three: Draw the loop of working yarn through the slip knot already on the hook. This completes your first chain stitch.

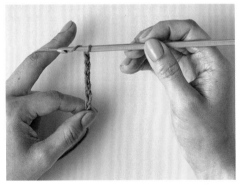

Four: Repeat this process, encircling the yarn with the hook and drawing a loop through the loop already on the hook, for each new stitch. Move the fingers of your yarn hand along the foundation chain as you work to maintain the tension. Continue until you have the number of chain stitches you need. When working in rows, this is called the foundation chain. When joined into a ring for working in rounds, this is called the foundation ring.

Counting chain stitches

When working from any pattern, you will need to make a specific number of chains to create the foundation row or ring. To count the chains accurately, it is crucial to be able to recognise the formation of each chain.

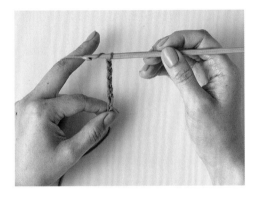

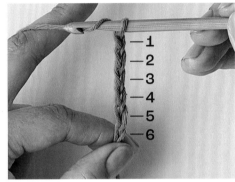

The front of a chain

The front of a foundation chain looks like a series of V shapes, each made by the working yarn. Each V is one chain loop, which is smooth on the front side. It is best to count the chains from this front side whenever possible.

The reverse of a chain

The reverse side of the foundation chain is made up by a row of bumps, which sit behind the V shapes on the front side and run vertically from the slip knot to the hook. These are called the back bumps. Whereas the front side is smooth, the reverse side is more textured.

Counting chains

Begin counting the chains from the base of the hook downwards. Do not count the loop on the hook as, at all times, a loop remains on the hook right up the point when you fasten off. I find the easiest way to count stitches is by counting the Vs on the front side to determine the number of chains. Before you start working your pattern beyond the foundation chain or foundation ring, count the chains again to make sure you have exactly the right number.

Basic stitches →

There are just five basic stitches used in crochet which can be combined to make a wide array of shapes, patterns and textures. They range from simple slip stitch up to quadruple trebles, their height increasing in stages depending on the number of times the yarn is wrapped around the hook and drawn through. Don't be confused if you find the same name used for different stitches – UK and U.S. patterns use alternative terminology, so always check the origin of any pattern before you start work, and check the alternative names on the following pages.

CROCHET

Slip stitch (sl)

This is a shallow and functional stitch. It is possible to work it in rows to make a fabric, but it is mostly used for joining stitches together, such as the beginning and end of rows when working in the round or for decreasing. Use it to add an interesting edging and a fun pop of colour to a piece. Before that, it is the perfect stitch to start with in order to practise holding the hook and controlling the yarn.

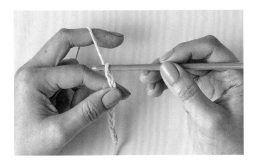

One: Make a foundation chain of evenly worked chain stitches to the length required. Not including the loop on the hook, count along to the second stitch from the hook.

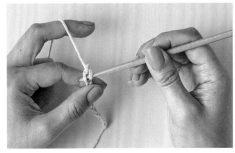

Two: Insert the tip of the hook through the second chain from the hook, passing it under only one strand of the chain.

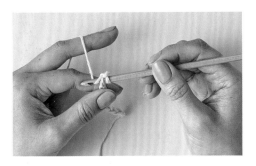

Three: Take the hook under, behind and then over the yarn (yarn round hook – yrh) so the yarn is caught by the lip.

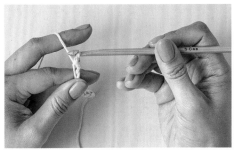

Four: Holding the base of the foundation chain, draw the yarn back through the two loops now on the hook (the second chain and original active loop on the hook). There is now one loop on the hook. This completes one slip stitch.

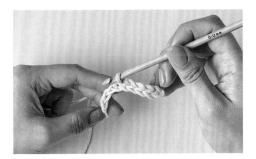

Five: Continue working slip stitch by inserting the tip of the hook into the next chain along and repeating steps 3 and 4.

 TOM'S TIP: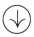

When working any crochet stitches, make sure you slide each stitch up onto the thicker part of the hook (the shank) before moving on to the next stitch.

Double crochet (U.S. single crochet)

This is the easiest crochet stitch to learn and one that everyone should start with. It is a versatile and dense stitch and can be used either on its own or in combination with other stitches. Once you have mastered this stitch, the other stitches will come easily! It can be worked in rows, continuous spiral rounds, or joined rounds. It is often used to make toys and accessories because the fabric it forms is quite textured and stiff.

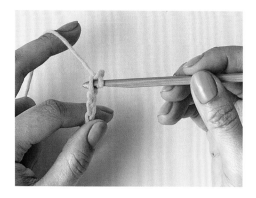

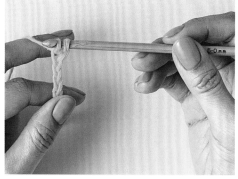

One: Make a foundation chain of evenly worked chain stitches to the length required. Not including the loop on the hook, count along to the second stitch from the hook. Insert the tip of the hook through the second chain from the hook, passing it under only one strand of the chain.

Two: Take the hook under, behind and then over the yarn (yarn round hook – yrh) so the yarn is caught by the lip.

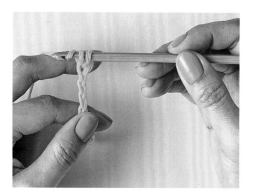

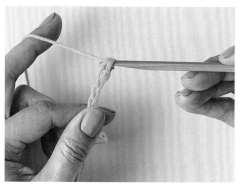

Three: Holding the base of the foundation chain, draw the yarn back through the first loop on the hook only (the second chain), leaving the new loop and the original active loop on the hook. There are now two loops on the hook.

Four: Take the hook under, behind and then over the yarn (yarn round hook – yrh) so the yarn is caught by the lip.

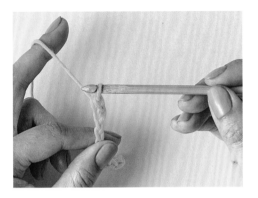

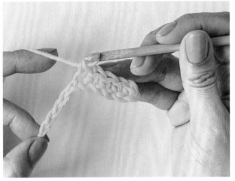

Five: Draw the yarn back through both loops on the hook (the new loop and the original active loop on the hook) in one smooth, continuous action and allowing the yarn to flow through your fingers while maintaining a constant tension. There is now one loop on the hook. This completes one double crochet stitch.

Six: Continue working double crochet into each chain of the foundation chain by inserting the tip of the hook into the next chain along and repeating steps 2 to 5.

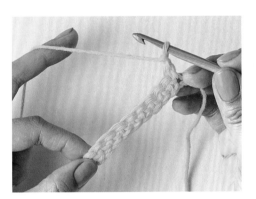

Seven: If you need to work another row of double crochet, turn the work so the working yarn is at the righthand edge. To begin this new row, make one chain stitch for the turning chain (see page 218) that doesn't count as a stitch but brings the work up to the same height as the double crochet stitches that follow. Work each double crochet stitch into both strands of the top of the double crochet stitches below.

Finished stitch: A fabric made up of double crochet stitches will look like this.

Half treble crochet (U.S. Half double crochet)

The half treble crochet is the next stitch up from double crochet in order of stitch heights (it is taller than a double crochet stitch but half the height of a treble crochet stitch). This stitch produces a fairly dense but fluid fabric, which isn't too lacy, and so it can be used for many different projects. It is essentially the same as double crochet, apart from an extra yarn round hook at the beginning of each stitch. The abbreviation for half treble crochet is htr (U.S. hdc).

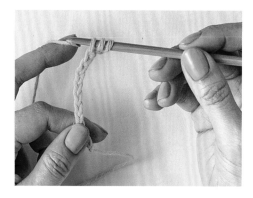

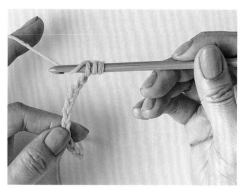

One: Make a foundation chain of evenly worked chain stitches to the length required. Take the hook under, behind and then over the yarn (yarn round hook – yrh) so the yarn is caught by the lip.

Two: Not including the loop on the hook, insert the tip of the hook through the third chain from the hook, passing the hook under only one strand of the chain. Yarn round hook (yrh) so the yarn is caught by the lip.

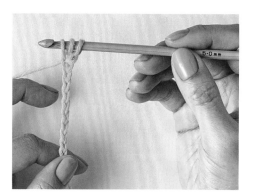

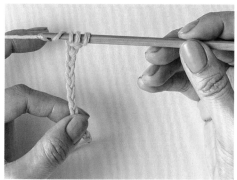

Three: Holding the base of the foundation chain, draw the yarn back through the first loop on the hook only (the third chain), leaving the new loop, yrh and original active loop on the hook. There are now three loops on the hook.

Four: Yarn round hook (yrh) so the yarn is caught by the lip.

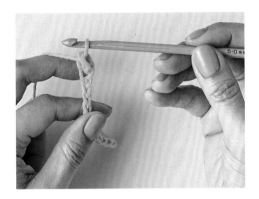

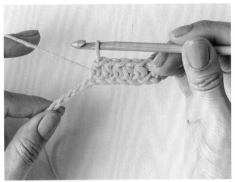

Five: Draw the yarn back through all three loops on the hook (the new loop, yrh and original active loop on the hook) allowing the yarn to flow through your fingers while maintaining tension. There is now one loop on the hook. This completes one half treble crochet stitch.

Six: Continue working one half treble stitch into each chain of the foundation chain by inserting the tip of the hook into the next chain along and repeating all the steps, remembering to yrh before inserting the hook through the chain.

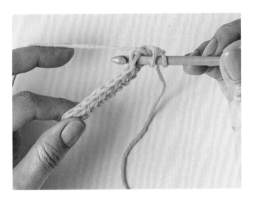

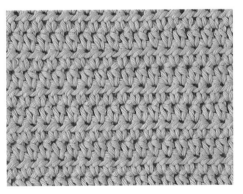

Seven: If you need to work another row of half treble crochet, turn the work so the working yarn is at the righthand edge. To begin this new row, make two chain stitches for the turning chain, which counts as the first half treble stitch of this row. Skip the first stitch at the base of the turning chain, then yrh and work a half treble under both strands of the second stitch in the previous row. Work each half treble crochet stitch into both strands of the top of the half treble crochet stitches in the row below and into the top of the second turning chain of the previous row.

Finished stitch: A fabric made up of half treble crochet stitches will look like this.

Treble crochet (U.S. Double crochet)

Treble crochet is a more open stitch that is twice the height of double crochet. It creates a softer, more fluid fabric that is used in many crochet patterns. Treble crochet is the third of the five basic crochet stitches. You will find that your work grows more quickly with this taller stitch, so it is really satisfying. The abbreviation for treble crochet is tr (U.S. dc).

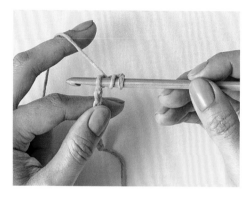

One: Make a foundation chain of evenly worked chain stitches to the length required. Take the hook under, behind and then over the yarn (yrh or yarn round hook).

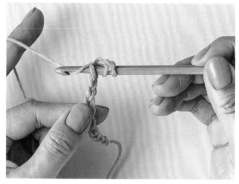

Two: Not including the loop on the hook, insert the tip of the hook through the fourth chain from the hook, passing the hook under only one strand of the chain. Yarn round hook (yrh) so the yarn is caught by the lip.

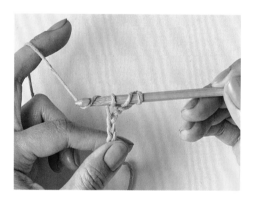

Three: Holding the base of the foundation chain, draw the yarn back through the first loop on the hook only (the fourth chain), leaving the new loop, yrh and original active loop on the hook. There are now three loops on the hook.

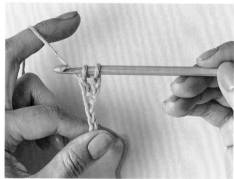

Four: Yarn round hook (yrh) so the yarn is caught by the lip. Draw the yarn through the first two loops on the hook, allowing the yarn to flow through your fingers while maintaining tension. There are now two loops on the hook.

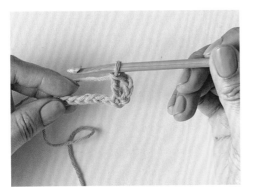

Five: Yarn round hook (yrh) so the yarn is caught by the lip. Draw the yarn back through the remaining two loops on the hook. There is now one loop on the hook. This completes one treble crochet stitch.

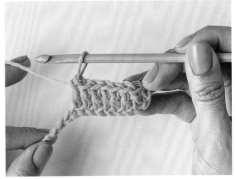

Six: Continue working one treble stitch into each chain of the foundation row by inserting the tip of the hook into the next chain along and repeating all the steps, remembering to yrh before inserting the hook through the chain.

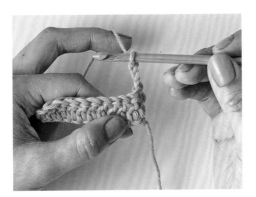

Seven: If you need to work another row of treble crochet, turn the work so the working yarn is at the righthand edge. To begin this new row, make three chain stitches for the turning chain, which counts as the first treble stitch of this row. Skip the first treble crochet stitch at the base of the turning chain, then yrh and work a treble crochet under both strands of the second treble crochet in the previous row. Work each treble crochet into both strands of the top of the treble crochet stitches in the row below, including in the top of the third turning chain of the previous row.

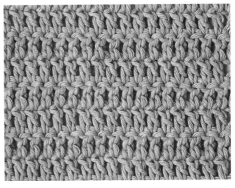

Finished stitch: A fabric made up of treble crochet stitches will look like this.

Double treble crochet (U.S. Triple crochet)

Double treble crochet is an even more open stitch than treble crochet that makes a loose, lacy fabric. Because the stitch is begun by wrapping the yarn around the hook twice, rather than just once, this stitch is a taller version of the treble crochet stitch. It works up really quickly, adding height and detail fast. The abbreviation for double treble crochet is dtr (U.S. trc).

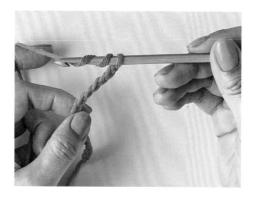

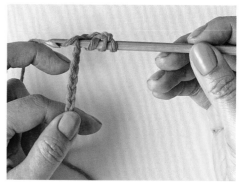

One: Make a foundation chain of evenly worked chain stitches to the length required. Take the hook under, behind and then over the yarn (yarn round hook – yrh) twice.

Two: Not including the loop on the hook, insert the tip of the hook through the fifth chain from the hook, passing the hook under only one strand of the chain. Yarn round hook so the yarn is caught by the lip.

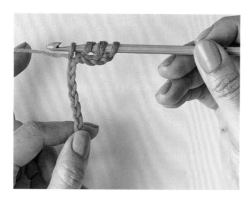

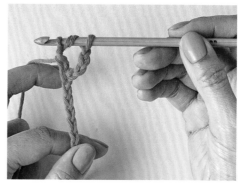

Three: Holding the base of the foundation chain, draw the yarn back through the first loop on the hook only (the fifth chain), leaving the new loop, two yrh and original active loop on the hook. There are now four loops on the hook.

Four: Yarn round hook so the yarn is caught by the lip. Draw the yarn back through the first two loops on the hook, allowing the yarn to flow through your fingers while maintaining tension. There are now three loops on the hook.

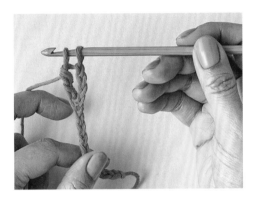

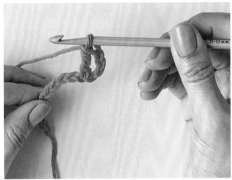

Five: Yarn round hook so the yarn is caught by the lip. Draw the yarn back through the first two loops on the hook. There are now two loops on the hook.

Six: Yarn round hook so the yarn is caught by the lip. Draw the yarn back through the remaining two loops on the hook. There is now one loop on the hook. This completes one double treble crochet stitch.

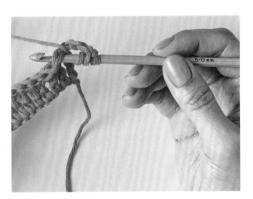

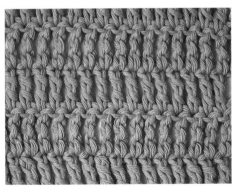

Seven: Work one double treble crochet into each chain of foundation row, remembering to yrh twice before inserting the hook into the chain. To work another row of treble crochet, turn the work so that the working yarn is at the righthand edge. To begin this new row, make four chain stitches for the turning chain, which counts as the first stitch of this row. Skip the first double treble crochet stitch at the base of the turning chain, yrh twice and work a double treble crochet under both strands of the second double treble crochet in the previous row.

Finished stitch: A fabric made up of double treble crochet stitches will look like this.

Working turning chains

To be able to crochet successfully when working in rows, and the work is turned between each row, you must make turning chains before starting the next row of stitches. The turning chain brings the yarn up to the right height to work the first stitch in the next row. The number of chains you need in a turning chain is determined by the height of the basic crochet stitch you are using.

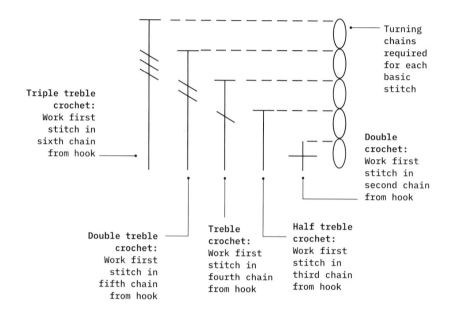

Turning chains required for each basic stitch

Triple treble crochet: Work first stitch in sixth chain from hook

Double crochet: Work first stitch in second chain from hook

Double treble crochet: Work first stitch in fifth chain from hook

Treble crochet: Work first stitch in fourth chain from hook

Half treble crochet: Work first stitch in third chain from hook

The standard symbols for each of the basic crochet stitches (see page 233) demonstrates the comparative heights of the different stitches. These symbols clearly show how a double treble crochet is much taller than a double crochet, for example. Because the basic crochet stitches vary in height, they required different length turning chains in order to keep the fabric neat and straight. The diagram above highlights the length of turning chain needed to bring the work up to the right height before working a new row of those stitches.

Double crochet
(U.S. Single crochet)

`All rows` Turning chain of one chain (does not count as a stitch) and insert hook into first stitch of row below.

Half treble crochet
(U.S. Half double crochet)

`Foundation row` Miss two chains at the beginning of the foundation row.

`Following rows` Make a turning chain of two chains (does count as first stitch of the row) and insert hook into second stitch of row below. By missing the first stitch you have made the turning chain the first stitch of the new row.

Treble crochet
(U.S. Double crochet)

`Foundation row` Miss three chains at the beginning of the foundation row.

`Following rows` Make a turning chain of three chains (does count as first stitch of the row) and insert hook into second stitch of row below. By missing the first stitch you have made the turning chain the first stitch of the new row.

Double treble crochet
(U.S. Triple crochet)

`Foundation row` Miss four chains at the beginning of the foundation row.

`Following rows` Make a turning chain of four chains (does count as first stitch of the row) and insert hook into second stitch of row below. By missing the first stitch you have made the turning chain the first stitch of the new row.

Triple treble crochet
(U.S. Double treble crochet)

`Foundation row` Miss four chains at the beginning of the foundation row.

`Following rows` Make a turning chain of five chains (does count as first stitch of the row) and insert hook into second stitch of row below. By missing the first stitch you have made the turning chain the first stitch of the new row.

Working in rows

Generally, projects that are flat with straight sides are worked in rows. With rows, you turn your work over from right to left and start another row again, so the end of the previous row sits immediately below the beginning of the next row.

Working in rounds

Both flat and cylindrical shapes are made in the round, by crocheting each round into the top of the previous round, without turning the work. Double crochets (U.S. single crochets) are worked in a continuous spiral without any standing chain – the equivalent of a turning chain. When using any taller stitches, you will need to make standing chains at the beginning of each round to be at the right height to work first stitch. I like the fact that when you are working in the round, you don't have to sew many seams afterwards!

Increasing and decreasing →

Just like in knitting, there will be patterns that call for increasing (inc) in a row or a round to make the piece wider or decreasing (dec) the number of stitches to make it narrower. The pattern will specify the right way to do this as there are a number of different techniques.

Increasing

The most common increases are made by working another stitch (or multiple stitches) into the row you are currently working. Commonly increases are "paired increases" where you increase by one stitch at the beginning of a row and then again at the end of the same row. The technique for increasing at each of a row is shown here on double crochet. With treble crochet and other stitches, the same technique is used – you simply work two stitches into one.

Increasing at the start of a row

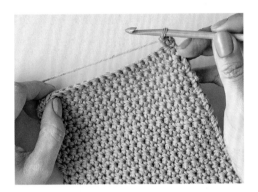

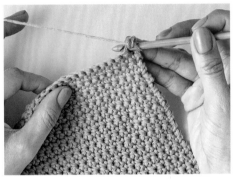

One: Make a turning chain of the appropriate height. Here it is double crochet, so that is a turning chain of one chain. Work a full stitch into the correct stitch on the row below, depending on the crochet stitch being worked. As it is double crochet being worked here, that is one double crochet into the first stitch on the row below.

Two: Insert the hook once more into the same stitch on the row below and work a second stitch where the first stitch was just worked. Here, a second double crochet is worked in the same place as the first double crochet. This completes the increase by one stitch at the beginning of the row. Continue working one double crochet, or whatever stitch you are working, in the usual way into each stitch to the end of the row.

Increasing at the end of a row

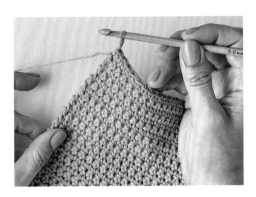

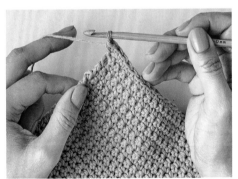

One: Work to the last stitch in the row below and then, at the end of the row, work a double crochet, or whatever stitch you are working, into this last stitch of the row, but do not turn the row or fasten off.

Two: Insert the hook once again into the same place as the last stitch worked and make a second stitch into the last stitch on the row below. Here, a second double crochet is worked in the same place as the first double crochet. This completes the increase by one stitch at the end of a row.

Decreasing

There are several ways of decreasing stitches. This is slightly trickier than increasing stitches but, in essence, it's about turning two stitches into one. You can simply skip a stitch as you work, although this may leave a hole. It's best to spend a bit of time using one of these decreasing techniques, which have different shaping effects. Decreases can be made at any point along a row (your pattern should tell you where). As with increases, decreases are most frequently worked as pairs at either end of a row, especially for garments. The techniques below show you how to make decreases in double crochet.

Decreasing at the beginning of a row

One: To decrease one stitch at the beginning of a row of double crochet, work up to the last yarn round hook of the first double crochet in the usual way, but do not complete the stitch. There are now two loops on the hook.

Two: Insert the hook through the next stitch and draw a loop through. There are now three loops on the hook.

Three: Wrap the yarn around the hook and draw a loop through all three loops in one go. This completes the decrease. Where there were two stitches, there is now only one.

Decreasing at the end of a row

One: Work to the last two stitches in the row below and then, at the end of the row, insert the hook through the top of the second to last stitch and draw a loop through. There are now two loops on the hook.

Two: Insert the hook through the last stitch in the row below and draw a loop through. There are now three loops on the hook.

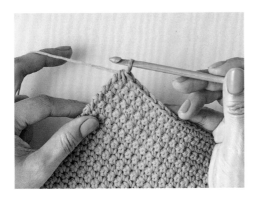

Three: Wrap the yarn round the hook and draw a loop through all three loops in one go. This completes the decrease. Where there were two stitches, there is now only one.

TOM'S TIP:

You can use the same principle to make decreases on other stitches, including treble crochet, by making two incomplete stitches up to the last yarn round hook for each stitch and then drawing a loop through both at the same time. You can also decrease more than one stitch at a time in the same way. To make a "double decrease" and turn three stitches into one, work three incomplete double crochet or treble crochet up to the last yarn round hook and join them together at the top with the last yarn round hook.

Stitches every crocheter should know ⊕

When I first started to crochet, I learnt all the basic stitches (see pages 208–217) before experimenting with other crocheted fabrics. But once you have the double crochet and treble crochet techniques under your belt, you can use these two main crochet stitches to create different textures and patterns.

CROCHET

Written instructions are given below for my favourite texture stitch patterns to get you started. Just take things slow, working row by row or round by round, and soon you will see an exciting stitch pattern emerge.

Woven stitch

Sometimes called linen stitch or moss stitch, this combination of stitches creates a textured fabric that is similar to its knitted counterpart. This is a good starter stitch for novice crocheters that results in a solid fabric, but one with more drape than double crochet (U.S. single crochet) and a subtle all-over texture, which is also reversible. It is made by working double crochet and chains alternately, and then working double crochets in the chain spaces of the preceding row with chains between them.

Make a foundation chain with an even number of chains.
Row 1: 1dc in 2nd chain from hook, * 1ch, miss 1 ch, 1dc in next chain, repeat from * to end, turn.
Row 2: 1ch (does not count as a stitch), 1dc in 1st dc, 1dc in next 1-chain space, * 1ch, 1dc in next 1-chain space, repeat from * to last dc, 1dc in last dc, turn.
Row 3: 1ch (does not count as a stitch), 1dc in 1st dc, * 1ch, 1dc in next 1-chain space; repeat from * to last 2 dc, 1ch, miss 1 dc, 1dc in last dc, turn.
Repeat Rows 2 and 3 to form pattern.

Rope stitch

Made by working a V-shape combination of two treble crochet (U.S. double crochet) and 1 chain into each chain space on the row below, this simple rope stitch makes a fluid fabric that is perfect for blankets and throws. Because the rope stitch is quite open, with lots of spaces between stitches, it traps warm air and makes a lovely snuggly blanket.

Make a foundation chain with a multiple of three chains.
Row 1: 1tr in 4th chain from hook, 1ch, 1tr in next chain, * miss 1 chain, 1tr in next chain, 1ch, 1tr in next chain, repeat from * to last chain, 1tr in last chain at end, turn.
Row 2: 3ch (counts as first tr), work (1tr, 1ch, 1tr) all in each 1-chain space to end of row, 1tr in top of 3-chain at end, turn.
Repeat Row 2 to form pattern.

Bobble stitch

Bobble stitches are really cute and add a fun element to crochet projects. Basically, bobbles are made by working lots of treble crochet together in the same stitch until they "pop" out of your work on the wrong side. You can place bobbles next to each other, as here, or you can spread them apart and position them wherever you fancy.

Here is the technique for making a bobble:
1 bobble = (yrh, insert hook in stitch, yrh, draw loop through, yrh, draw loop through first 2 loops on hook) 5 times all in same stitch, yrh, draw loop through all 6 loops on hook.

Make a foundation chain with an uneven number of chains.
Row 1: 1dc in 2nd chain from hook, dc to end of row, turn.
Row 2: 1ch, *1dc in 1st st, 1 bobble in next st, rep from * to last st, 1dc in next st, turn.
Row 3: 1ch, 1dc in 1st st, dc to end of row, turn.
Row 4: 1 bobble in 1st st, *1dc in next st, 1 bobble in next st, rep from * to last 2 sts, 1dc in each of last 2 sts, turn.
Row 5: Work as Row 3.
Repeat Rows 2 to 5 to form pattern, finishing with a Row 3.

Loop stitch

The loop stitch is a versatile way to add texture to a crochet project and looks brilliant on loads of different items. The loops can be made as big or as small as you like by adjusting the position of your tension finger. For a smaller loop you can use a pencil or for a longer loop you can use two fingers. You can even trim the loops for a slightly different effect.

Here is the technique for making a loop:
1 loop st = insert hook in stitch, wrap yarn around index finger held at preferred length for loop, wrap hook clockwise around yarn in front of index finger, catch yarn laying behind index finger, pull yarn through stitch (two loops on hook), yarn over, pull through remaining loops, remove finger from loop.

Make a foundation chain with the preferred number of chains plus 1 chain for turning.
Row 1: 1dc in 2nd chain from hook, dc to end of row, turn.
Row 2: 1ch (does not count as stitch), 1 loop st in each st to end of row, turn.
Row 3: 1dc in 1st st, dc to end of row, turn.
Repeat Rows 2 and 3 to form pattern, finishing with a Row 2.

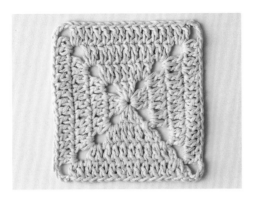

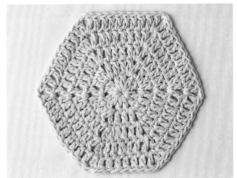

Treble crochet square

Note: Do not turn at the end of rounds but continue with the right side of the motif always facing.

Foundation ring: Make 4ch and join with a slip stitch to 1st chain to form a ring.
Round 1 (RS): 5ch (counts as 1tr and 2-chain space), [3tr in ring, 2ch] 3 times, 2tr in ring, join with a slip stitch to 3rd of 5-chain at beg of round. *3tr along each side of square.*
Round 2: Work 1 slip stitch in 1st space, 7ch (counts as 1tr and 4-chain space), 2tr in same sp, *1tr in each tr to next space, work (2tr, 4ch, 2tr) all in next space, repeat from * twice more, 1tr in each tr to next space, 1tr in same space as 7-chain, join with a slip stitch to 3rd of 7-chain at beg of round. *7tr along each side of square.*
Round 3: Repeat Round 2. *11 tr along each side of square.*
Round 4: Repeat Round 2. *15 tr along each side of square.*

Treble crochet hexagon

Note: Do not turn at the end of rounds but continue with the right side of the motif always facing.

Foundation ring: Make 4ch and join with a slip stitch to 1st chain to form a ring.
Round 1 (RS): 3ch (counts as 1st tr), 1tr in ring, (1ch, 2tr in ring) 5 times, 1ch, join with a slip stitch to top of 3-chain at beg of round.
Round 2: Work 1 slip stitch in 1st tr, 1 slip stitch in next chain, 3ch (counts as 1st tr), *1tr in each of next 2tr, work (1tr, 1ch, 1tr) in next 1-chain space, repeat from * 4 times more, 1tr in each of next 2tr, 1tr in last 1-chain space, 1ch, join with a slip stitch to top of 3-chain at beg of round.
Round 3: 3ch (counts as 1st tr), 1tr in each tr to 1st 1-chain space, work (1tr, 1ch, 1tr) in 1st 1-chain space, * 1tr in each tr to next 1-chain space, work (1tr, 1ch, 1tr) in next 1-chain space, repeat from * to end, join with a slip stitch to top of 3-chain at beg of round.
Rounds 4 and 5: Repeat Round 3 twice.

Crochet Essentials

Reading a crochet pattern →

A crochet pattern will include the same details as a knitting pattern, including the skill level, materials needed, recommended tension, and instructions for working your crocheted fabric. Patterns can look daunting at first, but once you get started and you begin to recognise the frequently used abbreviations, it will all start to make perfect sense.

Understanding crochet abbreviations

Crochet abbreviations work like those in knitting and make what could be a very long piece of text much shorter. Generally, each pattern will also include any specific abbreviations. Understanding this shorthand will help you read any crochet pattern.

UK and US terminology

Depending on the nationality of the designer, crochet patterns can be written using either UK or U.S. terms. Although I am British, I learnt the U.S. terms first because I watched a lot of online tutorials by American designers. However, in this book I always give the UK term first with the U.S. term following in brackets. I know this part is a bit confusing, but it is vitally important to know what terminology the pattern is using and what stitch you are required to work.

General

Instructions are written using UK terminology with the U.S. terminology given in round brackets () afterwards

[] instructions are given for the smallest size first, with changes for the larger sizes given in order within square brackets afterwards

() work any instructions within round brackets as many times as directed afterwards

★ repeat instructions following the single asterisk as many times as directed afterwards

★ ★ repeat instructions between asterisks as many times as directed or from a given set of instructions

alt alternate

approx. approximately

beg begin or beginning

cc contrasting colour

ch(s) chain(s)

ch-sp chain space

cm centimetres

cont continue

dc double crochet (U.S. single crochet)

dc2tog double crochet two stitches together (U.S. single crochet two stitches together)

dec decrease or decreasing

dk double knitting (U.S. light worsted weight)

dtr double treble crochet (U.S. treble crochet)

foll follow(s) or following

g grams

htr half treble crochet (U.S. half double crochet)

htr2tog half treble two stitches together (U.S. half double crochet two stitches together)

in inch(es)

inc increase or increasing

lp(s) loop(s)

m metres

meas measures

mc main colour

miss skip

mm millimetres

oz ounces

patt(s) pattern(s)

pm place marker

qtr quadruple treble crochet (U.S. triple treble crochet)

quintr quintuple treble crochet

rem remain or remaining

rep repeat or repeating

rnd(s) round(s)

RS right side

sl st slip stitch

sm slip marker

sp(s) space(s)

ss slip stitch

st(s) stitch(es)

tbl through back loop

tch turning chain

tfl through front loop

tog together

tr treble crochet (U.S. double crochet)

tr2tog treble two stitches together

trtr triple treble crochet (U.S. double treble)

WS wrong side

yrh yarn round hook

Reading a crochet pattern

Most patterns will be split into different parts, so just tackle each one at a time. I just tick off what I have done as I go. Make the pieces in the order given in the instructions, whether it is a garment, toy or something else, and just take it one step at a time. Work along each row or round bit by bit, rather than trying to read the entire instruction and then complete the row or round without referring back.

Most commercial crochet patterns follow this format:

1 **Skill level:** Some patterns may also advise the skill level, so beginners may have basic crochet stitches and basic shaping and colourwork. As a beginner, I would advise looking for small items like the Friendship Bracelets on pages 252–255 that are quick to make and relatively easy in order to build confidence. The first item I completed was my hat for Robbie. You could try the Bucket Hat on pages 266–269 to practise making motifs and some other simple stitches.

2 **Measurements:** If the pattern is for a garment, usually a range of sizes are given. Based on the measurements give, choose which size you want to make and follow that throughout the instructions. Otherwise, if a project is one-size, like a cushion, then the finished dimensions are given.

3 **What you will need:** This will tell you the type of yarn, the standard yarn weight, the meterage (yardage) and the number of balls needed. Always try to use the yarn specified by the pattern designer, but if you cannot source that particular yarn, choose a suitable substitute yarn (see page 28). It will also tell you anything else you need to complete the project, like stitch markers.

4 **Tension (gauge):** This is the number of stitches and rows in a certain area, usually 10cm (4 inch) square. Work a tension (gauge) swatch before starting to crochet any project and change the hook size if necessary to achieve the recommended tension.

5 **Abbreviations:** This will give you a key to all of the abbreviations used within the pattern.

6 **Pattern instructions:** This is either written out line by line or presented in chart form with a key alongside to decode the chart. Designers will aim to give you the right tips and information to make your work a success. Instructions for a crochet project will always start with the number of chains needed for the foundation chain.

7 **Finishing instructions:** This will tell you how to finish off the project, including what seaming techniques to use when stitching pieces together.

Cosy Slippers

EASY

The first thing I do when I get home is kick off my shoes and get cosy in my slippers. This boot-style version is stylish and soft, crocheted in super chunky 100% merino wool, to keep toes, and ankles toasty. Quick to make for you and for the whole family, with a junior size, then get creative and customise with stripes and pompoms.

Measurements

Adult size	M	L	
Foot length	24.5	27.5	cm
	9½	11	in

Junior size	XS	S	
Foot length	18.5	21.5	cm
	7¼	8½	in

What you will need
- MWL The Chunky One
 100% merino wool, 65m (71 yards)
 per 100g (3½ oz)

ADULT SIZE Quantity:
- **A** 3 x 100g (3½ oz) balls in Towelling Teal
- **B** 1 x 100g (3½ oz) ball in Dustin Lance Black
- **C** 1 x 100g (3½ oz) ball in Aqua
- **D** 1 x 100g (3½ oz) ball in Gold Medal
- **E** 1 x 100g (3½ oz) ball in Jump Pink
- **F** 1 x 100g (3½ oz) ball in Lychee White

JUNIOR SIZE Quantity:
- 2 x 100g (3½ oz) balls in Jump Pink
- Scraps in random colours, for pompoms
- 6mm (US J/10) crochet hook
- 7mm (US K/10½ or US L/11) crochet hook
- Yarn needle

Tension (gauge)
10 sts and 12 rows to 10cm (4 in) over dc using 7mm (US K/10½ or US L/11) hook, or the size required to give the correct tension.

Abbreviations
See page 229.
dc2tog (insert hook in next st, yrh and draw loop through) twice, yrh and draw through all 3 loops on hook. One stitch decreased.

Special technique
Changing colour at end of row (see page 275).

Note
The slippers are made in two separate pieces – the upper and the sole.

Working from a chart

Depending on the project, your crochet pattern may come with a colour chart or stitch diagram, as well as written instructions. Being able to decipher these charts and diagrams and understand what each symbol denotes, means that you can crochet in any language. As they give an immediate visual impression of what the finished piece will look like, they are great for people who are really visual learners.

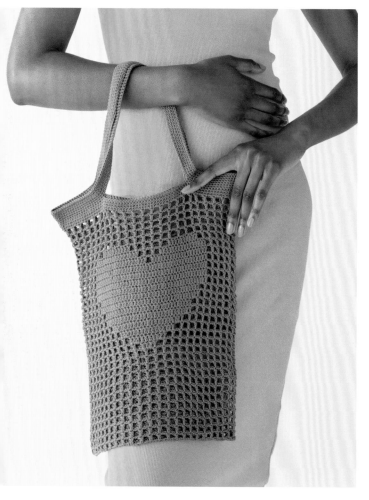

Crochet charts

Sometimes crochet charts in the form of a grid are used alongside written patterns, especially where complicated colourwork design or filet crochet is better represented as a visual image. In these charts, each square represents a stitch or group of stitches. It will show you what colours are used for certain stitches or a block of stitches and how they are placed in relation to each other, so you can visualise the overall effect of the colour or pattern in your piece. Some charts show a small section of a pattern repeat, which should be read in the same way that you would a knitting chart (see page 73).

Filet crochet chart and key

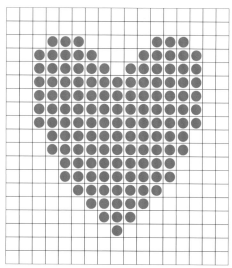

Key: ⬜ work open mesh
🔵 work solid block

Crochet stitch diagrams

Increasingly, crochet patterns are being conveyed in the form of diagrams made up of a series of symbols that are used to represent stitches and roughly imitate the size and shape of the actual stitch. Each row or round will have a number so you know which direction you are working in and stitches will be shown in relative sizes, to give you a good idea of how the pattern will look. They are particularly useful because you are able to see where to work each stitch.

Working in rows from a stitch diagram

When working in rows you start in the bottom lefthand corner with the foundation chain. The rows are likely to be numbered and so you follow the row numbers from the bottom of the diagram to the top. Usually, odd-numbered rows run from right to left and even-numbered rows run from left to right. Each row may be linked with a turning chain.

Working in rounds from a stitch diagram

If you are working in the round, you generally work from the centre outwards. Similarly, each round is numbered and so you follow the ascending row numbers outwards in concentric circles. They are designed for right-handed crocheters; left-handed crocheters will need to work from the chart as a mirror image.

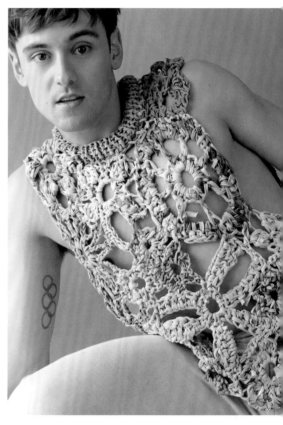

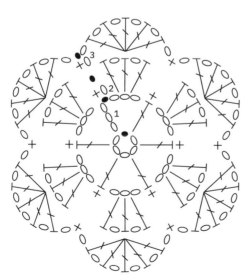

Key:

○ chain

● slip stitch

+ double crochet

† treble crochet

5 treble crochet in same stitch

Working a tension or gauge swatch

It is really important to get into the habit of completing a tension or gauge swatch for every project that you are about to embark on, so the final size of your finished project is correct. We all crochet slightly differently – some tighter, some looser – so you may need to adjust how much tension you apply to the working yarn or change the size of the hook you are using in order to achieve the same size stitches as the pattern designer intended. I know working a tension swatch may seem a bit tedious, but what is far worse is to get to the end of a project only to find out that it does not fit!

If the pattern states the number of stitches and rows measured over a 10cm (4 inch) square, always work a tension swatch at least a few centimetres (an inch) extra as often the side stitches can be a little tighter than the main fabric, so you can take your measurement from the middle of the swatch.

Lay your swatch flat or block it without stretching it. Measure out 10cm (4 inches) across the centre with a ruler or tape measure and mark with pins. Count the number of stitches between the pins and jot that number down. Count the number of rows in the same way.

If the number of stitches and rows meets the number stated in the pattern, then great! If not, you may need to go up a hook size if you crochet with a tight tension, or down a hook size, if you are a loose crocheter. Work the swatch again to check you are on track, then use the size of hook that best matches the recommended tension. Every crocheter's work is different, so every garment will end up looking and fitting slightly differently.

TOM'S TIP:

When you have lots of crochet tension swatches, put them to good use and repurpose them into something useful. Depending on the fibre of the yarn, they can make great coasters around the house. Or embroider each one with an initial and give them as gifts.

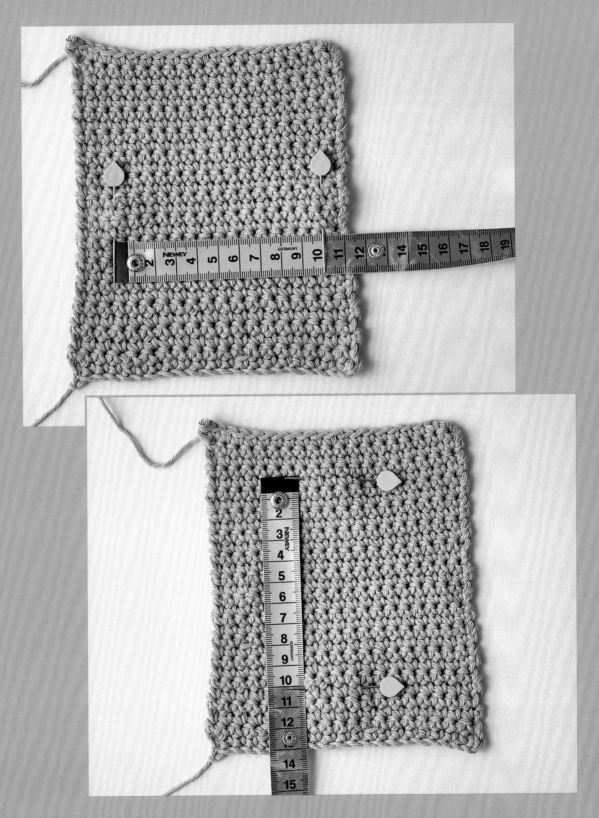

Troubleshooting tips →

Whether you are just starting out or have years of crochet experience, there will always be times when your crocheting doesn't quite go to plan. Here are some of the most common mistakes and how you can fix them. When I first started, I made every single one of these mistakes (many times over).

CROCHET

Wrong tension or gauge

When I started crocheting, I found one of the hardest things to achieve was getting the correct tension. When your tension is too slack, this results in looser stitches and possibly holes, whereas if it is too tight, it can be hard to insert the hook into the chains and the resulting fabric can be too stiff. Always practise new stitches on a tension (gauge) swatch – it helps with getting the technique down and sorting your tension. I think it's a case of finding a comfortable finger position holding the yarn and then practise, practise, practise.

TOM'S TIP:

If it is your foundation chain that is too loose or too tight, try this: If your chain is too tight, try a hook that is one size larger than the pattern calls for and then switch back to the recommended size for the first row or round. If your chain is too loose, go down a hook size to make your foundation chain.

Your project is getting wider

If your crochet is growing in width, don't panic – we've all been there! If this happens, it means you are gaining some extra stitches along the way. It is really important to count and keep track of your rows and stitches. There are cool little row counters that you can put on your finger, which you adjust each time you complete a row. There are also stitch markers to mark the first and last stitch of the row. I do the same as I do with knitting and put my stitch markers in every 10 rows. If I am working in the round, I put in a stitch marker at the beginning of each new round.

Crocheting through the front loop only

When you are starting out, it is easy to crochet through the front loop only and then wonder why your crochet fabric does not look quite right. Some patterns may call for this technique but if not, be sure you are counting your stitches and that you work into every stitch.

The best way to recognise if you have been doing this is when the front and back of your crochet look slightly different or if your piece has grown larger than expected. Make sure that you go under both front and back loops.

Finishing
your makes →

You have finished your project
– congrats! After spending time
creating something beautiful,
the last thing you want is for it
to unravel and so you must take
the time to finish the piece off
properly. Don't leave anything
to chance!

CROCHET

Fastening off

Once you have finished crocheting any piece, you need to fasten off securely, so the stitches do not unravel. Fastening off is incredibly simple as there will be only one loop left on your hook at the end of your work.

 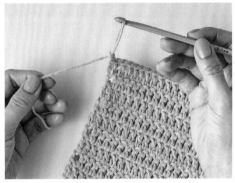

One: Complete the final row or round so that you are left with one loop on the hook. Cut the yarn at approx. 30cm (12 inches) from the hook. Wrap the cut yarn around the hook and draw it through the last remaining loop on the hook.

Two: Slide the hook out of the loop and bring the yarn end through the loop. Gently pull on the yarn end to tighten the knot and secure the stitch.

Weaving in yarn ends

I prefer to work over any yarn ends that are the result of changing colour or adding in a new ball of yarn as I crochet, so there is less weaving in to do at the end of a project. It depends on what the pattern calls for, however, and there is always the very last yarn end to deal with after fastening off.

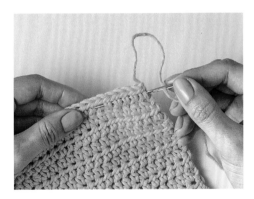 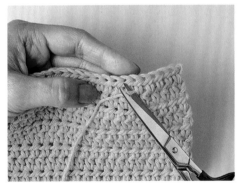

One: To disguise any yarn ends that have not already been "enclosed" by working over them, thread the yarn end through a yarn needle and neatly weave the yarn through six or more stitches on the wrong side of the work.

Two: Carefully snip the yarn end close to the crochet fabric, making sure you do not cut the fabric itself.

Crochet seaming methods

When piecing together a crocheted garment or any other project, use the seaming method described in the pattern, if specified. Before sewing up your creation, block each piece carefully (see page 86) by either steam blocking or spray blocking. Always sew seams with the same yarn used to crochet the fabric, threaded through a blunt-tipped yarn needle.

Backstitch seam

Resulting in a sturdy seam, joining pieces with backstitch is the best method to use for sewing together items like bags and toys.

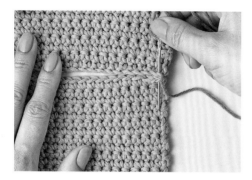

One: Line up the crochet pieces side by side, with their wrong sides facing upwards, and secure the yarn with a few oversew stitches made in the same spot.

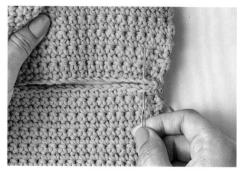

Two: Insert the needle through the edges of both pieces, taking the yarn forward by two crochet stitches.

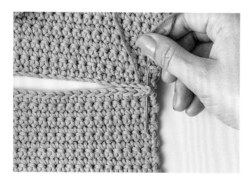

Three: Next, take the yarn backwards by one stitch. On the backwards stitch, be sure to insert the needle in the same place as the end of the last backwards stitch.

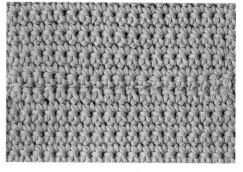

Four: Continue to the end of the seam. Secure the yarn to fasten off.

Mattress stitch seam

This is my favourite method of seaming pieces as it creates the neatest flat seam. You can use it on crochet fabric made up of any stitch.

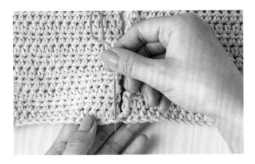

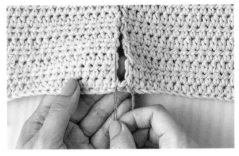

One: Lay the pieces side by side with right sides upwards. Bring the needle up at the left corner of the righthand piece. Make a double stitch across to the right corner of the other piece.

Two: Take the needle up half-way through the first stitch on the left edge.

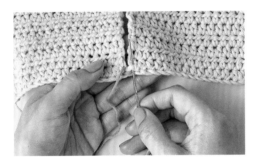

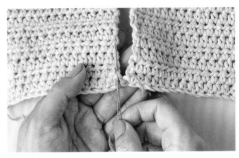

Three: Make the next stitch along the centre of the crochet stitch or turning chain at the edge of the righthand piece.

Four: Make the next stitch in the same way, working along one crochet stitch or turning chain on the lefthand piece.

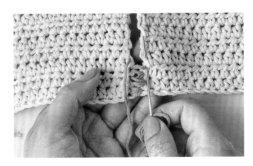

Five: Continue along the seam, alternating between the righthand and lefthand pieces, taking a stitch on each side.

Six: After every few stitches, pull the sewing yarn taut so that the seam stitches disappear and are no longer visible on the right side of the crochet.

**Whip
stitch
seam**

This seaming method, which is sometimes called an overcast stitch seam, is one of the quickest ways to join your crochet pieces together. It is virtually invisible and creates a strong join.

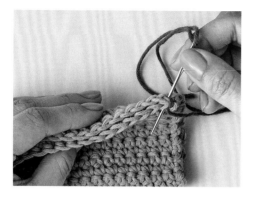

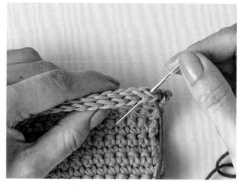

One: Thread a blunt-tipped sewing needle with a length of yarn that is around two or three times the length of the edges you are seaming. Place the two crochet pieces with their right sides together and secure the yarn with a few oversew stitches in the same spot.

Two: Starting at the righthand edge, join pairs of crochet stitches by sliding the needle through all four loops. Bring the yarn needle in the same direction with each stitch. Do not overtighten.

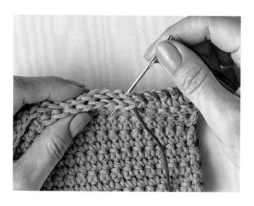

Three: Repeat until you have sewn through the back loops of all pairs of crochet stitches. When you reach the final corner, fasten off and weave in the yarn end.

Four: An alternative way to work this discrete seam is to pick up just the outside loops of each stitch.

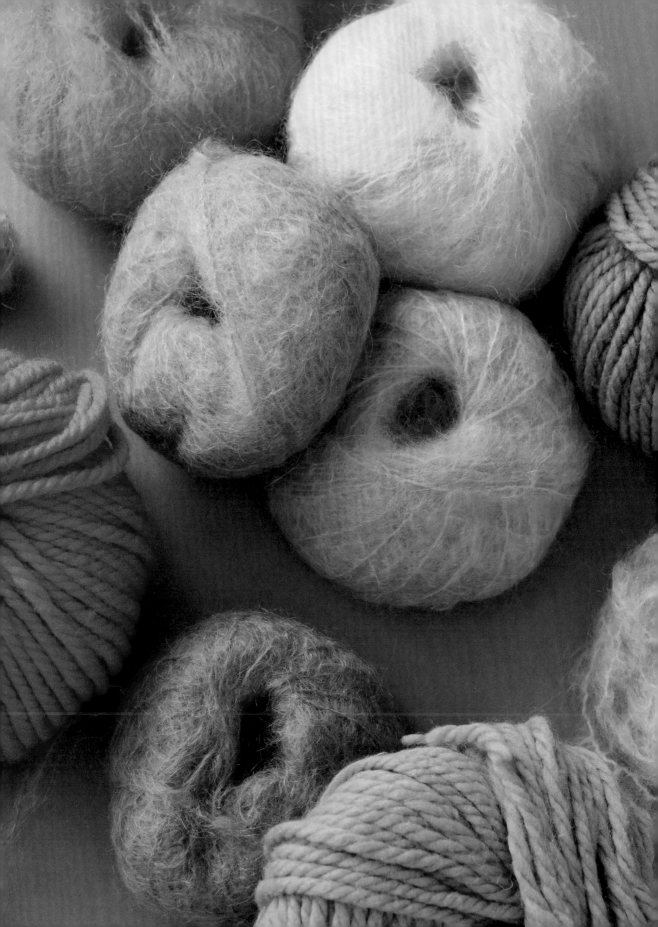

Crochet Projects

05

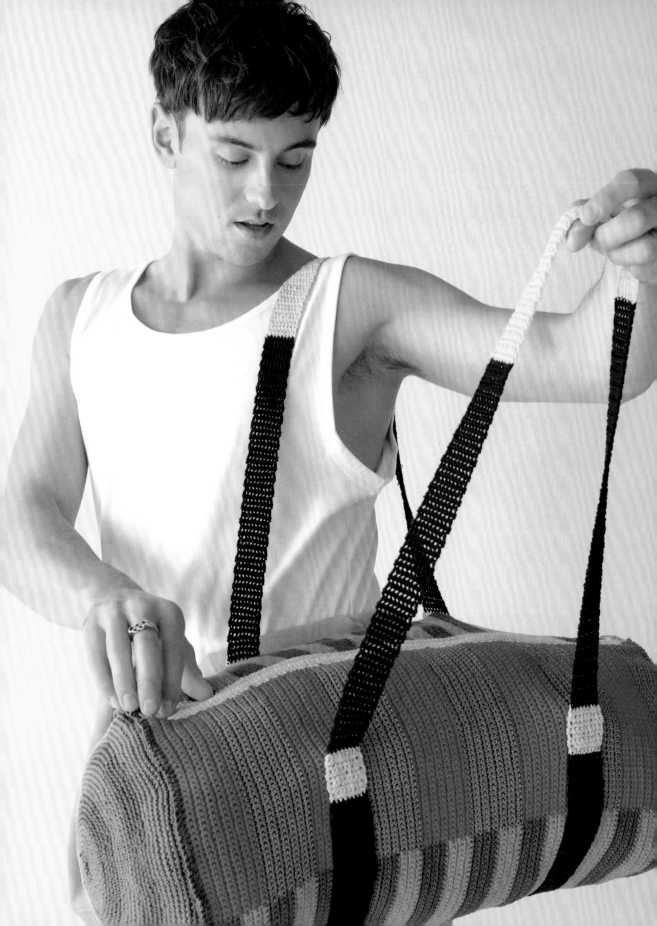

Kit Bag

When I'm training, I live out of a kit bag, so I decided to crochet one! Based on the classic cylindrical sports bag and made a little more trendy in stripes of tonal colours, simply crochet a wide rectangle and two circles, and sew in a zip to create a practical bag for heading to the gym, the beach, or just to the armchair with your latest project!

Measurements
Approx. 50cm (19¾in) long and 27cm (10¾in) diameter, excluding handles

What you will need
- Rico Essentials Cotton DK
 100% cotton, 120m (131 yards)
 per 50g (1¾ oz)
- **A** 3 x 50g (1¾ oz) balls in Dark Teal (40)
- **B** 10 x 50g (1¾ oz) balls in Red (02)
- **C** 3 x 50g (1¾ oz) balls in Pumpkin (87)
- **D** 2 x 50g (1¾ oz) balls in Alga (73)
- **E** 1 x 50g (1¾ oz) ball in Banana (63)
- **F** 2 x 50g (1¾ oz) balls in Black (90)
- 3.5mm (US E/4) crochet hook
- 4mm (US G/6) crochet hook
- 1 zipper 48cm (19 inches) long
- Yarn needle
- Sewing needle

Tension (gauge)
21 sts and 25 rows to 10cm (4in) over dc using 4mm (US G/6) hook, or size required to achieve the correct tension (gauge).

Abbreviations
See page 229.

Special techniques
Working in the round (see page 250).

Notes
When instructed to switch colours, do this on last stitch of current colour as follows: insert hook in last stitch of current colour, yarn around hook with current colour and pull loop through, drop current colour, pick up next colour, yarn around hook with next colour and pull through both loops to complete the dc. Next colour is now on the hook.

To make

Body of bag

Using 4mm (US G/6) hook and **A**, ch122, change to **B** and ch46, turn.

Row 1 (RS): Starting in 2nd st from hook and using **B**, work 45dc, switching to **A** at colour change (see Notes), work 122dc to end, ch1 (does not count as a st throughout), turn. *167 sts.*

Row 2: Starting in 2nd st from hook and using **A**, 122dc switching to **B** at colour change on previous row, 45dc to end, ch1, turn.

Rows 3 to 6: Repeat Rows 1 and 2 twice.

Rows 7 to 12: Replacing **A** with **C**, repeat Rows 1 to 6.

Rows 13 to 24: Replacing **B** with **D**, repeat Rows 1 to 12.

Rows 1 to 24 set colour sequence of 6 rows **A** and **B**, 6 rows **C** and **B**, 6 rows **A** and **D** and 6 rows **C** and **D**.

Rows 25 to 120: Repeat Rows 1 to 24 four times more, following colour sequence as set. At end of last row of **C** and **D**, omit final ch1, cut yarn and draw end through to fasten off.

Zipper edge

With RS facing, using 4mm (US G/6) hook, join **E** to right-most st on one short edge of bag body and ch1.

Row 1 (RS): Dc along this short edge of bag body using **E**, working into the end of each row, ch1, turn. *120 sts.*

Row 2: Starting in 2nd st from hook, 1dc in each st to end, ch1, turn.

Row 3: Starting in 2nd st from hook, 1dc in each st to end, cut yarn and draw end through to fasten off.

Circular ends (make two)

Make one circular end using **A** and **D** and another using **B** and **C**, alternating colours after every 5 rounds.

Using 4mm (US G/6) hook and first colour (either **A** or **B**), ch4, slip st in 1st ch to form a ring.

Round 1 (RS): Ch1 (does not count as a st), 6dc into ring. *6dc.*

Continue to work in a spiral without joining each round.

Round 2: 2dc in each st. *12dc.*

Round 3: [1dc, 2dc in next st] 6 times. *18dc.*

Round 4: [2dc, 2dc in next st] 6 times. *24dc.*

Round 5: [3dc, 2dc in next st] 6 times, switching to next colour (either **D** or **C**) on last yrh of last dc. *30dc.*

Continue in this way, alternating colours after 5 rounds, and on subsequent round working 1 additional dc, before working increase. Always work increase [2dc in next st] in 2nd dc of 2dc increase on previous round.

Work until diameter meas 27cm (10¾ in).

Cut yarn and draw end through to fasten off.

Handles (make two)

Using 3.5mm (US E/4) hook and **F**, ch9, turn.

Row 1 (RS): Starting in 2nd st from hook, 8dc, ch1, turn. *8dc.*

Rows 2 to 56: Continue in **F** and work 55 rows in dc starting in 2nd st from hook and finishing with a ch1, turn. On Row 56, before working the final ch1, switch to **E** on last dc of row (see Notes), ch1, turn.

Rows 57 to 65: Using **E**, work 9 rows in dc starting in 2nd st from hook and finishing with a ch1 as before. On Row 65, before working the final ch1, switch to **F** on last dc of row (see Notes), ch1, turn.

Rows 66 to 130: Using **F**, work 65 rows in dc starting in 2nd st from hook and finishing with a ch1 as before. On Row 130, before working the final ch1, switch to **E** on last dc of row (see Notes), ch1, turn.

Rows 131 to 160: Using **E**, work 30 rows in dc starting in 2nd st from hook and finishing with a ch1 as before. On Row 160, before working the final ch1, switch to **F** on last dc of row (see Notes), ch1, turn.

Rows 161 to 225: Using **F**, work 65 rows in dc starting in 2nd st from hook and finishing with a ch1 as before. On Row 225, before working the final ch1, switch to **E** on last dc of row, ch1, turn.

Rows 226 to 234: Using **E**, work 9 rows in dc starting in 2nd st from hook and finishing with a ch1 as before. On Row 234, before working the final ch1, switch to **F** on last dc of row, ch1, turn.

Rows 235 to 289: Using **F**, work 55 rows in dc starting in 2nd st from hook and finishing with a ch1, turn.

Final row: Starting in 2nd st from hook, 1dc in each st to end, cut yarn and draw end through to fasten off.

To finish

Weave in any yarn ends.
Stitch zipper in place, centred along two yellow edges of bag body, using **E** and neat backstitch. At one end of zipper, stitch edges of crochet together for 2cm (¾ in) using whip stitch. Repeat at other end of zipper. Use 4mm (US G/6) hook to attach circular ends to long edges of bag body using **C** for **B** and **C** circle and **A** for **A** and **D** circle as follows: Make a slipknot on hook. Working from right side of work, insert hook through edge stitches of both pieces of bag body and circular end, and join yarn with a sl st. Ch1 (does not count as a st) and work dc all around, working through both thicknesses, join with a sl st to 1st dc and fasten off. (Use pins to keep your work in position before crocheting to achieve an even seam without stretching or puckering.)
Stitch handles in position, short edges meeting on bottom centre of bag body. Use backstitch and change cotton colour from **F** to **E** to match crochet being stitched down.

Masterclass

Working in the round

The ends of this kit bag are circular. Rather than being worked backwards and forwards in horizontal rows, you make a central ring and continue working outwards in a circle. When working in rounds, the right side of the work is facing you at all times. The shape of the circle is created by the increases that are made as you work in the round.

Instead of joining the first and last stitches of each round with a slip stitch, these circular bag ends are worked in a spiral, with the first stitch of each round being worked into the first stitch of the previous round, so you don't really see where one round ends and another begins. The downside of working in a spiral this way is that the finished circular piece will end with a small bump where the stitches are fastened off - but this bump will disappear into the seam of the bag once it is made up, so it's no big deal.

One Work the required number of chains for the short foundation chain - here it is six chains. Insert the hook into the first chain made (that is furthest away from the hook), wrap the yarn round the hook and draw a loop through the chain and the loop on the hook to close the ring with a slip stitch.

Two Work a standing chain for the first round. The number of chains worked for this standing chain depends on the stitch being used. For double crochet, as shown here, it is one chain. For treble crochet it would be three chains. Except for double crochet, this counts as the first stitch.

Three Now work each stitch of the first round as instructed in the pattern. Work the stitches into the centre of the ring by inserting the hook into the space and not into the loops of the foundation ring. While working the first round of stitches, lay the yarn end around the top of the chain so the yarn tail is covered by the stitches being worked.

Four The last stitch of the first round should be made in the last stitch of the foundation ring. When all the double crochet stitches of the first round are complete, mark the last stitch of the round with a stitch marker - here it is the sixth stitch. Pull the yarn tail to close the centre hole and clip it off close to the crochet stitches.

Five Start the second round by working into the next available stitch, which should be the first stitch of the first round. For this second round, work 2 double crochet into each double crochet stitch, as instructed in the pattern. The last stitch of the second round should be made in the stitch just to the right of the stitch marker.

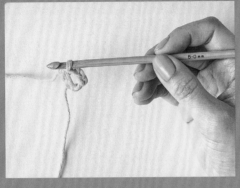

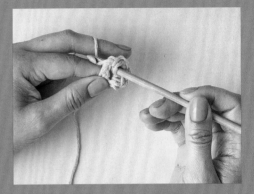

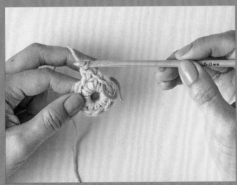

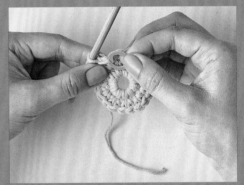

TOM'S TIP:

Stitch markers are your friend when working in the round. Because it's not always that easy to determine where a new round starts, keep moving the stitch marker each time to identify the last stitch in each round, until your piece is the size required. The number of stitches in each round increases as the circle of stitches grows in size, but the last stitch will always be at the same point.

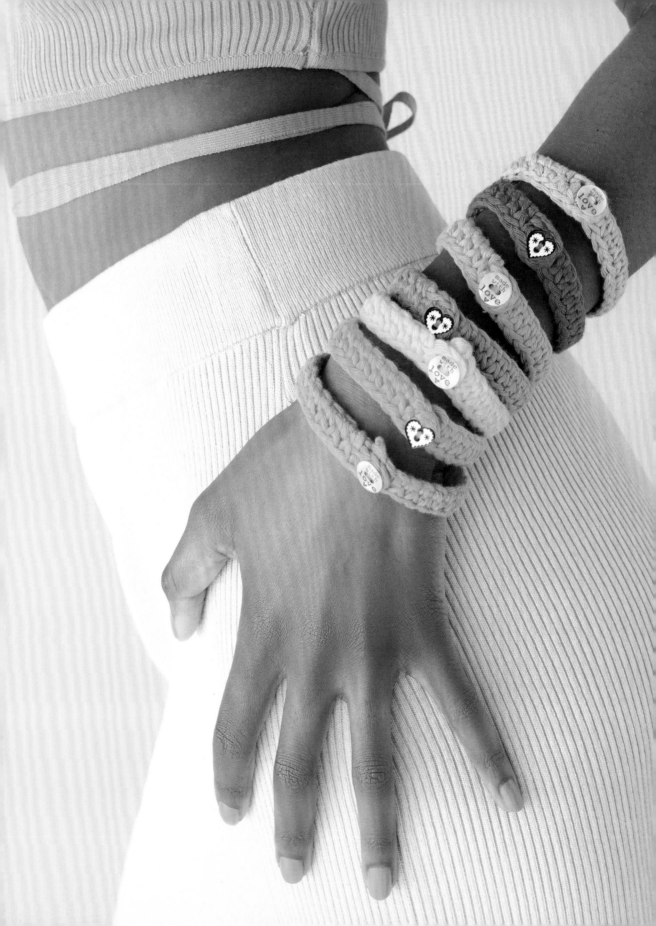

Friendship Bracelets

The ultimate beginner's crochet project and ideal for using up leftover scraps from other makes. You'll need a button to fasten them, so why not save one from a worn-out shirt, or seek out thrift stores and haberdasheries to find something unique to customise. Super fun, super easy and super quick. Swap with friends, send to a loved one, or make these bracelets in all the colours of the rainbow to wear with pride.

Measurements
One size
Approx. 21cm (8¼ in) long

What you will need
- Paintbox Yarns Cotton Aran
 100% cotton, 85m (93 yards) per 50g (1¾ oz)

Quantity:
Small amounts of the following colour
(one colour per bracelet):
- **A** Marine Blue (634)
- **B** Blood Orange (620)
- **C** Sailor Blue (640)
- **D** Buttercup Yellow (623)
- **E** Pale Lilac (646)
- **F** Grass Green (630)
- **G** Lipstick Pink (652)

- 4mm (US G/6) crochet hook
- 12mm (½ in) button (one for each bracelet)
- Matching sewing thread and needle

Tension (gauge)
14 sts to 10cm (4 in) over dc using 4mm (US G/6) hook, or size required to achieve the correct tension (gauge).

Abbreviations
See page 229.
Knit stitch (also called waistcoat stitch): This stitch is just like a regular dc but instead of working the dc into the top two loops of the dc you work it through the two front vertical posts of the dc.

Notes
To adjust the length of the bracelet, add on to or take away from the first row of chain stitches.

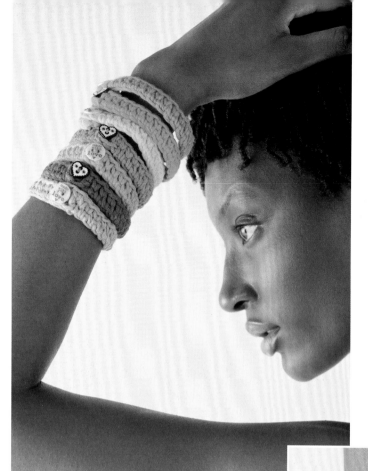

To make

Using 4mm (US G/6) hook and chosen colour, ch31.
Row 1 (RS): 1dc in 2nd ch from hook, 1dc in every ch to end of row, turn. *30dc.*
Row 2: Ch1, work 1 knit st (see Notes) in every dc to end of row, ch5 for button loop, sl st in 1st dc of Row 1. Cut yarn and drawn end through final dc to fasten off.

To finish

Weave in any yarn ends.
Gently steam bracelet so that it lies flat.
Sew on button to the opposite end from the button loop.

Masterclass

Working the knit stitch

By working the double crochet stitch in a slightly different way it is possible to create a fabric made up of lots of Vs in vertical columns that actually resembles knitted stocking (stockinette) stitch. Insert the hook in between the "legs" of the V of the dc on the row below. When working this stitch, it is worth going up a hook size than recommended on the yarn label as you need the stitches to be loose enough to be able to insert the hook into the Vs.

One Insert the hook into the centre of the double crochet stitch in the row below, between the two vertical strands of yarn that for the "legs" of the V. Flip the work so you can see the wrong side of the fabric. The hook must emerge between the two vertical strands at the back of the double crochet stitch and under the horizontal strand.

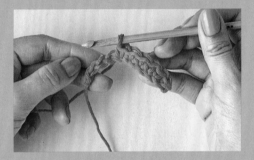

Two Finish the double crochet stitch as usual by working yarn round hook and drawing a loop through. Work yarn round hook and draw it through both loops on the hook. You have completed one knit stitch.

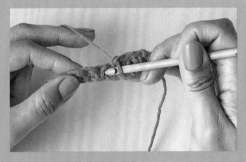

Three Repeat these steps to work a knit stitch in each double crochet on the previous row or round. Continue working in this way to create a fabric that resembles knitted stocking stitch.

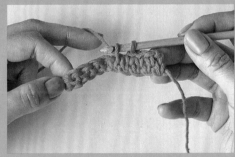

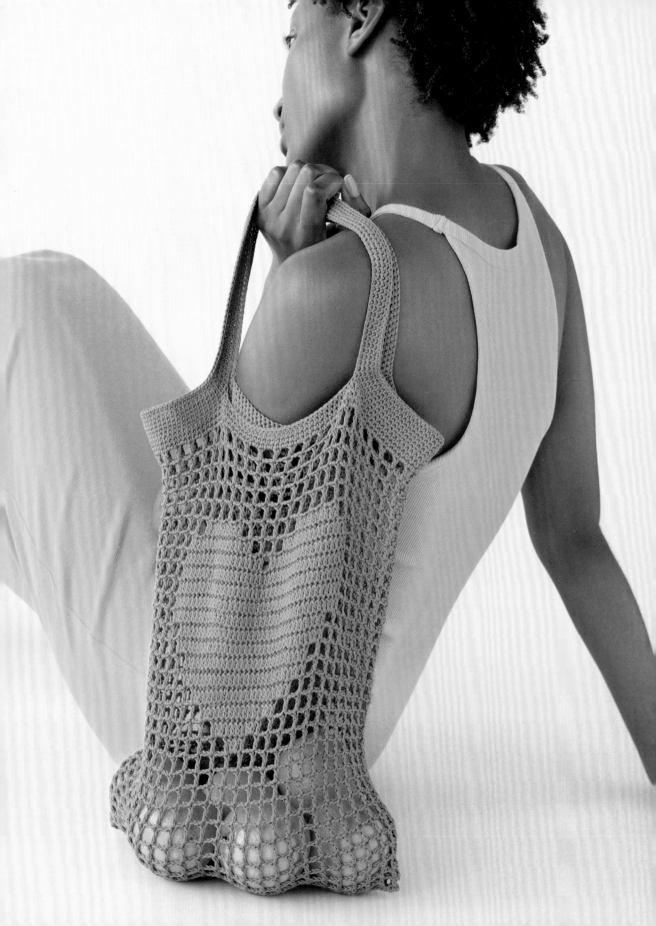

Tote Bag

If "reduce, reuse, and recycle" is your mantra, this crocheted tote is just your bag. Replace single-use plastic with this shopper, ideal for carrying your everyday essentials; eco-friendly, handmade, and chic. Made by working in the round to be seam free, and with a heart motif to show how much you care. Why not make it as a gift, or size it up by using fatter yarn and a larger hook to create a beach bag.

Measurements

Approx. 30cm (12 in) wide x 35cm (13¾ in) long, excluding handles
Approx. 55cm (21¾ in) long, with handles

What you will need

- Rico Essentials Cotton DK
 100% cotton, 120m (131 yards)
 per 50g (1¾ oz)
Quantity:
- 3 x 50g (1¾ oz) balls in Alga (73)
- 3mm (US C/2 or D/3) crochet hook
- 3.5mm (US E/4) crochet hook
- Yarn needle

Tension (gauge)

Approx. 8 blocks and 9 rounds to 10cm (4 in) over patt using 3.5mm (US E/4) hook, or the size required to achieve the correct tension (gauge).

Abbreviations

See page 229.

Special techniques

Working filet crochet (see pages 260–261).

Notes

This design uses a technique called filet crochet to create a heart motif. Filet crochet is worked by forming an open mesh for the background (called open squares) and filling in the open squares to form the motif pattern (called closed squares).
An open square is made over 3 stitches, working [1tr, ch2, miss ch2-sp].
A closed square is made over 3 stitches, working [1tr in next tr and 2tr in ch2-sp] to fill the square.
A chart is provided for the heart motif, which is worked with closed squares. The motif is placed on the first half (front) of the bag. When working from the chart, read each round from right to left and start reading chart from bottom righthand corner.

To make

Main bag

Using 3.5mm (US E/4) hook, ch144 and join with a sl st to 1st ch to form a large ring, making sure the chain is not twisted.
Next round (RS): Ch5 (counts as 1tr and ch2-sp), miss 2 ch, [1tr in next ch, ch2, miss 2 ch] to end of round, sl st to 3rd ch of beg ch5. *48 open squares.*
Next round: Ch5 (counts as 1tr and ch2-sp), miss ch2-sp, [1tr in next tr, ch2, miss ch2-sp] to end of round, sl st to 3rd ch of beg ch5.
Rep last round 10 times more.

Start working from Round 1 of chart as follows:
Round 1: Starting with ch5 as before, work 12 open squares in total, 1 closed square, then [1tr in next tr, ch2, miss ch2-sp] to end of round and sl st to 3rd ch of beg ch5.
Continue in this way, following Rounds 2 to 15 of chart, plus 5 open rounds.
Change to 3mm (US C/2 or D/3) hook.
Next round: Ch1 (does not count as a st throughout), 1dc into each tr and 2dc in each ch2-sp to end of round, sl st to beg ch1. *144 sts.*
Next round: Ch1, 1dc in each dc to end of round, sl st to beg ch1.
Repeat last round twice more.
Do not fasten off; continue with handles.

Handles (make 2)

Round 1: Ch1, 1dc in next 21 dc, ch90 to make first handle, miss next 30dc, 1dc in next 42dc, ch90 to make second handle, miss next 30dc, 1dc in each st to end of round, sl st to beg ch1. *324 sts.*
Round 2: Ch1, 1dc in each dc and ch to end of round, sl st to beg ch1.
Round 3: Ch1, 1dc in each dc to end of round, sl st to beg ch1.
Repeat last round 3 times more.
Fasten off.

To finish

Weave in any yarn ends.
Join the bottom seam on the inside of the bag by hand-sewing with whip stitch or using a crochet slip stitch, making sure the heart motif lies centrally on the front side.

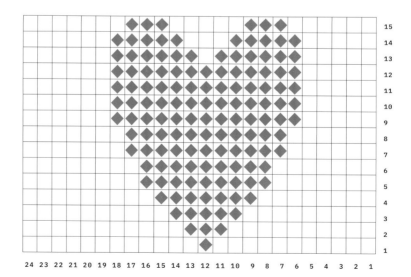

Key: ☐ open square
◆ closed square

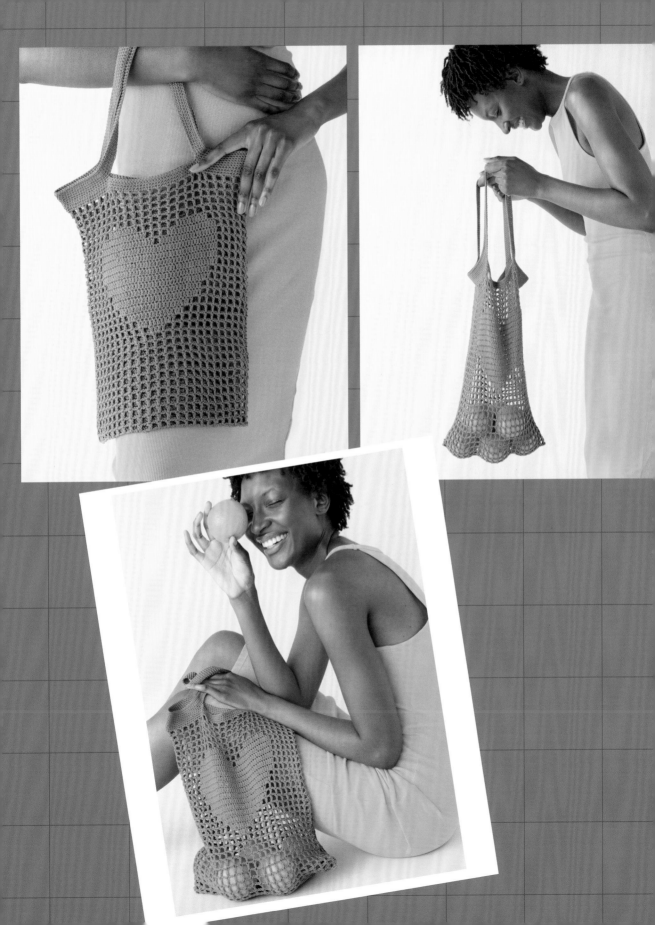

Masterclass

Working filet crochet

Crochet is such a versatile yarncraft: it can create an incredibly dense and sturdy fabric where the stitches are tightly packed, or it can be used to create a fluid, lacy fabric through openwork techniques where the open spaces play just as an important role as the chains that separate them.

Filet crochet is the easiest of all the openwork techniques. Once you learn how to work the simple structure of the open squares or mesh and the closed squares or blocks, all you need to do is follow a simple chart to form motifs, such as the heart on the tote bag, or any other geometric pattern.

Reading filet crochet charts

Filet crochet charts are the simplest of all. The chart on page 258 shows the heart motif, indicating which squares of the filet mesh need to be filled in as solid blocks in order to form the heart shape. Each square on the chart represents either a filet space or a filet block. The heart motif is a symmetrical design, but lefthanded crocheters do need to work from filet crochet charts and instructions in a mirror image.

Start working from the filet crochet chart as instructed in the pattern to place the motif in the correct position. Working the chart from the bottom upwards, make the blocks and spaces on the chart. Because this tote bag is made in the round, all the rows are read from right to left. However, if you are working in rows then read the first row and all following odd-numbered rows from right to left, and then even-numbered rows from left to right.

Making a basic filet open square

The basic open filet square is made up of alternating trebles and 2 chains to form an open grid or mesh. The trebles sit on top of each other to stack vertically, while the chains sit horizontally, except the turning chains that link the side edges.

 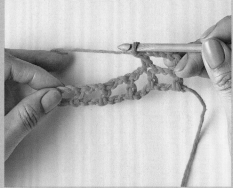

Making basic filet closed square

The pattern motifs of filet crochet are created by filling in some of the mesh squares and leaving others empty. In other words, the designs are built up with solid squares and square holes. Having learned how to work the open filet mesh, understanding how to fill them in to form solid blocks is easy. Rather than making 2 chains between each treble, work 2 trebles instead to fill in a solid block. The rules are very simple: working chains forms an empty square, working trebles fills in the square.

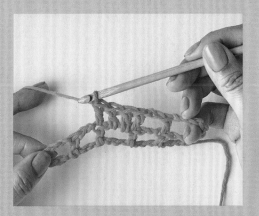 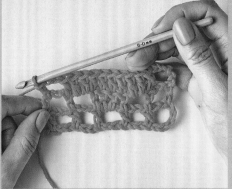

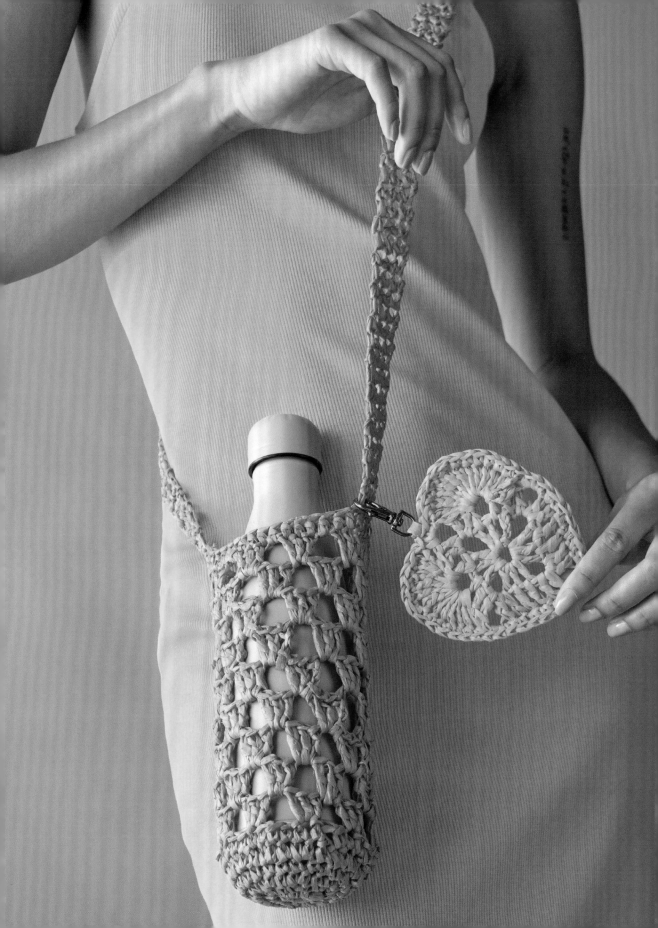

Bottle Carrier

Keeping hydrated has never looked so cool! Made in paper raffia for durability and style, this is a highly practical project to carry your water bottle to a festival, to the beach, or just on the daily commute. I like to make them to transport a bottle to a dinner party, and then the bottle carrier becomes a gift for the host too! Personalise with a keyring in a coordinating colour like I have, using the heart keyring from pages 276–279.

Measurements
One size
Approx. 10cm (4 in) in diameter and 15cm (6 in) high, excluding strap

What you will need
- Wool and the Gang RaRa Raffia
 100% paper, 250m (273 yards) per
 100g (3½ oz)

Quantity:
- 1 x 100g (3½ oz) ball in Vitamin C
 (or Hot Pink)
- 4.5mm (US 7) crochet hook
- Stitch marker
- Yarn needle

Tension (gauge)
4 blocks of 3tr and 1ch and 6 rows to 10cm (4 in) over patt using 4.5mm (US 7) hook, or the size required to achieve the correct tension (gauge).

Abbreviations
See page 229.

Notes
Move the stitch marker onto the last stitch of every round as you work.

To make

Base ring: Using 4.5mm (US 7) hook, ch6 and join with a sl st in 1st ch to form a ring.
Round 1 (RS): Ch1 (does not count as a st), 8dc into ring, placing marker on last st. *8dc.*
Round 2: 2dc in each dc to end of round. *16dc.*
Round 3: *1dc in next dc, 2dc in next dc, rep from * to end of round. *24dc.*
Round 4: 1dc in each dc to end of round.
Round 5: *1dc in next dc, 2dc in next dc, rep from * to end of round. *36dc.*
Round 6: 1dc in each dc to end of round, join with a sl st to 1st dc. Remove marker.
Round 7: Ch3 (count as 1st tr), 2 tr in same place as beg ch3, ch1, (miss 3 dc, 3tr in next dc, ch1) 8 times, miss 3 dc, sl st to 3rd ch of beg ch3.
Round 8: Sl st in next 2tr, sl st in ch1-sp, 3ch (counts as 1st tr), 2tr into same ch1-sp, ch1, *3tr in next ch1-sp, ch1, rep from * to end of round, sl st to 3rd ch of beg ch3. Repeat last round 7 times more.
Round 16: Ch2 (counts as 1st htr), 1htr in next 2 tr, 1htr in next ch1-sp, *1htr in next 3 tr, 1htr in next ch1-sp, rep from * to end of round, sl st to 2nd ch of beg ch2, sl st in next htr.

Make first handle

Next row: Ch1 (does not count as a st), 1dc in next 3 htr, turn. *3htr.*
Next row: Ch1, 1dc in next 3dc, turn. *3dc.*
Repeat last row until strap meas 65cm (25½ in). Fasten off, leaving a long yarn end.

Make second handle

Miss next 15 htr to left of first handle. Rejoin yarn with sl st to next htr and work as follows:
Next row: Ch1, 1dc in next 3 htr, turn. *3htr.*
Next row: Ch1, 1dc in next 3 dc, turn. *3dc.*
Repeat last row until strap meas 65cm (25½ in). Fasten off, leaving a long yarn end.

To finish

Join both handles making sure they are not twisted. Fasten off very securely. Weave in any yarn ends. Customise as preferred.

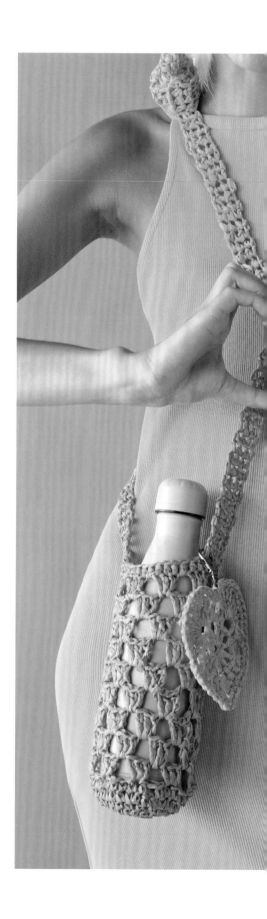

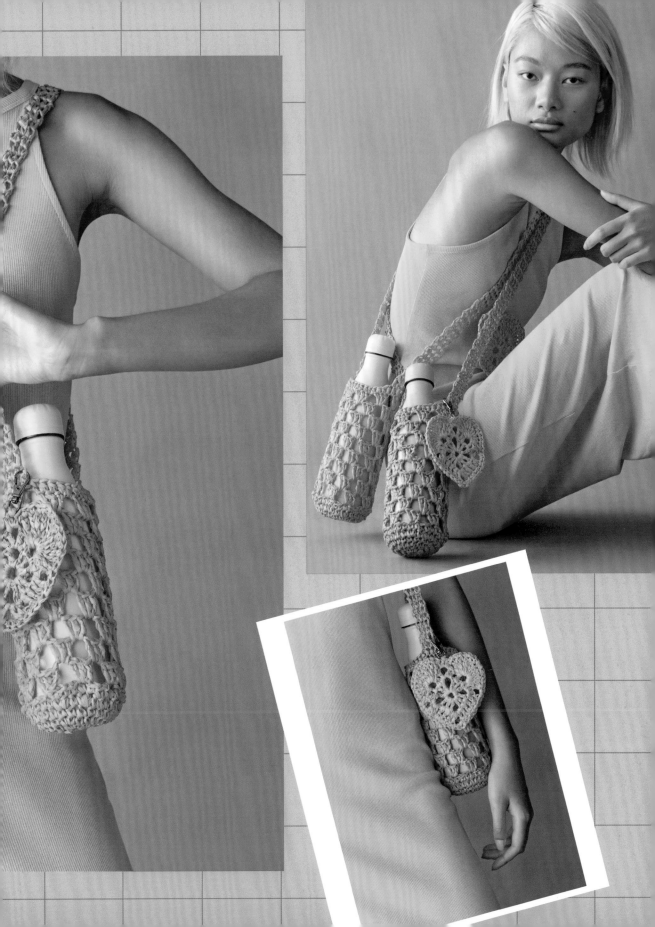

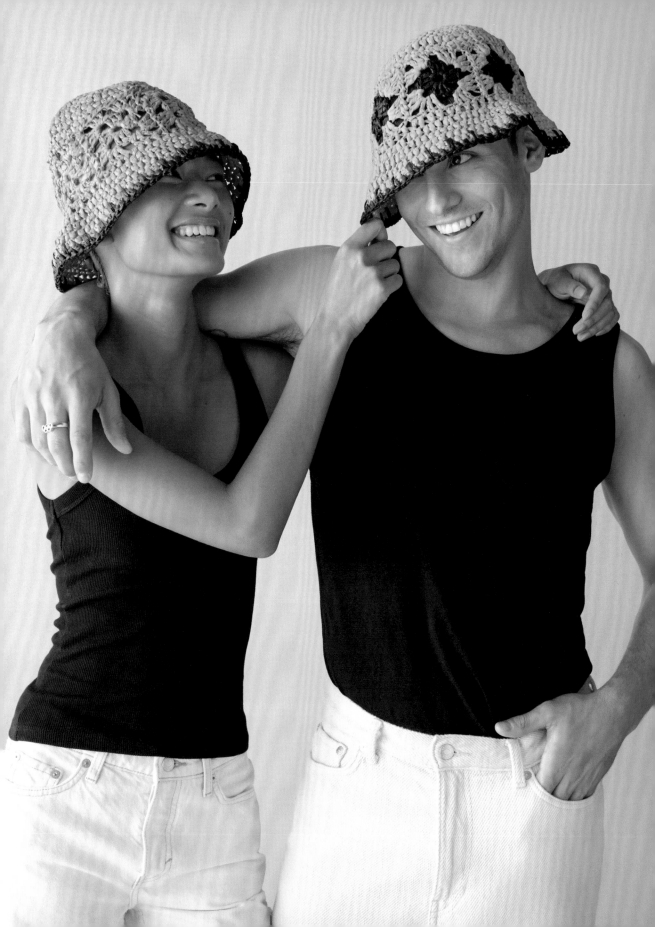

Bucket Hat

It will only take a couple of hours of chilled mindful crocheting to look almost instantly summer festival chic in this 90s-style bucket hat. Using a combination of crochet techniques and motifs this is a quick accessory to make for yourself – I bet pretty soon all your friends will want to be in the gang too! Pair your bucket hat with the bottle carrier on pages 262–265 and you're ready for the main stage.

Measurements
One size
To fit approx. circumference of head 60cm (23¾ in)
A larger hat can be made using a 5.5mm (US I/9) crochet hook throughout

What you will need
- Wool and the Gang RaRa Raffia
 100% paper, 250m (273 yards) per 100g (3½ oz)
Quantity:
Colourway 1
- **A** 1 x 100g (3½ oz) ball in Vitamin C
- **B** 1 x 100g (3½ oz) ball in Coal Black
Colourway 2
- **A** 1 x 100g (3½ oz) ball in Hot Pink
- **B** 1 x 100g (3½ oz) ball in Coal Black

- 5mm (US H/8) crochet hook
- Yarn needle

Tension (gauge)
12sts and 10 rows to 10cm (4 in) over htr using 5mm (US H/8) hook, or size required to achieve the correct tension (gauge).

Abbreviations
See page 229.

Note
Ch2 at the start of each round counts as the 1st htr.

To make

Top of hat

Using 5mm (US H/8) hook and **A**, ch4 and join with a sl st to 1st ch to form a ring.
Round 1 (RS): Ch2 (counts as 1st htr throughout), 13htr into ring, join with a sl st 2nd ch of beg ch2. *14 sts.*
Round 2: Ch2, 2htr in next st, (1htr in next st, 2htr in next st) 6 times, sl st to 2nd ch of beg ch2. *21 sts.*
Round 3: Ch2, 1htr in next st, 2htr in next st, (1htr in next 2 sts, 2htr in next st) 6 times, sl st to 2nd ch of beg ch2. *28 sts.*
Round 4: Ch2, 1htr in next 2 sts, 2htr in next st, (1htr in next 3 sts, 2htr in next st) 6 times, sl st to 2nd ch of beg ch2. *35 sts.*
Round 5: Ch2, 1htr in next 3 sts, 2htr in next st, (1htr in next 4 sts, 2htr in next st) 6 times, sl st to 2nd ch of beg ch2. *42 sts.*
Round 6: Ch2, 1htr in next 4 sts, 2htr in next st, (1htr in next 5 sts, 2htr in next st) 6 times, sl st to 2nd ch of beg ch2. *49 sts.*
Round 7: Ch2, 1htr in next 5 sts, 2htr in next st, (1htr in next 6 sts, 2htr in next st) 6 times, sl st to 2nd ch of ch2. *56 sts.*
Round 8: Ch2, 1htr in next 6 sts, 2 htr in next st, (1htr in next 7 sts, 2htr in next st) 6 times, sl st to 2nd ch of beg ch2. *63 sts.*
Fasten off.

Motifs (make 7)

Using 5mm (US H/8) hook and **B** (for Colourway 1) or continuing in **A** (for Colourway 2), ch4 and join with a sl st in 1st ch to form a ring.
Round 1 (RS): Ch5 (counts as 1tr and 2ch), (3tr, 2ch) 3 times into ring, 2tr into ring, join with a sl st to 3rd ch of beg ch5.
4 groups of 3tr and 4 ch2-sp.
Fasten off.
Join **A** with a sl st to any ch2 corner space and work as follows:
Round 2: Ch5 (counts as 1tr and 2ch), 3tr in same corner sp, *1ch, (3tr, 2ch, 3tr) in next 2ch corner sp, rep from * twice more, ch1, 2tr in same sp as ch5 at beg of round, sl st to 3rd ch of beg ch5.

8 groups of 3 tr and 4 ch2-sp.
Fasten off leaving a long end of approx. 50cm (20 in) for sewing motifs together.

When all 7 motifs are complete, join motifs together using yarn ends to whip stitch through adjoining stitches to make a long strip. Join ends of long strip to make a circular band.
Sew the edge of top of hat to one edge of this circular band.

Brim

With RS of hat facing, rejoin **A** with a sl st to corner of any one of the motifs and work as follows:
Next round: Ch2 (counts as 1htr throughout), work 8htr across first motif, then work 9htr across each of rem six motifs, join with a sl st to 2nd ch of beg ch2. *63 sts.*
Next round: Ch2, *1htr in next st, 2htr in next st. rep from * to end of round, sl st to 2nd ch of beg ch2. *94 sts.*
Next round: Ch2, *1htr in next st, rep from * to end of round, sl st to 2nd ch of beg ch2.
Repeat last round twice more, changing to **B** on last yrh of last st, ready to work spiky edging as follows:
Next round: Ch2, *1htr in each of next 2 sts, miss next st and work a htr into row below this st as follows: yrh, insert hook through space in row below, yrh and draw through, yrh and draw through 3 loops on hook, rep from * to end of round.
Fasten off.

To finish

Weave in any yarn ends.

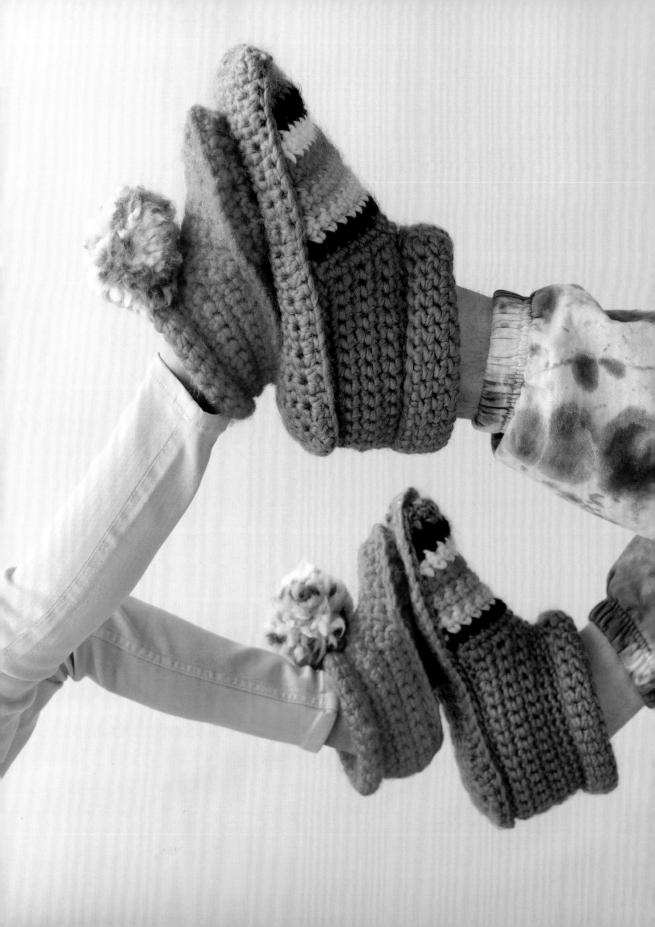

Cosy Slippers

The first thing I do when I get home is kick off my shoes and get cosy in my slippers. This boot-style version is stylish and soft, crocheted in super chunky 100% merino wool, to keep toes, and ankles toasty. Quick to make for you and for the whole family, with a junior size, then get creative and customise with stripes and pompoms.

Measurements

Adult size	M	L	
Foot length	**24.5**	**27.5**	cm
	9½	**11**	in

Junior size	XS	S	
Foot length	**18.5**	**21.5**	cm
	7¼	**8½**	in

What you will need
- MWL The Chunky One
 100% merino wool, 65m (71 yards)
 per 100g (3½ oz)

ADULT SIZE Quantity:
- **A** 3 x 100g (3½ oz) balls in Toweling Teal
- **B** 1 x 100g (3½ oz) ball in Dustin Lance Black
- **C** 1 x 100g (3½ oz) ball in Aqua
- **D** 1 x 100g (3½ oz) ball in Gold Medal
- **E** 1 x 100g (3½ oz) ball in Jump Pink
- **F** 1 x 100g (3½ oz) ball in Lychee White

JUNIOR SIZE Quantity:
- 2 x 100g (3½ oz) balls in Jump Pink
- Scraps in random colours, for pompoms
- 6mm (US J/10) crochet hook
- 7mm (US K/10½ or US L/11) crochet hook
- Yarn needle

Tension (gauge)
10 sts and 12 rows to 10cm (4 in) over dc using 7mm (US K/10½ or US L/11) hook, or size required to achieve the correct tension (gauge).

Abbreviations
See page 229.
dc2tog (insert hook in next st, yrh and draw loop through) twice, yrh and draw through all 3 loops on hook. One stitch decreased.

Special technique
Changing colour at end of row (see page 275).

Note
The slippers are made in two separate pieces – the upper and the sole.

To make adult size

Slipper upper (make 2)

Leg
Working in rounds, using 7mm (US K/10½ or US L/11) hook and **A**, ch30[33] and join with a sl st to form a ring (making sure chain is not twisted when chain is joined).
Round 1 (RS): Ch1, 1dc in same place as sl st, 1dc in each ch to end of round, join with a sl st to 1st dc. *30[33] sts.*
Round 2: Ch1, 1dc in same place as sl st, 1dc in each st to end of round, join with a sl st to 1st dc.
Repeat last round 6 times more.
Do not fasten off; continue with heel.

Heel
Work in rows as follows:
Next row: Ch1, 1dc in same place as sl st, 1dc in each st to end of round, turn. *30[33] sts.*
Next row: Ch1, 1dc in each st to end of row, turn. *30[33] sts.*
Next row (dec): Ch1, dc2tog, 1dc in each st to last 2 sts, dc2tog, turn. *29[31] sts.*
Next row: Ch1, 1dc in each st to end of row, turn.
Repeat last row 1[2] times more.
Do not fasten off; continue with instep.

Instep
Work in rounds as follows:
Next round: Ch1, 2dc in 1st dc, 1dc in each st to last dc, 2dc in last dc, then work 11[13]dc across instep row ends, join with a sl st to 1st dc.
Next round: Ch1, 1dc in same place as sl st, 1dc in each st to end of round, change to **B** and join with a sl st to 1st dc, turn.
Do not fasten off; continue with top of foot.

Top of foot
Work in rows, changing colours where indicated.
Next row: Using **B**, ch1, 1dc in next 14[16] sts, changing to **C** on last st, turn. *14[16] sts.*
Size L only
Next row: Using **C**, ch1, 1dc in next 16 sts, turn. *16 sts.*

Both sizes
Next row: Using **C**, ch1, 1dc in next 14[16] sts, changing to **D** on last st, turn. *14[16] sts.*
Next row: Using **D**, ch1, 1dc in next 14[16] sts, turn.
Next row: Using **D**, ch1, 1dc in next 14[16] sts, changing to **E** on last st, turn.
Size L only
Next row: Using **E**, ch1, 1dc in next 16 sts, turn. *16 sts.*
Both sizes
Next row (dec): Using **E**, ch1, 1dc in each st to last 2 sts, dc2tog, changing to **F** on last st, turn. *13[15] sts.*
Next row (dec): Using **F**, ch1, 1dc in each st to last 2 sts, dc2tog, turn. *12[14] sts.*
Next row: Using **F**, ch1, 1dc in each st to end of row, changing to **B** on last st, turn.
Next row: Using **B**, ch1, 1dc in each st to end of row, turn.
Next row (dec): ch1, 1dc in each dc to last 2 sts, dc2tog, changing to **A** on last st, turn. *11[13] sts.*
Next row (dec): Using **A**, ch1, 1dc in each st to last 2 sts, dc2tog, turn. *10[12] sts.*
Next row (dec): Using **A**, ch1, 1dc in each st to last 2 sts, dc2tog, changing to **C** on last st. *9[11] sts.*
Next row (dec): Using **C**, ch1, 1dc in each st to last 2 sts, dc2tog, turn. *8[10] sts.*
Fasten off.

Sole (make 2)

Using 7mm (US K/10½ or US L/11) hook and **A**, ch6[7] and work in rows as follows:
Row 1: 1dc in 2nd ch from hook, 1dc in each ch to end, turn. *5[6] sts.*
Row 2: Ch1, 1dc in each st to end of row, turn.
Row 3 (inc): Ch1, 2dc in 1st st, 1dc in each st to last st, 2dc in next st, turn. *7[8] sts.*
Row 4: Ch1, 1dc in each st to end of row, turn.
Repeat last row until sole meas 13[15]cm (5¼[6] in).
Next row (inc): Ch1, 2dc in 1st st, 1dc in each st to last st, 2dc in last st, turn. *9[10] sts.*
Next row: Ch1, 1dc in each st to end of row, turn.
Repeat last row until sole meas 22.5[25.5]cm

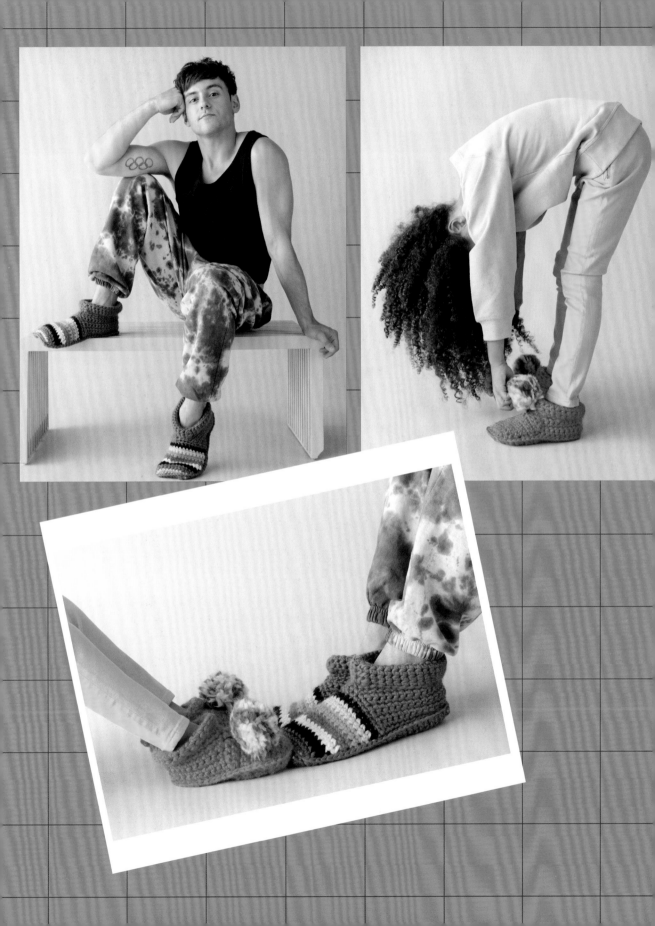

(9[10] in).
Next row (dec): Ch1, dc2tog, 1dc in each st to last 2 sts, dc2tog, turn. *7[8] sts.*
Next row (dec): Ch1, dc2tog, 1dc in each st to last 2 sts, dc2tog, turn. *5[6] sts.*
Fasten off.

To finish

See instructions below.

To make junior size

Slipper upper (make 2)

Leg
Working in rounds, using 7mm (US K/10½ or US L/11) hook, ch23[27] and join with a sl st to form a ring (making sure chain is not twisted when chain is joined).
Round 1 (RS): Ch1, 1dc in same place as sl st, 1dc in each ch to end of round, join with a sl st to 1st dc. *23[27] sts.*
Round 2: Ch1, 1dc in same place as sl st, 1dc in each st to end of round, join with a sl st to 1st dc.
Repeat last round 3[4] times more.
Do not fasten off; continue wth heel.

Heel
Work in rows as follows:
Next row: Ch1, 1dc in same place as sl st, 1dc in each st to end of round, turn. *23[27] sts.*
Next row (dec): Ch1, dc2tog, 1dc in each st to last 2 sts, dc2tog, turn. *21[25] sts.*
Next row: Ch1, 1dc in each st to end of row, turn.
Do not fasten off; continue wth instep.

Instep
Work in rounds as follows:
Next round: Ch1, 1dc in each st to end of previous row, then work 8[10]dc across instep row ends, join with a sl st to 1st dc.
Next round: Ch1, 1dc in same place as sl st, 1dc in each st to end of round, join with a sl st to 1st dc, turn.
Do not fasten off; continue wth top of foot.

Top of foot
Work in rows.
Next row: Ch1, 1dc in next 9[11] sts, turn. *9[11] sts.*
Repeat last row 4[5] times more.
Next row (dec): Ch1, 1dc in each st to last 2 sts, dc2tog, turn. *8[10] sts.*
Repeat last row 3 times more. *5[7] sts.*
Fasten off.

Sole (make 2)

Using 7mm (US K/10½ or US L/11) hook, ch4 and work in rows as follows:
Row 1: 1dc in 2nd ch from hook, 1dc in next 2 ch, turn. *3[4] sts.*
Row 2: Ch1, 1dc in each st to end of row, turn.
Row 3 (inc): Ch1, 2dc in 1st st, 1dc in next st, 2dc in next st, turn. *5[6] sts.*
Row 4: Ch1, 1dc in each st to end of row, turn.
Repeat last row until sole meas 9.5[11.5]cm (3¾[4½] in).
Next row (inc): Ch1, 2dc in 1st st, 1dc in each st to last st, 2dc in last st, turn. *7[8] sts.*
Next row: Ch1, 1dc in each st to end of row, turn.
Repeat last row until sole meas 15.5[18.5]cm (6[7¼] in).
Next row (dec): Ch1, dc2tog, 1dc in each st to last 2 sts, dc2tog, turn. *5[6] sts.*
Next row (dec): Ch1, dc2tog, 1dc in next st, dc2tog, turn. *3[4] sts.*
Fasten off.

To finish

Pin sole to upper, easing to fit. Using 6mm (US J/10) hook, join yarn with a sl st to centre of heel. Inserting hook through both layers, ch1 and work dc all around. Join with a sl st to 1st dc. Fasten off. Weave in any yarn ends.

Adding pompoms (make 2)
Using up scraps of different colours of yarn, make two pompoms (see page 191). Using the long yarn ends used to secure the pompoms, sew the pompoms securely to the top of the slippers.

Masterclass

Changing colour at the end of a row

Swapping colours between rows is a useful technique to learn, as it opens the door to all kinds of striped and colour block crochet projects. You can also use this technique to add a new ball of the same colour yarn when you run out.

One Work all the way along the row, stopping when there is just one stitch left to go. Crochet this stitch as usual, until you get to the final stage when you are about to pull the yarn through the last two loops on the hook. Let the working yarn drop down and hold the new yarn across your hook, leaving a 20cm (6 inch) yarn tail.

Two Wrap the new colour yarn around your hook anti-clockwise and draw it through the final two loops to complete the last stitch of the row.

Three Turn the work and make the required number of turning chains from the new yarn. Continue stitching as usual along the row.

Four Tie the yarn tails together with a knot to stop the edges unravelling. You can weave them in and trim the ends now, or wait until your piece is finished.

Heart Keyring

When you need a quick crafty fix, this keyring is great for working up easily on the go. Use up leftover yarn from larger projects and combine motifs, letters, and tassels to make unique keyrings. Clip on your handbag, lunchbox, bottle carrier, suitcase, gift... let your imagination go wild.

Measurements
Heart approx. 11cm (4¼ in) long
Letter approx. 14cm (5½ in) long
Tassel approx. 14cm (5½ in) long

What you will need
- Wool and the Gang RaRa Raffia 100% paper, 250m (273 yards) per 100g (3½ oz)
Quantity:
- 1 x 100g (3½ oz) ball in Vitamin C
- 4.5mm (US 7) crochet hook
- Yarn needle
- Lobster clasp keyring

Tension (gauge)
An exact tension (gauge) is not critical for this project.

Abbreviations
See page 229.

Special techniques
Working shells (see page 279).

To make

Heart

Using 4.5mm (US 7) hook, ch4 and join with a sl st in 1st ch to form a ring.
Round 1 (RS): Ch3 (counts as 1tr), 2tr into ring, (ch2, 3tr into ring) 3 times, ch2, join with a sl st to 3rd ch of beg ch3. *4 groups of 3tr and 4 ch2-sp.*
Round 2: Ch3 (counts as 1tr), 1tr in sp between beg ch3 and next tr, 1tr in sp between next 2 tr, (2tr, ch2, 2tr) in corner sp, *(1tr in sp between next 2tr) twice, (2tr, ch2, 2tr) in corner sp, rep from * once more, (1tr in sp between next 2tr) twice, (2tr, ch2, 1tr) in corner sp, sl st to 3rd ch of beg ch3. *6tr along each side and 4 ch2-sp.* Fasten off.

Top right section of heart
With RS facing, rejoin yarn between 3rd and 4th tr of one side and work as follows:
Next round (part round): Ch3 (counts as 1tr), 5tr in same sp at base of beg ch3, 6dtr in same sp. *12 sts.* Fasten off.

Top left section of heart
With RS facing, rejoin yarn between 3rd and 4th tr of next side and work as follows:
Next round (part round): Ch4 (counts as 1dtr), 5dtr in same sp at base of beg ch4, 6tr in same sp. *12 sts.* Fasten off.

With RS facing, rejoin yarn with a sl st to ch2-sp at base of heart and work as follows:
Final round: Ch1, 2dc in same sp, 1dc in next 6 tr, 2dc in next ch2-sp, now work into sts from part rounds as follows: 1dc in 6 tr and 6 dtr of right section of heart, 3dc in next ch2-sp, 1dc in next 6 dtr and 6 tr of left section of heart, 2dc in next ch2-sp of Round 2, 1dc in next 6 tr, join with a sl st to beg ch1. *45 sts.*
Fasten off. Weave in any yarn ends.

Letter

Follow instructions for chosen letter from pages 308–315, but using 4.5mm (US 7) hook.

Tassel

Cut 2 lengths, 50cm (20 in) long and set aside. Take a book or piece of cardboard approx. 18cm (7 in) long and wrap the leftover yarn approx. 30 times around the length (the more wraps the fuller the tassel will be). Cut the end of the yarn and slide the looped bundle off the book, holding it in the centre. Take one 50cm (20 in) length of yarn and fold in half. Thread the folded end through the looped bundle at one end. Tie it up by threading the two opposite ends through the folded yarn. Pull up tightly and knot securely. This will be the thread with which to fasten on to the keyring. Take the other 50cm (20 in) length and tie around the looped bundle 3cm (1¼ in) down from the hanging thread. Wind the ends around the bundle to secure, tuck in the ends, knot and trim off. Cut through the loops at the opposite end of the bundle, trim and gently shake out to create a tassel.

To finish

To attach each element to the keyring clasp, use leftover yarn and thread through the top of each element, knotting securely. Weave in any yarn ends for a neat finish.

Masterclass

Working shells

The rounded upper corners of the heart motif are created by working lots of long
stitches into a single space to create a fan-like effect. For a decorative finish,
use the same technique to make a length of scalloped edge trim. This would also make
a good border for a throw, worked directly into the edge of the crocheted fabric.

One Make a foundation chain, slightly longer than the length required. Add on the number
of standing chains for the stitch you're using; these shells are made from double
trebles (triple trebles), so there are four standing chain. Work the first double
treble in the fifth chain from the hook.

Two Create the shell shape by making seven more double trebles into the same chain.

Three Skip the next four foundation chain and anchor the finished shell in place with a
slip stitch in the fifth chain along. This gives you the same length as the standing
chain and ensures the shell will lie flat.

Four Start the next shell with a double treble in the fifth chain along from the slip
stitch and make seven more double trebles into the same chain. Anchor as before in
the fifth chain along and repeat to the end of the foundation chain.

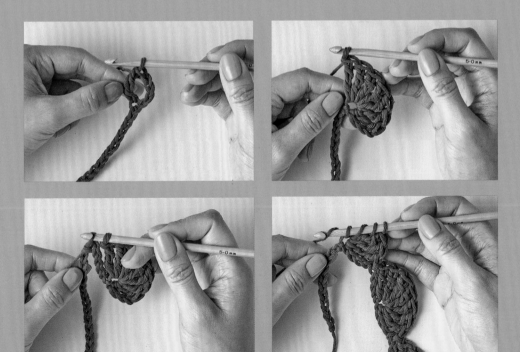

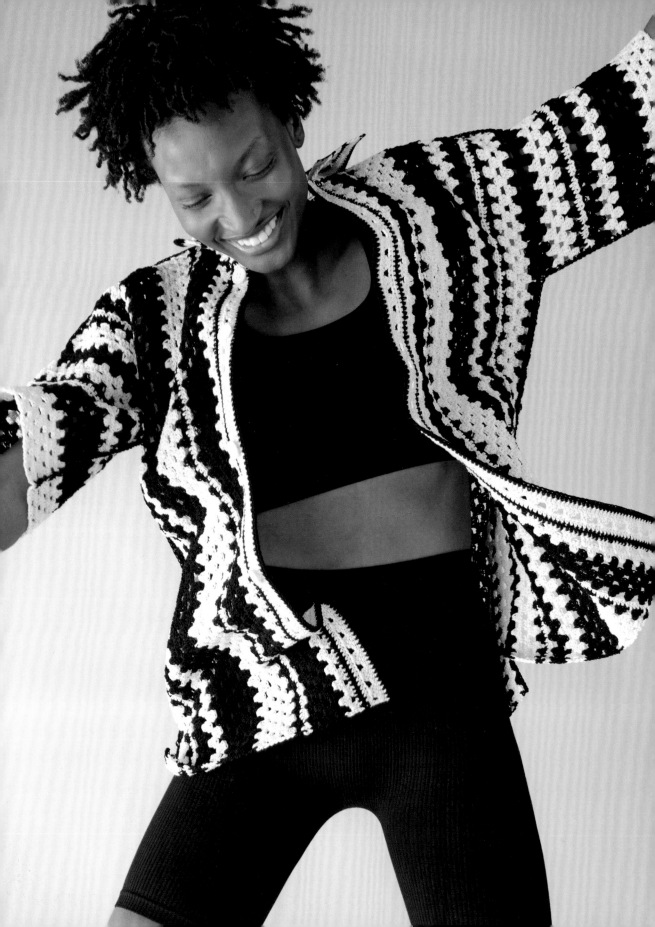

Polo Shirt

A crafty take on a classic "polo", this black and white shirt has a real beach-to-bar vibe. Designed in very simple pieces with little shaping, this garment is as easy to make as it is to wear. Crocheted in a cool, sustainable linen yarn with a good drape – it's the perfect shirt for every summer occasion.

Measurements
See chart below. The shirt is designed to be worn with approx. 4.5cm (1¾ in) to 19.5cm (7¾ in) ease.

What you will need
- Erika Knight Studio Linen
 85% recycled linen, 15% linen, 120m (131 yards) per 50g (1¾ oz)

Quantity:
- **A** 7[8:9:10:11:12] x 50g (1¾ oz) balls in Kumo (black)
- **B** 7[8:9:10:11:12] x 50g (1¾ oz) balls in Milk (white)

- 3mm (US C/2 or D/3) crochet hook
- Stitch markers
- 5 buttons, 18mm (¾ in) in diameter
- Yarn needle

Tension (gauge)
22 sts and 11 rows to 10cm (4 in) over pattern using 3mm (US C/2 or D/3) hook, or size required to achieve the correct tension (gauge).

Abbreviations
See page 229.

Special techniques
Using slip stitch to travel along a row (see page 287).

Notes
The back and fronts are crocheted from edge to edge.
Both fronts are the same because the wrong side and right side are nearly identical.
Change colour on last yoh of last st of row.
Ch3 at beg of row counts as 1tr.
Ch2 at beg of row counts as 1htr.

Adult size	XS	S/M	L/XL	XXL	XXXL	XXXXL	
Actual chest	103.5	111	122	136.5	147.5	154.5	cm
	40¾	43¾	48	53¾	58	61	in
Length	62	66	68	69.5	71	73	cm
	24½	26	26¾	27½	28	28¾	in
Sleeve length	18	18	19	19	20	20	cm
	7	7	7½	7½	8	8	in

To make

Back

Using 3mm (US C/2 or D/3) hook and **A**, ch140[148:152:156:160:164] and work as follows:

Row 1: 2tr in 4th ch from hook, ch1, *miss 3 ch, 3tr in next ch, ch1, rep from * to last 4 ch, miss 3 ch, 1tr in last ch, changing to **B** when finishing last st, turn. *34[36:37:38:39:40] x (3tr, ch1 clusters) and 1 tr; 137[145:149:153:157:161] sts.*

Row 2: Using **B**, ch3, 2tr in 1st ch1-sp, ch1, (3tr, 1ch) in every sp end of row, 1tr in top of ch3, turn.

Row 3: Using **B**, ch3, 2tr in 1st ch1-sp, ch1, (3tr, ch1) in every sp to end of row, 1tr in top of ch3, turn.

Repeat last 2 rows 0[0:0:1:1:1] time more.

Row 4[4:4:6:6:6]: Using **B**, ch3, 2tr in 1st ch1-sp, ch1, (3tr, ch1) in every sp to end of row, 1tr in top of ch2, changing to **A**, turn.

Row 5[5:5:7:7:7]: Using **A**, ch3, 2tr in 1st ch1-sp, ch1, (3tr, ch1) in every sp to end of row, 1tr in top of ch3, changing to **B**, turn.

Row 6[6:6:8:8:8]: Using **B**, ch2, (1htr in 1st ch1-sp, 1htr into each of next 3tr) to last 3 sts, work 1htr into each of next 2tr and top of turning ch, changing to **A**, turn.

Row 7[7:7:9:9:9]: Using **A**, ch3, 2tr in 1st htr, ch1, (miss 3htr, 3tr in next htr, ch1) to last 2htr, miss these 2htr, 1tr in top of turning ch3, turn.

Row 8[8:8:10:10:10]: Using **A**, ch3, 2tr in 1st ch1-sp, ch1, (3tr, ch1) in every sp to end of row, 1tr in top of ch3, changing to **B** for sizes XS, S/M, L/XL and XXL, turn.

Sizes XXXL and XXXXL only
Repeat last row twice more, changing to **B** on last row, turn.

All sizes
Row 9[9:9:11:13:13]: Using **B**, ch3, 2tr in 1st ch1-sp, ch1, (3tr, ch1) in every sp to end of row, 1tr in top of ch3, turn.

Repeat last row 0[0:0:0:0:2] times more.

Row 10[10:10:12:14:16]: Using **B**, ch3, 2tr in 1st ch1-sp, ch1, (3tr, ch1) in every sp to end of row, 1tr in top of ch3, changing to **A**, turn.

Row 11[11:11:13:15:17]: Using **A**, ch3, 2tr in 1st ch1-sp, ch1, (3tr, ch1) in every sp to end of row, 1tr in top of ch3, turn.

Row 12[12:12:14:16:18]: Using **A**, ch3, 2tr in 1st ch1-sp, ch1, (3tr, ch1) in every sp to end of row, 1tr in top of ch3, turn.

Row 13[13:13:15:17:19]: Using **A**, ch3, 2tr in 1st ch1-sp, ch1, (3tr, ch1) in every sp to end of row, 1tr in top of ch3, turn.

Row 14[14:14:16:18:20]: Using **A**, ch3, 2tr in 1st ch1-sp, ch1, (3tr, ch1) in every sp to end of row, 1tr in top of ch3, turn.

Repeat last row 0[1:2:3:3:3] time(s) more, changing to **B** on last row, turn.

Row 15[16:17:20:22:24]: Using **B**, ch3, 2tr in 1st ch1-sp, ch1, (3tr, ch1) in every sp to end of row, 1tr in top of ch3, turn.

Row 16[17:18:21:23:25]: Using **B**, ch3, 2tr in 1st ch1-sp, ch1, (3tr, ch1) in every sp to end of row, 1tr in top of ch3, turn.

Row 17[18:19:22:24:26]: Using **B**, ch3, 2tr in 1st ch1-sp, ch1, (3tr, ch1) in every sp to end of row, 1tr in top of ch3, turn.

Row 18[19:20:23:25:27]: Using **B**, ch3, 2tr in 1st ch1-sp, ch1, (3tr, ch1) in every sp to end of row, 1tr in top of ch3, turn.

Repeat last row 0[1:2:3:3:3] time(s) more, changing to **A** on last row, turn.

Row 19[21:23:27:29:31]: Using **A**, ch3, 2tr in 1st ch1-sp, ch1, (3tr, ch1) in every sp to end of row, 1tr in top of ch3, changing to **B**, turn.

Row 20[22:24:28:30:32]: Using **B**, ch2, (1htr in next ch1-sp, 1htr into each of next 3 tr) to last 3 sts, work 1htr into each of next 2 tr and top of turning ch, changing to **A**, turn.

Place marker to show end of shoulder.**

Back neck
Row 21[23:25:29:31:33]: Using **A**, ch3, 2tr in 1st htr, ch1, (miss 3 htr, 3tr in next htr, ch1) to last 3 sts, miss 2htr, 1tr in top of turning ch.

Row 22[24:26:30:32:34]: Using **A**, ch3, 2tr in 1st ch1-sp, ch1, (3tr, ch1) in every sp to end of row, 1tr in top of ch3, turn.

Row 23[25:27:31:33:35]: Using **A**, ch3, 2tr in 1st ch1-sp, ch1, (3tr, ch1) in every sp to end of row, 1tr in top of ch3, turn.

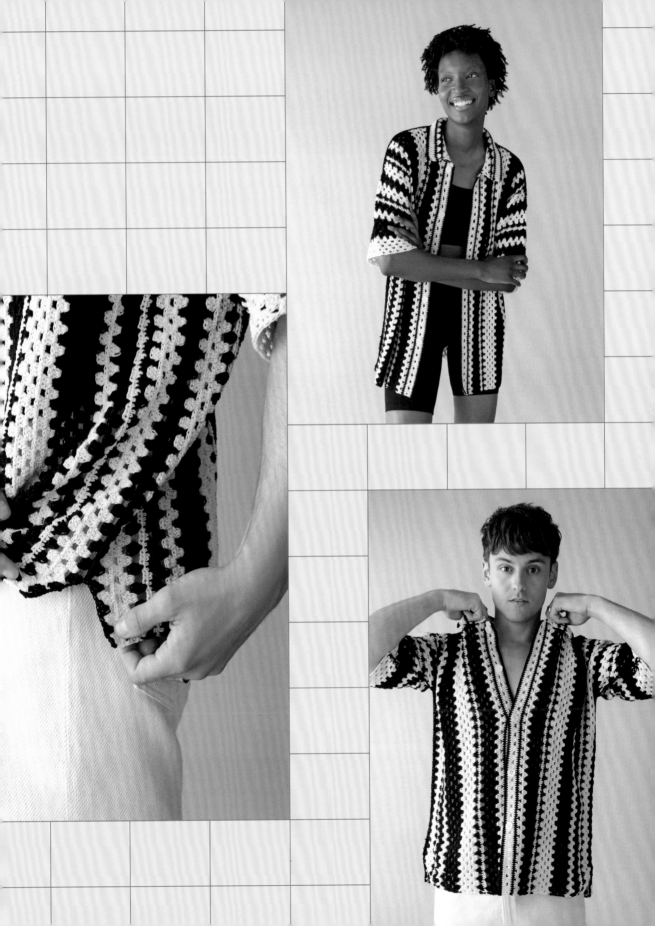

Row 24[26:28:32:34:36]: Using A, ch3, 2tr in 1st ch1-sp ch, (3tr, ch1) in every sp to end of row, 1tr in top of ch3, changing to B, turn.

Row 25[27:29:33:35:37]: Using B, ch3, 2tr in 1st ch1-sp, ch1, (3tr, ch1) in every sp to end of row, 1tr in top of ch3, turn.
Repeat last row 0[0:0:0:2:2] times more, turn.

Row 26[28:30:34:38:40]: Using B, ch3, 2tr in 1st ch1-sp, ch1, (3tr, ch1) in every sp to end of row, 1tr in top of ch3, changing to A, turn.

Row 27[29:31:35:39:41]: Using A, ch2, (1htr in next ch1-sp, 1htr into each of next 3 tr) to last 3 sts, 1htr in each of next 2 tr and 1htr in top of turning ch, changing to B, turn.

Row 28[30:32:36:40:42]: Using B, ch2, (1htr in each htr) to end of row, 1htr in the top of turning ch, turn.

Row 29[31:33:37:41:43]: Using B, ch3, 2tr in 1st htr, ch1, (miss 3 htr, 3tr in next htr, ch1) to last 3 sts, miss 2 htr, 1tr in top of turning ch, turn
Repeat last row 0[0:2:2:0:0] times more.

Row 30[32:36:40:42:44]: Using B, ch2, (1htr in next ch1-sp, 1htr in each of next 3 tr) to last 3 sts, 1htr in each of next 2 htr and 1htr in top of turning ch, changing to A turn.

Row 31[33:37:41:43:45]: Using A, ch2, (1htr in each htr) to end of row, 1htr in top of turning ch, changing to B, turn.

Row 32[34:38:42:44:46]: Using B, ch3, 2tr in 1st htr, ch1, (miss 3 htr, 3tr in next htr, ch1) to last 3 sts, miss 2 htr, 1tr in top of turning ch, turn.
Repeat last row 0[0:0:0:2:2] times more.

Row 33[35:39:43:47:49]: Using B, ch3, 2tr in 1st ch1-sp, ch1, (3tr, ch1) in every sp to end of row, 1tr in top of ch3, changing to A, turn.

Row 34[36:40:44:48:50]: Using A, ch3, 2tr in 1st ch1-sp, ch1, (3tr, ch1) in every sp to end of row, 1tr in top of ch3, turn.

Row 35[37:41:45:49:51]: Using A, ch3, 2tr in 1st ch1-sp, ch1, (3tr, ch1) in every sp to end of row, 1tr in top of ch3, turn.

Row 36[38:42:46:50:52]: Using A, ch3, 2tr in 1st ch1-sp, ch1, (3tr, ch1) in every sp to end of row, 1tr in top of ch3, turn.

Row 37[39:43:47:51:53]: Using A, ch3, 2tr in 1st ch1-sp, ch1, (3tr, ch1) in every sp to end of row, 1tr in top of ch3, changing to B, turn. Place marker to show start of shoulder.

Shoulder

Row 38[40:44:48:52:54]: Using B, ch2, (1htr in next ch1-sp, 1htr in each of next 3 tr) to last 3 sts, 1htr in each of next 2 htr and 1htr in top of turning ch, changing to A, turn.

Row 39[41:45:49:53:55]: Using A, ch3, 2tr in 1st htr, ch1, (miss 3 htr, 3tr in next htr, ch1) to last 3 sts, miss 2 htr, 1tr in top of turning ch, changing to B, turn.

Row 40[42:46:50:54:56]: Using B, ch3, 2tr in 1st ch1-sp ch, (3tr, ch1) in every sp to end of row, 1tr in top of ch3, turn.

Row 41[43:47:51:55:57]: Using B, ch3, 2tr in 1st ch1-sp, ch1, (3tr, ch1) in every sp to end of row, 1tr in top of ch3, turn.

Row 42[44:48:52:56:58]: Using B, ch3, 2tr in 1st ch1-sp, ch1, (3tr, ch1) in every sp to end of row, 1tr in top of ch3, turn.

Row 43[45:49:53:57:59]: Using B, ch3, 2tr in 1st ch1-sp, ch1, (3tr, ch1) in every sp to end of row, 1tr in top of ch3, turn.
Repeat last row 0[1:2:3:3:3] time(s) more, changing to A on last row, turn.

Row 44[47:52:57:61:63]: Using A, ch3, 2tr in 1st ch1-sp, ch1, (3tr, ch1) in every sp to end of row, 1tr in top of ch3, turn.

Row 45[48:53:58:62:64]: Using A, ch3, 2tr in 1st ch1-sp, ch1, (3tr, ch1) in every sp to end of row, 1tr in top of ch3, turn.

Row 46[49:54:59:63:65]: Using A, ch3, 2tr in 1st ch1-sp, ch1, (3tr, ch1) in every sp to end of row, 1tr in top of ch3, turn.

Row 47[50:55:60:64:66]: Using A, ch3, 2tr in 1st ch1-sp, ch1, (3tr, ch1) in every sp to end of row, 1tr in top of ch3, turn.
Repeat last row 0[1:2:3:3:3] time(s) more, changing to B on last row, turn

Row 48[52:58:64:68:70]: Using B, ch3, 2tr in 1st ch1-sp, ch1, (3tr, ch1) in every sp to end of row, 1tr in top of ch3, turn.
Repeat last row 0[0:0:0:0:2] times more.

Row 49[53:59:65:69:73]: Using **B**, ch3, 2tr in 1st ch1-sp, ch1, (3tr, ch1) in every sp to end of row, 1tr in top of ch3, changing to **A**, turn.

Row 50[54:60:66:70:74]: Using **A**, ch3, 2tr in 1st ch1-sp, ch1, (3tr, ch1) in every sp to end of row, 1tr in top of ch3, turn.

Row 51[55:61:67:71:75]: Using **A**, ch3, 2tr in 1st ch1-sp, ch1, (3tr, ch1) in every sp to end of row, 1tr in top of ch3, changing to **B** for sizes XS, S/M, L/XL and XXL, turn.

Sizes XXXL and XXXXL only
Repeat last row twice more, changing to **B** on last row, turn.

All sizes
Row 52[56:62:68:74:78]: Using **B**, ch2, (1htr in next ch1-sp, 1htr in each of next 3 tr) to last 3 sts, 1htr in each of next 2 htr and 1htr in top of turning ch, changing to **A**, turn.

Row 53[57:63:69:75:79]: Using **A**, ch3, 2tr in 1st htr, ch1, (miss 3 htr, 3tr in next htr, ch1) to last 3 sts, miss 2 htr, 1tr in top of turning ch, changing to **B**, turn.

Row 54[58:64:70:76:80]: Using **B**, ch3, 2tr in 1st ch1-sp, ch1, (3tr, ch1) in every sp to end of row, 1tr in top of ch3, turn.

Row 55[59:65:71:77:81]: Using **B**, ch3, 2tr in 1st ch1-sp, ch1, (3tr, ch1) in every sp to end of row, 1tr in top of ch3, turn.
Repeat last row 0[0:0:2:2:2] times more.

Row 56[60:66:74:80:84]: Using **B**, ch3, 2tr in 1st ch1-sp, ch1, (3tr, ch1) in every sp to end of row, 1tr in top of ch3, changing to **A**, turn.

Row 57[61:67:75:81:85]: Using **A**, ch3, 2tr in 1st ch1-sp, ch1, (3tr, ch1) in every sp to end of row, 1tr in top of ch3.
Fasten off.

Fronts (make two the same)

Work as given for back to ** but do not change to **A** on last st. *20[22:24:28:30:32] rows worked.*

Shape neck
Using **B**, sl st in 1st 5htr, then change to **A**.
Row 21[23:25:29:31:33]: Using **A**, ch3,

2tr in the same st, ch1, (miss 3 htr, 3tr in next htr, ch1) to last 3 sts, miss 2 htr, 1tr in turning ch, turn.

Row 22[24:26:30:32:34]: Using **A**, ch3, 2tr in 1st ch1-sp, ch1, (3tr, ch1) in every sp until 2 blocks from the end, 1tr in last ch-sp, turn.

Row 23[25:27:31:33:35]: Using **A**, ch3, 2tr in 1st ch1-sp, ch1, (3tr, ch1) in every sp to end of row, 1tr in top of ch3, turn.

Row 24[26:28:32:34:36]: Using **A**, ch3, 2tr in 1st ch1-sp, ch1, (3tr, ch1) in every sp until 2 blocks from the end, 1tr in top of ch3, changing to **B**, turn.

Row 25[27:29:33:35:37]: Using **B**, ch3, 2tr in 1st ch1-sp, ch1, (3tr, ch1) in every sp to end of row, 1tr in top of ch3, turn.
31[33:34:35:36:37] x [3tr, ch1 clusters] and 2tr.

Row 26[28:30:34:36:38]: Using **B**, ch3, 2tr in 1st ch1-sp, ch1, (3tr, ch1) in every sp to end of row, 1tr in top of ch3, changing to **A** for sizes XS, S/M, L/XL and XXL, turn.

Sizes XXXL and XXXXL only
Repeat last row twice more, changing to **A** on last row, turn.

All sizes
Row 27[29:31:35:39:41]: Using **A**, ch2, (1htr in 1st ch1-sp, 1htr into each of next 3 tr) to last 3 sts, work 1htr into each of next 2 tr and 1htr in top of turning ch, changing to **B**, turn.

Row 28[30:32:36:40:42]: Using **B**, ch2, (1htr in each htr) to end of row, 1htr in top of turning ch, turn.

Row 29[31:33:37:41:43]: Using **B**, ch3, 2tr in 1st htr, ch1, (miss 3 htr, 3tr in next htr, ch1) to last 3 sts, miss 2 htr, 1tr in top of turning ch, turn.
Repeat last row 0[0:2:2:0:0] times more.

Row 30[32:36:40:42:44]: Using **B**, ch2, (1htr in 1st ch1-sp, 1htr into each of next 3tr) to last 3 sts, work 1htr into each of next 2 tr and 1htr in top of turning ch, changing to **A**, turn.

Row 31[33:37:41:43:45]: Using **A**, ch2, (1htr in each htr) to end of row, 1htr in top of turning ch.
Fasten off.

then 25[25:27:27:29:29] dc up right front neck, 33[33:37:37:41:41] dc across back neck, 25dc down left front neck ending 2cm (¾ in) from left front edge, turn. 84[84:92:92:100:100] and work collar as follows:

Next row: Using **B**, ch3, 2tr in 1st dc, ch1, (miss next 3 dc, 3tr in next dc, ch1) to last 3 sts, miss 2 dc, 1tr in turning ch, turn.

Next row: Using **B**, ch3, 2tr into 1st ch1-sp, ch1, (3tr, ch1) in every sp to end of row,1tr in top of ch3, turn.

Next row: Using **B**, ch3, 2tr into 1st ch1-sp, ch1, (3tr, ch1) in every sp to end of row, 1tr in top of ch3, changing to **A**, turn.

Next row: Using **A**, ch2, (1htr in next ch-sp, 1htr into each of next 3 tr) to last 3 sts, 1htr in next 2 tr and 1htr in top of ch3, changing to **B**, turn.

Next row: Using **B**, ch3, 2tr in 1st htr, ch1 (miss 3 htr, 3tr in next htr, ch1) to last 3 sts, miss 2 sts and work 1tr in top of turning ch, changing to **A**, turn.

Next row: Using **A**, ch2, (1htr in 1st ch-sp, 1htr into each of next 3 tr) to last 3 sts, 1htr in next 2 tr and 1htr in top of ch3, changing to **B**, turn.

Next row: Using **B**, ch2, 1htr in each htr to end of row, turn.

Next row: Using **B**, ch3, 1tr in each htr to end of row, changing to **A** turn.

Next row: Using **A**, ch2, 1htr in each tr to end of row.
Fasten off.

Sleeves (make two)

Using 3mm (US C/2 or D/3) hook and **A**, ch88[92:96:100:104:108].
Work rows 1 to 20[20:21:21:22:22] as for back.
Fasten off.

Join shoulders

Join both shoulders by matching the stripes and the markers on the back and working a row of dc through both layers using **A**. The seam is on the outside of the work which is now the RS of your work. Place markers 19[20:21:22: 23:24]cm (7½ [7¾:8¼:8¾:9:9½] in) down from shoulder at sides on back and both fronts to show start of armholes.

Collar

With RS facing, using 3mm (US C/2 or D/3) hook and **A**, rejoin yarn 2cm (¾ in) from right front edge, work ch1 (counts as a st),

To finish

Weave in any yarn ends.
Pin sleeves between markers with wrong sides together. Using **A** rejoin yarn with ch1 and work a row of dc through both layers so the seam is on the RS of your work.
Join side and sleeve seams using the same method, leaving 5cm (2 in) open at bottom edge to make side vents.
Sew buttons on right front, evenly spaced. The buttonholes are the spaces between blocks on the left front.

Masterclass

Using slip stitch to travel along a row

Slip stitch is a way of moving along a row of crochet but without adding any extra height to your work. Here it is used at the neck edge of the polo shirt to unobtrusively reduce the number of stitches in the rows and create a neat opening.

One Work a slip stitch directly into the first stitch of the row where you will be decreasing – there is no need to make a turning chain.

Two Continue working slip stitches into the top of the previous row until you have made the number given in the pattern or you reach the point where you want to continue with tall stitches.

Three Make the number of standing chain required for the stitch you are using, then continue crocheting to the end of the row. There is now a small step at the top corner of your work.

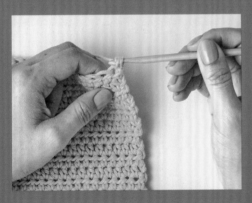
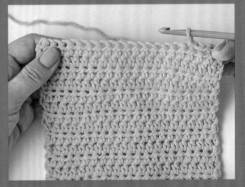

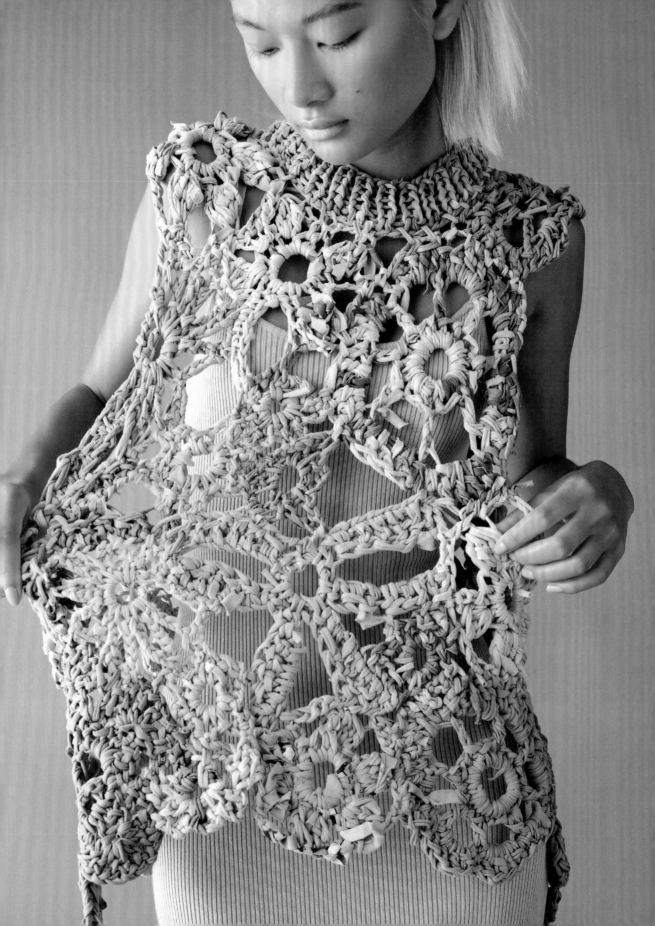

Motif Vest

Believe it or not, this fashion-forward vest is made from old t-shirts for the ultimate in upcycling chic. Dig out any worn-out, un-loved or out-grown cotton t-shirts and simply cut into continuous strips to create your own yarn. Crochet lots of individual motifs with a big hook, then lay them out using a favourite vest as a template, pin in place and oversew together. I love the idea that a t-shirt that I have worn and loved can be given a new life as something completely different.

Sizing guidance

This project is made up of individual motifs, and is a little free-form. For larger or smaller sizes, you will need to make more or fewer motifs and experiment with their placement, using a t-shirt as a template. The below measurements are a guide only. The number of motifs listed are for the S/M size. Fewer motifs will be needed for XS size and more will be needed for the larger sizes.

What you will need

- Lightweight t-shirts in assorted colours, cut into strips and wound into balls (see page 293).

Quantity:

- Approx. 640[700:770:850:930:1025]g (22½[24¾:27:29:32¾:36] oz) total weight of yarn
- 12mm (US 00) crochet hook
- Stitch marker
- 10mm (US 00) circular needle, 40cm (16 in) lengths

Abbreviations

See page 229.

Bobble (motif 5): 5tr into next dc until 1 loop of each remains on hook, yrh and draw through all 6 loops on hook.

Bobble (motif 12): 3dtr into next dc until 1 loop of each remains on hook, yrh and draw through all 4 loops on hook.

Special techniques

Making your own yarn from fabric (see page 293).

Adult size	XS	S/M	L/XL	XXL	XXXL	XXXXL	
Suggested actual chest	90	100	110	120	130	140	cm
	35½	39¼	43¼	47¼	51¼	55	in
Suggested length	50	54	58	58	62	62	cm
	19¾	21¼	22¾	22¾	24½	24½24	in

To make

Motifs

Motif 1: Gemini spoke (make 4)
Approx. 18cm (7 in) in diameter
Base ring: Ch8, join with sl st.
Round 1: Ch1, 16dc into ring, sl st to 1st dc.
Round 2: Ch6 (counts as 1tr and ch3), miss next dc, (1tr in next dc, ch3, miss 1 dc) 7 times, sl st to 3rd of ch6.
Round 3: Ch1, 1dc in same place as last sl st, (4tr in next ch3-sp, 1dc in next tr] 7 times, 4tr in next ch3 -sp, sl st to 1st dc.
Fasten off.

Motif 2: Large gardenia bloom (make 2)
Approx. 20cm (7¾ in) in diameter
Base ring: Ch5, join with sl st.
Round 1: Ch6 (counts as 1tr and ch3), (1tr in ring, ch3) 5 times, sl st to 3rd of ch6.
Round 2: Ch1, 1dc in sl st, *(1tr, ch1, 1tr, ch1, 1tr) in next ch3-sp, 1dc in next tr, rep from * 5 times more missing dc at end of last rep, sl st to 1st dc.
Round 3: Ch1, 1dc in 1st dc, *ch1, miss 1tr, (1tr, ch1) 5 times into next tr, miss 1tr, 1dc into next dc, rep from * 5 times more missing dc at end of last rep, sl st to 1st dc.
Fasten off.

Motif 3: Medium gardenia bloom (make 2)
Approx. 15cm (6 in) in diameter
Base ring: Ch5, join with sl st.
Round 1: Ch6 (counts as 1tr and ch3), (1tr in ring, ch3) 5 times, sl st to 3rd of ch6.
Round 2: Ch1, 1dc into sl st, *(1tr, ch1, 1tr, ch1, 1tr) in next ch3-sp, 1dc in next tr, rep from * 5 times more missing dc at end of last rep, sl st to 1st dc.
Fasten off.

Motif 4: Small gardenia bloom (make 2)
Approx. 8cm (3¼ in) in diameter
Base ring: Ch5, join with sl st.
Round 1: Ch6 (counts as 1tr and ch3), (1tr in ring, ch3) 5 times, sl st to 3rd of ch6.
Fasten off.

Motif 5: Canterbury bell (make 6)
Approx. 12cm (4¾ in) in diameter
Base ring: Ch6, join with sl st.
Round 1: Ch1, 12dc in ring, sl st to 1st dc.
Round 2: Ch3, 4tr in same st as last sl st until 1 loop of each tr remains on hook, yrh and draw through all 5 loops on hook (1 bobble made at beg of round), *ch5, miss 1dc, 1 bobble in next dc, rep from * 4 times more, ch5, sl st to top of 1st bobble.
Fasten off.

Motif 6: Orchid blossom with short legs (make 2)
Approx. 18cm (7 in) in diameter
Base ring: Ch6, join with sl st.
Petal: (Ch6, 1dc in 2nd ch from hook, 1htr in next ch, 1tr in next ch, 1htr in next ch, 1dc in next ch, sl st in ring) 6 times.
Fasten off.

Motif 7: Orchid blossom with long legs (make 2)
Approx. 20cm (7¾ in) in diameter
Base ring: Ch6, join with sl st.
Petal: (Ch8, 1dc in 2nd ch from hook, 1htr in next ch, 1tr in next ch3, 1htr in next ch, 1dc in next ch, sl st in ring) 6 times.
Fasten off.

Motif 8: Pinwheel with 10 legs (make 1)
Approx. 16cm (6¼ in) in diameter
Base ring: Ch8, join with sl st.
Round 1: Ch1, (1dc, ch12) 10 times in ring, sl st to 1st dc.
Fasten off.

Motif 9: Pinwheel with 8 legs (make 2)
Approx. 14cm (5½ in) in diameter
Base ring: Ch8, join with sl st.
Round 1: Ch1, (1dc, ch12) 8 times in ring, sl st to 1st dc.
Fasten off.

Motif 10: Pinwheel with 6 legs (make 12)
Approx. 13cm (5 in) in diameter
Base ring: Ch6, join with sl st.
Round 1: Ch1, (1dc, ch4) 6 times in ring, sl st to 1st dc.
Fasten off.

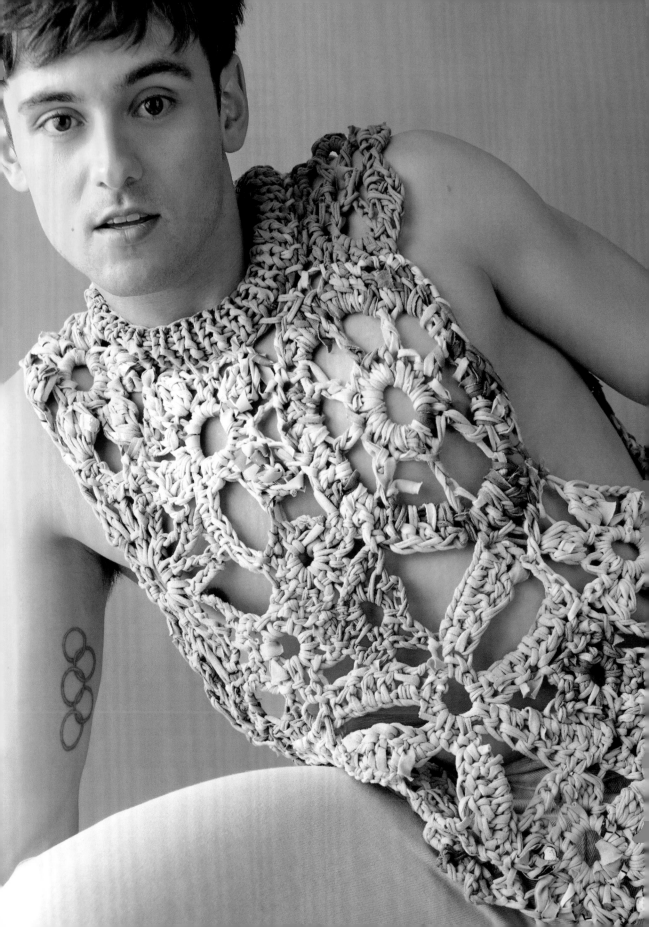

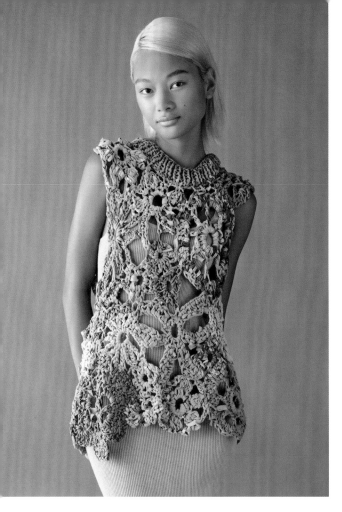

Motif 11: Pinwheel with 8 different length legs (make 2)
Adjustable size
Base ring: Ch8, join with sl st.
Round 1: Ch1, (1dc, ch12) twice, (1dc, ch10) twice, (1dc, ch8) once, (1dc, ch6) twice and (1dc, ch4) once, sl st to 1st dc. Fasten off.

Motif 12: Four petal flower (make 2)
Approx. 8cm (3¼ in) in diameter
Base ring: Ch5, join with sl st.
Round 1: Ch1, 12dc in ring, sl st in 1st dc.
Round 2: *Ch4, 1 bobble in next dc, ch4, sl st in each of next 2 dc, rep from * 3 times more, missing 1 sl st at end of last rep, ch7, 1dc in 2nd ch from hook, 1dc in each of next ch5, sl st in 1st dc on 1st round. Fasten off.

Neckband

Knitted separately and attached after body of vest has been finished.
Using 10mm (US 15) circular needle, cast on 52[56:60:64:68:72] sts, place marker to show start of round, and work 5 rounds in k1, p1 rib, ending at marker.
Cast off loosely in rib.

To finish

Make a paper pattern of your favourite sleeveless vest or use the actual vest as the pattern and simply pin the motifs onto the front. You may have to crochet a few more of the smaller motifs to fill in any big spaces.

Sew the motifs together using the t-shirt strips in any colour, knotting lengths together as you work. You can also use the ends left after fastening off each motif for sewing up. Repeat for the back. Then join the shoulders and the side seams.

Pin neckband in place, easing fit around neckline and whip stitch onto vest. Weave in any unused ends.

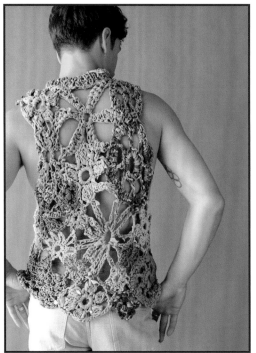

Masterclass

Making your own yarn from fabric

Both crochet and knitting can be worked using any continuous length of yarn,
and that includes strips of t-shirt fabric as used here. There is no need to be
painstakingly accurate when cutting up the t-shirts, just keep the strips no more
than 1cm (00 inch) wide.

One Take each t-shirt and cut off the neckband, sleeves and hem. Next, cut along the
shoulders and sides seams so that you have two flat pieces of fabric.

Two Lay the fabric out so that it is as wrinkle-free as possible. Starting at one
corner of the fabric, cut along one side 1cm (00 inch) in from the edge, but
stopping when you are 1cm (00 inch) from the end.

Three Next, make another cut in the opposite direction, 1cm (00 inch) from the previous
cut and again stopping before you reach the end of the fabric. Continue making
cuts in this way across the whole surface of the fabric. This will make one
continuous 2.5cm (1 inch) wide length of fabric in a sort of spiral.

Four Join all the lengths of t-shirt fabric together with a simple knot and wind into
balls of separate colours. Now it is ready to be crocheted or knitted up.

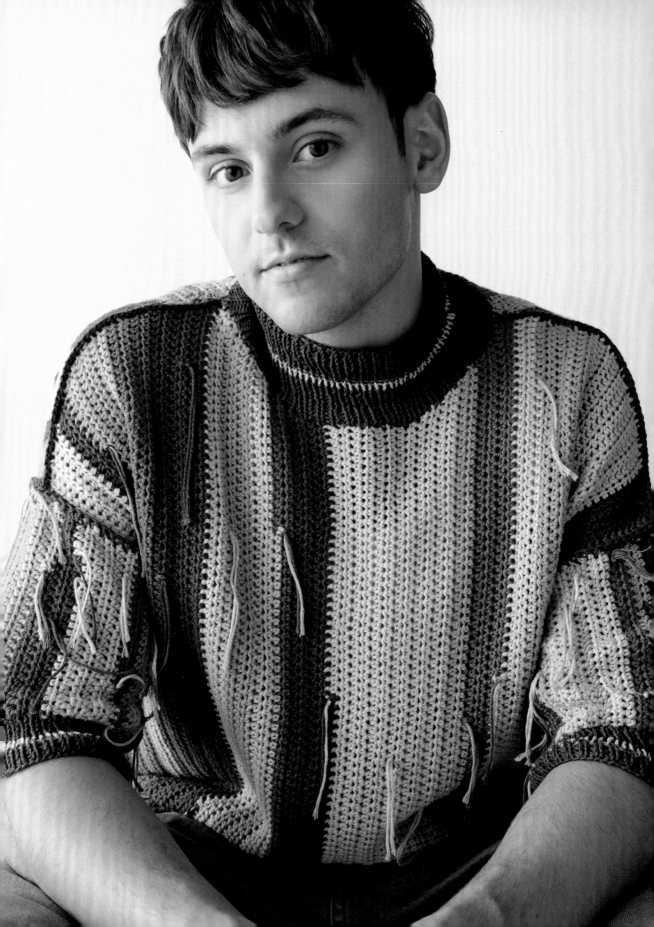

Random Stripe Sweater

This wide, cropped t-shirt-style sweater makes a feature of the knotted ends of the colour changes. A brilliant stash-buster project, the random colour stripe – which varies each time – is achieved simply by knotting different lengths together. Finished with a ribbed neckband and cuffs, this project is all about celebrating the making process.

Measurements
See chart below. Sweater to be worn with approx. 11cm (4¼ in) to 26cm (10¼ in) ease.

What you will need
- Kremke Soul Wool Morning Salutation 51% lyocell, 49% cotton, 110m (120 yards) per 50g (1¾ oz)

Quantity:
- **A** 3[3:4:4:4:5] x 50g (1¾ oz) balls in Blue
- **B** 3[3:4:4:4:5] x 50g (1¾ oz) balls in Indigo
- **C** 3[3:4:4:4:5] x 50g (1¾ oz) balls in Pink
- **D** 3[3:4:4:4:5] x 50g (1¾ oz) balls in Lemon
- **E** 4[4:5:5:6:6] x 50g (1¾ oz) balls in Jade

- 3.5mm (US E/4) crochet hook
- 4mm (US G/6) crochet hook
- 5mm (US H/8) crochet hook
- 3.75mm (US 5) circular knitting needle, 40cm (16 in) length
- Stitch markers
- Yarn needle

Tension (gauge)
15 sts and 13 rows to 10cm (4 in) over htr on 4mm (US G/6) hook, or size required to achieve the correct tension (gauge).

Abbreviations
See page 229.
Inc work 2htr in first st. 1 st inc.
Dec work htr2tog over next 2 sts. 1 st dec.

Special techniques
Winding yarn for stripes (see page 299).

Notes
The sweater is crocheted edge to edge in htr throughout.
The foundation row is the RS for this pattern.

Adult size	XS	S/M	L/XL	XXL	XXXL	XXXXL	
Actual chest	107.5	117	126	138	147.5	160	cm
	42½	46	49½	54½	58	63	in
Length (from side seam)	54	57	58	61	62	65	cm
	21¼	22½	22¾	24	24½	25½	in
Sleeve length	21	22	23	23	24	25	cm
	8¼	8¾	9	9	9½	10	in

To make

Prepare the yarn
Before starting work, cut the yarn into various lengths and then randomly knot them together. Wind the knotted lengths into one multi-coloured ball (see page 299). Each garment will be unique. You can leave the knotted ends showing on the RS or push them through to the WS to hide them.

For the back, take one ball of each colour and from each cut the following lengths:
1 x 7m (8 yards)
2 x 15m (17 yards)
2 x 22m (24 yards)
1 x 28m (31 yards)

Repeat for the front but start using any leftover yarn from the first ball.

For each sleeve, take one ball of each colour and from each cut the following lengths:
1 x 2m (3 yards)
2 x 4m (5 yards)
2 x 6m (7 yards)
1 x 8m (9 yards)

Back

Using 5mm (US H/8) hook, ch83[87:89:93: 95:99].
Change to 4mm (US G/6) hook.
Foundation row (RS): 1htr in 3rd ch from hook, 1htr in each ch to end, turn. *81[85:87:91:93:97] htr.*
Row 1: Ch2 (not counted as st here and throughout), 1htr in each st to end, turn.

Shape right shoulder
****Sizes XS, S/M and L/XL only**
Row 2 (RS inc): Ch2, 2htr in 1st st (shoulder edge), 1htr in each st to end, turn. *82[86:88:–:–:–] sts.*
Row 3: Ch2, 1htr in each st to end, turn.
Row 4: Ch2, 1htr in each st to end, turn.
Row 5 (inc): Ch2, 1htr in each st to last st, 2htr in last st (shoulder edge), turn. *83[87:89:–:–:–] sts.*

Inc as above at shoulder edge on every following 3rd row 5 times more. *88[92:94:–: –:–] sts.*
Sizes S/M and L/XL only
Next row: Ch2, 1htr in each st to end, turn.
Next row: Ch2, 1htr in each st to end, turn.
Repeat last 2 rows –[0:1:–:–:–] times more, placing a marker to show end of shoulder shaping.
Sizes XXL and XXXL only
Row 2 (RS inc): Ch2, 2htr in 1st st (shoulder edge), 1htr in each st to end, turn. *–[–:–:92:94:–] sts.*
Row 3: Ch2, 1htr in each st to end, turn.
Repeat last row twice more.
Row 6 (inc): Ch2, 2htr in 1st st (shoulder edge), 1htr in each st to end, turn. *–[–:–: 93:95:–] sts.*
Inc as above at shoulder edge on every following 4th row 5 times more. *–[–:–: 98:100:–] sts.*
Next row: Ch2, 1htr in each st to end, turn.
Next row: Ch2, 1htr in each st to end, turn, Repeat last 2 rows –[–:–:0:1:–] times more.
Sizes XXXXL only
Row 2 (RS inc): Ch2, 2htr in 1st st (shoulder edge), 1htr in each st to end, turn. *–[–:–:–:–:98] sts.*
Row 3: Ch2, 1htr in each st to end, turn.
Row 4: Ch2, 1htr in each st to end, turn.
Repeat last 2 rows once more.
Row 7 (inc): Ch2, 1htr in each st to last st, 2htr in last st (shoulder edge), turn. *–[–:–:–:–:99] sts.*
Inc as above at shoulder edge on every following 5th row 5 times more. *–[–:–:–:–:104] sts.*
Next row: Ch2, 1htr in each st to end, turn.
Next row: Ch2, 1htr in each st to end, turn.
All sizes
88[92:94:98:100:104] sts.
Place marker to show end of shoulder shaping.**

Back neck
Work 28[30:32:32:34:34] rows straight, ending with WS facing for next row, turn, placing marker at shoulder edge of last row. Work 0[2:4:2:4:2] rows straight.

***Shape left shoulder
Sizes XS, S/M and L/XL only
Next row (dec): Ch2, 1htr in each st to last 2 sts, htr2tog over last 2 sts (shoulder edge), turn. *87[91:93:–:–:–] sts.*
Work 2 rows straight.
Next row: Ch2, htr2tog over next 2 sts (shoulder edge), 1htr in each st to end, turn. *86[90:93:–:–:–] sts.*
Dec as above at shoulder edge on every following 3rd row 5 times more. *81[85:87:–:–:–] sts.*
Work 2 rows straight.

Sizes XXL and XXXL only
Next row (dec): Ch2, 1htr in each st to last 2 sts, htr2tog over these last 2 sts (shoulder edge), turn. *–[–:–:–:97:99:–] sts.*
Work 3 rows straight.
Next row: Ch2, 1htr in each st to last 2 sts, htr2tog over these last 2 sts (shoulder edge), turn. *–[–:–:96:98:–] sts.*
Dec as above st shoulder edge on every following 4th row 5 times more. *–[–:–: 91:93:–] sts.*
Work 2 rows straight.

Sizes XXXXL only
Next row (dec): Ch2, 1htr in each st to last 2 sts, htr2tog over these last 2 sts (shoulder edge), turn. *–[–:–:–:–:103] sts.*
Work 4 rows straight.
Next row: Ch2, htr2tog over next 2 sts (shoulder edge), htr in each st to end, turn. *–[–:–:–:–:102] sts.*
Dec at shoulder edge on every following 5th row 5 times more. *–[–:–:–:–:97] sts.*
Work 2 rows straight.

All sizes
Fasten off.***

Front

Using 5mm (US H/8) hook, ch83[87:89:93: 95:99].
Change to 4mm (US G/6) hook.
Foundation row (RS): 1htr in 3rd ch from hook, 1htr in each ch to end, turn. *81[85:87:91:93:97] sts.*
Row 1: Ch2 (not counted as st here and throughout), 1htr in each st to end, turn.

Shape left shoulder
Work as given for right shoulder on back from ** to **, ending with WS facing for next row. *88[92:94:98:100:104] sts.*

Shape neck
Next row (2 st dec): Ch2, 1htr in each st to last 2 sts, turn. *86[90:92:96:98:102] sts.*
Dec 1 st at neck edge on next 8 rows. *78[82:84:88:90:94] sts.*
Work 10[12:14:14:16:16] rows straight, ending with RS facing for next row.
Inc 1 st at neck edge on next 8 rows. *86[90:92:96:98:102] sts.*
Next row (RS, 2 sts inc): Ch2, 2htr in 1st st, 1htr in each st to end, turn. *88[92:94:98:100:104] sts.*
Work 0[2:4:2:4:2] rows straight.

Shape right shoulder
Work as given for left shoulder on back from *** to ***.

Sleeves (make 2 the same)
Using 5mm (US H/8) hook and ball made for sleeves, ch27[29:31:31:33:33].
Change to 4mm (US G/6) hook.
Foundation row (RS): 1htr in 3rd ch from hook, 1htr in each ch to end, turn. *25[27:29:29:31:31] sts.*
Row 1: Ch2 (not counted as st here and throughout), 1htr in each st to end, turn.
Repeat last row until sleeve meas 38[40:42: 44:46:48]cm (15[16:16½:17¼:18:19] in) from start.
Fasten off.

To finish
Join both shoulders with WS of work tog by matching markers on back with front shoulders using 3.5mm (US E/4) hook and any colour rejoin yarn at start of shoulder and work as follows:
Ch1, then work row of dc through both layers. The seam is on the outside (RS) of work.
Place markers 19[20:21:22:23:24]cm (7½[8:8¼:8¾:9:9½] in) down from shoulder on back and front to show start of armholes.

Pin sleeves between armhole markers with WS tog. Rejoin any colour yarn, ch1, then work a row of dc through both layers. The seam is on the outside (RS) of work. Join side and sleeve seams using same method.

Neckband

With RS facing, 3.75mm (US 5) circular needle, and **B**, and starting at left shoulder, pick up and knit 15 sts down left front neck, 18[18:22:22:24:24] sts across front neck, 15 sts up right front neck and 44[46:52:52:54:54] sts across back neck, place marker to show start of round. *92[92:104:104:108:108] sts.*
Work k1, p1 rib in rounds in following colours:
10 rounds **B**, ending at marker.
2 rounds **A**, ending at marker.
9 rounds **B**, ending at marker.
Cast off (bind off) in rib.

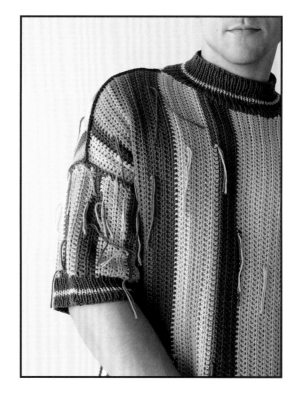

Cuffs

With RS facing, 3.75mm (US 5) circular needle and **B**, and starting at underarm seam pick up and knit 80[84:88:92:96:100] sts evenly around sleeve, place marker to show start of round.
Work in k1, p1 rib in rounds in following colours:
5 rows **B**, ending at marker.
2 rows **A**, ending at marker.
4 rows **B**, ending at marker.
Cast off (bind off) in rib.

Only weave in the yarn ends used for joining the garment and knitting the collar and cuffs.
Leave the knots made when making up the balls of yarn at the start of your work to show on RS of sweater.

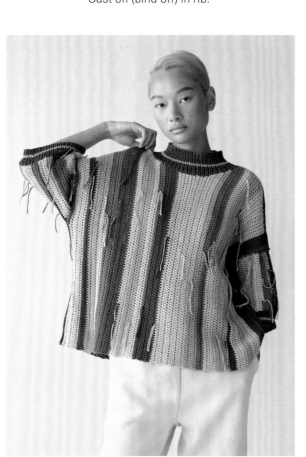

Masterclass

Winding yarn for stripes

This method of cutting up and then rejoining coloured yarns creates random stripes as you work, meaning that no two versions of this pattern will ever be the same. Your garment will be utterly unique to you. Once you've completed your project, you can either leave the knotted ends showing on the right side of the garment or poke them through to the wrong side to hide them.

Cut your chosen yarns into various lengths. Using a simple overhand knot, randomly tie two different coloured lengths of yarn together. Wind the knotted yarns into one multi-coloured ball ready to start crocheting.

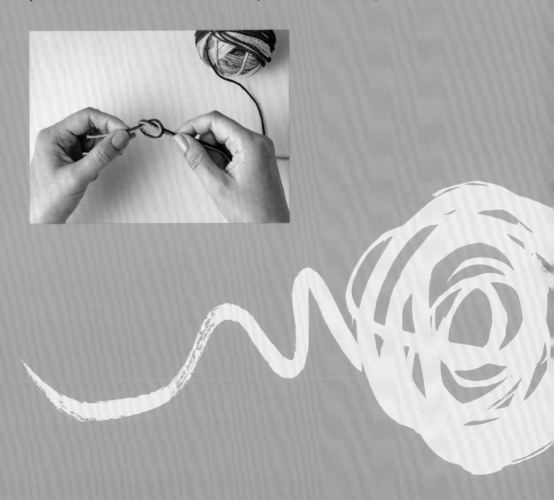

Plant Pots

I am a real plant lover, and have houseplants everywhere in our home, so love the idea of making woolly jumpers for them. These plant pot covers are made using a crochet stitch that mimics a knit stitch and uses three ends of yarn held together to create a super chunky colour-marl effect. Another great stash-busting project to use up scraps from other makes, you'll soon find other uses for these practical holders – keep pens and crayons tidy on your desk, keep on a shelf by the front door for keys and other bits and bobs, or even contain your cosmetics on your dressing table.

Measurements
Small: Approx. 10cm (4 in) diameter x 9cm (3½ in) tall
Medium: Approx. 12cm (4¾ in) diameter x 12cm (4¾ in) tall
Large: Approx. 18cm (7 in) diameter x 16cm (6¾ in) tall

What you will need
- MWL The Chunky One
 100% merino wool
 65m (71 yards) per 100g (3½ oz)
Quantity:
Small
- **A** 1 x 100g (3½ oz) ball in Lychee White
- **B** 1 x 100g (3½ oz) ball in Dustin Lance Black

Medium
- **B** 1 x 100g (3½ oz) ball in Dustin Lance Black
- **C** 1 x 100g (3½ oz) ball in Jump Pink
- **D** 1 x 100g (3½ oz) ball in Gold Medal
Large
- **B** 1 x 100g (3½ oz) ball in Dustin Lance Black
- **D** 1 x 100g (3½ oz) ball in Gold Medal
- **E** 1 x 100g (3½ oz) ball in Cinnamon Swirl
- 20mm (US S) crochet hook
- Stitch marker
- Yarn needle

Tension (gauge)
5 sts and 6 rows to 10cm (4 in) over patt with three yarn strands held together on 20mm (US S) hook, or size required to achieve the correct tension (gauge).

Abbreviations
See page 229.
Knit stitch (also called waistcoat stitch): This stitch is just like a regular dc but instead of working the dc into the top two loops of the dc you work it through the two front vertical posts of the dc.

Notes
Three yarn strands held together for pot. The small pot has two strands of A and one strand of B held together.
The medium and large pots have one strand of each of 3 colours held together.
All pots are worked in a continuous round. Place a marker on last st of round and move it up as you work.

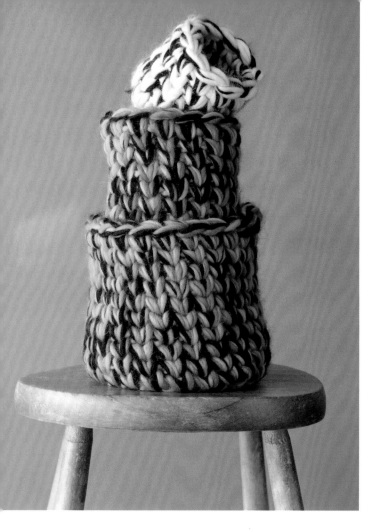

Medium pot

Using 1 strand each of **B**, **C** and **D** held together, ch4 and join with a sl st in 1st ch to form a ring.
Foundation round (RS): Ch1, 6dc in ring, place marker on last dc. *6 sts.*
Round 1: 2dc in each st to end of round. *12 sts.*
Round 2: *1dc in next st, 2dc in next st, rep from * to end of round. *18 sts.*
Round 3: 1dc in each st to end of round. Continue in knit stitch (see Notes) as follows:
Round 4: 1 knit st in each st to end of round. Repeat last round 6 times more.
Fasten off.

Large pot

Using 1 strand each of **B**, **D** and **E** held together, ch4 and join with a sl st in 1st ch to form a ring.
Foundation round (RS): Ch1, 6dc in ring, place marker on last dc. *6 sts.*
Round 1: 2dc in each st to end of round. *12 sts.*
Round 2: *1dc in next st, 2dc in next st, rep from * to end of round. *18 sts.*
Round 3: *1dc in each of next 2 sts, 2dc in next st, rep from * to end of round. *24 sts.*
Round 4: 1dc in each st to end of round. Continue in knit stitch (see Notes) as follows:
Round 5: 1 knit st in each st to end of round. Repeat last round 9 times more.
Fasten off.

To finish all sizes

Weave in any yarn ends.

To make

Small pot

Using 2 strands of **A** and 1 of **B** held together, ch4 and join with a sl st in 1st ch to form a ring.
Foundation row (RS): Ch1, 6dc in ring, place marker on last dc. *6 sts.*
Round 1: 2dc in each st to end of round. *12 sts.*
Round 2: 1dc in each st to end of round. Continue in knit stitch (see Notes) as follows:
Round 3: 1 knit st in each st to end of round.
Repeat last round 4 times more.
Fasten off.

Masterclass

Working with two or more yarns at the same time

You can create interesting colours or textural effects in your knitting or crochet by using two or more yarns held together at the same time as if you were knitting or crocheting with a single yarn. You simply hold the yarns together as one and get going with your pattern as usual. For the best results always work a tension or gauge swatch first so you know exactly how many stitches you need and which size needles or hook to use for your chosen pattern. Remember that using more than one yarn at a time will change the weight of yarn, making it thicker. In terms of yarn size, this is a rough guide:

- Two strands of super fine weight (1) = one strand of fine weight (2)
- Two strands of fine weight (2) = one strand of light worsted weight (3)
- Two strands of light worsted weight (3) = one strand of worsted weight (4)
- Two strands of worsted weight (4) = one strand of bulky weight (5)
- Two strands of bulky weight (5) = one strand of super bulky (6)

If you knit or crochet with two yarns of contrasting colour, you will be left with a speckled or tweedy looking fabric and this effect is called marl. This can be used to emphasise shape and form because it can add real depth to your fabric and you can also create ombre patterns. You can also turn any regular pattern into a marled effect by using two thinner strands of yarn, so the result has the same gauge as the original pattern. Mix and match different colours to get the results that you love the look of.

A contrast in texture of the yarns can create interesting results too, so you can add a fluffy mohair yarn to a smooth wool yarn or a silky yarn with a novelty yarn – the combinations are endless.

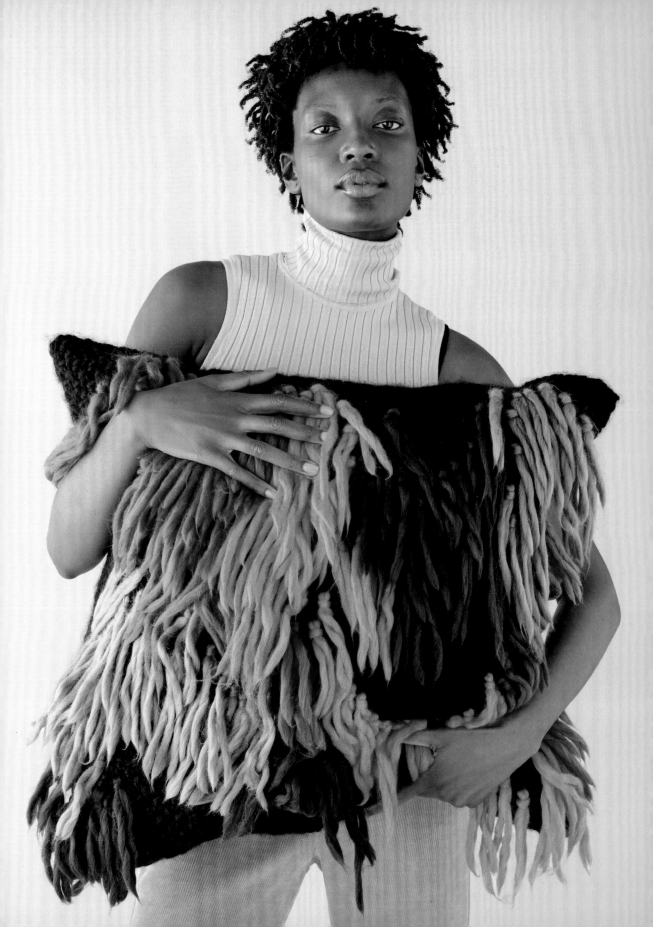

Shaggy Cushion

Is it a monster? Is it a pet? No, it's a cushion! Brighten up your space with this bold and fun homeware item. It has a retro feel with shaggy fringes in random patches of colour to add textural interest and is a great way to add a splash of colour to your living space without investing in all-new decoration. It might look complicated, but this is a great beginner's crochet project. What are you waiting for?

Measurements
One size
Approx. 60cm (23¾ in) x 60cm (23¾ in)

What you will need
- MWL The Chunky One
 100% merino wool
 65m (71 yards) per 100g (3½ oz)

Quantity:
- **A** 8 x 100g (3½ oz) balls in Dustin Lance Black
- **B** 1 x 100g (3½ oz) balls in Damson in Distress
- **C** 1 x 100g (3½ oz) balls in Jump Pink
- **D** 1 x 100g (3½ oz) balls in Toweling Teal
- **E** 1 x 100g (3½ oz) balls in Tokyo Blue

- 10mm (US N/15) crochet hook
- 60cm (23¾ in) square cushion pad (pillow insert)
- Yarn needle

Tension (gauge)
Approx (5dc + ch1) and 10 rows to 10cm (4 in) over patt using 10mm (US N/15) hook, or size required to achieve the correct tension (gauge).

Abbreviations
See page 229.

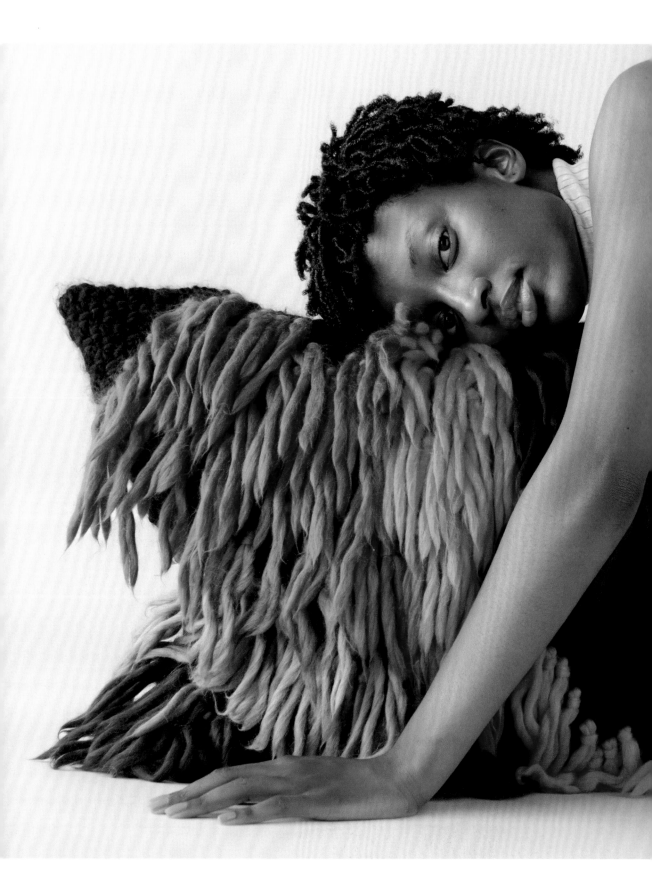

To make

Back and front
(both alike)

Using 10mm (US N/15) hook and **A**, ch62.
Row 1 (RS): 1dc in 3rd ch from hook, *1ch, miss next ch, 1dc in next ch, rep from * to end of row, turn.
Row 2: 1ch (counts as 1st dc), 1dc in 1st ch1-sp, *1ch, 1dc in next ch1-sp, rep from * to last sp, 1ch, 1dc in turning ch, turn.
Repeat Row 2 until work meas 60cm (23¾ in). Fasten off.

To finish

Weave in any yarn ends.

Add fringing
(on one side of cushion only)

Add to one side of cushion only, using photograph as a guide to colour placement, or create your own pattern. Cut scraps of contrast colour yarns (**B, C, D, E**) into lengths of approx. 22cm (8¾ in) long. For each fringe, take a length of yarn and fold in half. Push crochet hook horizontally through the first dc. Using the crochet hook pull the folded yarn down half-way through the stitch, then take the loop and pull the ends through to secure. Repeat in random patches of colour using the photograph as a guide, if you wish. Trim each fringe to neaten to approx 10cm (4 in), or as desired.

With RS of work together, pin around three sides. Backstitch round these three sides being careful not to catch the loops in the seam as you work. Turn RS out. Insert the cushion pad (pillow insert) and join the final seam with whip stitch.

Alphabet Bunting

Handmade bunting adds a heartfelt touch. Here is an entire alphabet of lower-case letters, plus a cute heart motif, that can be crocheted individually or in multiples to combine into bunting for any occasion. Imagine 'happy birthday to you' in crochet letters pegged onto a string for family birthdays – whether draped across the wall at a kid's party or strung between two trees in the park for an outdoor gathering. But don't stop there – choose a single letter, or a whole word, and add to a gift tag, make into a keyring, or appliqué onto a sweater, t-shirt, or cushion for a really personal touch.

Measurements
Letters Approx 11cm (4¼ in) tall
Heart Approx. 8cm (3¼ in) tall

What you will need
- Kremke Soul Wool Karma Cotton
 70% cotton, 30% recycled polyamide
 105m (115 yards) per 50g (1¾ oz)
Quantity:
- **A** 1 x 50g (1¾ oz) ball in Orange (04)
- **B** 1 x 50g (1¾ oz) ball in Aquamarine (15)
- **C** 1 x 50g (1¾ oz) ball in Violet (19)
- **D** 1 x 50g (1¾ oz) ball in Lime (9)
- **E** 1 x 50g (1¾ oz) ball in Deep Pink (6)
- **F** 1 x 50g (1¾ oz) ball in Yellow (02)
- 4mm (US G/6) crochet hook
- Yarn needle

Tension (gauge)
An exact tension (gauge) is not critical for this project.

Abbreviations
See page 229.

To make

Individual letters

a

Foundation row: Ch49, turn.
Round 1: Working in 2nd st from hook, 7dc, (sk1, 1dc) 5 times, 29dc, 3dc in end st, now work along other side of foundation chain, 45dc, 2dc in last st, ch1, turn.
Round 2: Working in 2nd st from hook, 6dc, (2dc in next st, 1dc) 6 times, 6dc, sl1, ch5, working in 2nd st from hook, 4dc, start working in dc next to bottom of ch5, 7dc, (2dc in next st, 1dc) 5 times, 2dc (2dc in next st) 3 times, 4dc, (sk1, 1dc) 4 times, sl1 through next st and through 1st st of crossbar of "a" (this is at beg of row as it curls into place), making sure work is not twisted. Do not turn.
Round 3: 29dc, sl1, 2dc, (2dc in next st) 3 times, 16dc, (2dc in next st, 1dc) twice, 9dc, (2dc in next st) 3 times, sk1, sl1, cut yarn and draw through loop on hook to finish. Sew row ends of crossbar in place.

b

Foundation row: Ch24, join to first dc with a sl st, ch1.
Round 1: 24dc, join to first ch with a sl st, ch7, turn.
Round 2: Working in 2nd st from hook, 6dc along ch7, 6dc, (2dc in next st, 1dc) 3 times, 7dc, (2dc in next st, 1dc) 3 times, sk1.
Round 3: Sl2, (working along ch7) 4dc, 3dc in end st, 35dc, sk1.
Round 4: Sk2, 3dc, (2dc in next st) 3 times, 13dc, ch5, working in 2nd st from hook, 3dc, sk1, sl1, 2dc, (2dc in next st, 1dc) 3 times, 2dc in next st, 6dc, (2dc in next st, 1dc) 3 times, sl1, sk1, 4dc, (2dc in next st) 3 times, 17dc, 3dc in end st, sk1, sl1, 28dc, sk1, sl1, cut yarn and draw through loop on hook to finish.

c

Foundation row: Ch34, turn.
Round 1: working into 2nd st from hook, dc32, dc3 into next st, dc32, dc3 into end st, dc1, (sk1, dc1) 7 times, dc6, (sk1, dc1)

7 times, dc3 into next st
Round 2: dc3, (dc2 into next st, dc1) twice, dc19, (dc2 into next st, dc1) twice, dc2, dc2 into next 3 sts
Round 3: dc19, dc2 into next 3 sts, dc37, dc2 into next 3 sts, slip 1, cut yarn and draw through loop on hook to finish.

Foundation row: Ch34, turn.
Round 1: Working in 2nd st from hook, 32dc, 3dc in next st, now work along other side of foundation chain, 32dc, 3dc in end st, 1dc, (sk1, 1dc) 7 times, 6dc, (sk1, 1dc) 7 times, 3dc in next st.
Round 2: 3dc, (2dc in next st, 1dc) twice, 19dc, (2dc in next st, 1dc) twice, 3dc, 2dc in next 3 sts.
Round 3: 20dc, 2dc in next 3 sts, 37dc, 2dc in next 3 sts, sl1, cut yarn and draw through loop on hook to finish.

d

Foundation row: Ch24, join to first ch with sl1.
Round 1: 24dc, ch1, (2dc in next st, 1dc) 12 times, sl1 in ch1 at beg of round.
Round 2: 36dc, sl2, ch9, working in 2nd st from hook, 7dc, sk1, sl1 in next st of previous round, (2dc in next st, 2dc) 9 times, sl1, ch5, working in 2nd st from hook, 3dc, sl1 in next st of previous row, 6dc.
Round 3: Working along ch9, sk1, 6dc, 3dc in end st, 5dc, sk2, sl1, 30dc, sk1, sl1, sk2, 2dc, 3dc in end st, 3dc, sk1, sl1, 11dc, (2dc in next st) 3 times, 4dc, sk2, sl2, [5dc, (2dc in next st, 2dc) twice] twice, 10dc, sl1, cut yarn and draw through loop on hook to finish.

e

Foundation row: Ch47, turn.
Round 1: Working in 2nd stitch from hook, 7dc, (sk1, 1dc) 5 times, 29dc, 3dc in end st, now work along other side of foundation chain, 46dc, 2dc in last st, ch1, turn.
Round 2: Working in 2nd st from hook, 6dc, (2dc in next st, 1dc) 6 times, 27dc, (2dc in next st) 3 times, 1dc, (sk1, 1dc) 9 times, sl1 through next st and through 1st st of

crossbar of "e", making sure work is not twisted.

Round 3: 40dc, (2dc in next st, 1dc) 6 times, (2dc in next st) 3 times, dc through next st and 7th st of crossbar of "e" with a sl st, cut yarn and draw through loop on hook to finish. Sew row ends of crossbar in place.

f

Foundation row: Ch24, turn.

Round 1: Working in 2nd st from hook, 22dc, 3dc in end st, now work along other side of foundation chain, 22dc, 3dc in end st.

Round 2: 8dc, ch5, working in 2nd st from hook, 3dc, sl1, 1dc in st next to ch5, 1dc, (sk1, 1dc) 6 times, (2dc in next st) 3 times, 22dc, (2dc in next st) 3 times, 6dc, sl1, sk1, 3dc, 3dc in end st, 2dc, sl1, sk1, 3dc, sk1, 1dc, sk1, sl1, cut yarn and draw through loop on hook to finish.

g

Foundation row: Ch45, turn.

Round 1: Working in 2nd stitch from hook, 43dc, ch1, turn, working in 3rd st from hook, 32dc, (2dc in next st, 1dc) 4 times, 2dc in next 3 sts, sl1 in 17th st from far end, making sure work is not twisted.

Round 2: 4dc, (sk1, 1dc) 5 times, 1dc, (2dc in next st) 3 times, 22dc, sl1, ch5, working in 2nd st from hook, 2dc, sk1, sl1, dc in st next to ch5, (2dc in next st, 2dc) 7 times, 2dc in next st, sk2, sl1 attaching to crossbar.

Round 3: 2dc, (sk1, 1dc) 3 times, 1dc, (2dc in next st, 1dc) twice, 5dc, (2dc in next st, 2dc) twice, 11dc, sk1, sl1, 2dc, 3dc in st at top, 2dc, sk1, 7dc, (2dc in next st, 2dc) 6 times, 3dc, sk1, sl1, cut yarn and draw through loop on hook to finish.
Sew row ends of crossbar in place.

h

Foundation row: Ch28, turn.

Round 1: Working in 2nd st from hook, 18dc, sl1, turn, 1dc in 1st st from hook, ch8, turn, working in 2nd st from hook, 7dc, 2dc in next st, 8dc (remaining foundation chs), 3dc in end st, turn, now work along other

side of foundation chain, 6dc, (sk1, 1dc) 5 times, 8dc, 3dc in last st.

Round 2: 8dc, (2dc in next st, 1dc) 4 times, sk1, 6dc down other side of ch8, 3dc in end st, 7dc, sk1, 4dc, sk1, 3dc, 3dc in next 3 sts.

Round 3: 8dc, (sk1, 1dc) 3 times, 6dc, 2dc in next 3 sts, 19dc, sl1, sk1, 5dc, (2dc in next st) 3 times, 13dc, sk1, sl1, cut yarn and draw through loop on hook to finish.

i

(for "dot")

Foundation row: Ch3, join with slip st, ch1.

Round 1: 6dc in 'ring', sl st to 1st dc, ch1.

Round 2: (2dc in each st) 6 times, sl st to ch1, ch1. *12 sts.*

Round 3: 12dc, sl st to ch1, cut yarn and draw through loop on hook to finish.

(for "stem")

Foundation row: Ch14.

Round 1: Working in 2nd st from hook, 12dc, 3dc in next st, now work along other side of foundation chain, 12dc, 3dc in end st.

Round 2: 12dc, 2dc in next 3 sts, 12dc, 2dc in next 3 sts.

Round 3: 33dc, sl1, cut yarn and draw through loop on hook to finish.
Attach dot to top of stem.

j

(for "dot")

Foundation row: Ch3, join with sl st, ch1.

Round 1: 6dc in 'ring', sl st to 1st dc, ch1.

Round 2: (2dc in each st) 6 times, sl st to ch1, ch1. *12 sts.*

Round 3: 12dc, sl st to ch1, cut yarn and draw through loop on hook to finish.

(for "stem")

Foundation row: Ch16, turn.

Round 1: Working in 2nd st from hook, 14dc, 3dc in end st, now work along other side of foundation chain, 14dc, 3dc in end st.

Round 2: 3dc, 2dc in next 3 sts, 8dc, 2dc in next 3 sts, 5dc, (sk1, 1dc) 4 times, 5dc, 2dc in next 3 sts.

Round 3: 32dc, sl1, cut yarn and draw through loop on hook to finish.
Attach dot to top of stem.

k

Foundation row: Ch20, turn.
Round 1: Working in 2nd st from hook, 18dc, 3dc in last st, now work along other side of foundation chain 6dc, sl1, ch12, working in 2nd st from hook, 11dc (*), 1dc in same place last st of previous 6dc, ch13, working in 2nd st from hook, 12dc, sl1 in dc at base of last dc of 12dc (*), now work along rem ch on other side of foundation chain sk1, 9dc, 3dc in next st, 18dc, (2dc in next st) 3 times.
Round 2: 4dc, sl1, sk4, sl1, sk1, 7dc working in other side of ch, 3dc in next st, 9dc, sl1, sk4, sl1, 8dc working in other side of ch, 3dc in next st, 8dc, sl1, sk4, sl1, 8dc, (2dc in next st) 3 times, 19dc, sl1, cut yarn and draw through loop on hook to finish.

l

Foundation row: Ch24, turn.
Round 1: Working in 2nd st from hook, 22dc, 3dc in end st, now work along other side of foundation chain 22dc, 3dc in end st.
Round 2: 7dc, 2dc in next 3 sts, 12dc, (2dc in next st, 1dc) 5 times, 2dc in next 3 sts, 2dc, (sk1, 1dc) twice, 6dc, 2dc in next 3 sts, sl1, cut yarn and draw through loop on hook to finish.

m

Foundation row: Ch40, turn.
Round 1: Working in 2nd st from hook, 15dc, ch24, turn, working in 2nd st from hook, 23dc, 23dc along original foundation chain, 3dc in end stitch.
Round 2: Now work along other side of foundation chain 12dc, (sk1, 1dc) 7 times, 10dc, 3dc in end st, 12dc, (sk1, 1dc) 7 times, 12dc, 3dc in end st, 15dc, (2dc in next st, 1dc) 3 times, (1dc, sk1) twice, (1dc, 2dc in next st) 3 times, ch4, turn, working in 2nd st from hook, 3dc, dc in base of last dc before ch4, 15dc, 3dc in end st.
Round 3: 10dc, (sk1, 1dc) 5 times, 10dc, (2dc in next st) 3 times, 10dc, (sk1, 1dc) 5 times, 11dc, (2dc in next st) 3 times, 23dc, sk1, sl1, 30dc, sl1, cut yarn and draw through loop on hook to finish.

n

Foundation row: Ch36, turn.
Round 1: Working in 2nd st from hook, ch34, 3dc in next st, now work along other side of foundation chain 11dc, (2dc in next st, 1dc) 4 times, 1dc, ch5, working in 2nd st from hook, 3dc, sl1 in base of ch5, 2dc in next st, 13dc, 3dc in end st, 13dc, (sk1, 2dc) 4 times, 10dc, (2dc in next st) 3 times.
Round 2: 23dc, sl1, sk1, 3dc, 3dc in end st, 2dc, sl1, sk1, sl1, 13dc, (2dc in next st) 3 times, 10dc, (sk1, 2dc) 4 times, 10dc, sl1, cut yarn and draw through loop on hook to finish.

o

Foundation row: Ch30, join to 1st ch with sl st making sure work is not twisted, ch1.
Round 1: 30dc, join to ch1 from previous round with a sl st, ch1.
Round 2: 10dc, (2dc in next st, 1dc) 3 times, 8dc, (2dc in next st, 1dc) 3 times, sl st to 1st dc, ch1. *36 sts.*
Round 3: 36dc, sl st to 1st dc, ch1.
Round 4: (2dc into next st, 2dc) 12 times, sl st to 1st dc, ch1. *48 sts.*
Round 5: Dc to end of round, sl1, cut yarn and draw through loop on hook to finish.

p

Foundation row: Ch24, join to 1st ch with sl1.
Round 1: 24dc, ch1, (2dc in next st, 1dc) 12 times, sl1 in ch1 at beg of round.
Round 2: Sl3, ch9, working in 2nd st from hook, 7dc, sk1, sl1 in next st from previous round, (2dc in next st, 2dc) 9 times, sl1, ch5, working in 2nd st from hook, 3dc, sl1 in next st of previous row, 8dc.
Round 3: Working along ch9, 7dc, 3dc in end st, 5dc, sk2, sl1, 30dc, sk1, sl1, sk2, 2dc, 3dc in end st, 3dc, sk1, sl1, 15dc, (2dc in next st) 3 times, 4dc, sk2, sl2, [5dc, (2dc in next st, 2dc) twice] twice, 5dc, sl1, cut yarn and draw through loop on hook to finish.

q

Foundation row: Ch24, join to 1st ch with a sl st, ch1.
Round 1: 24dc, join to 1st ch with a sl st, ch7, turn.

Round 2: Sl2, (working along ch7) 4dc, 3dc in end st, 1dc, ch5, turn, working in 2nd st from hook, 3dc, sk1, sl1, 13dc, ch5, turn, working in 2nd st from hook, 3dc, sl1, sk1, sl1, 19dc, sl1, sk2, sk1, 4dc, 2dc in next 2 sts, sk1, 3dc, 3dc in next st, 2dc, sl1, sk2, sl1, 11dc, sl1, 2dc, 3dc in end st, 2dc, sl1, sk2, sl1, 3dc, (2dc in next st, 1dc) 3 times, 3dc, (2dc in next st, 1dc) 3 times, sl2, turn.
Round 4: Sk2, 21dc, sl1, cut yarn and draw through loop on hook to finish.

r
Foundation row: Ch26, turn.
Round 1: Working in 2nd st from hook, 24dc, 3dc in end st, 10dc, (sk1, 1dc) 6 times, 2dc, 3dc in end st.
Round 2: 10dc, sl1, ch5, working in 2nd st from hook, 3dc, sk1, sl1 in st next to base of ch5, 12dc, (2dc in next st) 3 times.
Round 3: 15dc, sk1, 1dc, sk1, 2dc in next 3 sts, (1dc, 2dc in next st) 4 times, sl1, sk1, 3dc, 3dc in next st, 3dc, sk1, 14dc, sl1, cut yarn and draw through loop on hook to finish.

s
Foundation row: Ch40, turn.
Round 1: Working in 2nd st from hook, 1dc, (2dc in next st, 1dc) 3 times, 23dc, (sk1, 1dc) 3 times, 2dc in last st, 8dc, (2dc in next st, 1dc) 5 times, 3dc, (sk1, 1dc) 5 times, 6dc, 3dc in last st.
Round 2: 7dc, (2dc in next st, 1dc) 4 times, 6dc, (sk1, 1dc) 4 times, 9dc, 2dc in next 3 sts.
Round 3: 26dc, (sk1, 1dc) 4 times, 4dc, 2dc in next 3 sts, 26dc, (sk1, 1dc) 4 times, 5dc, sl1, cut yarn and draw through loop on hook to finish.

t
Foundation row: Ch24, turn.
Round 1: Working in 2nd st from hook, 22dc, 3dc in end st now work along other side of foundation chain, 22dc, 3dc in end st.
Round 2: 3dc, (sk1, 1dc) 6 times, 3dc, ch5, turn, working in 2nd st from hook, 3dc, sl1, 1dc in st next to ch5, 2dc, 2dc in next 3 sts.
Round 3: 12dc, (2dc in next st, 1dc) 5 times, 2dc in next 3 sts, 2dc, (sk1, 1dc) twice, 5dc, sl1, sk1, 3dc, 3dc in end st, 2dc,

sl1, sk1, 3dc, 2dc in next 3 sts, sl1, cut yarn and draw through loop on hook to finish.

u
Foundation row: Ch36, turn.
Round 1: Working in 2nd st from hook, ch34, 3dc in next st, 11dc, (2dc in next st, 1dc) 6 times, 10dc, 3dc in end st, 13dc, (sk1, 2dc) 4 times, 13dc, (2dc in next st) 3 times.
Round 2: 40dc, (2dc in next st) 3 times, 9dc, (sk1, 2dc) 5 times, 7dc, sl1, cut yarn and draw through loop on hook to finish.

v
Foundation row: Ch33, turn.
Round 1: Working in 2nd st from hook, 14dc, decrease 2 across next 3 sts (push hook through next st, sk1 st, push hook through next st, wrap yarn around hook and pull through all sts on hook), 14dc, 3dc in end st.
Round 2: Now work along other side of foundation chain 15dc, 3dc in end st, 15dc, 2dc in next st, 12dc, decrease 4 across next 5 sts (push hook through next st, sk3 sts, push hook through next st, wrap yarn around hook and pull through all sts on hook), 12dc, 3dc in next 3 sts.
Round 3: (15dc, 2dc in next 3 sts) twice, 10dc, decrease 4 across next 5 sts (push hook through next st, sk3 sts, push hook through next st, wrap yarn around hook and pull through all sts on hook), 10dc, sl1, cut yarn and draw through loop on hook to finish.

w
Foundation row: Ch40, turn.
Round 1: Working in 2nd st from hook, 15dc, ch24, turn, working in 2nd st from hook, 23dc, 23dc along original foundation chain, 3dc in end st.
Round 2: Now work along other side of foundation chain, 12dc, (sk1, 1dc) 7 times, 10dc, 3dc in end st, 12dc, (sk1, 1dc) 7 times, 12dc, 3dc in end st, 8dc, sk2, 7dc, (2dc in next st, 1dc) 3 times, (1dc, skip 1) twice, (1dc, 2dc in next st) 3 times, 15dc, 3dc in end st.
Round 3: 10dc, (sk1, 1dc) 5 times, 10dc, (2dc in next st) 3 times, 10dc, (sk1, 1dc)

5 times, 11dc, (2dc in next st) 3 times, 23dc, sk1, sl1, 24dc, sl1, cut yarn and draw through loop on hook to finish.

x

Foundation row: Ch25, turn.
Round 1: Working in 2nd st from hook, 10dc, sl1, ch12, working in 2nd st from hook, 11dc, sl1, ch12, working in 2nd st from hook, 11dc, sl1 in next st on original foundation row, ch12, 11dc, 3dc in end st.
Round 2: (8dc, sl1, sk4, sl1, 8dc, 3dc in end st) 4 times.
Round 3: (7dc, sl1, sk2, sl1, 7dc, 2dc in next 3 sts) 3 times, 7dc, sl1, sk2, sl1, 7dc, sl1, cut yarn and draw through loop on hook to finish.

y

Foundation row: Ch20, turn.
Round 1: Working in 2nd st from hook, 9dc, sl1, ch10, working in 2nd st from hook, 8dc, sl1 in st next to ch10, 9dc, 3dc in end st.
Round 2: 7dc, sk2, 7dc, 3dc in end st, 8dc, sl1, sk4, sl1, 4dc, (2dc in next st) 3 times.
Round 3: 9dc, sk1, 6dc, 2dc in next 3 sts, 6dc, sl1, 8dc, (2dc in next st) 3 times, 7dc, sl1, 7dc, (2dc in next st) 3 times, 16dc, sl1, cut yarn and draw through loop on hook to finish.

z

Foundation row: Ch40, turn, working in 2nd st from hook, 38dc, 3dc in last st, turn.
Round 1: 9dc, sl1, sk2, sl1, 14dc, 2dc in next 2 sts, 8dc, 3dc in end st.
Round 2: 8dc, sl1, sk2, sl1, 14dc, 2dc in next 2 sts, 10dc, 3dc in end st, 7dc, push hook through next st and following 5th st, wrap yarn and draw through all loops on hook to sl1, 11dc, 2dc in next 3 sts, 7dc, 2dc in next 3 sts, 5dc, push hook through next st and following 7th st, wrap yarn and draw through all loops on hook to sl1, 12dc, 2dc in next 3 sts, 11dc, sl1, cut yarn and draw through loop on hook to finish.

Heart

Using 4mm (US G/6) hook, ch4 and join with sl st to form a ring.
Round 1: Ch3 (counts as 1tr), 2tr in ring, [ch2, 3tr in ring] 3 times, ch2, join with sl st to 3rd ch.
Round 2: Ch3 (counts as 1tr), 1tr between first 2tr, 1tr between next 2tr, [2tr, ch2, 2tr] in corner space, *(1tr between next 2tr) twice, [2tr, ch2, 2tr] in corner space, rep from * once more, (1tr between next 2tr) twice, [2tr, ch2, 1tr] in corner space, sl st to 3rd ch. Fasten off.

Top right section of heart

Rejoin yarn between 3rd and 4th tr of one side and work as follows:
Next round: Ch3 (counts as 1tr), 5tr in same space at bottom of chain, 6dtr in same space. Fasten off.

Top left section of heart

Rejoin yarn between 3rd and 4th tr of next side and work as follows:
Next round: Ch4 (counts as 1dtr), 5dtr in same space at bottom of chain, 6tr in same space. Fasten off.

To finish

With RS facing and using contrast colour, rejoin yarn to ch2-sp at bottom of heart and work as follows:
Ch1, 2dc in same space, 1dc in each of next 6tr, 2dc in next ch2-sp, 1dc in each of next 6tr and 6dtr of right section of heart, 3dc in next ch2-sp, 1dc in each of next 6dtr and 6tr of left section of heart, 2dc in next ch2-sp, 1dc in next 6tr. Join with sl st to 1st ch. Fasten off. Weave in any yarn ends.

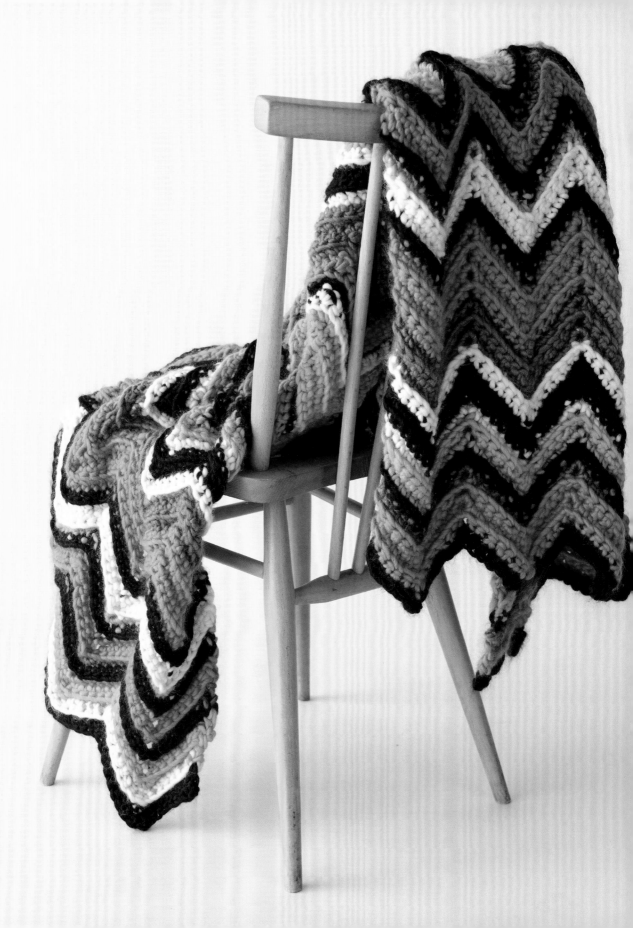

Chevron Throw

A great way to show off your crafty side at home, this throw uses stylish colours in a random stripe repeat. Crocheted in super chunky 100% merino wool for luxurious cosiness, It is reversible, so there is no right or wrong side – just drape it across the sofa, over the end of the bed, on an armchair or around your shoulders.

Measurements
One size
Approx. 105cm (41½ in) wide x 145cm (57 in) long

What you will need
- MWL The Chunky One
 100% merino wool
 65m (71 yards) per 100g (3½ oz)

Quantity:
- **A** 4 x 100g (3½ oz) balls in Dustin Lance Black
- **B** 5 x 100g (3½ oz) balls in Cinnamon Swirl
- **C** 2 x 100g (3½ oz) balls in Toweling Teal
- **D** 3 x 100g (3½ oz) balls in Gold Medal
- **E** 2 x 100g (3½ oz) balls in Lychee White
- 12mm (US P/16) crochet hook
- Yarn needle

Tension (gauge)
16 sts to 17cm (6¾ in) and 10 rows to 20cm (8 in) using 12mm (US P/16) hook, or size required to achieve the correct tension (gauge).

Abbreviations
See page 229.

Special techniques
Creating a ridge stitch (see page 319).

Notes
Join in every new colour on the last stitch of the row and leave a long end when cutting the yarn to weave in when you have finished. To join colour, insert hook in last stitch, yarn around hook with current colour and pull loop through, drop current colour, pick up next colour, yarn around hook with next colour and pull through both loops to complete the dc. Next colour is now on the hook.

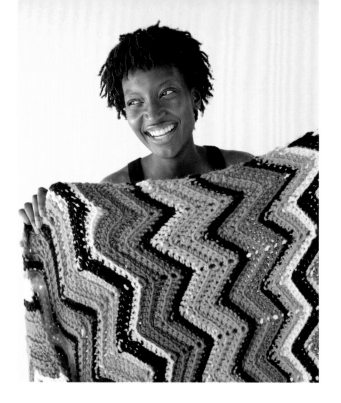

Throw

Using 12mm (US P/16) hook and **A**, ch116 loosely and work as follows:

Row 1 (RS): Insert hook in 3rd ch from hook, yrh and draw through a loop, insert hook in next ch, yrh and draw through a loop, yrh and draw through all 3 loops on hook (counts as first dc3tog), ******1dc into each of next 6 ch, 3dc into next ch, 1dc in each of next 6 ch, *insert hook in next ch, yrh and draw through a loop*, rep from * to * twice more, yrh and draw through all 4 loops on hook (called dc3tog), rep from ** to end. Change to **B** when finishing the last st of row (see Notes), turn.

Note: From this point, insert hook into back loop only of each st throughout and continue in colours as set by 80-row stripe sequence.

Row 2: Ch2, insert hook in st at base of ch2, yrh and draw through a loop, insert hook in next st, yrh and draw through a loop, yrh and draw through all 3 loops on hook (counts as first dc3tog), *1dc in each of next 6 sts, 3dc in next dc, 1dc in each of next 6 sts, dc3tog, rep from * ending last rep by working last step of dc3tog into 2nd of beg ch2 of prev row, turn..

Row 2 is repeated throughout following the stripe sequence. The first 2 rows of the stripe sequence have already been worked. Tick off the rows as you complete them.

To finish

Weave in any yarn ends.

To make

80-row stripe sequence

1 row **A**	1 row **A**
3 rows **B**	1 row **E**
1 row **C**	4 rows **D**
1 row **A**	1 row **A**
2 rows **D**	3 rows **B**
1 row **E**	1 row **C**
2 rows **A**	1 row **A**
1 row **E**	2 rows **D**
3 rows **C**	1 row **E**
4 rows **B**	2 rows **A**
1 row **A**	1 row **E**
2 rows **E**	3 rows **C**
1 row **D**	4 rows **B**
1 row **A**	1 row **A**
2 rows **B**	2 rows **E**
1 row **C**	1 row **D**
1 row **A**	1 row **A**
3 rows **D**	2 rows **B**
1 row **E**	1 row **C**
2 rows **A**	1 row **A**
1 row **E**	3 rows **D**
3 rows **C**	1 row **E**
2 rows **B**	2 rows **A**

Masterclass

Creating a ridge effect

Rather than inserting the hook through both strands at the top of a stitch in the row below to make a new stitch, working into the back strand only makes an attractive ridged line along the row at the front of the work. This is because the front strand that isn't worked is pushed onto the surface of the crochet and becomes a decorative detail. For this throw, the technique of working into the back loop only is used in combination with a series of increases and decreases to create the chevron design with added texture.

One Looking at the rope of chains that sit on the top of the row just completed, identify the back strand of the first chain. Whereas you would ordinarily work through both strands, here insert the hook through the back strand only.

Two Finish the stitch as usual. You will see how working through the back strand only as forced the front strand to sit on the surface of the work and has formed a ridge.

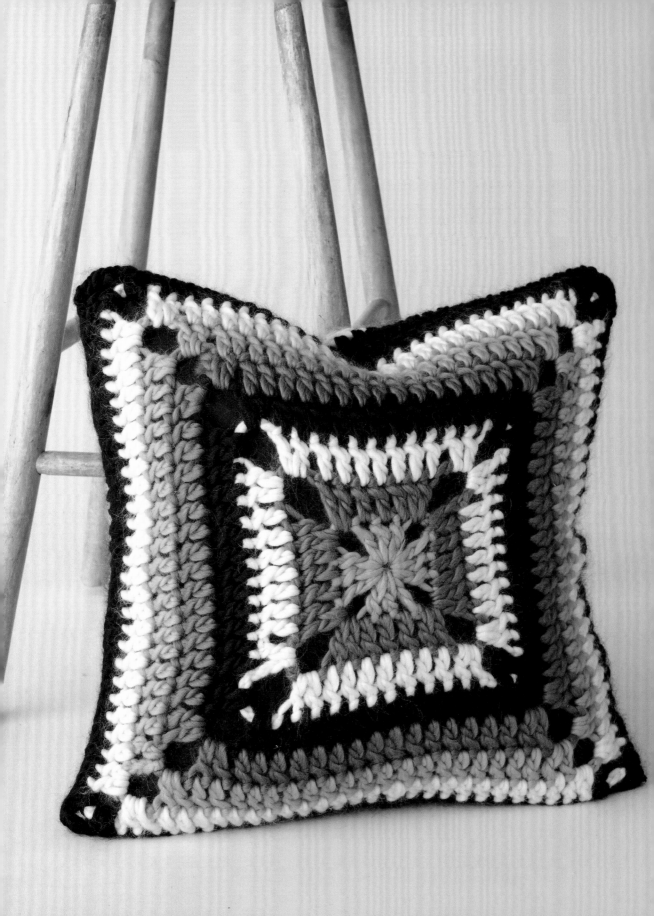

Granny Square Cushion

The ubiquitous granny square is probably one of the best-known crochet patterns and one of the first things I learned how to crochet from a YouTube tutorial. Easy to grasp, this traditional motif takes on a contemporary feel when scaled up to cushion size. Make two, sew them together, and... "ta dah"... a cushion!

Measurements
One size
50cm (19¾ in) x 50cm (19¾ in)

What you will need
- MWL The Chunky One
 100% merino wool
 65m (71 yards) per 100g (3½ oz)
Quantity:
- **A** 1 x 100g (3½ oz) ball in Gold Medal
- **B** 1 x 100g (3½ oz) ball in Toweling Teal
- **C** 1 x 100g (3½ oz) ball in Lychee White
- **D** 1 x 100g (3½ oz) ball in Dustin Lance Black
- 12mm (US P/16) hook
- 50cm (19¾ in) square cushion pad
 (pillow insert)
- Yarn needle

Tension (gauge)
7 tr to 10cm (4 in) and 4 rows to 11cm (4½ in) over patt using 12mm (US P/16) hook, or size required to achieve the correct tension (gauge).

Abbreviations
See page 229.

Special techniques
Joining on a new colour (see page 323).

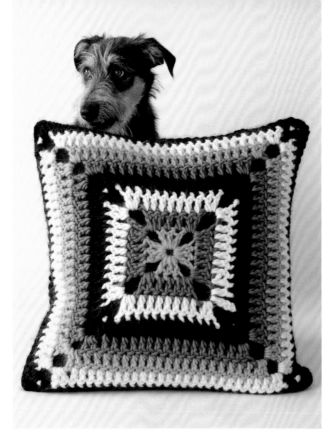

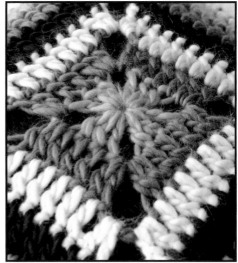

To make

Back and front (both alike)

Base ring: Using 12mm (US P/16) hook and **A**, ch4, join with a sl st in 1st ch to form a ring.

Round 1 (RS): Ch5 (counts as 1tr and 2ch), (3tr in ring, ch2) 3 times, 2tr in ring, join with a sl st to 3rd ch of beg ch5. *4 groups of 3tr and 4 ch2-sps.*
Fasten off.

Round 2: Using **B**, rejoin yarn with a sl st in any corner ch2-sp, ch7 (counts as 1tr and ch4), *2tr in same ch2-sp, 1tr in each tr across side of square to next corner ch2-sp**, 2tr in next ch2-sp, ch4, rep from * twice more and from * to ** again, 1tr in same sp as beg ch7, sl st to 3rd ch of beg ch7. *4 groups of 7tr and 4 ch4-sps.*
Fasten off.

Round 3: Using **C**, as Round 2. *4 groups of 11tr and 4 ch4-sps.*
Fasten off.

Round 4: Using **D**, as Round 2. *4 groups of*

15tr and 4 ch4-sps.
Fasten off.

Round 5: Using **B**, as Round 2. *4 groups of 19tr and 4 ch4-sps.*
Fasten off.

Round 6: Using **A**, as Round 2. *4 groups of 23tr and 4 ch4-sps.*
Fasten off.

Round 7: Using **C**, as Round 2. *4 groups of 27tr and 4 ch4-sps.*
Fasten off.

Round 8: Using **D**, Using D, as Round 2. *4 groups of 31tr and 4 ch4-sps.*
Fasten off.

To finish

Weave in any yarn ends. You may wish to cover your cushion pad (pillow insert) in black fabric, or a contrast colour to show through the spaces in the crochet.
Join three sides of cushion cover using whip stitch. Insert the cushion pad (pillow insert) and close the final seam.

Masterclass

Joining on a new colour

When bringing in a new colour at the beginning of a motif round, fasten off the old colour and join on a new colour with a slip stitch. Joining on the new colour with a slip stitch makes a firm attachment.

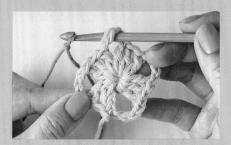

One Make a slip knot with the new colour. Insert the hook at the position on the motif instructed by the pattern and draw the slip knot through.

Two Start the new round with the specified numbers of chains, drawing the first chain through the slip knot.

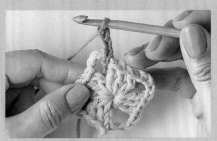

Three Work the stitches of the round over both yarn tails (the new colour and the old colour), so there are fewer ends to darn in later. Alternatively, to reduce bulk, start the new colour in a different place and weave in one tail at a time.

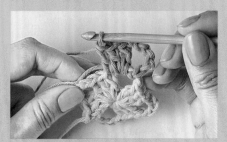

Four When you reach each corner of the previous round, after working the specified number of stitches, remember to work a number of chains to form the corners of the current round.

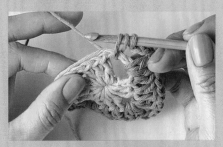

Five When the motif is finished, trim the yarn ends that have been worked over back to neaten, but do not snip them too close to the stitches as that way they would be more likely to unravel.

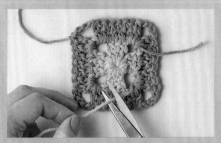

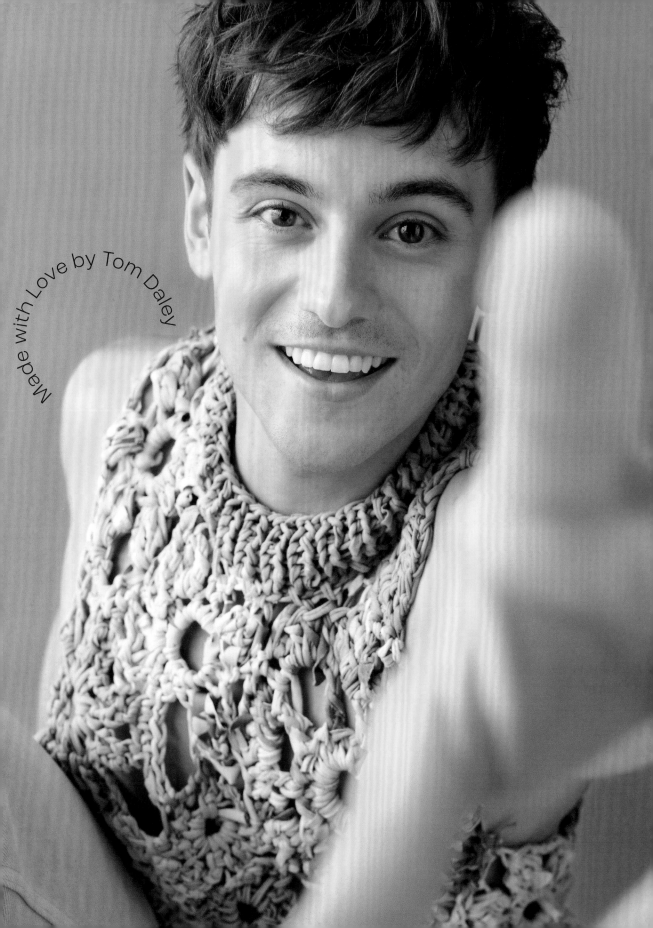

Made with Love by Tom Daley

EMBRACE YOUR

CREATIVITY

Caring For Your Makes

06-

Aftercare

When you've invested so much time
and love in creating a handmade
piece, it is really important
to care for your knitted or
crocheted projects. If they are
properly looked after, they can
last for many, many years to
come – items that you have made
for your kids could be passed
onto their children. Here are
some of the best ways to care
for your knitted and crocheted
pieces once made and worn.

• Laundering

The most important thing with laundering is to check the yarn labels for washing or dry-cleaning instructions. I always keep the label with the yarn care instructions in a drawer or take a photo and keep it on my phone. On the rare occasions that a yarn says that it needs to be dry cleaned, remember to take the label with you to the dry cleaners, so they use the correct solvents on it. If something is labelled as dry clean only, you still may be able to hand wash it with cool water but always check first using a knitted or crocheted swatch to see what happens!

Some yarns, like acrylic or cotton, can go into the washing machine on a cold, gentle wash cycle but most animal fibres will need to be hand-washed in cold water. Never wash a wool item in hot water because this will make it become "felted", so the fabric will become tighter, stiffer and harder, rather than softer or more fluid. Unless this is the effect you are going for, in which case, wash away!

If your item is made up of more than one type of yarn, always use the gentlest method of washing. So, if you have two yarns and one says dry clean only and the other allows for machine washing, always stick to dry cleaning.

Whether hand washing or machine washing, always use a specially formulated wash for wool and other animal fibres or a mild detergent, which is designed for delicate fabrics. Always follow the instructions when it comes to how much wool wash or detergent to add. If something is going in the washing machine, place the detergent in the dispenser drawer rather than directly in the drum, so it does not create any unnecessary friction during the wash cycle that could damage your item.

When you are hand washing an item, use a decent-sized bowl or sink where there is space to submerge your item and for water to go around it easily. Fill the bowl or sink with water, add the wool wash and mix this in properly before adding your item. Be gentle with it – so give it a good dunk and swish the water around it rather than kneading or scrubbing. If the water goes dirty quite quickly, don't be surprised. Hand-wash items are laundered less frequently than machine-wash ones, so they will gather dirt and oils that will quickly leech into the water. If the water becomes murky, you can always drain it away, squeezing your item as you do so. Do not lift the item out of the sink or bowl because the weight of the water can pull it out of shape.

Nowadays, most commercially available yarns are colorfast, but it is always worth doublechecking. Take a length of yarn, wet it thoroughly and then wrap it tightly around a sheet of white paper towel. Leave the yarn to dry, then unwind it from the paper towel. If it has left behind any mark then the yarn is not colorfast.

 Machine-wash on cold cycle

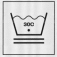 Machine-wash on gentle cycle

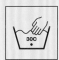 Hand-wash in cold water

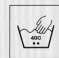 Hand-wash in warm water

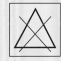 Do not bleach

 Dry-cleanable in any solvent

 Dry-cleanable in certain solvent

 Do not dry-clean

 Do not tumble-dry

 Do not iron

 Iron on a low heat

 Iron on a medium heat

329

Caring For Your Makes

• <u>Removing stains</u>

We all have accidents! In our house, spilling drinks can be a common occurrence. If your knitting or crochet has become stained for any reason, immediately soak up any excess liquid or scrape away any solid matter. Then get some mild detergent on a dishcloth and blot the stain directly with it, as soon after the stain has occurred. Be sure to dab the fabric rather than rubbing, as this can damage the fibres of the fabric. Soak washable garments in cold water for 30 minutes and then rinse as if you were washing and drying normally. Stubborn stains might need to be soaked longer, like overnight.

Different stains may require different treatments – some people swear by white vinegar for getting rid of alcohol and coffee stains, whilst white spirit can work wonders for oily stains.

Always be sure to check that this will not damage the yarn and can be done safely. If your garment is too delicate (or the stain is too stubborn), your local dry cleaners will be able to advise you on the best way of getting a stain out or complete the stain removal for you.

• <u>Rinsing and drying</u>

When you have hand washed any items, rinse them thoroughly in cold water until the water runs clear because this means all soap particles that could matt the fibres or irritate sensitive skin have been washed away. (Some specialist wool washes do not need rinsing out, so check the instructions on the bottle.) Do not wring out or twist the item to get rid of the water, instead gently squeeze out as much moisture as you can. Lift the item from the sink or basin, supporting it from underneath so it doesn't sag, and transfer to a clean dry towel. Roll it up in the towel to press out more water.

Lay the item flat on a second clean dry towel to soak up any moisture, then reshape it by gently patting it out before leaving it somewhere to dry. Do not use hangers because your items might stretch out of shape. You need to dry your item where the air can flow around it easily but away from a direct source of heat like a radiator and out of direct sunlight, so avoid resting items next to windows. Instead, lie flat and ease any garments into their original shape, carefully adjusting any ribbed bands at the waist, cuffs and neckline. Fold down any collars and fasten any buttons. Lay the arms flat. You may need to dry one side and then flip it over to dry the other.

TOM'S TIP:

When you think about washing your sweater, ask yourself whether it could be aired instead. One of the best things about wool is that it stays fresher between washes than garments made of synthetics or cotton. Wool garments don't actually need laundering that frequently if they are well aired and rested between wears, so give them an air instead and use a liberal spritz of clothing mist spray to get rid of any odours and make them smell nice if you want. I read somewhere that "airing is caring", so follow this motto!

When drying larger items like blankets, re-position them frequently so they do not pull out of shape due to the weight of the water. Allow all items to dry for at least 24 hours and larger items will need to be dried for 24 hours on each side.

If any yarn ends work themselves loose during laundering, don't be tempted to simply trim them away as this may lead your work to eventually unravel. Pull any yarn ends all the way out and then sew them in properly again (see pages 88 and 239).

• <u>Ironing</u>

If your item is full of creases and needs to be ironed, proceed with caution! Always check the yarn label first and use the iron on a low setting. If the iron is too hot, this can cause discolouration and, in the worst cases, scorch marks. Avoid this by pressing down very gently on low heat, bearing in mind that most fibres just need a little steam to make the creases fall out of them.

• <u>Pilling</u>

There is nothing more annoying than those little bobbles or balls of fluff that can appear on knitted items over time. It happens when bits of fibre separate from the strand of yarn and then become agitated, so they roll up into little balls and tends to occur in areas where there is a lot of friction, such as the sides of a sweater or around the underarms. Resist the temptation to tug at them because this can pull more of the yarn away from the strand. Instead, comb or brush away or, after going over the item with sticky tape, use a special shaving tool to gently remove them.

TOM'S TIP:

Little hole in your sweater? Don't ignore it! Always repair any holes before washing your item because the friction caused by washing can make any hole bigger. There are different ways to mend a hole, and one of these is visible mending (see page 343).

Caring For Your Makes

• <u>Storing and protecting</u>

Once your items are clean and dry store them carefully. If you are putting heavy wool sweaters away for the summer, the best options are polythene ziplock bags or airtight tubs because this will minimise moisture and reduce the risk of mould, as well as keep moths out. Some people also use cedar balls or dried herbs lavender and sage to repel moths.

Moths love all natural fibres like wool, cashmere, silk and cotton because they contain a special protein called keratin that the larvae use as nutrition. They have also been known to munch on acrylics, even though they hold no nutritional value!

It is really important to launder your items before you put them away. This will get rid of any larvae eggs and stains that would set in after time. It will also banish perspiration stains and natural oils that are like candy to moths!

• <u>Folding</u>

Do you know how to properly fold a sweater? Never hang your knitwear up because it will stretch out of shape. Instead, fold a sweater or cardigan neatly to save space and avoid it having a hard crease down the front.

One: Lay your knitwear on a flat surface, front side facing down. Fold one side into the centre, then one sleeve down at an a angle.

Two: Fold the second side into the centre and take the sleeve down at the same angle. Try to avoid the two sleeves overlapping.

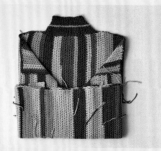

Three: Life the hem of the knitwear and fold the bottom third of the folded sweater up to enclose most of the sleeves.

Four: Lift the shoulders of the knitwear and fold the top third over the rest of the sweater to make a neat package. Job done!

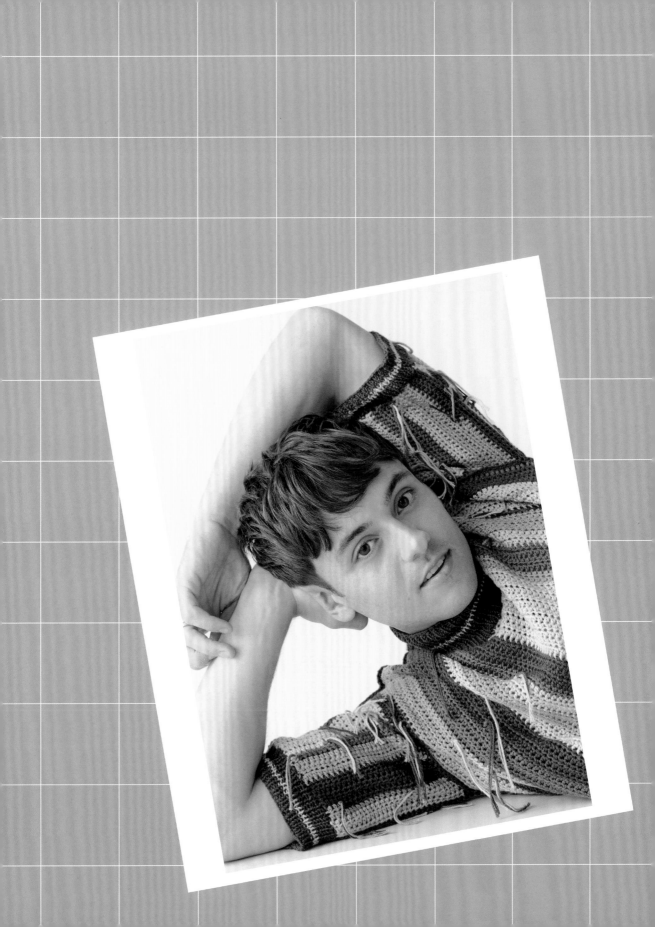

How to...

I love being part of a community of like-minded crafters, where everyone is really supportive and encouraging. Being able to use my social platforms to share ideas and get feedback from followers is amazing. Here are some of the best tips I have picked up that I hope will inspire you in the same way!

Gift your makes

I love giving handknitted or crocheted gifts and always include the yarn label or ball band from the yarn so the recipient knows how to care for it. This is important for the longevity of the make, as some yarns will need to be handwashed (see pages 328–331).

One of the first things I did when I started knitting was to create a school name-style label. It says 'Made with Love by Tom Daley' in rainbow colours. I sent off for a load and now I always put them in items I have made. I hate sewing them in, so I sometimes get my mum to do it for me!

I always fold the item really carefully, wrap it in tissue paper and put it into a suitably sized box. Get creative with the wrapping, maybe by match your gift wrap to your make. I like to use some leftover yarn from the gift instead of a ribbon, but you could make a heart motif, a tassel or an initial letter (see pages 308–315).

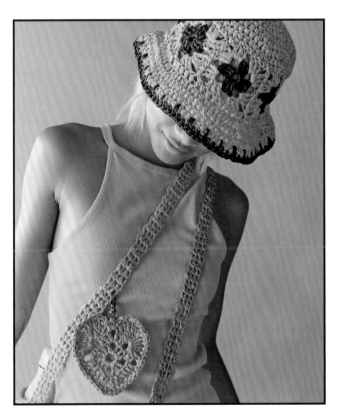

Once I have worn a sweater a few times, but need to make space for new knitwear, I often give it away to someone who I think will love it. If I have loved making it and wearing it, I figure that someone else will too! Why not customise it with embroidery or appliqué or encourage the recipient to do the same (see page 155).

The longer we can keep existing clothes in our wardrobes and out of landfill the better for the planet. Handmade sweaters, blankets and other items can become treasured heirlooms for the next generation, made even more precious knowing that every stitch has been made with love.

Fit knitting or crochet into your day

Life can be busy but one of the great things about knitting and crochet is how portable it is. Here are my tips to make crafting an everyday activity.

Take a portable project with you

If you're working on several projects, keep larger ones at home and choose a smaller and more portable one that you can take with you on the train during your commute, to the office for a few minutes crafting on your lunch break, or even at the side of the pool during a major sporting competition! I find that crochet is especially portable, particularly quick makes like the Friendship Bracelets (see page 252) or motifs like the Heart Keyring (see page 276).

Craft as you travel

I first started knitting on the plane to Canada in 2020. It is such a great way to occupy your mind (and hands) when travelling, which inevitably involves lots of waiting around at airports and stations. Whenever I travel with my synchronised diving partner Matty (Lee), he constantly complains that I am elbowing him in the ribs because I am knitting.

Knit and crochet projects are portable, just make sure you have the right kit and be realistic about what you can complete in the time you have. It's best to leave the complex patterns and colourwork at home. Work on circular needles so your stitches are less likely to slide off the needles during transit. Also, gadgets like knitting point protectors are useful. Always check with your airline first. but generally you're allowed to carry both crochet hooks and knitting needles in cabin and hold luggage. However, only small scissors are allowed in cabin luggage, so choose a neat pair of embroidery ones for your travel kit.

Make it a priority

If you find yourself watching TV most evenings or spending hours scrolling through social media feeds, why not focus on your knitting or crochet instead? Make it a priority and part of your everyday routine and your skills will soon come on in leaps and bounds. It's a great way to keep your hands busy rather than doom scrolling on your phone!

Use it as an incentive

If I have work or chores to do that I have been putting off, I tell myself that once I have completed them, then I can reward myself with a few hours knitting or planning a new project. Invariably I get whatever I need to do completed much more quickly this way. I also use it as a re-set to refresh my mind when going between different parts of my day – like from a meeting with my agent to picking my son up from school. It's a great way to leave work behind and get back to me.

Join a group

I have found the knitting and crochet community to be such an amazing place to hang out. Everyone has something in common, wherever you are from no matter what your age. I think these groups are a great way to dedicate time to knitting and crochet and make some new friends as well. If you can't find a group local to you, why not set one up at home, in your favourite pub or café, or local community space.

Complete every project

Loads of knitters abandon a project halfway through, leading to a high number of UFOs (un-finished objects). This can be demoralising, so I don't distract myself with new yarns or design ideas before I completing the one I am currently working on. Sometimes it's the very last stage of a make, the sewing up, that prevents you from completing a project. In this case – why not learn to knit in the round on circular needles for a seam-free, no-sewing-up-required make – the Leg Warmers (see page 104) or the Top Down Fairisle Sweater (see page 138) are great for this. I love the satisfaction of finishing something I have been working on. It's so rewarding when you can try it on, or gift it to a friend.

Manage your yarn stash

Are you wondering how you can take control of your growing yarn stash? If you're into crafting the chances are you will have lots of yarn. I often buy a bit too much yarn for a project, so I always try to create something from my surplus. Several projects in this book make great stash-busters, including the Friendship Bracelets (see page 252), Heart Keyring (see page 276), Random Stripe Sweater (see page 294) and Plant Pots (see page 300). There are loads of different ways you can manage your yarn, but here are my tips.

Keep it all in one place

This might sound obvious, but it makes sense to have all your yarn stored in one location. You will also need to decide how to keep it – whether that's in clear plastic or wire boxes or somewhere else, like a re-purposed cabinet or bookshelf, or even a spare wall. If, like me, you're running out of room, always make use of vertical wall space. I keep mine in my closet where I have a special circular storage area. Then I have some overflow in wire baskets.

Have somewhere for your WIP

If you have a WIP (work in progress), keep all the yarn and bits 'n' bobs for that project together in one place. I keep mine in my Team Great Knittin' tote bag, so I can carry it around with me when I am on the go.

Decide how to organise it

Group your yarns in whatever way makes the most sense to you: that could be by colour, weight, fibre or brand. If you divide your yarn into boxes in a particular way, they can be labelled, so you can find any yarn more easily. Originally, I sorted my yarns by colour. While liked the fact that I could respond to the colours when starting a new project, I found that wasn't the best way for me. Now it is more random, but that works. It's creative chaos, which leads to some unexpected results. Don't be disheartened if you see Instagram posts of incredible yarn stashes; they never stay that way for long. It's better to use up yarn than to hoard it.

Make balls from loose yarn

If you have lots of loose bits of yarn, these can become tangled really easily, so I've found one of the best ways to stay organised is by making sure all my yarn is in some kind of structure. I like to wind my yarn into balls. Always keep the label so you know what the weight, fibre and care instructions are, the easiest way to do this is to tuck the label into the ball. This is a great opportunity to take an inventory of what you have, so you can start planning what you can make with this yarn – like a random stripe sweater (see page 294) or pompoms for a dog hat (see page 188). If you don't think you will use it, gift it to another crafter or donate it to a charity shop, retirement home or college, so someone else can make good use of it. You can also keep all your small bits of yarn too small for anything else together in a jar to use as stuffing for toys. Put any other crafty off-cuts, like felt or material in there too.

Organise your other supplies

As well as organising your yarn, take the opportunity to sort out your other crafting supplies. Keep straight needles and dpns grouped together using hairbands and make sure everything is labelled. Some people keep crochet hooks in pencil cases, bottles, or jars. I keep mine in a drawer with a cutlery tray insert.

TOM'S TIP: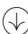

I always advise keeping yarn off the floor, away from dust, pets and any creepy-crawlies. Water is also a no-no. A great way to store yarn is in vacuum-packed bags because these will also keep out moths, who just love to munch through those delicious natural fibres.

Be mindful while you make

Knitting and crocheting are amazing tools for mindfulness and relaxation. For me, they are important forms of self-care and help me to remain calm, even in stressful situations. Clinically proven to reduce anxiety, relieve stress, and re-focus the mind, knitting and crochet are thought to improve self-esteem because you're left with something tangible at the end. Practice stimulates the whole brain and can even slow cognitive decline.

Focus on your breath

All mindfulness and meditation practice focuses on the breath. Think about slowing your inhalations, taking a few seconds longer to exhale, if possible. This will engage your parasympathetic nervous system and turn the dial down on your sympathetic nervous system. This means your heart rate will drop, your blood pressure will lower, and you will be in a state of calm.

Challenge yourself

Practising knitting and crochet makes you focus on what you are doing and the stitches in hand. Try to not let your mind wander to thoughts of the past, future, or your to-do list. If you find your mind starting to think about what you are going to cook for dinner, or if you have remembered to feed the cat, it might be a good opportunity to try a more complex stitch which requires your full attention. I find that even the simple task of counting stitches is a great way to remain in the moment with my knitting or crochet.

Create a space to craft

If you're trying to craft more mindfully, find a quiet space to work away from too many distractions (turn off the TV and put your phone on silent). Find a comfortable spot and give yourself time to sit and relax. When I am not knitting poolside, I love to knit and crochet outside because being in nature I find very calming. At home I like to sit at the kitchen table. Personally, I find the table better for my posture and to support my elbows. Sometimes I'll light a candle or play music while I work.

Engage your senses

Knitting and crochet are wonderfully sensory activities. Consider the softness of the yarn as it moves through your fingers. Listen to the clack of the needles as you work. Employ all your senses.

Reflect on your knitting

Take time to think about your knitting journey, including how knitting fits into your life, how your projects work out, how the physical aspect of knitting feels, and even how knitting may have changed your life.

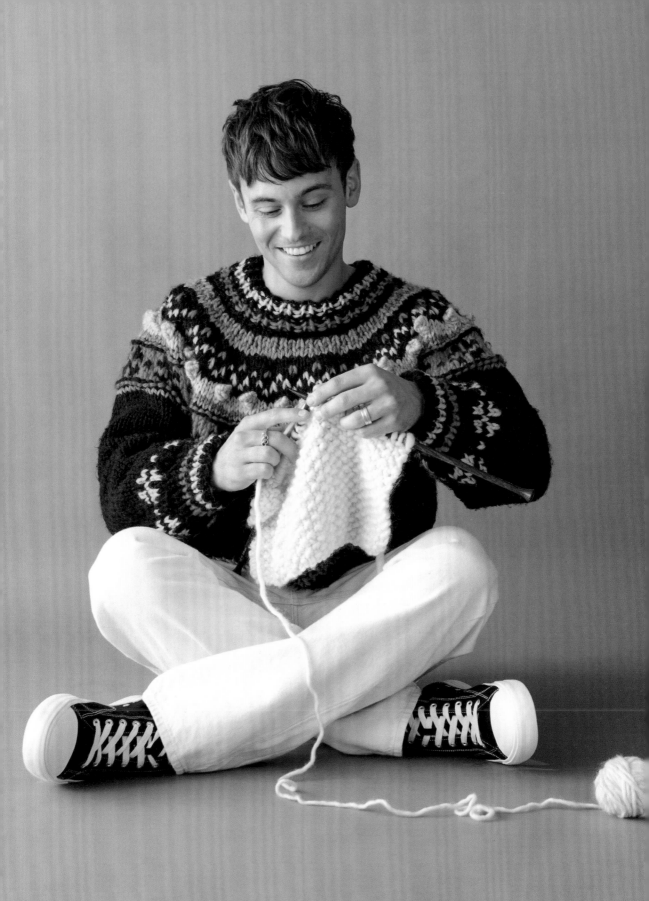

Knit or crochet with upcycled yarns

I am trying to make more sustainable and eco-friendly choices, and making clothes, slowly, by hand, is already a more planet-friendly choice than buying ready-to-wear fast fashion. But I am also learning more about the yarns that I choose to craft with. You can buy yarns made from recycled fibres or even create your own upcycled yarn out of textiles that you already have at home. Why not cut up worn out t-shirts into continuous strips to knit or crochet with (see page 293) or unravel a tired old sweater and re-use the yarn to make something new. (This is known as "frogging" because when you "rip it" back, it sounds like "ribbit, ribbit" – the noise a frog makes!)

There are loads of advantages to knitting or crocheting with recycled yarns. Not only does it do good to the planet, by reducing and reusing waste that may end up going to landfill sites, but it can save you money too. It can also be a great way of finding unusual yarns to work with. Win, win.

What are recycled yarns?
Recycled yarns are either made from pre- or post-consumer recycled fibres, such as plastic bottles or denim jeans or recycled textiles. The fibres are broken down, re-spun and blended with other fibres such as cotton to create new yarns.

Where can you buy them?
If you choose to purchase recycled yarns, there are many choices from big brand names to smaller, indie spinners. Check out your local yarn store or favourite online retailer and ask them for eco-friendly yarns. You can also look out in charity shops, thrift stores and yard sales for hand-knitted garments to upcycle. Be sure to see how they are constructed to ensure they can be frogged (unravelled) and that you can reclaim the yarn.

How do I unravel an old garment?
Start by finding the edges and unpicking the seams carefully by cutting through the sewing stitches. Don't make the mistake of chopping the wrong bit! Simply start from the cast-off edge and unravel the yarn with care, rolling the yarn into a ball as you go. This ball will grow as the item shrinks!

What do I need to know?
Knitting or crocheting with recycled yarns is a slightly different experience from working with new yarns. Check the garment for any care labels and you may wish to hand wash the item in a delicate detergent and leave to dry flat before you begin to unravel it. Sometimes the old yarn can retain the shape of its previous life and not be as smooth. All natural fibres such as 100% wool will be better for reuse, but you may need to steam the yarn before you work with it to help the fibres relax.

What about colour?
Be aware that colours may not be consistent and may vary from one ball to another. Weigh the yarn to ensure you have enough for your project, or incorporate the variations into your design by uses stripes or colour blocking. Yarns can also be re-dyed (or over-dyed), but always check the fibre content and test a small swatch.

Prolong the life of a garment

When unpacking last winter's knits, or rediscovering an old friend sweater at the back of your wardrobe, you might find a few unexpected holes that weren't there before. Wear and tear over time, particularly on the heels of socks or the elbows of sweaters, as well as moths who love to eat natural fibres, will inevitably result in a few holes. But rather than consigning a treasured make to the dustbin or recycling, see this as another opportunity to customise and make it your own.

Darning

The traditional technique of darning has long been used to make small repairs when holes appear in knitwear. It is a thrifty way to extend the life of a garment. Essentially, you stitch a square of simple running stitches around the hole, leaving a good margin all the way round, then you weave the yarn back and forth between the running stitches to patch over the hole. You can use the same yarn and colour to darn over a hole so that it is practically invisible, but I love using a technique called visible mending to make a deliberate feature of the repair. Practitioners like Celia Pym and Tomofholland have made invisible mending on knitwear into an art form.

Appliqué

Instead of using contrasting colour threads to visibly darn over an area, you could cover it completely with a crochet motif or letter – just appliqué the new patch over the existing hole. It is a really fun and creative way to extend the life of your knitting and give your much-loved piece an even more individual edge.

Duplicate stitch

One of my favourite techniques is duplicate stitch, sometimes called Swiss darning (see page 187). This is an type of embroidery that is stitched over knitted stocking (stockinette) stitch. It can reinforce areas of your knitting that are wearing thin but that are not quite a hole yet. Duplicate stitch gives an elegant finish and maintains the original structure of the knitted fabric. And you can even use it to add colourful motifs to your knits that would be more complicated to do using other techniques.

There are loads of other techniques you might like to try, such as embroidery, darning, appliqué, and sashiko. YouTube is your friend when it comes to looking up ideas and experimenting.

Own your making

When it comes to developing your own style of knitting or crochet, there are no rights or wrongs. Whether you want to try something new, completely overhaul your wardrobe or become the next street style sensation – anything goes!

Find the silhouettes you love

Part of feeling confident in your handmade garments is finding shapes and textures that make you feel good. Start by looking at the knitwear in your wardrobe already and your most-loved pieces. Think about why those items are your fave and note down the elements that you love – it could be a roll-neck sweater, a cropped sleeveless vest or a shawl-collar cardigan that are all great for layering. I love oversized knits, and find that using a chunky yarn creates really cosy garments.

Recreate the catwalk

I love seeing the latest designs from fashion houses on the catwalk. One of the best things about being able to knit and crochet is that you can recreate designer styles for a fraction of the price. I knitted my version of JW Anderson's patchwork cardigan, made famous by Harry Styles – it cost me less than a tenth of the original price of the real version. My interpretation of a monochrome Gucci dress that I crocheted for my friend Sophie was really fun to make and cost me £10 in yarn!

Create a mood board

Start a mood board of outfits you love to figure out your style. Online, you can pin images to boards on Pinterest or bookmark photos into your saved folder on Instagram. Offline, you can go old-school by tearing out pages from magazines and pasting them onto card or a pinboard. Your mood board doesn't have to feature knitwear. Anything can be knitspiration – interiors, art, your fave influencer's latest outfit...

Break the rules

Making something unique by hand means you can wear whatever you like. It can be a bit nerve-wracking trying new looks and stepping out of your comfort zone, but your confidence will grow the more you do it. Experiment with incorporating external seams, visible yarn ends or embroidered motifs into your design. If you fancy embroidering your pet cat onto your sweater, do it!

Look to other knitters

I find that just talking about knitting and crochet with like-minded makers can inspire me and give me style ideas. I love browsing patterns online and in magazines. It can a be inspiring to look at the work of extreme knitters – a group of exuberant knitwear designers reimagining the whole craft of knitwear.

"

Every *piece* is unique to *you.*

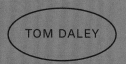
TOM DALEY

"

Recommended Yarns

There is a yarn specified for each of the designs in the project sections of this book. You can stick with the recommended yarn. If so, you just need to pick your favourite shade. However, if you want to use a different yarn to the one specified in the pattern, you need to compare the tensions given on the yarn label to be confident that the finished result and dimensions will not differ too dramatically from the project measurements given. The yarns used throughout this book are listed below in alphabetical order.

Cascade 220 Aran
100% Peruvian highland wool
200m (219 yards) per 100g
(3½ oz)
18–20 sts to 10cm (4 in) on
4.5–5mm (US 7–8)
www.cascadeyarns.com

Coop Knits Socks Yeah!
75% fine superwash merino
wool, 25% nylon
212m (232 yards) per 50g (1¾ oz)
36 sts x 50 rows to 10cm (4 in)
on 2.25–2.75mm (US 1–2)
www.coopknits.co.uk

Debbie Bliss Nell
78% mohair, 13% wool, 9%
polyamide
100m (109 yards) per 50g (1¾ oz)
14 sts x 20 rows to 10cm (4 in)
on 6mm (US 10)
www.debbieblissonline.com

Erika Knight Studio Linen
85% recycled linen, 15% linen
120m (131 yards) per 50g (1¾ oz)
21 sts to 10cm (4 in) on
3.5–4mm (US 4–6)
www.erikaknight.co.uk

Hayfield Bonus Chunky
100% acrylic
137m (150 yards) per 100g
(3½ oz)
14 sts x 19 rows to 10cm
(4 in) on 6.5mm (US 10½)
www.sirdar.com

Kremke Soul Wool Karma Cotton
70% cotton, 30% recycled
polyamide
105m (115 yards) per 50g (1¾ oz)
18 sts x 26 rows to 10cm (4 in)
on 3–4mm (US 3–6)
www.kremkegarne.de

Kremke Soul Wool Morning Salutation Vegan
51% lyocell, 49% cotton
110m (120 yards) per 50g (1¾ oz)
20 sts to 10cm (4 in) on 3–4mm
(US 3–6)
www.kremkegarne.de

MWL The Chunky One
100% merino wool
65m (71 yards) per 100g (3½ oz)
10 sts x 12 rows to 10cm (4 in)
on 10mm (US 15)
www.bytomdaley.com

Paintbox Yarns Cotton Aran
100% cotton
85m (93 yards) per 50g (1¾ oz)
20 sts x 24 rows to 10cm (4 in)
on 4.5mm (US 7)
www.lovecrafts.com

Rico Essentials Cotton DK
100% cotton
120m (131 yards) per 50g (1¾ oz)
22 sts x 28 rows to 10cm (4 in)
on 3–4mm (US 3–6)
www.rico-design.com

Rowan Pure Wool Superwash Worsted
100% wool
200m (219 yards) per 100g
(3½ oz)
20 sts x 25 rows to 10cm
(4 in) on 4.5mm (US 7)
www.knitrowan.com

Rowan Big Wool
100% merino wool
80m (87 yards) per 100g (3½ oz)
7.5–9 sts x 10–12.5 rows to
10cm (4 in) on 10–16mm
(US 15–19)
www.knitrowan.com

Schachenmayr Bravo
100% acrylic
133m (145 yards) per 50g (1¾ oz)
22 sts x 30 rows to 10cm (4 in)
on 3–4mm (US 3–6)
www.schachenmayr.com

Wool and the Gang RaRa Raffia
100% paper
250m (273 yards) per 100g
(3½ oz)
19 sts x 16 rows (single
crochet) on 4.5mm (US 7)
www.woolandthegang.com

And for buttons
Textile Garden
www.textilegarden.com

Thank you ☺

I feel so lucky to be able to write a book about something that I love so much. When I first picked up a pair of needles and some yarn, I could not have imagined that knitting and crocheting would soon turn into one of my greatest passions.

A huge thank you to:

The team at YMU – Alex McGuire, Holly Bott, Amanda Harris, and Elise Middleton, for your continued support and help.

To the HQ team and everyone involved in creating my book, including Erika Knight and Arabella Harris at KnightKraft, Louise McKeever, Lisa Pendreigh, and Georgina Rodgers, and to the hugely talented creative team I worked with on the photoshoots, including Nikki Dupin and Emma Wells at Studio Nic&Lou. This process has been so enjoyable – thanks so much for making it a lot of fun! I am so grateful for everyone's hard work and energy in helping me realise my vision.

To Lance for introducing me to knitting (and for never moaning about my ever-growing yarn stash!) and to Robbie, my family and friends for appreciating my handmade gifts and cheering on my crafting.

To my fellow knitters and crocheters – Team Great Knittin' – I can't wait to see what we make next! #MadeWithLoveGetYourKnitsOut

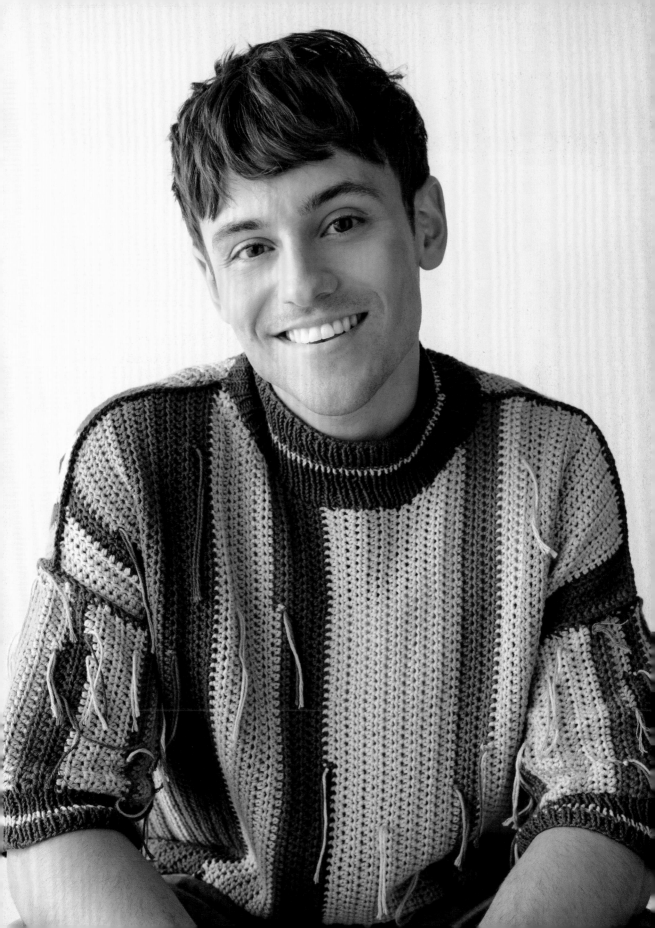

An imprint of HarperCollinsPublishers Ltd
1 London Bridge Street, London, SE1 9GF

www.harpercollins.co.uk

HarperCollinsPublishers
1st Floor, Watermarque Building
Ringsend Road, Dublin 4, Ireland

10 9 8 7 6 5 4 3 2 1

First published in Great Britain by
HQ, an imprint of HarperCollinsPublishers Ltd 2022

ISBN 978-0-00-854682-3

This book is produced from independently certified FSC™ paper
to ensure responsible forest management.

For more information visit:
www.harpercollins.co.uk/green

Printed and bound in Italy by Rotolito S.p.A.

Editorial Director: Louise McKeever
Project Editor: Lisa Pendreigh
Project Design Consultants: Erika Knight and Arabella Harris at KnightKraft
Pattern Grading: Rosee Woodland for Light Work Collective
Pattern Technical Editing and Proofing: Helen Birch, Tricia Gilbert, Amelia Hodsdon,
Faye Perriam-Reed and Lynne Rowe for Light Work Collective
Knitters and Crocheters: Judith Cheek, Gillian Ely, Sarah Ford, Lucinda Ganderton, Erika Knight,
Sally Lee, Joanne Marsh, Lisa Pendreigh, Karin Rayner, Jemima Schlee and Juliana Yeo
Photography: Daniel Fraser
Photography Assistant: Andreas Parperi
Art Direction and Design: Nikki Dupin and Emma Wells @ Studio Nic&Lou
Models: Minmie @ iMM, Naomy @ Body London, Alanna @ Bruce and Brown and Ned the dog
Casting production: Bella Robinson
Styling: Sairey Stemp
Hair and Makeup: Liz Martins and Brady Lea
Step photography: Cara Cormack
Hand model: Chinh Hoang
Production: Halema Begum